AHMANSON · MURPHY
FINE ARTS IMPRINT

THE AHMANSON FOUNDATION
has endowed this imprint
to honor the memory of
FRANKLIN D. MURPHY
who for half a century
served arts and letters,
beauty and learning, in
equal measure by shaping
with a brilliant devotion
those institutions upon
which they rely.

THE PUBLISHER AND THE UNIVERSITY OF CALIFORNIA PRESS
FOUNDATION GRATEFULLY ACKNOWLEDGE THE GENEROUS
SUPPORT OF THE AHMANSON • MURPHY IMPRINT IN FINE ARTS.

THE PUBLISHER GRATEFULLY ACKNOWLEDGES THE GENEROUS
SUPPORT OF THE LITERATI CIRCLE OF THE UNIVERSITY OF
CALIFORNIA PRESS FOUNDATION, WHOSE MEMBERS ARE:

JONATHAN NOVAK CONTEMPORARY ART
MICHELLE AND BILL LERACH
MELONY AND ADAM LEWIS
SHARON SIMPSON

THE FRUITS OF EMPIRE

CALIFORNIA STUDIES IN FOOD AND CULTURE

DARRA GOLDSTEIN, EDITOR

THE FRUITS OF EMPIRE

Art, Food, and the Politics of Race
in the Age of American Expansion

Shana Klein

UNIVERSITY OF CALIFORNIA PRESS

THE PUBLISHER AND THE UNIVERSITY OF CALIFORNIA PRESS
FOUNDATION GRATEFULLY ACKNOWLEDGE THE GENEROUS
SUPPORT OF THE WYETH FOUNDATION FOR AMERICAN ART IN
MAKING THIS BOOK POSSIBLE.

University of California Press

Oakland, California

© 2020 by Shana Klein

Cataloging-in-Publication Data is on file at the Library of Congress.

ISBN 978-0-520-29639-8 (cloth : alk. paper)

Manufactured in the United States of America

29 28 27 26 25 24 23 22 21 20
10 9 8 7 6 5 4 3 2 1

CONTENTS

ACKNOWLEDGMENTS

FOR A BOOK THAT TRAVERSES so many disciplines and subject areas, research at many different archives and conversations with scholars in many different fields are necessary. I am indebted to the following institutions, fellowships, and colleagues who have helped shape my book.

First, I extend thanks to the following institutions and their staff who have made this research possible. Those listed are just a few of many, organized by the first to last institutions that I visited. I express my tremendous appreciation to Sara Duke at the Library of Congress; Krystal Appiah, Erika Piola, and William Royce Weaver connected to the Library of Congress; Amelia Goerlitz and Eleanor Harvey at the Smithsonian American Art Museum; Emily Guthrie and Rosemary Krill at the Winterthur Museum, Garden, and Library; Paul Erickson, Laura Wasowicz, and Nan Wolverton at the American Antiquarian Society; David Mihaly at the Huntington Library; Axel Borg at the University of California, Davis, Shields Library; Paula Johnson at the Smithsonian's National Museum of America History; Carolyn Kastner and Eumie Stroukoff at the Georgia O'Keeffe Museum; and Michele Cohen at the United States Capitol. I am forever grateful for the fellowships

I was awarded from the institutions listed above as well as generous support from fellowships with the Henry Luce Foundation, American Council of Learned Societies, the Ephemera Society of America, the German Historical Institute, and the Family Farris Innovation Award at Kent State University. In the same way that still-life paintings of food are an "embarrassment of riches" in the words of Simon Schama, so too is the full roster of institutions that have funded and believed in my project.[1]

I also extend my deepest gratitude to the following colleagues who so generously read sections of my book and offered invaluable feedback. Erica Hannickel, Anthony Lee, and Mary Ovick significantly shaped my first chapter on grapes; Catherine Holochwost, Laura Turner Igoe, and the editors at *Southern Cultures* greatly enriched my research and second chapter on oranges; Psyche Forson-Williams, Tanya Sheehan, and the Chesapeake Food Studies Workshop provided meaningful feedback on my book chapter addressing watermelon; Monica Bravo and a workshop at the National Museum of American History offered most insightful commentary on the banana in my fourth chapter; DeSoto Brown, Bonnie Miller, Gary Okihiro, Erin Sweeney, and many fruitful discussions with Sascha Scott profoundly influenced my fifth chapter on the Hawaiian pineapple. I extend gratitude to the advisors in my graduate program at the University of New Mexico as well as my colleagues at Kent State University, who provided course relief while I worked on this book manuscript. This project also has been supported by fellow foodie historians: Lia Kindinger, Guy Jordan, and our contributors to "The Gustatory Turn in American Art" in the journal *Panorama* as well as Leo Schmieding and our contributors to *Edible Matters* and *San Francisco Cuisines*— two special issues in the journals *Southern California Quarterly* and *California History*. In the wider scope of my career, I am grateful for the support of Kirin Makker, Katharina Vester, and Lisa Strong, who mentored me in the beginning stages. Conversations with Bill Gerdts and a visit to his extensive library have also made an indelible mark on my research. This book is not a piece but a sum of these many collaborations.

This manuscript could not have been published without the close reading and book-altering feedback from anonymous peer reviewers and those named: Warren Belasco, Marcia Chatelain, and Katherine Manthorne. Their encouragement, combined with the faith of Nadine Little, my editor at the University of California Press, and the talent of my consulting editor, Marina Belozerskaya, brought this book to fruition. I am also thankful for the administrative support of Dawn Hall, Archna Patel, Victoria Baker, and the managerial gymnastics of Kathy Borgogno who helped secure permission rights to many images that seemed impossible to locate. It has been a dream to publish with the University of California Press—a perfect marriage of food studies and art history scholarship.

Finally, if this acknowledgments section was a pot of soup, the heartiest portions would be reserved for my academic advisor and hero Kirsten Buick, my mother Sherrill Kushner, and my husband Adam Reisig. Kirsten Buick and Sherrill Kushner are champions of civil rights and role models for fighting social injustice; they have read

countless versions of my book chapters and lived with this topic since its beginnings. This manuscript is a product of their infinite wisdom and consultation. Adam Reisig has not so much shaped my research as he has participated in yearslong boycotts of his most favorite food chains in solidarity with me and my findings along the course of researching this book. I am grateful for his support and hope that the good fight continues long after this book has been printed.

All royalties for this book will go to the Coalition of Immokalee Workers, a Florida, farmworker-based human rights organization internationally recognized for its achievements in the fields of social responsibility, human trafficking, and gender-based violence at work. More information can be found at: http://ciw-online.org.

INTRODUCTION

"AMERICA IS A NATION** of fruit-eaters," declared the commissioner of the US Viticultural Convention in 1886.[1] In the last decades of the nineteenth century, Americans consumed an unprecedented amount of fruit as it grew more accessible with technological advancements and expansionist laws that boosted the production and consumption of fruit across the country. What was once a luxury food mainly affordable to the elite was now becoming democratized and accessible to people of all social classes.[2] The growing availability of fruit matched its growing visibility in American still life paintings, prints, photographs, and advertisements (fig. 1). Still life pictures of food, in fact, became staples in American homes during the 1860s and '70s, with lithography firms such as Currier and Ives and Louis Prang distributing inexpensive still life prints to the masses for decorating their dining rooms.[3] Not only accessible to consumers of all classes, representations of fruit were also accessible to artists across race, gender, and skill level—artists who were usually prohibited from depicting the nude figure or the loftier subjects of

1

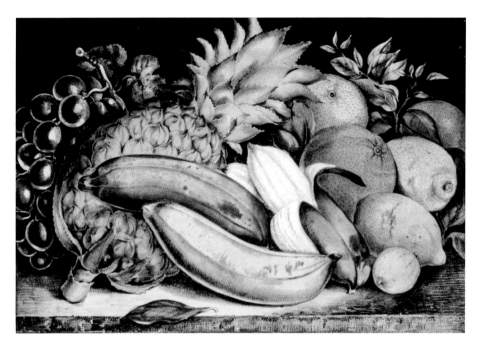

FIGURE 1
Currier and Ives, *Fruits of the Tropics,* ca. 1871. Hand-colored lithograph. Library of Congress, Prints and Photographs Division, Washington, DC.

history painting reserved for experienced artists, typically white and male. The very content of fruit pictures was also democratic in spirit, often promulgating a message of inclusivity in pictures uniting fruits from the North and South on American tables after the Civil War. Its sweet taste and cheerful color lent fruit naturally to joyful messages of unity and abundance designed to uplift the nation after a period of political turmoil. The surge in fruit and its imagery after the Civil War promoted optimistic ideals of inclusivity and equality.

As much as fruit represented these ideals, its production, consumption, and depiction also hinged on inequities of power and exclusive hierarchies of race that showed through in images of the late nineteenth and early twentieth centuries. While pictures of California grapes, for instance, galvanized American support behind a new center for American grape culture, they also denigrated the role of Mexican and Chinese laborers who harvested the very grapes that catapulted California to success. Pictures of orange groves in Florida similarly celebrated new industries in the South while also endorsing the North's consumption of southern land and paternalistic program to "rescue" newly freed African Americans from southern barbarism. Images of watermelons offer the most obvious example of how fruit pictures reflected exclusivity; depictions of African American men stealing watermelons and salivating over them propagated stereotypes about the savagery of black people that challenged their new

privileges and status as citizens in society. Representations of bananas and pineapples in the twentieth century continued to disparage people of color in advertisements that exoticized or sanitized them and minimized their role in the production process. Increased representations of fruit coincided with intense periods of national expansion as well as xenophobia. Because pictures of fruit were so embedded in conversations about race, labor, and territorial gains, they are useful artifacts for studying attitudes about America's expanding and diversifying empire.

Food, in general, is a good measure of national aspirations in the United States because it had been long used to represent and advance the nation's political ambitions. Since the eighteenth century, Americans invented recipes for independence cake, election cake, and congressional bean soup in honor of the nation's republican ideals and practices.[4] Recipes for George Washington and Abraham Lincoln cake also honored America's leaders, and the presidents themselves grew fruit on their estates to model fine taste and agrarian virtues for the nation.[5] American eaters even sculpted their food in the shape of iconic national artifacts and figures, constructing a Liberty Bell from towers of oranges and a sculpture of Christopher Columbus from chocolate (fig. 2).[6] Americans honored their most esteemed leaders and symbols by translating their likenesses into rich, delicious foods. Performing citizenship through food was an important exercise in the last decades of the nineteenth century, when Americans were accused of having no distinct cuisine of their own. This charge was hard to stomach for Americans who believed that "the advancement of a people is measured by its proficiency in the *cuisine*."[7] Russian Grand Duke Alexis Alexandrovich was one critic who proclaimed during his visit in 1871 that America possessed an unsophisticated cuisine, plainly derivative of French food and techniques. This outraged Chef James Parkinson, who defended American gastronomy in a lengthy manifesto listing the "scores and scores of dishes which are distinctly and exclusively American," highlighting the nation's fruit in which "America leads the world, and will take the largest number of first-class gold medals."[8] Parkinson concluded his essay by declaring that "we are not the sheep of French pastures," a direct dig at the Russian duke.[9] This exchange confirms that food was more than a nutritional substance for survival; it was a nationalistic symbol that measured the accomplishments of American society.

At the same time that food was used to honor and uplift the country, it also was used to weaken certain communities. As early as the eighteenth century, patriots famously boycotted imported British tea to protest British forces and the taxes they imposed on such goods. By the turn of the nineteenth century, American abolitionists boycotted sugar, rice, and other foods produced by enslaved labor in order to weaken slave-powered industries. Abolitionists protested slave-produced goods in paintings, prints, and ceramic bowls engraved with messages that bluntly stated, "Sugar, Not Made By Slaves." Boycotts of slave labor persisted into the Civil War era, when many northerners refused to purchase southern foods on those grounds. Protests penetrated both sides of the Mason-Dixon Line; many Americans in the South used the same strategy to boycott

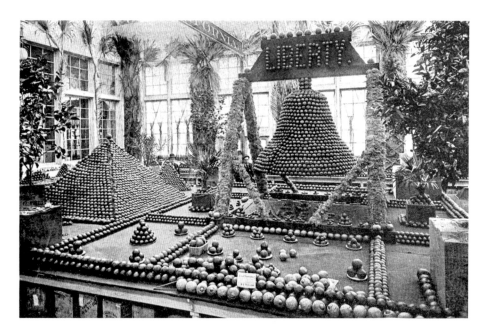

FIGURE 2

"Liberty Bell": And Other Citrus Exhibits. Bell contained 6,500 oranges—Horticultural Building California World's Fair Commission, *Final Report of the California World's Fair Commission: Including a description of all exhibits from the state of California, collected and maintained under legislative enactments, at the World's Columbian Exposition, Chicago,* 1893, unnumbered page between pages 90 and 91. HathiTrust Digital Library, digitized by Google, original from University of California.

northern goods "tainted with abolitionism."[10] Americans readily understood that food could be used as a political tool to undermine an enemy. It had been deployed as a tactic of war even before the nation's founding in the seventeenth century, when colonial settlers burned fields of corn grown by Native Americans to threaten their health and survival.[11] The American government used food again as a weapon against Native Americans in the late nineteenth century, replacing cornmeal with white flour on reservations in efforts to force indigenous people to assimilate to Euro-American foodways.[12] Food, in short, was a long-standing political device for policing people and empowering one cultural group over another. Its role in establishing structures of power and governing the distribution of resources is what makes food so important to study, especially food in the decades after the Civil War, when the country was incorporating new citizens after Emancipation, contending with the swell in European and Asian immigration, and accumulating land in all directions. This book contextualizes fruit and its representation, particularly in the age of "high imperialism"—a time period of intense territorial acquisition between the Civil War and World War I.

This project pays special attention to the relationship between national expansion and fruit cultivation because throughout history, fruit was perceived as an assistant to

the country's growth because it civilized people and landscapes. Horticultural manuals enforced this idea, insisting that the establishment of orchards, vineyards, and orange groves would advance the American empire by converting wild frontiers into refined gardens. Hester Poole wrote in her 1889 manual, "To the horticulturist the world owes more than can be estimated. To tame straggling brambles and wild trees into prolific subjection, and to cause them to shower their melting and aromatic sweetness upon making is to greatly help the march of true civilization."[13] This march had major consequences for the colonization of Native American land, where figures like Johnny Appleseed encouraged farmers on the western frontier to cultivate orchards and bear fruit on what was perceived as a God-given landscape to white settlers.[14] Frequent descriptions of America as a land "flowing with milk and honey," based on the biblical verse alluding to the rich landscape God promised to the Israelites, also used food to endorse white American settlement.[15] Writer Edward Mansfield explicitly connected the cultivation of fruit and land with indigenous removal in his 1850 lecture to the Cincinnati Horticultural Society, declaring:

New nations, new trees, new fruits, new flowers have come to magnify and glorify the face of nature, with far more than its original magnificence; and you, ladies and gentleman, have come to testify to this revival of civilization. . . . We are now entering the era of high and finished civilization. . . . The race of Pontiac and Little Turtle has disappeared! . . . a new race has come. . . . A stronger race, a better destiny, a higher glory . . . will soon build the house of a new and better Garden.[16]

America's garden was built at the expense of Native Americans and on the stolen land of the "Pontiac and Little Turtle." The theft and perceived transformation of this land into fruitful gardens was made to seem inevitable. Mansfield's lecture set the stage for the last half of the nineteenth century, when horticulturists and fruit growers were told that it was their destiny to cultivate America's frontiers and build a new, more civilized society.

Alongside fruit cultivators, many artists and advertisers created depictions of fruit that worked in service of national expansion. Still life artists portraying fruit from the American West, South, Central America, and Pacific showed the greatest support for expanding the American empire, flaunting the material rewards of colonizing land in tropical and semi-tropical environments. What better way to sell Americans on incorporating tropical territories than by visualizing the colorful fruits from those very regions? Picturing fruit from faraway lands on dining room tables promoted America's commercial investments across the country and broader hemisphere, asserting the fruit's rightful placement in American homes. Representations that advertised the benefits of cultivating fruit at the nation's borders merged with the goals of the Homestead Act, Pacific Railroad Act, and Hatch Act—laws that facilitated the opening of fruit-growing frontiers for economic investment in the late nineteenth century. America's territorial conquest

was thus intertwined with its commercial conquest through visual and consumer expressions that stimulated, supported, and naturalized national expansion.

Though many pictures made it clear that fruit cultivation carried the mission of national expansion, the visual culture of fruit was not unilateral in encouraging the nation to expand its borders of citizenship. The same artists, patrons, and viewers who celebrated the incorporation of fruit-growing lands in some instances showed resistance to incorporating the immigrants and people of color who labored, prepared, and consumed these fruits. Artists and viewers wrestled with the integration of people that accompanied territorial expansion by using several devices in pictures to assimilate and naturalize, or disparage and minimize, the role of immigrants and people of color in American fruit industries. This is one of the ironies of empire building: many supporters of national expansion also disavowed it by not wanting to engage with or incorporate the people in regions that they sought to incorporate. Pictures of food thus reflect a diversity of perspectives on nation building and the country's shifting racial makeup that occurred as a result of the growing empire. This book examines how images of fruit were bound up with the politics of race and national expansion in the age of high imperialism and beyond.

FIVE INGREDIENTS: A SYNOPSIS OF THE BOOK'S CHAPTERS

This topic is explored in five chapters, each focusing on a specific fruit: grape, orange, watermelon, pineapple, and banana. Of the wide spectrum of fruits, these are the ones that most clearly and directly informed conversations about national expansion and the politics of race that defined the construction of the American empire. The term *empire* in this case is borrowed from Eric T. Love's seminal text, *Race over Empire: Racism and U.S. Imperialism,* which defines it as "a system of colonization enacted by people in various roles, capacities, and bodies of government to exert control and dominance over people, places, and things."[17] Love sees empire making as "driven by the occupation of land, pursuit of a 'civilizing mission,' economic exploitation, and political intervention reproducing differentiation and inequality among the people it incorporates."[18] Under this definition, the commercial exploitation embedded in the cultivation and representation of fruit can be understood as another form of American imperialism. The following five chapters examine how representations of fruit contributed to the US conquest of people, places, and things by both reflecting and shaping the driving forces behind this conquest.

The first chapter, "Westward the Star of Empire: California Grapes and Western Expansion," begins with an analysis of grapes because they were the most visible fruit in depictions that displayed the United States as a powerful empire. Americans long admired the grape's regal lineage, devoting thousands of paintings and prints to its classical and biblical roots. The grape's popularity in art rose alongside national efforts to build an American grape industry, which bore a heavy load of political ambitions. Many hoped that this industry would improve America's agricultural economy after the Civil War, elevate the country's cultural sophistication, and advance westward expansion by cultivating fruit on land in the western frontier. This enterprise was

made possible by a largely immigrant workforce in California, whose backbreaking labor helped to transform the region into an "American Rhineland." Images of Mexican grape growers and Asian grape pickers, however, sparked controversy among viewers who feared that laborers of color would spoil the purity of America's fruit lands through physical contact with their perceived unhygienic body parts. This first chapter introduces readers to the social politics of fruit and the ways in which its visual representations triggered debates over the racial consequences of westward expansion.

The second chapter, "The Citrus Awakening," shifts from the American West to the American South and examines how the Florida orange carried visions of imperial progress. Surprisingly, northerners, rather than southerners, spearheaded the citrus industry in Florida. Moving south after the Civil War, many northern migrants found that cultivating oranges helped cultivate northern money and political influence in the South. As a result, orange cultivation became a political strategy used to empower Northerners and to advance their visions of southern Reconstruction. Paintings by Harriet Beecher Stowe and Martin Johnson Heade and photographs by William Henry Jackson were accessories to this project, showing vibrant views of Florida orange culture for northern audiences. The orange represented not only the promise of a new South for northerners, but also a new future for African American freedmen who were encouraged to participate in the citrus industry as a way to improve their status after the Civil War. The motivation for this, too, was in part an attempt by northerners to control people and land in the South. By exploring the political context of the Florida orange and expanding scholarly inquiry beyond the well-studied California orange industry, this chapter emphasizes how growing and depicting fruit had political consequences for the expanding nation and its new citizens.

While the first two chapters establish the politics of cultivating fruit, the third chapter explores the politics of consuming it. This chapter, "Cutting Away the Rind," charts the evolution of a cruel racial trope in magazines, paintings, photographs, and silverware that depicted African Americans with a savage appetite for watermelon. This trope emerged in the decades after Emancipation to validate claims that African Americans were an uncivilized people unfit for citizenship. Images of African Americans stealing the fruit from watermelon patches specifically disparaged black men and grappled with anxieties about their growing access to public land and resources in the Reconstruction era. Still life paintings of watermelons stabbed, cut open, and bleeding with juice also resonated with the racial violence of the time period. Many scholars focus on watermelon imagery in the South and in the twentieth century, but this chapter begins earlier in the nineteenth century and in the North to demonstrate how images of watermelon were used widely to support or challenge claims of racial inferiority. This third chapter examines how the promise of oranges for African Americans in the Reconstruction era descended into the malicious intentions behind images of watermelon in the Jim Crow era.

The fourth chapter, "Seeing Spots: The Fever for Bananas, Land, and Power," reveals how representations of fruit continued to support systems of inequality as

small banana businesses expanded to large, corporate-controlled plantations abroad in the early twentieth century. This shift culminated in the United Fruit Company, a major American distributor of bananas, which controlled the politics, transportation, and other key resources in the regions where they established businesses. While most scholarship on United Fruit focuses on the men who shaped the company's policies and labor practices, this study focuses on the image makers and housewives who marketed the banana, helped assimilate the fruit, and advertise the company's broader "civilizing" mission in Central America and the Caribbean. The consequences of this mission, however, were fatal. United Fruit was ruthless in advancing its economic interests in countries like Guatemala, organizing a number of deadly coups to remove banana lands from local control. Several contemporary artists have used their art to criticize US banana companies, including Moisés Barrios, who paints surrealist images of American soldiers and war planes occupying bananas to critique US intervention in Latin American politics. This chapter probes how representations of the banana supported or, in some cases, resisted American ambitions abroad at a time when the country was expanding businesses outside the borders of the United States.

The final chapter, "Pineapple Republic," describes the most explicit case study of how fruit serviced national expansion and the American incorporation of territories. The pineapple is a prime example of the alliance among fruit, art, and empire because leaders of the Hawaiian pineapple industry worked directly with artists, world's fair exhibitors, and leaders in the American government to conquer indigenous land in Hawai'i, incorporate it into the American empire, and secure American interests in the Pacific. This mission was supported by the Dole Hawaiian Pineapple Company, which organized some of the earliest pineapple exhibits at world's fairs to garner support for the investment in and annexation of Hawai'i. In the 1920s and '30s, the Hawaiian Pineapple Company created photographs and advertisements in collaboration with well-known artists to elevate the pineapple's reputation among American consumers and paint a wholesome portrait of its Asian workers—many of whom were the target of exclusionary immigration laws and racism. By the 1950s, the Hawaiian Pineapple Company incorporated more Native Hawaiian people into its advertisements, pushing for the acceptance of Hawaiians as citizens in support of the campaign for statehood, which promised to benefit the Hawaiian pineapple industry. This last chapter highlights the partnership between fruit, race, and empire and the ways in which fruit corporations used visual images intelligently and strategically to support national expansion in the twentieth century.

METHODOLOGICAL APPROACHES TO THE VISUAL CULTURE OF FOOD

The notion that food bears cultural meaning and expresses national values is not new. There is a robust canon of interdisciplinary scholarship ranging from food studies to material culture that is vital for scholars to know and employ when interpreting representations of food. Beginning in the mid-twentieth century, a constellation of Ameri-

can and French anthropologists, such as Roland Barthes, Pierre Bourdieu, Mary Douglas, and Claude Lévi-Strauss, all investigated the social codes embedded in food and taste.[19] They discovered that in contrast to some animals that digest almost anything, humans make distinctions between what is edible versus inedible, thereby revealing taste to be a social construction determined by an eater's cultural background, upbringing, education, and social class. These philosophers analyzed what people ate, where they ate, and what utensils they used—finding that the difference between using a fork or a chopstick, for instance, signified class structure and social privilege.[20] No object "is without conscious symbolic load," explained Mary Douglas.[21] Anthropologists of the twentieth century laid the groundwork for the contemporary food studies field by analyzing the anthropology of a meal and taxonomy of the dinner table.

Today's food studies scholars carry the torch of earlier anthropologists to demonstrate how food is a prominent site for the construction of race, gender, and other discourses of identity. The research of Sydney Mintz, Gary Okihiro, Melanie DuPuis, Kyla Tompkins, and Psyche Williams-Forson specifically shows how food shapes concepts of identity and has been used throughout history to establish hierarchies of power.[22] Such examinations are complemented by the field of environmental history, where scholars Frieda Knobloch, Philip Pauly, and Steven Stoll have analyzed agriculture's role in asserting control over land and people.[23] Their work reveals how the simple act of growing food on a plot of land inevitably transforms, domesticates, and enforces dominion over the landscape. It is not just food, then, that reflects the distribution of power, but the very spaces where food is grown. With the understanding that food is intrinsically intertwined with the politics of colonialism and power, *The Fruits of Empire* seeks to expand on this canon of scholarship by demonstrating how representations of food in the United States also contributed to national construction.

This book brings together methodologies from multiple disciplines: anthropology, food studies, and, most significantly, visual and material culture and art history. This combination is necessary for studying food because Americans produced many rituals and consumer goods around activities such as the consumption of food. Kenneth Ames, T.H. Breen, and Jules Prown pioneered approaches to American material culture and encouraged scholars to study the history of such everyday objects as grape scissors or banana stands because ordinary goods transmit ideas about those who fabricated and used them.[24] Scholar Arjun Appadurai looks more expansively at material culture by examining the "social life" of things and recognizing how commodities are objects in motion that travel through different stages from production to consumption, with their meaning changing in each context.[25] It is useful to study the "social life" of fruit from field, to table, to canvas because many fruit painters in the United States were themselves amateur horticulturists or had patrons invested in food businesses and, as a result, were interested in the aesthetics of fruit as much as its cultivation and sale. The fact that food itself is a representation with aesthetic properties shaped by the way it is grown, prepared, and consumed also warrants a deeper

consideration of its material culture. This book imports ideas from the disciplines of material and visual culture in order to understand how artists and viewers vested meaning in representations of food and the objects used to grow and eat food.

Despite the layered meanings of fruit pictures, they have been historically dismissed as mindless, mechanical exercises in the replication of nature. Still life depictions of fruit have been long disparaged for their lack of didacticism and moral instruction—qualities that were present in the more prestigious genres of history and allegorical paintings. A critic for the *North American Review* wrote in 1831, "We would not absolutely denounce what is called still-life painting, but we value it very lightly; and we protest against . . . those works, of which the whole supposed merit consists in an imitation of what is in itself entirely insignificant."[26] Almost fifty years later, this notion persisted in an article from the *Art Amateur* journal, which similarly professed, "the painting of fruit and still-life is generally considered a lower and unimportant branch of art when compared with figure and landscape painting . . . as there are less difficulties to contend with in its pursuits and not the opportunities they offer for the embodiment of sentiment and imagination."[27] In sum, still life painting was considered less physically and conceptually challenging than higher genres of art. Scholars of the twentieth century continued to view still life paintings as unchanging and having little narrative or plot; art historian Norman Bryson described still life painting as slow-moving, defined by things that lack importance or narrative.[28] Yet, this viewpoint also propelled him to "look at the overlooked" and pay attention to what is usually disregarded, realizing that still lifes are, in fact, full of meaningful narratives and semiotic power. The following text carries on this mission to study mundane and overlooked objects such as fruit imagery and its role as a platform for discussing the aspirations of the nation.

Since still life depictions of fruit play a central role in this book, art historical methodologies have been most fundamental to this research, particularly the pioneering work of William Gerdts, Wolfgang Born, Norman Bryson, and Charles Sterling.[29] Gerdts's prolific writings have been especially seminal, providing the most comprehensive archive of fruit painters in the country.[30] When few academics turned their attention to American still life painting, these scholars proved how the ordinary objects painted by artists were full of signs and codes that reveal the larger cultural structures and concerns of a society. A more recent generation of scholars, such as Alexander Nemerov and Nancy Siegel, has expanded the field to explore the deeper connections between food, art, and the politics of identity.[31] The most revelatory research to date has been conducted by Judith Barter, whose exhibition and book, *Art and Appetite: American Painting, Culture, and Cuisine,* reveals how "American paintings have used food to reflect on issues related to class, politics, commerce, and art."[32] Depictions of food also reflected on issues of race, and nowhere is this more convincing than in Krista Thompson's book, *An Eye for the Tropics,* which shows how pictures of Caribbean fruit and landscapes governed ideas about race and policed people of

color.[33] *The Fruits of Empire* stands on the shoulders of these thinkers who first contemplated the cultural landscape of food in American art.

While an increasing number of scholars of American art are recognizing food's interpretive possibilities, scholarship in Dutch art has long tussled with the uneven politics of food.[34] This is not surprising, given that European art history is a more established field, and historians of Dutch art have an especially vibrant canon of still life paintings to study. Julie Berger Hochstrasser offers a particularly rigorous analysis of food and the inequitable systems of labor that produced it in her book, *Still Life and Trade in the Dutch Golden Age*.[35] Hochstrasser does not shy away from describing the histories of slavery and exploitation behind many of the commodities visible in Dutch painting, asking the haunting questions: who consumes what? And at whose expense?[36] She wonders how the wealth and accumulation evinced in Dutch still lifes have been created on the backs of the under- and uncompensated. The same questions can be directed to still life representations in the United States, where American artists were profoundly inspired by Dutch masters and borrowed many of their visual devices. Like in Dutch art, food in American art is the perfect subject for studying social stratifications because it is vital for life and reflective of social decisions that are inextricably linked with the operations of a society. Food, in other words, tells us about power relations. Applying queries in the area of Dutch art history to the subject of American art helps to see how food and its representations were useful devices for addressing social disparities in this part of the world.

A recent generation of food studies scholars also has highlighted the role that food plays in establishing social inequalities. Melanie DuPuis, for one, explains that food "offers an opportunity to engage with the politics of inclusion and exclusion" because people have used dietary choices to create strong boundaries between ideal citizens and those who do not fit the ideal.[37] This resembles the process of "culinary imperialism," which, like Jeffrey Pilcher's definition of "cultural imperialism," insists on the superiority of Euro-American foodways and the push for immigrants and people of color to abandon their own culinary traditions.[38] Kyla Tompkins makes clear in her book *Racial Indigestion* that eating has played a significant part in the privileging of whiteness and has been central to the production of raced and gendered bodies.[39] Perhaps this is why food has been so useful for developing stereotypes and pejorative terms like "beany," "kraut," and "cracker"—terms used to denigrate people of color, immigrants, and people of the lower classes.[40] Even though food is a universal object that all people require to survive, it is stratified by class, race, and other social divisions. This book brings together the cultivation, representation, and consumption of food to examine how images of fruit participated in the process of including or excluding groups in American society.

THE REPRESENTATION OF FOOD AND FOOD AS REPRESENTATION

While many scholars have proven how food industrialists and dietary reformers used food to produce and reinforce racial difference and inequality, more attention needs

to be paid to how artists and image makers reified, resisted, and wrestled with these social issues. Attention to visual representations should be a requirement for any scholar studying American food because consumers in the United States frequently encounter food through images and not just the foods themselves. There are likely many instances when American consumers first learned about certain foods through pictures that showed comestibles unavailable in markets. Images of food were, in these cases, the first point of contact for American eaters. More dangerously, racist representations of food were ubiquitous, reiterating stereotypes and fortifying imbalances of power in advertisements, journals, and photographs that spread widely to consumers across social classes. Attitudes about race and gender pervaded even the most seemingly innocent object like a crate label, allowing cultural beliefs and ideologies to become part of the natural fabric of everyday life. As some of the most widely available and accessible cultural forms in society, representations of food and the agendas they supported formed the nation's consciousness.

In addition to its ubiquity, the seductiveness of food imagery is also part of its power. Viewers in the nineteenth century often commented on how pictures of fruit look good enough to eat, taste, or cook. Representations of dead and hanging game, on the other hand, could not make the same claim. The savory qualities of fruit pictures not only seduced viewers with imaginings of a dreamy meal but also helped naturalize and make appetizing messages about race and national expansion that simmered beneath the surface. This book provides abundant examples of how artists depicted clean, colorful, and juicy fruits to entice migration to faraway lands, manage anxieties about laborers and people of color living there, and sanitize unfamiliar foods considered racially impure. Controversial frontiers and people could be made more acceptable and digestible through seductive depictions of their fruit. Such picturesque depictions, combined with food's mundane qualities, made the image's discursive work subtle, strengthening the structures of power that underlay them. This study requires scholars to look beyond the edible and pretty aspects of food imagery to access the unsavory politics that have been obscured by its tasty appearance.

The task of this book, then, is to show how representations of fruit were shaped by the politics of empire and, in turn, shaped the empire. When looking at Dutch still life painting, Hochstrasser pursued a common goal but moved away "from looking at cultural artifacts as merely *reflective* of the cultural context that surrounds them, toward perceiving them rather as fundamentally *constitutive* of culture itself—as active agents in the development of the thoughts and ideas that steer the course of history."[41] This book takes on a similar call to action by investigating not only what representations of food *show* but also what they *do*. How did the producers of food images seek to shape national expansion and racial attitudes by idealizing, exoticizing, erasing, or editing out qualities about food laborers and consumers? How did artists use food to fashion, affirm, or challenge attitudes about food, land, and people at the core of national expansion? Fruit images had the potential to influence the nation in this way because

food struck the nerve of the nation's most heated debates over land, labor, race, and citizenship. These debates were not homogenous, and neither were the artistic interpretations of fruit that supported American imperialism. This book demonstrates how representations of food both reflected and shaped perspectives on race and national expansion through varying shades of oppression and resistance.

Studying the history of food in concert with its representation is at times messy because every food possesses its own historiography, as does every image of food. It is easy to confuse the individual histories of food with the histories of their representations because the history of food closely parallels that of food in art. For example, American artists started painting the banana at the same time as American consumers began gaining access to this fruit. More often than not, American artists depicted foods in real time when they were currently available. For this reason, the nineteenth-century still life painter Andrew John Henry Way dreaded the arrival of winter—the most challenging time for the fruit painter who "is almost at a loss for subjects beyond some foreign productions."[42] He also struggled with access to tropical fruits, which were "interesting to paint whenever they find their way to our markets occasionally."[43] Because the visibility of many foods in the market matched their visibility in pictures, it is easy to conflate the history of food with the history of its visual representation. While this book shuffles back and forth between the histories of fruit and its depictions, it prioritizes images of food over the foods themselves and the unique discursive work visual images performed.

By considering food through an interdisciplinary lens, this study promises to expand scholarship in several ways. First, the exploration of fruit imagery in cookbooks, trade card advertisements, and silverware designs widens the scope of scholarly inquiry by looking beyond the traditional fine arts to the broader material and visual culture of the United States. Joining low- and high-brow objects together paints a more complete picture of art and society that includes artists of different ranks and genres. Second, this project sheds light on the labor conditions for producing the foods visible in art, recovering the histories of immigrant workers and laborers of color who have been marginalized in scholarship. Understanding the circumstances of their work reveals how pictures of fruit often belie the realities of fruit labor and gloss over inequalities in the fruit industry. Lastly, the analysis of fruit imagery in California, Florida, Central America, and Hawai'i facilitates the rediscovery of several artists whose critical reception has been historically overlooked in an American canon focused on Northeastern art. Looking expansively at artists across regions and cultures reveals how the fruits they depicted symbolized global, diverse networks as America was expanding its borders. It is for this reason that the apple—the most patriotic, American fruit—is excluded from this book. For while the history of the apple tells a story about European colonialism and indigenous conquest in eighteenth- and early nineteenth-century North America, by the late nineteenth century, it embodied domestic pride and American nativism that did not expressly reflect the aspirations of

far-flung frontiers in the age of high imperialism.[44] By focusing on images of fruit grown on and in the borders and spaces where many people in the United States were themselves considered borderline citizens, my goal is to present a more expansive narrative of food in American art and open new fields of investigation around the transregional, interdisciplinary lives of food imagery.

This discussion is timely, with the recent rise in programming and museum exhibitions devoted to food. In addition to the landmark exhibition *Art and Appetite: American Painting, Cuisine, and Culture* presented by the Art Institute of Chicago in 2012, another major exhibition, *Audubon to Warhol: The Art of American Still Life* at the Philadelphia Museum of Art in 2016, also mined representations of food for meaning.[45] Interest in food has been demonstrated by the growing number of food studies programs across the country and food studies journals, such as *Food, Culture, and Society; Food and History;* and *Gastronomica.* There also has been a recent growth in archival institutions devoted to food, including the Fales Library Food and Cookery Collection at New York University, the Janice Bluestein Longone Culinary Archive at the University of Michigan, and the David Walker Lupton African American Cookbook Collection at the University of Alabama. All of these archives are recognized by the largest academic association for food—the Association for the Study of Food and Society (ASFS)—composed of more than one thousand members. *The Fruits of Empire* marks another step forward in the national project of studying food, seeking to illuminate the conversations about race and national expansion that pictures of fruit yielded to the surface.

1

WESTWARD THE STAR OF EMPIRE

California Grapes and Western Expansion

"**AMERICANS HAVE GRAPE** on the brain!" announced George Husmann in his 1865 article, "The New Era in Grape Culture."[1] The cultivation of grapes increased significantly in the mid- and late nineteenth century in part to reinvigorate American agriculture after the Civil War. The establishment of vineyards and grape-growing competitions galvanized farmers on both sides of the war to build a profitable fruit industry after many of the nation's fields had been neglected by farmers away at battle. The push to grow grapes in the Civil War era expanded on earlier grape-growing efforts in the antebellum period, when horticulturists in New York and Cincinnati helped advance the science of viticulture and advertise their grapes and wines on a mass scale. By the mid- and late nineteenth century, the grape craze was manifested in the hundreds of viticulture manuals and proliferation of grape-growing associations that focused on their economic value and cultural worth as a noble pursuit practiced by France, Germany, and Italy—a few of the grape-growing countries that the United States admired. Grape

growing was a cultural enterprise motivated by desires to assert America's sophistication and locate the United States in a lineage of Europe's perceived cultural leaders. Viticulture development promised to elevate America's cultural importance as well as colonize landscapes that were thought to be divinely sanctioned to white Americans. While scholars have uncovered how grape growers were enthusiastic supporters and communicators of national expansion, a deeper consideration of grape paintings and world's fair exhibits in the late nineteenth century reveals how image makers were also central to translating the mission of expansion.[2]

Because grapes promised to elevate America's status in the world, they were constantly exhibited in world's fair exhibitions that sought to map the United States—and specifically California—as the world's center for grape culture. The grape industry moved west to California in the late nineteenth century after a devastating virus destroyed vineyards in the East and Midwest. Grape exhibits at the 1876 Philadelphia Centennial and 1893 Columbian Exposition displayed the potential of cultivating California vineyards in banners, brochures, and decor that declared California's transformation into an American Rhineland. World's fairs specifically displayed the Spanish mission grape variety, which evoked historic California, after Catholic missionaries from Mexico established vineyards in the seventeenth and eighteenth centuries. Artists Samuel Marsden Brookes and Edwin Deakin also advertised the California mission grape in still life paintings that capitalized on a renewed interest in the state's Mexican history as part of the California Mission Revival movement. Visual representations of grapes in the late nineteenth century struck a unique balance in promoting California's future as a capital for grape culture while honoring the state's grape-growing past.

Americans looked admiringly at the genesis of California grapes and wine but not at the original planters or laborers of these vines. White American vintners criticized the Mexican planters of "Spanish California" for mistreating California grapevines. Claims that white farmers rescued these vines from Mexican owners were made to justify the earlier US conquest of California and validate what was perceived as the rightful transfer of its resources to a more competent race. Such racial prejudices seeped into world's fair exhibits that diminished the important contributions of Mexican grape growers as well as Native American grape laborers, who were forced to work vineyards under the control of Franciscan missions. Racist attitudes also penetrated images of Chinese grape laborers, who were at the center of debates over immigration reforms. In popular presses such as *Harper's Weekly,* images of Chinese men treading the California wine press sparked controversy in a time when many feared that Asian laborers did not meet the standards of white cleanliness and would thereby contaminate wine and destroy the integrity of America's vineyards. Illustrators had to negotiate these anxieties by recording images of grape labor without compromising the product's reputation for purity among their audience. Throughout history, food has triggered conversations about racial difference and purity, but the impact of these

conversations on artists and artworks depicting food has not been well understood or studied. The following study reveals how the representation of grapes supported visions of national expansion in California that relied on, yet excluded, people of color.

GRAPE RIVALRIES: THE QUEST FOR VITICULTURE SUPREMACY AT THE PHILADELPHIA CENTENNIAL

In 1864, Horace Greeley sponsored a grape-growing competition, offering $100 for the best table grape produced by an American farmer.[3] Grapes, a vine plant known scientifically as *Vitis vinifera*, had been growing in the United States for centuries, but grapes were not cultivated on a large scale until the nineteenth century, when markets formed around raisins, table grapes, and processed wines. Greeley searched for the hardiest and most adaptable market grape that could be successfully planted in any region, broadcasting the call widely in newspapers and agricultural periodicals—a task made easier by his status as editor of the *New York Tribune*. It might have seemed foolish for Greeley to sponsor this award in the middle of the Civil War, after soldiers had just fought devastating battles at Antietam and Gettysburg. To grow and submit one's best grape cutting might have seemed frivolous at this moment when all resources were directed to the war effort. Farmers themselves were a limited resource as they deserted their work in fields and vineyards to fight in the war. But Greeley, a clever politician and famous supporter of the Union, might have believed that sponsoring a grape premium in the last year of the Civil War would help unite Northern and Southern farmers and renew agricultural ties between the divided regions. It became increasingly important to uplift agricultural industries in the North and South in order to compete with the quickly growing agricultural economy of the American West, a formidable rival.[4] When the competition closed in 1866, the committee awarded Greeley's premium to Boston's Concord grape, which irritated Southern farmers who felt the decision was biased toward "northern sections … where the grape ripened earliest."[5] Even though Greeley praised the Concord, calling it a "grape for the millions," he, too, was disappointed with the selection of such a well-known grape, declaring that "all my money did, was to advertise a grape already known."[6] In the end, Greeley's competition failed; he was not able to select an innovative grape or unite American farmers.

Despite efforts to unite the North and South over grapes, a California industry was growing and boasting its accomplishments at the 1876 Philadelphia Centennial, where an eight-feet-tall and fourteen-inches-wide Spanish mission grapevine unseated England's Hamburg grapevine, formerly the world's largest specimen, at Hampton Court (fig. 3).[7] The Spanish mission grapevine was so massive that it had to be cut up, divided into sections, and boxed for shipment across the country to the fair in Philadelphia.[8] The vine's owner and tireless promoter, Michael Sarver, personally escorted it to the fair.[9] Nicknamed "La Parra Grande," or "the large vine," the mammoth grapevine was known as a horticultural prodigy and celebrity of Spanish California among the Centennial's thousands of visitors. Sarver delighted in the fact that his California vine

FIGURE 3

Centennial Photographic Co., photographer, *Philadelphia Mammoth Grape Vine of Santa Barbara—Agricultural Hall*, 1876. Albumen prints 1870–80, 4 × 3¼ in. Library Company of Philadelphia, P.8965.27e.

outgrew the previous record holder, boasting that the Hampton vine would have looked shrunken next to his mission vine, whose branches were twice the diameter.[10] The mission vine was a huge attraction in the Agricultural Hall, overshadowing the European Hamburg and placing stock in California's grape culture.

The Centennial display of the mission grapevine was a useful means for Sarver and other California promoters to encourage investment in the state. Placing the mam-

moth vine next to a booth of wines decorated by agricultural diplomas publicized California's success in viticulture and its ascendancy over New York and Ohio, earlier grape capitals in the mid-nineteenth century.[11] A host of pests, parasites, and a fungus known as black rot had destroyed grapes east of the Mississippi, inspiring European immigrant grape growers, specifically German and Hungarian growers, to push the grape industry farther west to California in the 1870s. The resistance of some California grapes to phylloxera, another grape pest, further propelled the industry westward. The exhibit of California grapes at the Philadelphia Centennial, therefore, was an important opportunity to publicize the nation's new center for grape culture. An article in the *Pacific Rural Press* praised the exhibit as "a means of advertisement for the coast" and "an immense value to the whole state of California."[12] Chef James Parkinson related the success of California grapes to the success of the United States more broadly, writing: "If the Centennial World's Fair should be the means of impressing the American people with the capabilities of our country to make excellent native wines from the pure juice of the grape, and so lessening the consumption of imported wines ... this of itself would be a service to good health and good morals which would a thousand times compensate for all the expenses of the exposition."[13] Parkinson was hopeful that the Centennial would confirm to the world that America had capable vintners and pure wines. With the mammoth mission grapevine, vintners carried similar aspirations as earlier vintners in the antebellum period to develop a uniquely American grape industry and outrank Europe in grape-growing supremacy.

Paradoxically, at the same time that this exhibit highlighted America's superiority over European grape growing, Sarver sold souvenirs and photographs emphasizing the Spanish heritage of the mammoth mission vine. He highlighted the grape's Spanish ancestry at a time when the history of California missions held great currency and Americans showed a greater interest in California's past around the Spanish Mission Revival movement. Beginning in the 1890s and stretching into the early twentieth century, the Mission Revival movement marked a rising fascination with literature and architecture inspired by the Spanish missions in California. Descriptions of sultry señoritas and gallant caballeros in booster literature and romance novels presented a nostalgic view of Spanish mission life in "Old California," a region that had actually been ruled by Mexico, and not Spain, since winning independence in 1821. Spanish power in the Americas had been dwindling in the early 1800s, when Mexico gained independence from Spain in 1821. By 1833, the Mexican government passed the Secularization Act, which stripped Mexican friars of their mission lands. Eventually, missions were taken over by wealthy Mexican families who created large-scale cattle ranches, maintaining power until the Mexican-American War, when California was conquered by the United States, which supported Anglo settlers in the region. California was a melting pot of people who identified culturally and racially in various ways during time periods of dramatic demographic shifts.[14] American narratives emphasiz-

ing California's "Spanish" influence from Europe was a way to whiten the lineage of California and minimize the presence of Mexican people who were derided as primitive and lazy, especially in the years around the Mexican-American War.

Sarver contributed to this revisionist history by celebrating the Spanish origins of the mission vine in his 1876 book, *The History and Legend of the Mammoth Grapevine*, where he claimed that the vine had been planted by a beautiful, young Spanish woman named Doña María Marcelina Feliz in current-day Los Angeles. Feliz received the grapevine from her lover, Don Carlos José Dominguez, who belonged to a wealthy family. Dominguez's upper-crust family disapproved of his relationship with Feliz, who was from a lower-station family. The Dominguezes ultimately drove her out of town, at which time Don Carlos gave her a grape cutting to be used as a riding switch for her journey to Santa Barbara. He asked Feliz to plant the cutting at her final destination as "a living memento of their plighted faith."[15] After carrying the grapevine for more than one hundred miles, Feliz planted it at the conclusion of her journey in the most beautiful spot in Santa Barbara's Montecito Valley.[16] There, Sarver said, it flourished more than any grapevine of its kind, symbolizing the couple's eternal love in spite of their forced separation and clashing social classes.

While Sarver capitalized on the vine's popular love story by publishing a book on it and creating a tourist attraction known as the Mammoth Grape Vine Resort in Montecito, he also distributed photographs of the vine at the Philadelphia Centennial that exploited nostalgic ideas about Spanish California (fig. 4). One photograph specifically conjured up the grapevine's legacy, showing it draped over a trellis and providing shade for a seated woman in a long hacienda-style dress. Centennial viewers were reminded of Feliz, whom the *Overland Monthly* described as "a queen among the maidens of her native place . . . her wealth of black hair fell in rippling waves far below her waist; and her large, dark eyes were fringed with silken lashes that matched the exquisite penciling of the arched brows above them."[17] The placement of Sarver's sitter underneath a grapevine next to an empty chair called to mind Feliz's tortured love story and her absent lover who gifted the grapevine that grows above her. In producing a long shot, profile view of this woman alone with an empty chair behind her, Sarver made an image that tugged at the heartstrings of viewers, making them feel privy to a private moment in which Feliz gazes off into the distance as if thinking about her lover's fate. Far from the bustling markets and fruit stands that sold grapes to consumers in the late nineteenth century, this photograph transported viewers to a romantic reverie of eighteenth-century California before the region's industrialization.

What seems like an innocent tale of love and romance actually supported a much darker narrative about the colonization of California. Planted in 1775, just one year before America's formation in 1776, the mammoth mission grapevine was raised on indigenous lands that New Spain's leadership had stolen as part of Alta California. Photographs of the vine transported viewers to this era in California, when Franciscan monk Junípero Serra chartered the first mission in California. Alongside the conquest

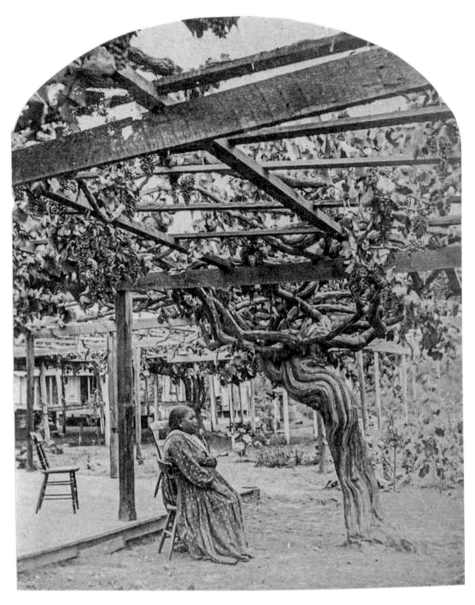

FIGURE 4

Centennial Photographic Co., photographer, *Philadelphia Mammoth Grape Vine in Santa Barbara*, 1876. Albumen prints 1870–80, 4 × 3¼ in. Library Company of Philadelphia, P.8965.27f.

of indigenous lands and building of the state's first missions, Franciscans established vineyards of imported plantings and cultivated grapes for trade and religious ceremonies. Franciscans also planted grapes for more political purposes: to import Spanish culture to California for the greater purpose of civilizing and colonizing the region. Historian Frieda Knobloch explains how agriculture has always served an intensely

colonial purpose and was used by settlers to conquer, transform, and domesticate "wild" territory.[18] In the eighteenth century, when California missionaries parceled Native American lands and turned sections into European-style vineyards, they too were exercising dominion over indigenous landscapes. This enterprise operated on the forced labor of Native Americans who in large part built the Spanish missions, cultivated mission vineyards, and raised livestock on mission properties.[19] In the same way that Spanish missionaries set out to civilize the California landscape, they also set out to civilize Native Americans in California and convert them to Spanish traditions. Portrayals of mission grapes did not acknowledge these circumstances, yet they were inseparable from the history of missionization in California and the dispossession of indigenous land that accompanied this imperial project.

Grape authority Thomas Hart Hyatt applauded the mission grape's long legacy and its role in accompanying Spanish colonizers throughout the world. In Sarver's book on the mammoth mission grapevine, he wrote:

> [The mission grape] is about the only kind retained by the Spanish residents whose forefathers introduced it with other varieties from Spain upon their first settlement of this country. Having been introduced by the Spanish Missionaries, and being the chief variety retained and cultivated by them at their Missions, it became known as the Mission grape. . . . They very much resemble a grape we have seen in Morocco, taken to that country, from Spain we presume, by the Moors, after the conquest.[20]

In following Spanish settlers from country to country along their conquests, the mission grape earned a reputation as a resilient fruit, born to assist the colonization of land. The fact that Father Junípero Serra, California's best-known colonizer, is credited with bringing the first Spanish mission grape to California only reinforced the fruit's deep connection to the early occupation of the state when Serra chartered the first of twenty-one missions in California.[21] When reading literature and seeing images of the mammoth mission grapevine together, it becomes clear how this grape was an ambassador of colonial California and a servant to advancing California settlement. It seems meaningful that the mammoth mission grapevine was planted a year before America's founding and then died in the same year as America's one-hundred-year anniversary.

Its display, and ultimate death in 1876, signified the triumph of Americanization in Alta California. At the same time that horticulturists celebrated the vine as a representation of this transfer of power, they also mourned the vine's death, which they blamed on the past generation of Mexican-era owners who supposedly neglected and mistreated it. Hyatt shared this perspective on the mammoth grapevine, writing, "There is no question that its ruin was caused by the bad treatment it received from its Spanish owners during the last ten, but more particularly, the last three years. It is very probable that it did not live out half its days." Only once the grapevine had come under the ownership of American experts like Michael Sarver, Hyatt claimed, had "the soil

[been] cultivated and enriched" and properly irrigated.[22] Descriptions of the vine's mistreatment by Spanish (read: Mexican) owners reflected wider racial stereotypes at this time, which portrayed Mexican farmers as lazy, uneducated, and incompetent compared to white American farmers. Journals and novels from this period also perpetuated stereotypes about the "lazy Spaniard" and the lack of character among Mexican farmers.[23] Many Americans, as a result, had supported the conquest of Alta California, its annexation to the United States after the Mexican-American War, and its transfer "from the hands of an inert race into the possession of a new and energetic people."[24] The display of the mammoth mission grapevine in photographs and exhibitions for the Philadelphia Centennial represented a unique paradox by honoring the legacy of "Spanish" civilization in California while celebrating the "rightful" delivery of Mexican California to white American hands.

"WESTWARD THE STAR OF EMPIRE TAKES ITS WAY": GRAPES AT THE CHICAGO EXPOSITION OF 1893

Almost twenty years later, a display at Chicago's Columbian Exposition in 1893 once again promoted California grapes and wines. Like the Philadelphia Centennial, the Columbian Exposition set out to display the world's greatest cultural achievements, particularly those of the United States. But unlike the Centennial, the exhibit of grapes at the Chicago Expo showed an even more elaborate and expensive display of grapes and wines, exhibiting them within an enormous grotto constructed at the base of a 28-by-28-foot hollow California redwood tree (fig. 5). Called the "California Big Tree Joint Wine Exhibit," this display in the Horticultural Hall was headlined by a banner publicizing "California Viticulture" and the names of four major wine entrepreneurs in the area.[25] Above the banner sat a sculpture of a brimming wine goblet, wine bottle, and cluster of grapes mounted on a massive tree trunk and hoisting two flags representing California and the United States. The union of these two flags illustrated how California viticulture was not solely a regional enterprise but a national one.

Organizers added to the sculptural program of the exhibit by displaying a Native American woman to the left of the tree and a Spanish padre on the right. These sculptures brought to life the history of the grapes in California that were first cultivated by Spanish missionaries with the labor of Native American people. While the padre and the Mission Indian appear as generic figures, a towering sculpture of a white woman in classical costume at the center of the tree likely depicted Minerva, the figure that appeared with a grizzly bear and grapes at her feet on the California state seal. With Minerva in the dominant position, this sculpture gestured literally to the forward advancement of California and the narrative of white progress that triumphed over the Indians and Franciscans flanking her sides. Compared to the neoclassical white Minerva, the indigenous woman and Spanish padre served merely as colorful relics of the past. Such displays echoed earlier images by Sarver that exploited California's Mexican heritage while placing it safely in the past to leave room for US expansion.

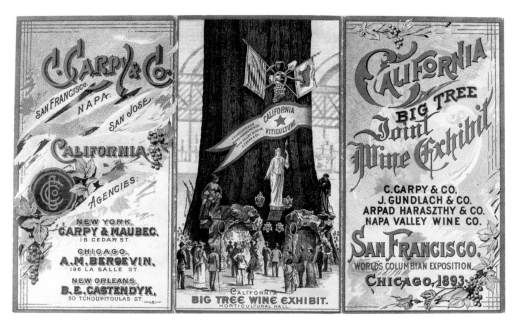

FIGURE 5

California Big Tree Wine Exhibit, Columbian Exposition, Chicago, 1893. Jay T. Last Collection of Fairs and Expositions Prints and Ephemera, 1834–1970, priJLC_FAIR. The Huntington Library, San Marino, California.

The relationship between grapes and western settlement was even more explicit in the interior tasting room of the Big Tree Wine Exhibit, which visitors could enter through the grotto's openings (fig. 6). A depiction of the room in an illustrated booklet shows a circular display of California wines exhibited underneath a panoramic mural of the San Francisco Bay. Captioned by a banner stating, "Westward the Star of Empire Takes Its Way," the imperial motivation behind grapes here was anything but subtle. Placing wine underneath a panoramic view of the Pacific Ocean depicted grapes as the "star of empire" that helped America "take its way" across the western frontier. Viewers were encouraged to migrate to the state with signs announcing, "Welcome Stranger to the Realm of the Golden State" and "Ye who enter here leave your cares behind." Viewers would have been especially compelled to invest in a California vineyard after learning about the astonishing profits made from exporting California wines each year. The same booklet claimed that exports of American wine more than doubled between 1882 and 1892.[26] Exhibitors publicized these statistics to attract investors willing to move west, invest in California land, and develop profitable commodities like grapes and wine for transportation on the railroad and accompanying shipping lines. The California rail, tourism, and grape industries shared a mutual interest in further developing and enlarging access to the state. Although an address delivered by Frederick Jackson Turner claimed that the western frontier was closing, California promoters were still looking to increase development there.[27] At this fair visited

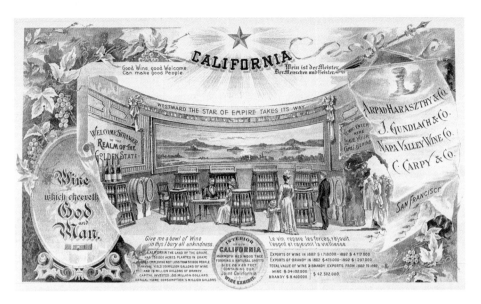

FIGURE 6

California Big Tree Wine Exhibit, Columbian Exposition, Chicago, 1893. Jay T. Last Collection of Fairs and Exposi-
tions Prints and Ephemera, 1834–1970, priJLC_FAIR. The Huntington Library, San Marino, California.

by more than twenty-eight million people, the exhibition of grapes was an invitation
for migrants, specifically moneyed ones, to invest in California.

The souvenir booklet of the *Big Tree Wine Exhibit* not only emphasized the profita-
bility of wine but also the virtues of drinking it in messages that declared: "Wine which
cheereth God and Man," "Give Me a bowl of Wine in this I bury all unkindness," and
"Good Wine, good Welcome, can make good People."[28] These phrases, some of which
were adapted from the New Testament, focused on the godliness of wine. This was a
clever strategy to minimize the drink's association with intemperance—a sin that tee-
totalers denounced in sermons declaring that wine was a wicked substance and a path-
way to harsher liquor. Temperance advocates formed "cold water armies," preaching
the abuses of wine in pamphlets, prints, and paintings, while women crusaders sang
hymns in front of saloons to shame their clientele.[29] Temperance poems written in the
shape of wine glasses further challenged alcohol consumption and urged readers to
consider "the wine question." Dr. Thomas Welch tried to restore the dignity of grapes
in 1869 by inventing an unfermented wine to replace alcohol in religious ceremonies.
His son, who inherited the Welch's grape juice company, made clear that this drink
was born "out of a passion to serve God by helping His Church to give its communion
the fruit of the vine, instead of the cup of devils."[30] Wine's associations with excess
and intemperance likely induced promoters at the Columbian Exposition to portray it
as a godly, virtuous drink in their souvenir materials.[31]

It is noteworthy that the booklet illustrated a woman, at center, guiding a child through the exhibit, symbolizing the education of a new generation, one that included women and promised to begin a new era in grape culture. Foregrounding a woman prominently in the image might have spoken to the increasing participation of women in California viticulture and desires to advertise grape growing as a family-friendly pursuit. The superintendent in the Department of Agriculture, William Saunders, for one, invited young women in his manual to experiment with grape cultivation, exhorting readers: "Friends of the vine everywhere, try it. Encourage your little girls to try it. . . . Your children . . . will take delight in watching the development of the young plant, trained by their young hands. I know it."[32] This viewpoint belonged to a wider canon of nineteenth-century literature that described fruit and plant cultivation as a training ground for young girls to practice raising children.[33] Manual writer William Chorlton also viewed grape growing as an uplifting activity for women, writing in his manual, "It is better for women to grow grapes and obtain a knowledge of plants and get healthy exercise than read exciting and voluptuous novels on the downy sofa."[34] Grapes, in this context, were not the gateway to sinful wines but wholesome objects at the center of exercises in fitness and womanhood. Structuring grape growing through the framework of parenting created an opportunity for women to shape viticulture industries and advance the development of vines in regions such as California. The subject of women's work with grapes and viticulture has been historically overlooked, yet etiquette and grape manuals suggest that women's "parenting" of fruits had broader consequences on the growth of fruit industries in the American West.

Articles from the late nineteenth century show how women's participation in grape growing went far beyond training plants in the home. Some women even owned their own vineyards, and at least one woman—a "Miss Hannah Millard"—illustrated a grape-growing manual.[35] By the turn of the twentieth century, artist Elizabeth Borglum became a famous still life painter with a specialty in grapes, joining the ranks of other well-known California painters.[36] Such examples displayed the professional contributions of women in California, which may have persuaded more women to migrate there. *Harper's Weekly* confirmed the role of women grape growers and reported that "instances are not rare of women engaging in the work of grape-growing with great profit and success . . . visitors, as a result, will find that the occupation is not for men alone."[37] Grape manual writer John Phin was another advocate of women in viticulture, writing: "Another point in this aspect of grape culture, and one in which we have strong confidence and ardent hope, is the employment which it promises to afford women. We are none of those who would desire to see woman rendered independent of man . . . but we cannot shut our eyes to the fact that there are vast multitudes of women whose labor receives no adequate remuneration."[38] Though Phin was careful not to endorse independence for women, he recognized the value of their work and invited more women to participate in American viticulture. Perhaps the viticulture industry was not as exclusive to men as scholarship suggests. The California Wine

Exhibit that minimized Mexican and Native American contributions to the industry instead welcomed white migrants—both white men and women—to participate in California's future.

PAINTING THE MISSION GRAPE: A RELIC
OF SPANISH CALIFORNIA

World's fair exhibits promoting California grapes shared similar subject matter with the grape paintings of California artists Samuel Marsden Brookes and Edwin Deakin. Brookes and Deakin devoted hundreds of still life paintings to grapes grown in their state, a subject that must have especially appealed to Brookes, who descended from a long line of British naturalists.[39] Brookes emigrated from England to the United States, and after pursuing a professional painting career in the Midwest, moved to San Francisco in the 1860s, where he was inspired by the region's natural resources. Sporting long hair and a sombrero, Brookes fashioned himself as a viticulture cowboy, traveling throughout the Sonoma and Napa Valleys together with Deakin in search of grapes for artistic inspiration.[40] Deakin, too, was a British immigrant; he followed Brookes to California in 1870.[41] Next to Baltimore artist Andrew John Henry Way, Brookes and Deakin were the most decorated grape painters, winning many awards for their still lifes. They painted mission, Concord, Muscat, and Tokay grapes. The sheer number of grape varieties in their paintings spoke to the fitness of California soil and its ability to nurture grapes of all types. Working out of a studio in an old house on San Francisco's Clay Street, Brookes and Deakin devoted the rest of their careers to the landscape of this region, dominating the California market for grape painting.

Although Brookes and Deakin plugged grapes into the standard artistic formula seen in still life pictures that showed a shallow view of fruits dangling from a garden wall, they also tailored their images to the Northern California landscape by including such local products as Eclipse champagne bottles, created by their friend and fellow Bohemian Club member Arpad Haraszthy, a pioneer of California wine and cosponsor of the Big Tree Joint Wine Exhibit.[42] Haraszthy was California's biggest wine promoter, founding the Buena Vista Winery in 1857. At the urging of California governor John Downey, he advocated for Congress to create a commission in the 1860s to fund his travel overseas to learn about European viticulture and import this knowledge back to California. The commission never materialized and Haraszthy ended up paying for his travels abroad, but the American government saw the potential of California wine country.[43] Brookes and Deakin traveled in the same social circle as many European-born vintners like Haraszthy, who were all united in the goal to promote California grapes.

Brookes celebrated the region's vibrant grape culture and growing interest in Spanish Mission culture in paintings like *California Mission Grapes* from 1865 (fig. 7). This image, painted in the last year of the Civil War, drew attention away from the nation's political strife to an idyllic snapshot of mission grapes: the repeated symbol of

old-world, Spanish California. Brookes offered an intimate view of this subject in a tightly cropped painting where grapes dominate the shallow foreground. Using few objects, he demonstrated how an artist did not need to produce a large-scale portrait of Mission architecture to evoke the "Spanish" heritage of California. With the simplest of lines, Brookes directed the viewer's eye down the steep diagonal of a wooden grapevine to the center of the composition focused squarely on a cluster of characteristically purple mission grapes. His delicate treatment of grapes, reflected in the small cluster suspended from a slender vine at top left, shows more decorum than his paintings of caught fish with their mouths hanging open in postmortem surrender. Critics admired the artist's small vignettes of fruit and game and his ability to "hide paint" in pictures displaying trompe l'oeil realism.[44] Such reactions harkened back to the ancient Greek myth of artists Parrhasius and Zeuxis, who, in a competition to prove the better artist, painted a portrait of grapes so true to nature that it caused birds to peck at the canvas.[45] Brookes accomplished this high degree of naturalism; he painted the mission grape with as much precision as a botanical engraver, including details about the grapes' globes, leaves, and branches for close study. Years ahead of the California Mission Revival movement in the 1890s, Brookes displayed a picturesque view of mission grapes that evoked nostalgia for California's colonial past.

Still life paintings of solitary grape clusters, pushed close to the viewer and labeled according to type, belonged to a well-established tradition of European classification. As Philip Pauly explains, after European growers increasingly hybridized varieties of plants in the eighteenth century, nineteenth-century botanists started to organize these species as part of a new enterprise called *horticulture*.[46] This endeavor spread to

the United States, where horticultural societies organized nomenclatural projects, seed exchange programs, and botanical engravings that detailed the biological and aesthetic features of each plant. American botanical gardens and journals were also designed to classify plants and invent a unique branch of American horticulture. Horticulturists placed a particular emphasis on fruits, believing that vegetables were too plebian, flowers too effete, ornamental shrubs too rare, and timber trees too common.[47] Nineteenth-century painters of fruit borrowed many elements from botanical engravers who sought to record every detail of a fruit for classification. The engravers' process was neither mundane nor innocuous; botanical engravings contributed to the production and circulation of powerful ideologies that sought to make exotic specimens familiar and claim land where these botanical specimens originated.[48] Painters like Brookes and Deakin, who isolated grape clusters to a minimal background and labeled them according to Euro-American types, fell in line with these larger survey practices. By repeating this formula in still life paintings, Brookes and Deakin reflected the project of national expansion and portrayed the United States as a powerful nation to survey and be surveyed.

Nearly twenty years after Brookes painted mission grapes, his peer, Deakin, painted a similar subject in *Grapes against a Mission Wall* (fig. 8). The sturdy structure in Brookes's painting has deteriorated in Deakin's canvas, showing a dilapidated surface with cracked plaster that falls loose. Deakin's grapevines also look thinner and scragglier, without the warm colors of Brookes's sunny composition. Critics admired Deakin's "stained walls" "mellowed by time." Another critic noted, "if Mr. Deakin could paint anything at all, it was a hard stone wall."[49] Deakin might have modeled his paintings after a plaster brick wall that Brookes used as a prop in their shared studio. Critics had once begged Brookes to abandon the faux wall, asking, "why will this able artist always fasten his cunning branches against bits of stuccoed brick-work, and never compose his beautiful studies into a picture?"[50] Deakin could not give up the wall either. Deakin's paintings of battered walls may not have replicated the vibrancy of mission culture in Brookes's earlier painting, but they demonstrated the appeal of mission structures as historic artifacts of a vanishing past.

Deakin's paintings of crumbling mission churches exposed how these buildings were in a critical state of neglect by the California government, which took ownership of mission churches after the state's annexation in 1848. Before the Mission Revival movement, these churches were unpopular, functioning primarily as Catholic parishes that were not considered suitable for upstanding Protestants.[51] Other churches were inhabited by cowboy robber gangs and gold-rush squatters, which further diminished the churches' original function.[52] Deakin documented the poor condition of California's twenty-one missions in two sets of oil paintings and one set of watercolors, which he began sketching in 1870 and completed in 1899 (fig. 9). This major undertaking of over nearly thirty years showed the deteriorating conditions of mission churches with their piles of loose stonework and patches of eroding paint. A critic of the time

praised Deakin for his devotion to these vanishing monuments, likening the artist to a mission follower who embarks on pilgrimages to churches across the state.[53] Deakin even cast himself as a mission disciple, decorating his sketches like religious votives with carved thorns, nails, and other Christian tropes.[54] But like the scraggly grapevines and deteriorating churches Deakin sketched, the influence of the Catholic Church had also deteriorated. The mission church had been severely weakened by secularization, the redistribution of church properties, and the growing prejudice toward the Catholic Church in a Protestant-dominant country.[55] The decay of mission churches also

FIGURE 9

Edwin Deakin, *Mission Nuestra Señora de la Soledad*, 1899. Oil on canvas, 20 × 30 in. Santa Bárbara Mission Archive-Library.

bolstered period notions that Mexicans were lazy, incompetent, and unable to sustain mission culture in the face of white American progress. Paintings of rundown mission churches and still lifes of dilapidated mission walls produced a complex juxtaposition for viewers; at the same time that they celebrated New Spain for establishing civilization in the West and then mourned its demise, these paintings also justified the US annexation of California and its takeover by what was deemed a superior civilization.

Deakin was eager to save these architectural relics from further decay. Along with photographer Carleton E. Watkins and illustrator Henry Chapman Ford, Deakin understood the value of mission culture to California's identity and the importance of recording this chapter of California heritage. Deakin treated his sketches as public documents that advocated for the conservation of California's mission architecture. He was so committed to producing these pictures of mission churches for the California public that Deakin refused to break up his series or sell them to private buyers, preferring to wait until he could release the sketches all together. Deakin might have imagined that these pictures would galvanize the public and inspire a campaign for historic preservation. Unfortunately, collectors in Chicago took greater interest in Deakin's sketches than viewers in California, which angered the artist's supporters who loathed the idea that his mission paintings should "hang at the University of Illinois! And proud California, wealthy California, cultured California stands idly by."[56] A writer for the *San Francisco Call* agreed that Deakin's mission paintings should remain

in the region and "in all justice, belong to the [California] State University."[57] The recommendation that they be displayed at a university spoke to the sketches' educational use in instructing viewers on the history of California—a specific version of history that did not acknowledge the costs of mission culture on Native American or Mexican communities. Deakin's pictures were eventually exhibited in San Francisco's Palace Hotel, where the urgency of preserving mission churches might have been lost on hotel guests and tourists.[58] No matter the audience, it was artists, and not grape growers alone, who expressed the deep connections between grapes and western expansion.

MISSIONARIES OF ART: CONVERTING THE TASTES OF THE CALIFORNIA PUBLIC

Deakin was an artist committed to preserving California heritage, so it is peculiar that many of his paintings of California grapes do not actually resemble the landscape of California. Rather, his paintings of grapes decorating classical pedestals and columns share a stronger resemblance to ancient Greco-Roman ruins that he may have seen while abroad in the 1880s (fig. 10). Deakin specifically invoked ancient Greece and Italy in the painting *Grapes and Architecture,* from 1896, which shows heaps of grapes spilling over a classical column and basin. His paintings pay tribute to Greco-Roman mythology in reliefs of nymphs, fawns, and figures of Bacchus, the ancient Roman god of wine, who wears a crown of grapes in the top left register. Below Bacchus and a relief sculpture of a bacchanal procession stands a dancing Greek maenad, a follower of Bacchus, who holds a thyrsus staff on the far left of the middle register. These Greco-Roman motifs typically are not found in Spanish Mission architecture. Shrouded in a hazy mist, Deakin's landscapes are ambiguous and placeless, a generic portrait of ancient ruins that do not show the adobe walls or clay tiles of Spanish California. The ambiguity of a number of Deakin's grape paintings calls into question why the artist would classicize the California mission landscape that he sought to protect.

It did not matter that Deakin's grape paintings looked explicitly classical; critics still interpreted them as portraits of California. One critic praised his classicized paintings for their "array of California grapes of all sizes and colors."[59] Another critic admired the artist's still lifes "overflowing with superb clusters of grapes peculiar to the vintage of this state."[60] A writer for the *Gazette* registered a similar reaction to Deakin's classically stylized painting of grapes, calling it "the most striking picture of California fruit ever placed on canvas."[61] In reading Deakin's classicized pictures as portraits of California, critics ignored their obviously embellished features. Critics also dismissed the fact that Deakin continued to paint grape pictures outside of California in the early 1880s while living in Utah and Colorado. Perhaps critics were eager to locate California in Deakin's classical depictions in order to elevate the cultural status of the state and solidify its reputation as the "Italy of the West" and the "American Mediterranean." Such descriptions were common in brochures and tourist

FIGURE 10

Edwin Deakin, *Grapes and Architecture*, 1907. Oil on canvas, 42⅛ × 32 in. Crocker Art Museum, long-term loan from the California Department of Finance, conserved with funds provided by Louise and Victor Graf.

literature about California. Art critics specifically forged a connection between the art of California and that of Italy, saying: "only in the warmer climates of the 'southern zones' where California and Italy reside, has art ever been generated or has it ever naturally thrive."[62] This notion that California and Italy shared climates and, by extension, cultures, hinged on earlier climate theories from the eighteenth century that claimed the weather and geographical positioning of a society determined its cultural success.[63] While climate philosophers traditionally used this theory to elevate the cultures of colder, northern climes, critics in California reversed this theory to exalt the societies of warmer temperatures. The reception of Deakin's work reveals the strong pressure in this time period to raise the reputation of California art and grapes and equate California with Italy, an arbiter of art and taste.

Vintners also bolstered California's reputation as an "American Italy" and "American Rhineland" by claiming that California wines equaled, or surpassed, the quality of wines produced in Europe. Promoters such as Thomas Hart Hyatt repeatedly pitted California wines against European grape culture, arguing that "we [in California] can produce as fine table grapes and as luscious raisins as France, Spain, Germany, or Italy."[64] Agoston Haraszthy similarly claimed that California "is superior in all the conditions of soil, climate, and other natural advantages, to the most favored wine-producing districts of Europe."[65] A writer for *Harper's Weekly* relayed an even stronger message in 1889, declaring that "California is a most phenomenal State. It is our Italy, our France, our Spain and Germany in one."[66] At a time when California was considered a young and unrefined frontier with little culture of its own, it was strategic to elevate the state to the perceived cultural leaders of Europe. The fact that many of California's growers were European immigrants, specifically German ones, made this desire to create a California Rhineland seem all the more personal. Claims of cultural superiority were also necessitated by criticisms from East Coast competitors who argued that California wines were "too young" and immature due to the inexperience of vintners who used bad casks and bad land and sacrificed quality for quantity.[67] California did not just have a rival in Europe but also in the East Coast, with vintners who had resisted a California wine industry ever since their own vineyards had been destroyed by a virus in the mid-nineteenth century. Struggling with feelings of inferiority, California vintners constantly positioned California wines in the context of European grape culture to boost California's reputation and publicize its resources to consumers.

Ultimately, California could not compete with the cultural achievements of Europe. Artists and critics in San Francisco were forthcoming about the inadequacies of their region, particularly in regards to the arts, writing, "the atmosphere of California at present is such that cultivated Europeans cannot breathe in it. . . . Truly San Francisco has few attractions for the man of culture."[68] Deakin agreed, telling a reporter that "the public [shows] indifference . . . and a profound lack of regard as to whether or not it takes any interest in art. The result is that . . . genuine admirers . . . of art, continue

[to be] very few in number, and the artist himself is the loser."[69] To assist the cultural development of California, one writer argued that the region needed "missionaries of art."[70] Critics credited Deakin and Brookes with this role, writing: "Of those to whom is due the credit of directing the taste of our people in the better channels . . . is . . . Samuel M. Brookes, the well-known painter of still life. He has been associated, as one of the organizers, with each concerted attempt to establish Art Unions and Schools, and has been well represented by his works at every public exhibition since his arrival in our city."[71] Brookes provided many new channels for art in San Francisco, through his roles as cofounder of the California Art Union, director of the California Art Association, and member of the Graphic Club and San Francisco Art Association. Deakin also helped establish the city's art institutions and mentor young artists; he was praised as "an educator in the finest sense of the word."[72] It seems fitting that artists enamored with California mission history were anointed as California's missionaries of art, driven by a higher calling to improve public taste.

The civilizing missions behind grape painting and grape growing were so in sync in the late nineteenth century that art and grape promoters described their impact in similar terms; art critics praised art's power to "awaken" a "dormant" California in the same way that vintners hoped their grapes would awaken California's "dormant resources."[73] The hope that grapes would "awaken" progress in California echoed the broader notion that fruit cultivation could civilize America's wilderness. Perhaps this is why a number of Brookes's and Deakin's grape paintings were displayed in the homes of politicians and tycoons deeply invested in "awakening" California, including William Alvord, mayor of San Francisco in the 1870s.[74] The artists' grape paintings were also displayed in California's agricultural societies and mechanic's fairs, where they were exhibited next to exhibits of furniture, industrial machinery, and dental specimens, which sought to display the state's cultural progress.[75] In the homes of California's leading political figures, and in industrial fairs that flaunted local innovations, still life paintings of grapes were not mere decoration but uplifting testaments to the state's past, present, and future progress.[76] It seems natural that Brookes and Deakin wanted to cultivate the taste of Californians since their paintings of grapes spoke literally to the cultivation, enrichment, and taste of California's landscape.

TREADING THE WINE PRESS: REPRESENTATIONS OF GRAPE LABOR IN CALIFORNIA

While grapes were widely visible in California paintings and world's fair exhibitions throughout the late nineteenth century, depictions of laborers picking or pressing grapes were not. Image makers may have skirted this content to avoid rendering the grueling conditions of workers who harvested and pruned grapes through the hazards of severe dust, insecticidal chemicals, and challenging weather.[77] Grape picking was also painful, requiring laborers to bend their backs at unnatural angles in order to properly clip grapes from their stems. To depict actual grape labor, then, was to

Paul Frenzeny. *The Vintage in California—At Work at the Wine Presses*, 187?. *Harper's Weekly*, October 5, 1878. Hand-colored etching, 13¼ × 20⅜ in; 15 × 22 in. sheet. California History Room.

confront the hardship that often accompanied this work. On rare occasions when grape labor was depicted, artists and illustrators portrayed it as pleasant and picturesque. Horticultural literature similarly disguised the realities of fruit cultivation by claiming that work in orchards and vineyards lacked the drudgery of life on a traditional farm.[78] Such notions obscured an honest portrayal of the taxing labor that characterized both contemporary and historical conditions for grape laborers.

An illustration published in 1878 in *Harper's Weekly* for an article titled "The Vintage in California" showed a rare image of workers in a California vineyard (fig. 11). This image was created by artist Paul Frenzeny, who was familiar with California viticulture as a member of the Bohemian Club alongside Brookes, Deakin, and Arpad Haraszthy.[79] Frenzeny depicted laborers cheerfully treading the wine press, hopping around wooden barrels, and hoisting their hands in the air. This scene looked more like a celebration than a truthful portrayal of backbreaking labor. The workers on the right of the illustration created wine by stomping grapes, a traditional method, while those on the left demonstrated the modern technique of pressing the fruit through grape-crushing machines, a new technology introduced in the 1870s. Readers of this article would have been impressed by this innovation, which used huge wire wheels to squeeze the grapes through large cast-iron cylinders. Famed author Helen Hunt Jackson declared this device to be an extraordinary sight to see, as grape juice gushed through the machine's "trough-like shoots" and produced an atmosphere "reeking

with winy flavor."[80] As few as two men could crush five thousand pounds of grapes in a day with the assistance of this new machine, as opposed to the crowd of people required by the old-fashioned method.[81] To a prospective investor interested in moving to California and entering the wine business, this machine would have looked highly desirable. This labor-saving device could increase production while reducing the number of employees, thereby enhancing the appeal of investing in California grapes. Frenzeny's illustration touted the technological advancements in Northern California that ushered in a new age of wine production.

Frenzeny depicted mostly Asian grape laborers stomping the wine press—an accurate portrayal since Chinese agricultural workers typically picked and pressed California grapes in the 1870s.[82] Chinese workers planted most of Sonoma County's grapevines between 1856 and 1869, replacing Spanish mission vines with new varieties that further severed ties between Spanish and Anglo California.[83] A writer for the *San Francisco Chronicle* believed Chinese laborers "make good pickers on account of their stolid industry and genius for plodding."[84] Another writer agreed that "the best hand in the grape field by all odds is the little Chinamen. He grows close to the ground [*sic*], so [he] does not have to bend his back like a large white man. Besides, he is very supple-fingered. And it does not take a John L. Sullivan to lift a bunch of grapes [*sic*]."[85] Comparing "John Chinamen," a popular stock caricature of Chinese workers, to the brawny boxer "John L. Sullivan" not only fueled fictions about the ease of grape labor but also perpetuated cruel stereotypes about Asian men as weak and unmanly compared to white Americans.[86] Such articles also denigrated Asian men by reducing them to their body parts, as if they were genetically engineered to grow grapes as a result of their height, posture, and finger size. These notions made Asian immigrants seem naturally equipped to work on American vineyards, enforcing degrading stereotypes about their appearance and abilities.

Despite the perception that Asian men were well suited for grape cultivation, a number of viewers criticized their participation in the California wine industry as portrayed by Frenzeny in *Harper's Weekly*. A writer for the *San Francisco Call* wrote:

> A recent number of Harper's Weekly, contained a full-page engraving purporting to represent a scene in a California vineyard. The artist was Frenzeny, and his pencil had had free and vigorous play. He has libeled the State, however. A feature in the picture was the number of Chinamen introduced, and especially a gang of Celestials who were shown treading the wine press . . . statements . . . from our leading wine manufacturers [were] denying that the juice is obtained from the grapes by foot pressure . . . and least of all by the pressure of Chinese feet.[87]

In criticizing Frenzeny for his "free and vigorous play," this objector suggested that the artist substituted his imagination for the truth about California vineyards. Other viewers complained that this illustration of "Chinamen" treading the wine press with

their "bare limbs" and feet has "without a doubt injured California wines to some extent."[88] The notion that Chinese workers were pressing grapes with their toes was especially unsettling to viewers. Descriptions of Asian laborers as filthy and immoral reflected xenophobic, "anti-coolie" attitudes of the time that sparked a wave of attacks against Chinese workers in the years before and after Frenzeny's print.[89] These attitudes were inflated by racist fears that Asian workers spread cholera, smallpox, and syphilis—diseases thought to have spread as a result of the crowded streets, decaying garbage, and stagnant water in districts like Chinatown in San Francisco.[90] Symptoms of these diseases were blisters and pustules, which were thought to infect people through clothing and goods laundered by Chinese people.[91] If the laundering of clothing by Chinese people was thought to spread infection, then the stomping of grapes by the feet of Chinese workers would have only deepened the unease among a xenophobic public. Perhaps this is why Frenzeny contrasted Asian workers using primitive grape methods with the newer, sanitary grape machinery, as if to signal that old techniques and laborers were artifacts of the past. The two white men enjoying a taste of wine with a pump and glass in the righthand corner of the composition further reinforced the racial hierarchies in place on the California vineyard and the intended consumer base for this wine.

Criticisms about Chinese workers creating American wine reveal how food and its artistic representation channeled larger anxieties about the Asian labor force in California. The reality of Asian laborers willing to work for lower wages than white laborers heightened these anxieties, which were worsened by the poor financial position of California throughout the 1870s.[92] Food was used to further malign Asian immigrants and widen the cultural gap between them and white Americans in California. In the same year that Frenzeny's illustration was published, the US secretary of state James G. Blaine worried that [Americans] "who eat beef and bread and who drink beer cannot labor alongside of those who live on rice." If Chinese immigration continued, Blaine said, "the American laborer will have to drop his knife and fork and take up the chop-sticks."[93] Blaine's belief that beef-eating Americans were incompatible with the rice-eating Chinese reflected food's perceived ability to change a person's way of life and destroy what were considered American traditions. Whether readers criticized Chinese laborers for polluting grapes with their "filthy" bodies or acknowledged them for enhancing grapes with their diminutive height and supple fingers, both claims essentialized Chinese people and invented characteristics that separated them from the ideals and values of white American citizens. Scholarly attention has been paid to the politicians and critics who insisted on this cultural division, but not the artists and viewers who also reinforced racial difference in images of grape labor.

Clearly, anxieties about Chinese grape laborers emerged at a time of intense racism. Just five years after Frenzeny's print was published, Chinese workers would be entirely prohibited from entering the United States with the passing of the 1882 Chinese Exclusion Act. The act received overwhelming support from congressmen in states with the

largest Chinese immigrant populations. In California, where white Americans of the lower classes felt displaced by Chinese workers during the economic panics of the 1870s, they created "anti-coolie" clubs and small labor organizations to push out Chinese people. One group even attempted to burn down San Francisco's Chinatown in 1877, a year before Frenzeny published his print.[94] By the late nineteenth century, the immigration acts became so prohibitive to Chinese people that they affected almost anyone who was not a diplomat or student.[95] Anthony Lee described the conditions for Chinese immigrant laborers in nineteenth-century San Francisco: "[they] had no right to citizenship, no claim to education, and no recourse to political or legal representation; they were subject to laws that they had little hope of contesting and no ability to change; and they were policed by a quasi-provincial government whose major goal was to corral an obedient and cheap workforce and, through friendly legislation, to turn the state's natural resources into steady cash."[96] Two decades of racial violence and policing in the late nineteenth century went largely unpunished. Grape laborers, and the artists who rendered them, were entangled in the time period's racist debates over citizenship in California.

The criticism of Frenzeny's illustration did not deter *Harper's Weekly* from publishing another depiction of California grape labor a decade later in 1888 (fig. 12). In this hand-colored wood engraving that accompanied the article "California Wine Culture," illustrator Charles Graham showed a picturesque view of vineyards in Napa and Marin Counties. Graham's depiction of grassy lands and leafy foliage portrayed the fertility of regions like Saint Helena, which produced nearly two million gallons of wine per year in the 1880s. In addition to providing views of the area's hops ranches and vineyards, Graham depicted an Asian grape picker in the top register wearing a conical hat—a common feature in images of Asian immigrant laborers from the time period. While this portrait subscribed to ethnic tropes, the man's enclosure in a picture frame also might have served to *reframe* traditional notions of grape workers and literally turn them *picture*-esque. Bathing the man in soft washes of color performed a kind of cleansing of the laborer, who some thought polluted the wine he produced. The man's earnest expression might have shifted the grape laborers' reputation as well, setting him apart from the rowdy grape workers who crushed grapes and hauled baskets in *Harper's* earlier illustration. In Saint Helena, a town known for its pro-Chinese attitude, Graham's depiction presented a more flattering portrait of grape workers than period caricatures.[97] Endowing the grape picker with dignity in a solitary portrait rather than a generalized composite picture perhaps was another strategy to exonerate him in a contested landscape.

While these formal strategies put a positive spin on California grape workers, they also might have signaled the decline of their role in the vine industry. In Graham's portrait of a lone grape picker looking woefully into the distance, the subject looks less like an active agent in the landscape and more like an artifact of the past. He is placed at a greater physical distance from the viewer and relegated to a picture frame, a device

FIGURE 12

Charles Graham, *Grape and Hop Culture in California*. Featuring images of *A Graper-Picker*; *San Rafael, with Mount Tamalpais in the Distance*; *Hop Ranch and Vineyards, St. Helena*. Printed in *Harper's Weekly*, January 21, 1888, page 44. Wood engraving hand colored, 13¼ × 9⅛ in. Courtesy The Old Print Shop, New York City.

used to freeze people in time. The man's fate is confirmed by his solemn expression, as he looks nostalgically across the horizon like the earlier portrait of a wistful Doña María Marcelina Feliz. This portrait of an Asian grape picker resembled contemporaneous pictures of the West's "vanishing Indians" who wear the same resigned expressions while contemplating what was perceived to be their imminent extinction.[98] Pictures of this genre show people of color defeated and deflated, unable to compete with the industrial progress of a white American nation. Such portraits were designed to elicit sympathy for the inevitable decline of Native Americans, or, in this instance, Asian immigrants, while embracing national progress in pictures of flourishing landscapes. According to this logic, Graham's grape worker will no longer pick and haul the

grapes seen in *Harper's* earlier illustration; he will be phased out by new machinery and other advancements. Chinese workers got written out of the picture plane and into a picture frame at the same time that they were denied entry into the United States. Depicting the grape picker in the language of the "vanishing Indian" was a result of racial and national cleansing.

Graham's 1888 illustration was, in a way, an answer to Frenzeny's image and a sign of the impending decline of Asian laborers as they were forced out of California's major agricultural industries in the wake of increasing violence and racism. Graham's message was particularly timely in 1888 with the passing of the Scott Act, one of the harshest immigration bans in the nineteenth century. The Scott Act prohibited Asian laborers from entering or reentering the country indefinitely. By the twentieth century, the overall drop in San Francisco's Chinese population was profound: a community of 26,000 people in 1890 dropped to 14,000 in 1900.[99] Asian workers were eventually joined by an increasing number of Italians, Mexicans, and other cultural groups in California vineyards in the twentieth century, when grapes continued to be a battleground for debates over labor abuses throughout the twentieth century, including the Delano Grape Strike of 1965.[100] Artistic representations of grapes did not just reflect these changes on the vineyard, but sparked conversations about immigration and concepts of racial difference. Although images in *Harper's Weekly* were designed to advertise California grape culture, they, along with paintings, photographs, world's fair exhibits, and booster literature about grapes, also triggered larger political questions about who should have the privilege of cultivating California land.

CONCLUSION

Representations of grapes in nineteenth-century art and the popular press reveal how this small fruit pressed on the nation's most heated debates over race, immigration, and western settlement. This point is particularly visible in depictions of Asian grape laborers, whose representation incited mixed reactions among viewers worried that people of color would pollute the purity of American fruit and wine. Stories about Mexican grape growers elicited similar responses from critics, who claimed that "Spanish" owners of the mammoth mission grapevine neglected and mistreated it. The erasure of Native American grape laborers from narratives about Spanish California also reflected racist attitudes in the United States and ambitions to obscure the violence of colonization that shaped the formation of the American West. These narratives entered into still life paintings and world's fair exhibits that minimized Mexican and Native American contributions to California viticulture at the same time that they romanticized them in nostalgic images of mission grapes and mission walls. The adaptable meanings of grapes proved useful for artists to advertise the California grape industry and depict the role of Native American, Mexican, and Chinese grape laborers in ways that naturalized messages about white American progress.

The cultural legitimacy the grape industry promised is why Americans made so many efforts to establish and develop it. From Horace Greeley's grape contest in 1864 to Michael Sarver's record-breaking mission vine at the Philadelphia Centennial, grapes were a measurement of social progress. The competition for viticulture supremacy in the nineteenth century persisted well into the twentieth century when, to the surprise of many, California wines succeeded French wines in the prestigious Paris Wine Tasting of 1976. In the "Judgment of Paris," eleven French judges performed blind wine tastings and declared California to be the winner in nearly all categories. Unseating France as the authority on wine astounded and alarmed many European critics who could not fathom that Californians could produce a superior wine to European ones. The "Judgment of Paris" would have thrilled nineteenth-century vintners and artists who were determined to elevate America, and specifically California, to the viticulture ranks of Europe. Exactly one hundred years after the California mission grapevine bested the European Hamburg grapevine at the Philadelphia Centennial, Americans once again celebrated a viticulture victory in 1976. This landmark competition marked another milestone in a long rivalry between America and Europe for cultural and market recognition.

In the end, Americans learned an important lesson from grapes: their cultivation and representation was a useful way to elevate the country's status and advance the settlement of land needed for this mission. Americans would apply this lesson again and again to fruits such as the Florida orange, the African watermelon, the Central American banana, and the Hawaiian pineapple, exploiting the qualities of fruit to accumulate land and resources for the American empire.

2

THE CITRUS AWAKENING

Florida Oranges and the Reconstruction South

—————

WELL-KNOWN AUTHOR and abolitionist Harriet Beecher Stowe painted the picture *Orange Fruit and Blossoms* after the Civil War (fig. 13). The inspiration for this painting was likely her orange grove in Mandarin, Florida, where Stowe wrote in a letter, "my part this winter has been painting orange trees as they look in our back lot loaded with clusters of oranges, green and ripe and with blossoms . . . against a blue sky."[1] The painting's clear sky and sunny colors reflected Stowe's optimism after the Civil War and her hopes for peace on the horizon as the country embarked on a path to recovery that Stowe helped shape. Stowe's dealings with oranges played an important role in her ambitions to rehabilitate the South; she specifically wanted to better the region's newly freed African Americans, some of whom she hired for her orange grove to provide a fresh start in their lives as citizens. Stowe also sold her paintings, including an orange still life, to raise money for freedmen in the South. The author's outspoken desire to move south, improve the region, and reincorporate it into the Union with the abolishment

43

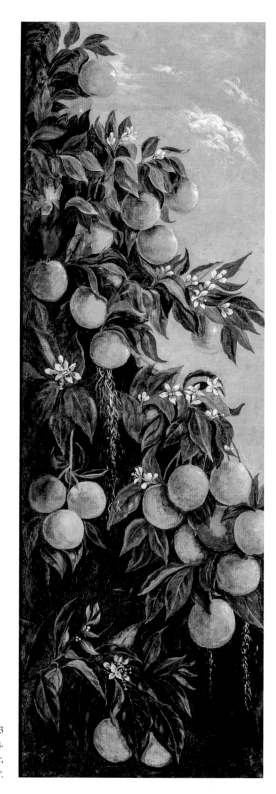

FIGURE 13
Harriet Beecher Stowe, *Orange Fruit and Blossoms*, 1867–84.
Oil on canvas, 42 × 15 in. Harriet Beecher Stowe Center,
Hartford, CT.

of slavery infused not only her writings but also her little-known painting practice. It was appropriate that Stowe used agriculture as a method to uplift the South, since many Americans after the war sought hope and opportunity in the nation's fields, vineyards, and orange groves.

At the end of the war, the fields of Florida were a particularly popular destination for northern migrants looking to revive the South and take advantage of new ventures in citrus production. Unlike cotton and tobacco, industries that had been shaken by the recent devastation of the Civil War and weakened by exhausted soil, fruits like oranges embodied the economic promise and sweetness of a new life. Migrant and horticultural literature in the Reconstruction Era sold readers on the potential of Florida oranges, declaring, "Of those who think themselves too poor to invest in an orange grove we would ask . . . are you not too poor to lose such an opportunity for investment? Owning an orange grove is better than life insurance."[2] Oranges were as much of a symbol of optimism as grapes were in California, and they were used in Reconstruction narratives about rebuilding the country. The Florida orange industry was born out of northern charity intended to help the South, but it is important to note that the cultivation of oranges was not motivated by altruistic reasons alone; orange cultivation was also a tool for migrants to gain money and political influence in the region. Citrus farming was more than an occupation; it was a political strategy to transform southern culture and advance northern visions of postwar recovery.

In addition to migrant literature and horticultural manuals, paintings and photographs widely publicized the benefits of growing oranges in Florida to northerners. While still life paintings by Martin Johnson Heade and Harriet Beecher Stowe offered a promising view of Florida orange culture to northern audiences, mainstream photographs by William Henry Jackson promoted the South through attractive views of Florida's newly developed hotels, railroads, and orange groves. Across low- and high-brow images, painters and photographers displayed idyllic representations of Florida oranges that aligned with the broader mission to entice northerners South, boost their influence in the region, and prompt a cultural renaissance. This vision of progress involved Florida's newly freed population of African Americans, who, many northerner migrants thought, would benefit from the work of orange cultivation. Images of African American citrus workers participating in a democratic and organized citrus industry supported the broader idea that fruit cultivation could civilize the nation's "wilderness" and people. These programmatic images of the Florida orange have received little attention compared to the visual culture of its western competitor, the California orange, yet Florida possessed a similarly vibrant canon of orange imagery that attracted consumers and migrants in the same time period, even earlier in some instances.[3] Expanding the story of America's oranges to Florida reveals the untold story of how a group of northern artists, politicians, railroad tycoons, and horticulturists strategically used depictions of oranges to bring northern migrants—and their attitudes about race and politics—to the South.

"THE NEW SOUTH": RECONSTRUCTING FLORIDA
AFTER THE CIVIL WAR

In the Reconstruction years and after, Florida and California were supreme rivals in the arena of agriculture. Their blossoming economies and semitropical climates made both regions ripe for an orange industry. In an effort to compete with their California counterparts, Floridians tried to steer migrants south instead of west by marketing the state as a family-friendly alternative to the lawless western frontier. One brochure promised that in the South, "There is a total absence of the wild, anxious, eager class of excited, young, single men arrayed in flannel shirts, broad felt hats, top-boots, armed with knives and immense navy revolvers, their brains filled with visionary ideas of suddenly acquired wealth, that are so plentiful in Western countries."[4] Another pamphlet asserted that "the rowdy and vagabond element" visible in the West was "at a minimum" in Florida.[5] An article titled "The New South versus the New West" explicitly pitted Florida against California and warned migrants that "the condition of things in the far West has been growing more and more gloomy in recent years. . . . The 'glorious West' [is] anything but a land of promise."[6] The most flattering representation of Florida appeared in "The Great South," a series of articles Edward King wrote for *Scribner's Weekly* in 1873 that spared no compliment to this region.[7] By celebrating Florida and diminishing the lure of California, Floridians hoped that migrant farmers and their families would abandon their dreams of moving west and head south.

Florida, however, was also at a disadvantage compared to California because the southern economy had been more intensely weakened by the Civil War. Although conditions in Florida were not as dire as in other southern territories closer to the war's epicenter, Floridians struggled with the devastation of cotton and tobacco plantations, farm buildings and agricultural machinery, and other essential supplies that had either deteriorated due to the lack of workers or had been redirected to support the war effort. The agricultural poverty of Florida solidified its reputation as a backward and primitive state, with one writer declaring in 1870: "The South is full a hundred years behind the North in many things; and this is more true when speaking of Florida than of the other southern states. It is a sort of a wild pasture-ground parceled out into great estates, several thousand acres each, under the old Spanish grants. Not a tenth of the land is yet cleared, while the remaining portion is but a tangle of swamp and pine-forest."[8] Even by 1879, two years after the close of Reconstruction and programs to rehabilitate the South, a writer in *Harper's Weekly* concluded that "Florida, it seems, is not a land of flowers, but rather a wilderness, where there is ample room for planting fruit and civilization."[9] Much of scholarship has focused on the primitive conditions of Virginia, the Carolinas, and Georgia after the Civil War, but Florida was considered just as regressive in its own way: a land of tangled swamp and wild forest that trailed years behind the agricultural progress of the North.

Numerous laws passed during and after the Civil War helped modernize agriculture in the South, including the Morrill Act of 1862 and the establishment of the US Depart-

ment of Agriculture in the same year. While it might seem ill-timed to create these laws in the midst of the Civil War, some in the government understood that legislation supporting agriculture was pivotal to the nation's stability and economic growth during this tumultuous time. The Department of Agriculture sought to improve farming in states like Florida by establishing agricultural universities across the South that offered farmers the latest education in crop cultivation, fertility maintenance, labor-saving devices, and fruit-growing strategies.[10] The Homestead Acts providing cheap southern land to migrants were also intended to improve Florida fruit and agriculture, leading one farmer to believe that if Florida "could be surveyed and opened under the homestead act to actual settlers . . . all tropical fruits . . . could be raised in great abundance."[11] This comment reinforces how fruit embodied larger dreams of settling and colonizing land. To further enhance Florida horticulture, the Florida Fruit-Growers' Association asked Congress in 1875 to institute a national garden in the state.[12] This marked a significant step toward reconciliation, which deviated from the tensions of years earlier when southern farmers were prohibited from even sending fruit specimens for educational purposes to the government during the Civil War. One northern farmer complained during the war, "The products of the South have been so far kept from us, as to place those that do reach to us, at prices unknown for many years, if ever in the history of the country."[13] New land policies and more conciliatory attitudes after the Civil War dismantled the barriers separating northern and southern farmers, slowly reversing the embargos that once segregated the two regions.

Many posters celebrated this new era, including the print *Reconstruction of the South* from 1867 (fig. 14), created by John Smith and lithographed by Charles Augustus Tholey. In this picturesque landscape of sunny skies, rolling hills, and fertile grasses, Smith showed a cheery portrait of the South after the Civil War. The irrigated plants and a barrel of wheat in the print's middle ground recall scenes of abundance popular in the Reconstruction Era, but on a closer look, viewers realize that the tools used to water the grasses and harvest the wheat are made of war cannons and swords. Smith's print echoed the words of Marshall P. Wilder, president of the American Pomological Society, who told the society during the Civil War in 1862: "We fondly cling to the hope that the day is coming yet, when war shall wash his bloody hand and sheath his glittering sword,—when our fields shall no longer be ploughed with the deadly cannon, or fertilized with the blood of our bretheren [*sic*],—and when peace shall again wreath her olive leaves around these distracted States, and bind them together in one great circle of life and love."[14] Wilder borrowed his prose from the Bible's book of Isaiah, describing nations that "beat their swords into plowshares" to express hope for the day when American battlefields will be characterized by peace in place of war and plowed with spades instead of cannons. Smith expanded on this idea by reserving the center of his composition for a portrait of George Peabody, a pioneer of education who established dozens of industrial colleges throughout the South. Standing under the umbrella of an American flag and eagle, the philanthropist holds a book stating:

FIGURE 14

Charles P. Tholey, published by John Smith, *Reconstruction of the South*, 1857. Lithograph 18¼ × 25⅞ in. Library of Congress, Print and Photographs Division, Washington, DC.

"George Peabody/2,000 000 for education," to which likely referred to his monetary impact on southern education. Depictions of agriculture warrant more consideration since they powerfully communicated visions of "the new South."

Smith also pointed to the racial consequences of the Civil War's closing in his depiction of black and white men welcoming southern Reconstruction. While the white figures stand tall and proud, hoisting their swords into the air, the three black figures are placed low to the ground, two of them kneeling and raising their hands in prayer or welcome. A group of white children at the center holds a banner stating, "COME UNCLE LEARN TO BE A CITIZEN," a reference to the "Uncle Tom" character in Harriet Beecher Stowe's famous novel. Although this banner symbolized an invitation for African Americans to exercise their new citizenship and participate in American democracy, it also condescendingly suggested that African Americans were primitive and required an education from white people. The tutorial in citizenship offered by mere children in Smith's print made the black figures seem all the more helpless. This unbalanced relationship is reinforced by the lower positioning of the African American figures who are located in nature, placed far away from symbols of civilization and technology such as the speeding train in the background. Several illustrations and sculptures after the Civil War reproduced this formula, portraying African

Americans in a crouched position, stooping below white figures to express gratitude for their help in securing their freedom. This canon of imagery denied the agency of African Americans and their unceasing resistance to slavery.[15] By repeating the tropes seen in earlier emancipation imagery, Smith celebrated the advancements of Reconstruction while keeping older systems of racism in place.

As evidenced by this paternalistic print, racism did not dissolve with the end of the Civil War and the emancipation of African Americans. Optimistic imagery of white Americans celebrating the dawn of a "New South" betrayed the fact that many southern confederates were bitter and stunned by the outcome of the Civil War. Feelings of defeat became an essential part of southern life, explains James Broomall.[16] Supporters of the Confederacy did not easily adopt a country run by a northern majority and resented having to publicly repudiate the South and swear allegiance to the United States in public oaths. Many white southerners were vexed with the physical destruction of the South after events like Sherman's march but also with the new political landscape where former Union soldiers and agents of the freedman's bureau worked to incorporate African American citizens. For most southern whites, the Reconstruction Acts and distribution of land to migrants and African Americans caused resentment. Reconstruction was not the seamless transition that Smith's print showed.

THE ORANGE CURTAIN: A NEW APPROACH TO SOUTHERN AGRICULTURE

While Smith's depiction of green grasses and barrels of grain were clear signifiers of a new era in the Reconstruction South, his message would have been even clearer had he depicted oranges, which gained widespread attention and carried the promise of a new and revitalized South. Originally brought to Florida in the sixteenth century by Spanish explorers, this fruit—historically grown in Asia, the South Pacific, and the Mediterranean—was not produced on a mass scale in the United States until the late nineteenth century with advancements in transportation and refrigeration.[17] Previous to the late nineteenth century, oranges were a luxurious treat and specialty eaten during the Christmas holiday.[18] The fruit was so special that even Union soldiers during the Civil War admired this food and refused to obey military orders to destroy Florida's orange groves.[19] In the decades after the war, many predicted sales from citrus would exceed the profits produced by cotton, tobacco, and rice—the South's most prevalent crops. A.J. Harris, a member of the Florida Fruit-Growers' Association, described the new enthusiasm for oranges in 1875, saying:

> In former times when our people's whole time and attention was engrossed in cotton and sugar culture, fruit-growing was looked upon rather with contempt. . . . Many of the finest wild groves were cut down and destroyed to make room for cotton and sugar culture, but of late years a new era has dawned upon our people, and they have been awakened to the

importance and profits of tropical fruit culture, and now these wild groves are highly prized and many of them have been and are being converted into sweet groves.[20]

Harris portrayed an "awakening" in which southerners suddenly discovered the economic importance of orange cultivation.[21] Horticulturists expressed excitement for oranges and predicted that "the golden apple" would dismantle the cotton curtain and become Florida's leading agricultural industry.

Unlike cotton, which famously divided Americans during the Civil War and narrowly benefited a small elite class of planters, fruit was thought to foster unity and agricultural diversity. In an issue of the *Semi-Tropical*, a monthly journal describing Florida's industries to northern readers, a contributor explained: "The whole Southern country to-day needs, more than all things else, a broader culture both in the field and in the school. This accomplished together with an entire revolution of her old-time intolerance and exclusiveness, and her road to independence and importance will be found both broad and easy."[22] Fruit, in this way, could help broaden southern agriculture and produce a more broad-minded, tolerant perspective in the South. The Florida fruit industry also promoted inclusivity in a brochure that invited all fruit growers from the United States and Europe to migrate to Florida, stating: "immigrants wanted: we want population from every state in the union, and from every country in Europe, we will give immigrants a hearty welcome, we want especially persons skilled in gardening and fruit growing."[23] Southerners welcomed European and northern migrants, saying: "let the heretofore slave states be filled with enterprising, industrious, and Union-loving people!"[24] Native Americans, however, were excluded from this call; Florida was Seminole territory in the 1700s, until the American government usurped and annexed it in 1819. The Indian Removal Act of 1830 that followed further subjugated Seminole people and forced them off their land onto undesirable reservations.[25] Like many American fruit initiatives, the call to cultivate Florida oranges took place on stolen Indian land, which was rooted in an even longer history of Spanish-European conquest. Fruit cultivation promised to increase diversity and democratize the South, but this promise did not extend to all.

THE SWEET TASTE OF REINCORPORATION: WOMEN AND THE FLORIDA ORANGE ENTERPRISE

While one would assume that booster literature on Florida oranges targeted men since historically they were the landowners and farmers with access to such an industry, there were many promotional articles in women's magazines that suggest otherwise. *Godey's Lady's Book* featured one essay from 1868 that proclaimed, "Florida . . . on account of its great adaptability to the cultivation of fruits, flowers, and vegetables, is destined to become the Italy of America. Oranges, bananas, pineapples . . . [and] an immense number of beautiful flowers, can be cultivated with but little trouble."[26] Readers would have taken this advice seriously from *Godey's*, an authority on the

American home and garden. In the later 1880s and '90s, *Godey's* intensified the promotion of Florida by publishing advertisements for Florida real estate:

> 40 × 100 feet, in Silver Springs Park, Fla. High, dry land. No swamps or malaria. Town only 5 months old. 67 Houses, 2 Hotels, 1 Church and 3 Stores. Population, 219; new arrivals weekly; 6 daily trains; over 2,600 merchants and professional people of every kind, also ladies, have already invested. List of names free. Every man and woman should own a lot in the land of *oranges*, lemons, bananas, pineapples, sunshine, tropical scenery, and health. *A popular and shrewd investment.* Prices will soon be doubled.[27]

Fruit played a noticeable role in these listings. Descriptions of the region's churches, stores, and houses were also selling points for women readers looking to move to a developed, family-friendly town. Reports that "ladies have already invested" in Florida real estate provided assurance to those who were contemplating a move south. Advertisers in Florida were wise to appeal to women since they, in addition to former slaves, were now legally empowered to take advantage of the Homestead Act and purchase land after the Civil War. The Homestead Act, among others, allowed people entry to purchase up to 160 acres of public land if they were willing to live on the tract and cultivate it for five years.[28] The only qualification for women was that they had to be the "head of a family" and at least twenty-one years old, specifically appealing to unmarried women.[29] Articles advertising Florida to women have not been well examined, yet they are important resources that shed light on women's new landowning privileges and their participation in Southern Reconstruction.

One woman more directly participated in Southern Reconstruction by writing migrant and horticultural manuals about Florida: Helen Garnie Warner. Warner was a Florida journalist who wrote two manuals: *Florida Fruits and How to Raise Them* and *Home Life in Florida*.[30] Both were praised as practical, intelligent, and informative books on the region.[31] It is meaningful that Warner contributed to this category of literature, which was typically dominated by men. That she authored a book on fruit cultivation seems especially unusual since this topic required an education in horticulture, historically a man's pursuit that depended on aristocratic roots and access to land on which to develop horticultural experience. Reading about Florida's agriculture and home life through a female perspective might have persuaded women to move to Florida, where a woman like Warner could enjoy professional opportunities and social mobility. Warner also assured readers of "the peaceful content and comfort of home life in Florida.[32] It was women, and not just men, who promoted migration to the South.

Another way in which women contributed to Florida Reconstruction was by publishing recipes in women's magazines and cookbooks that used Florida ingredients. Recipes for "Florida Orange Marmalade," "Florida Orange Wine," "Florida Orange Jelly," and "Florida Orange Cake" encouraged women in the 1870s and '80s to make meals inspired by the state's products.[33] Many of these recipes were included in the *National Cookery*

FIGURE 15

Orange ware souvenirs, Eggcup, Pin Trays, Creamer, and Two Miniature Sugars, pictured in Larry Roberts's *Florida's Golden Age of Souvenirs: 1890–1930* (Gainesville: University Press of Florida, 2001), 28. Courtesy of the University Press of Florida.

Book published for the 1876 Philadelphia Centennial by the Women's Centennial Executive Committee, whose mission was to collect recipes from around the country to represent a uniquely national cuisine with contributions by "the daughters of every State and Territory."[34] The diversity of recipes in the cookbook was remarkable; it included meals inspired by Native American, Caribbean, and Jewish cultures. "Dishes particular to the rich and poor" were also welcomed. The authors declared in the introduction that "our aim is to give the true savor of American life in all its varieties."[35] This cookbook reveals how food was used to foster unity in the decades after the Civil War and, on the surface, embrace America's diversity. With at least three recipes incorporating Florida oranges into classic American jellies and cakes, the Centennial cookbook might have helped bring Florida ingredients into American diets. What better way to fold the South back into the Union than to literally fold southern foods into traditional American recipes? Florida orange growers, in turn, would have been delighted that women were incorporating their product into widely distributed recipes. Women's integration of oranges into desserts made the South's assimilation that much sweeter and more effective.

To complete a meal, women could display their Florida orange cake next to decorative souvenir sets of saucers, spoons, eggcups, and creamers shaped like a Florida orange (fig. 15). Branded with the state's name on every saucer and surface, these objects served as advertisements for Florida in the dining room. This was a clever strategy since the dining room, of all spaces in the home, was highly visible and designed for socializing and eating with family and visitors. In this room that welcomed guests and symbolized the sophistication of the American family, a Florida orange serving set publicized the allure of the South. Manufacturers went to great lengths to translate the

orange's wrinkles and pores into porcelain and match the experience of touching a Florida orange. Eating actual oranges from citrus-inspired ceramics would have created a multisensory experience for diners who consumed the fruit. These ceramics typically made in New England and then sold in the South—only to boomerang north again with tourists—reflect the orange market's strong ties to the North. Souvenir sets shaped as Florida oranges were also the first of their kind; they predate the California spoons and souvenir sets of the twentieth century, suggesting that Californians may have borrowed from Florida designs.[36] Women's engagement with Florida ingredients, cookbooks, and migrant literature assisted in the promotion of Florida up North.

"THOSE GOLDEN BALLS DOWN YONDER TREE": HARRIET BEECHER STOWE IN FLORIDA

Advertisements for Florida oranges specifically urged New Englanders like Harriet Beecher Stowe to move south. Their migration was enabled by the Homestead Acts, which legalized northern seizure of southern properties, making it difficult for some southerners of the middle and lower classes to acquire new land.[37] Northern migration became so common that writer George Barbour described the state as a "northern colony" where "nearly all the railroads, steamboats, mills, factories, and the like, are directly or indirectly the product of New England or New York brain-work and capital."[38] In his book, *Florida for Tourists, Invalids, and Settlers,* Barbour praised northern "brain-work" for transforming the South by "clearing large tracts of fertile soil, setting out orange groves, experimenting with new crops ... and erecting ... fruit-preserving establishments."[39] By bringing new agricultural technologies to Florida, Barbour applauded northern migrants for "developing the true resources" of the state and "civilizing this entire region."[40] Citrus cultivation was a noteworthy part of this larger civilizing program. Just as cultivating vineyards was thought to produce social progress in the "wild west" of California, so did the transformation of Florida's wilderness into orange groves. What was once considered an agricultural wasteland was now deemed a civilized society due to the new technologies and industries that northerners brought with them.

The most famous northern crusader for Florida oranges was the famed novelist Harriet Beecher Stowe, who purchased a cottage and orange grove in Mandarin, Florida, in 1867. Photographs of Stowe's home show charming woodwork on the windows and porch, which provided a generous view of the Saint Johns River.[41] She likely had hoped that the beautiful setting and fresh air of Florida would rehabilitate her ailing son and army veteran, Frederick, who suffered from alcoholism and other mental health problems. While Stowe was in part driven to Mandarin by a more traditional sense of motherly duty, her settlement there and purchase of a thirty-acre orange grove was an unusual act for a woman before the Civil War. That Stowe owned her own orange grove and also managed a network of planters and pickers further represented a departure from gender norms. So serious about her orange business, Stowe even created her own crate labels advertising: "ORANGES FROM HARRIET BEECHER

STOWE—MANDARIN, FLA."[42] Stowe capitalized on the Homestead Acts, which empowered women, former slaves, and anyone deemed loyal to the Union to cheaply purchase land in the South after the war.

Stowe moved to Mandarin, a town near Saint Augustine and a southern enclave for northern abolitionists. There, she joined a powerful network that included Florida governor Harrison Reed, who founded the *Semi-Tropical* journal. Stowe likened herself to other northern migrants whom she praised as a "healthy, hardy energetic" people "applying the habits . . . and industries of New England to the development of the Floridian soil."[43] She marveled at "what can be done here [in Florida] by applying the patient, careful, and watchful labor which is given to the hard farms of the North."[44] By touting northern accomplishments in Florida, Stowe hoped that more northerners would migrate to the South, assist in its reconstruction, and thereby transform the political landscape. It was not unreasonable for Stowe to think that she could influence Florida's politics since northern republicans, combined with the large population of freedmen, could produce a voting majority that determined the political direction of Florida.[45] Stowe was a staunch abolitionist and unapologetic northerner wanting to help the South through years of Reconstruction to the benefit of northerners.

Stowe encouraged northern readers to move south in "Palmetto Leaves," a series of articles she wrote for a weekly column in the *Christian Union*.[46] Here, Stowe pleaded, "To all who want warmth, repose, ease, freedom from care . . . come! Come! Come sit in our veranda! This fine land is now in the market so cheap that the opportunity for investment should not be neglected."[47] Readers would have been especially compelled to move south after learning that Stowe yielded an astounding profit of $1,500 a year from her grove.[48] Keenly aware that northern migration could bring northern money and influence to the South, Stowe wrote several articles on the perks of orange culture in her efforts to rally "North Pole-ites" around Florida land speculation. She often described her idyllic orange grove, depicting an attractive portrait of Florida as the "Mediterranean of the South." In the same way that women's magazines recognized the important role women migrants could play in settling Florida, so too did Stowe in her weekly column for the *Christian Union*. Stowe's articles on her orange grove belonged to a larger canon of literature urging Yankee farmers to buy southern land and spread republican values.

As a constant cheerleader for Florida oranges, Stowe painted several still lifes of the fruit; these have gone largely unnoticed by scholars. One of her largest paintings—*Orange Fruit and Blossoms*—is also her most unusual (fig. 13). Instead of painting fruit on a traditional horizontal axis like many American still life painters, Stowe launched the canvas on a vertical trajectory, showing the fruit descending down a long bough. White orange blossoms dangle from branches like jewelry—a fitting metaphor since Stowe described the period in which orange blossoms begin to bud as "the week of pearls."[49] With clusters of oranges crowding the picture plane, Stowe's still life painting bursts with saturated color. If it were not for the pocket of blue sky in the right-hand corner, the entire composition would be consumed by the fruit. Stowe likely painted

this canvas during one of her winter residencies in Mandarin, where she produced many orange still lifes, writing in a letter, "my orange panel is finished and is better than the one I did last year we all think."[50] The shallow foreground of the painting suggests that Stowe had an intimate view of the scenery, perhaps provided by one of the windows in her home. She wrote, "a great orange tree hung with golden balls closes the prospect from my window. The tree is about thirty feet high, and its leaves fairly glisten in the sunshine."[51] The Florida orange that symbolized a new South for Stowe also facilitated an artistic exercise in mastering the properties of light and color on canvas.

In many ways, Stowe's paintings are unremarkable because they fell in line with gender norms of the time that promoted fruit painting as an appropriate exercise for women. In contrast to men who were encouraged to depict the more intellectual genres of art that required a study of the human figure and historical subjects, women and artists of color were limited to still lifes and other genres that ranked low on the hierarchy of the fine arts.[52] The limitations accompanying the still life genre did not bother Stowe, who saw dignity in painting the most mundane objects—a quality she admired in the Dutch master Rembrandt, who "chooses simple and every-day objects, and so arranges light and shadow as to give them a somber richness and mysterious gloom."[53] Stowe also admired the modest subject of fruit because it provided women with good training in child rearing. Along with her sister, Catharine Beecher, Stowe encouraged mothers to cultivate fruits with their daughters, viewing cultivation as a domestic exercise that promotes neatness, sharing, and nurturing skills. In her widely read advice manual, *The American Woman's Home,* Stowe told mothers: "Let them plant fruits and flowers and make their small Edens."[54] In her role as a fruit grower and fruit painter, Stowe contributed to a wide canon of domestic and horticultural literature that hailed fruit cultivation as a civilizing influence and a training ground where young girls could practice motherly love.

As a socially acceptable exercise for women, still life painting was the perfect vehicle for Stowe to use to advertise the South. In addition to her paintings of Florida oranges, Stowe's still lifes of lilies, jasmine, goldenrod, and magnolia flowers displayed the beauty of the southern landscape. A painting of the *Magnolia Grandiflora* (fig. 16) represents one of Stowe's favorite subjects, which she described as the "giants among flowers . . . worthy to be trees of Heaven."[55] While Stowe cited Renaissance and Dutch art as the inspiration for her still life paintings, she also admired more contemporary artists, such as printmaker Louis Prang, who produced popular chromolithographs that Stowe recommended for display in the home.[56] She may have been specifically influenced by a Prang picture from the same time period, which shares the title and shallow perspective of the magnolia flower, closely approaching it to show white petals cradled in a bed of green, waxy leaves.[57] Stowe discouraged visitors from shipping Florida's flowers up north, explaining that "it is far better to view the flowers ever fresh and blooming through imagination, than to receive a desolate, faded, crumpled remnant by mail."[58] She insisted that postmarked flowers could not match the

FIGURE 16
Harriet Beecher Stowe, *Magnolia
Grandiflora*, ca. 1872–75.
Watercolor and gouache on canvas,
18 × 15 in. Harriet Beecher Stowe
Center, Hartford, CT.

experience of seeing them in person. Stowe felt similarly about the Florida orange, scoffing at the "pithy, wilted, and sour" oranges in the North that "have not even a suggestion of what those golden balls are that weight down . . . yonder tree."[59] Stowe was proselytizing for Florida in her artwork and articles, urging northerners to make the southern pilgrimage to experience the region's treasures firsthand.

Few scholars have investigated Stowe's painting practice because it has unsurprisingly been eclipsed by her more prominent career as a novelist and abolitionist. Yet the author's training in art warrants deeper analysis, given that she was devoted to the pursuit of painting, which brought together her interests in art, oranges, and southern politics. In a letter to a family member, Stowe explained that she was "constantly employed, from nine in the morning till after dark at night, in taking lessons of a painting and drawing master."[60] Stowe's training was so intense that she allowed herself "only an intermission long enough to swallow a little dinner." Despite her commitment to mastery, she was an amateur artist who had a sense of humor about her uneven talent, writing in another letter, "I propose my dear grandmamma, to

send you by the first opportunity a dish of fruit of my own painting. Pray do not now devour it in anticipation, for I cannot promise that you will not find it sadly tasteless in reality."[61] Eventually, Stowe felt confident enough to submit some of her Florida paintings to an exhibition in Hartford, Connecticut, where she sat on the advisory board for the Hartford Society of Decorative Arts.[62] Stowe hoped that by painting Florida fruits and flowers, she might also sell these images and raise money for the South, writing, "I am painting a great panel of orange tree blossoms and fruit which I am going to sell for the benefit of our Church here."[63] It was not only the content of Stowe's orange paintings that promoted Florida, but their sale as well. Painting oranges was more than an exercise in polite culture for Stowe: it was a political device to uplift the South.

MARTIN JOHNSON HEADE AND THE GILDED AGE OF ORANGE STILL LIFE PAINTING

Painter Martin Johnson Heade joined Harriet Beecher Stowe's circle of northern citrus growers, painters, and politicians in Saint Augustine, Florida. Stowe was the first person Heade visited on arriving in Florida from the North in 1883, recounting in a letter, "When I landed at Jacksonville I took a run down to see Mrs. Stowe . . . I found her (& also her daughter) in a delightful mood, & I could hardly get away."[64] Stowe, in return, was an admirer of Heade and mentioned one of his landscape paintings in an essay on home decoration.[65] Heade was an accomplished Pennsylvania-born artist, known for his landscape paintings of stormy skies and glassy waters. His hyperrealistic style gained critical attention after his visits to South America in the 1860s and '70s, when he painted orchids and hummingbirds for naturalists such as James Cooley Fletcher.[66] After that trip and another to the Caribbean, Heade settled in Saint Augustine, painting there until his death at eighty-four. Unlike artists Thomas Moran or Winslow Homer, who only briefly visited Florida to paint its landscape, Heade produced more than 150 canvases of Florida's fruit and flowers; these mark the gilded age of his still life career.[67] Heade stood out from other artists for his intimate engagement with his subject matter and ability to show fruits, flowers, and birds as living organisms in a vibrant ecosystem.

Between 1883 and 1895, Heade painted nearly a dozen still lifes of oranges and orange blossoms at the height of citrus mania in Florida (fig. 17).[68] Heade preferred couplings of fruit, showing pairs of oranges bound together by a single branch, a blissful matrimony in nature. Heade maintained a low vantage point as he had done in pictures of Brazilian flowers, but tightened the view to achieve a closer perspective on the fruit. He showed them in full bloom, with buds on the brink of flowering, an antithesis to Dutch memento mori paintings that displayed bruised and rotten fruits to symbolize life's transience. The fruits' placement on velvet cloth and mahogany tables conjured a scene of luxury that contradicted period perceptions of Florida as a cultural backwater. In a nation that believed the cultivation of fruit advanced society,

FIGURE 17

Martin Johnson Heade, *Oranges and Orange Blossoms*, 1883/1895. Oil on canvas, 12⅛ × 20⅞ in. Sheldon Museum of Art, University of Nebraska–Lincoln, in loving memory of Beatrice D. Rohman by Carl H. and Jane Rohman through the University of Nebraska Foundation, U-4661.1996. Photo © Sheldon Museum of Art.

Heade's pictures spoke metaphorically of the blossoming and ripening of postwar Florida.

In the same decade when Heade painted delicate and tender still lifes of the Florida orange, California artist William J. McCloskey painted sharp and piercingly realistic representations of the fruit (fig. 18). Trained at the Pennsylvania Academy of the Fine Arts, where Heade had also exhibited his work, McCloskey favored illusionistic tables adorned with fruit. McCloskey relished the challenge of depicting oranges on polished surfaces, capturing the glowing reflections of the orange globes on mahogany table-tops. While oranges are at the center of his composition, it is the fruit's tissue paper that steals the viewer's attention. Tissue paper was a new packing material in the late nineteenth century, used by shippers to cushion the fruit and prevent it from bruising and spoiling during the transcontinental journey. Sculpting the tissue paper like the human form, McCloskey fashioned an orange with paper wings that looks like Nike of Samothrace about to take flight. The paper clings to the curves of the fruit like wet drapery—another allusion to ancient Greco-Roman art. In painting oranges in tissue paper gliding across the table, McCloskey flaunted his command of paint and mastery of trompe l'oeil, the illusionistic technique made famous by Pliny the Elder's story of ancient Greek artist Zeuxis, who painted a picture of grapes so realistic that birds flew down to peck at the painting, believing the fruit to be real. Throughout art history,

depicting fruit was an exercise in deception and experimentation with depths of field. Oranges provided an opportunity for artists such as McCloskey to showcase their skill and demonstrate their rightful place in the long lineage of still life painting.

While McCloskey painted oranges wrapped in tissue paper, Heade depicted them naked, dressed only in leaves and blossoms that highlighted their natural state and beauty. The simplicity of Heade's images is curious since he would have frequently seen the fruit protected by tissue paper and wooden crates due to his proximity to Jacksonville, Florida, one of the nation's biggest citrus distributors. Florida orange shipments were in such high demand around the time of Heade's paintings that agriculturist Reverend T. W. Moore advocated for daily citrus trains from Florida as far as the Northwest.[69] Heade, however, eliminated the shipping details from his paintings—details that alluded to the fruit's mass production. Instead, he showed the fruit freshly plucked from the orange grove with branches and leaves still intact. Perhaps Heade's decision to ignore the modernization of oranges echoed his wider political stance that Florida's natural landscape needed protection from industrialization. He protested the environmental damage caused by industrialization in a series of arti-

cles written under the pseudonym "Didymous" for the periodical *Forest and Stream,* expressing concern for the health of Florida's wetlands and wildlife. These attitudes might have colored his still life pictures, which focused on fresh and pristine fruit and a rejection of mass-produced goods.[70] Heade may have personally grown the oranges depicted in his still lifes, since he took great pride in his own citrus trees, discussing them in letters to his friend, Eben Loomis.[71] In evacuating the tissue paper from his paintings, and rendering every stem and stamen with taxonomical detail, Heade provided a more intimate, eco-conscious view of the fruit that deviated from those produced by his contemporaries.

Yet Heade also benefited from the industrialization of Florida and the rise of tourists who purchased his still life paintings as souvenirs. Critics at the time noted that, "Mr Heade's most popular pictures, today, are of orange blossoms and Cherokee roses, typical of Florida, making beautiful souvenirs of a visit to the State."[72] The artist was so quick to satisfy consumers, according to Heade scholar Theodore Stebbins, that if a flower still life was sold in his studio, he would paint a similar picture to replace it.[73] As souvenirs and ambassadors of Florida, Heade's still lifes were nominated by the *Florida Tatler* to represent the state at the Columbian Exposition of 1893.[74] Heade was very aware of the growing tourist market and worried that Florida was not developing quickly enough to serve it. In an article for *Forest and Stream,* he meditated on the development of Florida and complained that "the great obstacle in the way of settling this place rapidly has been the difficulty of getting here . . . but both the difficulties are about to be removed. A New rr. [railroad] has just been opened direct from Jacksonville. . . . Everything now is nicely arranged to make St. A[ugustine] by far the most attractive winter resort in Fla."[75] Heade naturally contemplated the development of Florida since his livelihood hinged on tourists and railroad magnates who constituted the region's art patrons. But as dependent as he was on the tourist market, Heade also criticized the invasion of northerners in the South, writing: "it seems to me that about every two thirds man I meet is a Northerner. They are crowding the crackers out and devouring their substance!"[76] In contrast to his friend and Florida booster Harriet Beecher Stowe, Heade expressed conflicting attitudes toward tourism in the state. He wanted all the amenities of the North without the environmental impact or influx of northerners (conveniently forgetting that he, too, was a northern migrant). At the same time that Heade served the tourist market with his paintings, he also had trouble reconciling the expansion of Florida with the consumption of its resources.

MANUFACTURING PARADISE: HENRY MORRISON FLAGLER AND THE PONCE DE LEÓN HOTEL

Amid the grand archways, electric lighting, and Louis Comfort Tiffany's stained-glass windows, tourists could purchase Heade's artworks at the fashionable Ponce de León Hotel. The Ponce de León was the brainchild of Florida railroad and Standard Oil

tycoon, Henry Morrison Flagler. Flagler spent 2.5 million dollars on his hotel, which opened in 1887.[77] He purchased more than two million acres of land in Florida, transforming the city of Saint Augustine into a major cultural center with plazas and hotels.[78] According to a writer in the *News Herald,* Flagler was Florida royalty and ruler of Saint Augustine: "At his own expense, [Flagler has] paved the adjoining streets, erected a town hall . . . and even owns the plaza where the post office stands. So he seems to control the sword of justice, and the fountains of mercy; the public highways and waterways; the earth and sky, and all that in them is in and about St. Augustine."[79] Flagler adopted the most colorful elements of Spanish design for the city's hotels, adorning them with terra-cotta balconies, salmon-colored arches, and orange groves. At the entrance of the Ponce de León, visitors saw murals by George Maynard depicting allegorical figures of "Adventure," "Civilization," "Conquest," and "Discovery."[80] Paintings on the subject of exploration were a fitting tribute to the hotel's namesake, Spanish explorer Juan Ponce de León, and to Flagler, who was deemed the next carrier of civilization to Florida. Flagler transformed Saint Augustine into a tropical paradise for tourists.

Flagler actively used artists to boost tourism, carving out a space behind the boiler room in the rear of the hotel for seven artist's studios, including one for Heade.[81] On "Artists' Row," Heade held weekly evening receptions for hotel guests and local Saint Augustinians who praised his two-story workspace as "the dean of studios."[82] While Heade profited from the built-in base of hotel guests who purchased many of his paintings, the Ponce de León benefited from "Artists' Row," which fostered artistic and literary talent that attracted tourists from all over the country. Critics praised "the good effect which the building of the Ponce de León has had on Florida travel this year," expressing gratitude for "this magnificent structure and its surrounding group of buildings [that] have exalted the interest and admiration of the whole world and have had the effect of bringing a class of visitors to this State who were rarely, if ever, known to come here before."[83] Another critic agreed that "the studios are among the most attractive places to visit in the city. The artists are courteous and obligingly show their pictures, taking infinite pains and pleasure as well in doing it."[84] Flagler was savvy in creating a niche for artists at his hotel since it enhanced the sophistication of his property while also advertising it in pictures of Florida that artists sold to tourists.

Although Flagler seemed to have preferred Heade's landscape paintings, commissioning two for display in his hotel (*View from Fern Tree Walk, Jamaica,* and *The Great Florida Sunset*), Heade's still lifes of oranges also advertised Flagler's Florida. In addition to building hotels and railroads in the region, Flagler invested in the state's agriculture and planted orange groves inside and outside his hotels.[85] A pamphlet describing the grove at the Ponce de León claimed, "in this beautiful garden one can find realized all his dreams of Southern splendor. . . . You look down over a sea of glossy, brilliant green, dotted thickly with golden oranges and combining richly with the deep

Southern sky."[86] Visitors to the Ponce de León could view oranges in the hotel grove and on Heade's canvases or ship the fruit to friends in the North by placing orders at El Unico, a gift shop at the nearby Hotel Cordova—another building owned by Flagler. Tourists could purchase other citrus souvenirs from this store, which sold "the prettiest orange knife known as the 'St. Augustine' that possessed handles embossed with representations of fruit."[87] Across pamphlets, paintings, and silverware, artists created representations of oranges that were vital to advertising the Florida that Flagler helped shape.

The success of Flagler's hotels and citrus ventures depended on the success of another enterprise: the railroad. The Florida orange industry used Flagler's East Coast Railroad to distribute fruit from towns such as Saint Augustine to Jacksonville, a southern hub that connected to other strategic railroad routes throughout the country. Flagler's investments in railroad technology transformed northern Florida into a highly specialized fruit-growing region. An 1887 trade card advertising an exhibition of Florida fruits demonstrates the intimate connection between fruit and rail in the late nineteenth century (fig. 19). Printed by the Jackson and Sharp Railroad Company based in Wilmington, Delaware, this card publicized the exhibit *Florida on Wheels,* "a rolling palace from the Land of Flowers laden with rare exhibits illustrating to tourists, invalids, and prospective settlers the attractions, advantages, and resources of that sunny land."[88] Visitors to this "conservatory on wheels" could view oranges, mangoes, and other produce that was transported on railcars painted with palm fronds flanked by American flags. The exhibit's main attraction was, not surprisingly, the orange, which was given priority on the front of the trade card.[89] Developers turned railroad cars into fruit museums and portable gardens that showcased the region's abundance.

It might seem strange that a Delaware railroad company would sponsor an exhibition on Florida fruit since the two states were located so far apart, but Jackson and Sharp had recently opened a railway line that transported passengers from Delaware to Florida, a trip that took from twenty-four to thirty-five hours. An exhibition on Florida fruit was a creative way to entice northerners south and draw interest in the company's new lines. Oranges were central to this campaign; northerners like Stowe used them to attract "snow birds" from the frozen North to the sunny South. The display of Florida oranges "on wheels" implied an ease with which people and fruit could be transported up and down the East Coast. The movement of oranges from grove to table, railcar to grocer, and south to north was a powerful demonstration of the increasing mobility that both fruit and people experienced in the late nineteenth century. Given the interconnected relationship among Florida fruit, transportation, and tourism, it is fitting that railroad moguls invested in exhibitions of Florida oranges to potential consumers in the North.

The marriage between fruit and rail is also visible in the pictures of photographer William Henry Jackson, another recipient of Flagler's patronage. Jackson participated

COMING.

FLORIDA ON WHEELS.

A Rolling Palace FROM THE Land of Flowers,

LADEN WITH RARE EXHIBITS,

ILLUSTRATING TO

TOURISTS, INVALIDS AND ✦ ✦ ✦ ✦ ✦

✦ ✦ ✦ ✦ ✦ PROSPECTIVE SETTLERS

THE

ATTRACTIONS, ADVANTAGES & RESOURCES

OF THAT SUNNY LAND.

(OVER.)

FLORIDA'S ROLLING EXPOSITION, 1887-8.

◎ A CONSERVATORY ON WHEELS ◎

IS now en route from the far Sunny South to the Frozen North, laden with Tropical Plants and Fruits in all their native luxuriance and splendor—A REGULAR ROLLING PALACE, built for Florida, at an enormous expense, at the well-known and long established Delaware Car Works of THE JACKSON & SHARP CO., Wilmington, Del., and Gorgeous with Golden Decorations and Tropical Scenery. Wait for the ORANGE TREES LADEN WITH YELLOW FRUIT, GROWING PINEAPPLES, THE BANANA, LEMON, MANGO and MAGNOLIA TREES. Watch for this unique and original Exposition, containing ORANGES, LEMONS, LIMES, CITRON, SHADDOCKS, GRAPE FRUIT, PERSIMMONS, FIGS, GUAVAS, PINEAPPLES, WATERMELONS, COTTON, TOBACCO, OKRA, SPONGES, CORAL, SHELLS and WONDERS FROM THE MIGHTY DEEP. Don't miss THE FLOATING ROCK, and A FAMILY OF ALLIGATORS captured on the picturesque banks of the beautiful St. Johns, and daily on exhibition together with hundreds of other exhibits at or near the Depot. Watch the papers for day and date, and then take

A TRIP TO FLORIDA.

HAIGHT & DUDLEY, PRINTERS, POUGHKEEPSIE, N. Y.

(OVER.)

FIGURE 19

Coming. Florida on Wheels. A Rolling Palace from the Land of Flowers Laden with Rare Exhibits, 1887–88. Poughkeepsie, NY: Haight and Dudley, printer, 1887. Trade card, 8 × 14 cm. Collection of the American Antiquarian Society. Photo Courtesy American Antiquarian Society.

as a photographer on Ferdinand V. Hayden's survey expedition of the western frontier. After mastering the artistic strategies of the picturesque and sublime in survey photographs of the West, Jackson applied these elements to commercial photographs of popular tourist destinations for railroad tycoons and photo distributors like the Detroit Publishing Company, of which he later became president. Well known

by the 1880s, Jackson attracted the attention of Henry Flagler, who hired him to photograph his hotels and, by extension, Flagler's East Coast Railroad, which sold rail tickets to the very sites that Jackson photographed. Jackson would have been comfortable working for Flagler since he was a longtime employee of the railroad companies that had hired him to advertise cross-country travel to tourists.[90] Accustomed to shooting photographs that attested to the cleanliness and natural beauty of a destination, Jackson was well aware of the job parameters and applied this to the Florida landscape.

Jackson met his patron's expectations by photographing seductive images of Flagler's hotels and the broader Florida landscape in sunny weather, surrounded by giant citrus trees and acres of land peppered with fruit. Occasionally, Jackson showed fruit pickers pulling orange orbs from the heavy trees and carrying baskets overflowing with fruit as if pickers barely made a dent in the tree's large inventory. Shooting from the low vantage point of a pedestrian, rather than the aerial view reserved for survey photographs, Jackson presented a landscape within reach to visitors. Even though black-and-white photographs dulled the bright hue of the fruit, Jackson's dreamy views conveyed all the qualities of tropical locations—fertility, exoticism, and an overabundance of nature. These were important for communicating the "imperial picturesque," a term Krista Thompson coined to describe picturesque views of Caribbean landscapes that assured non-Caribbean viewers these areas had been properly colonized and sanitized.[91] Photographs distributed to the masses as larger prints or smaller postcards were central to selling American consumers on tropical locations. The photographs were produced in "the hopes that people would buy the mission of these images and move to these places and make them more white and domesticated," writes Thompson.[92] Jackson's photographs of Florida were no different; they capitalized on migrant fantasies and employed all of the period rhetoric around tropical gardens and citrus cultivation to draw travelers southward.

Jackson's vast experience as a railroad photographer might explain why many of his orange grove views share a striking resemblance to views of the railway. This is evident in his photograph of Seville, Florida, which closely resembles his depiction of a railroad in the nearby town of Beresford (figs. 20 and 21). Both show a sandy trail extending to the horizon, marked by the tracks of a train or, in the photo of an orange grove, those of a plow. Each pathway is lined with a hedge of trees that tapers into a triangular patch of sky. By applying the same perspective and compositional elements to both photographs, Jackson equated the journey to Florida by rail with a journey through an orange grove. Framing the orange grove in the pictorial language of the railroad was fitting since they both promoted ideas about progress and national expansion; just as railroads were thought to clear the wilderness and bring civilization to the frontier, the cultivation of oranges was thought to improve Florida's wild landscape and civilize the southern frontier. The orange grove and railroad both represented physical and upward mobility. It was important to present the progress of Florida in photos to potential

William Henry Jackson, *Orange Grove, Seville, Florida*, 1880–97. Dry plate negative, 8 × 10 in. Library of Congress, Prints and Photographs Division, Detroit Publishing Company Collection.

William Henry Jackson, *J. T. & K. W. Near Beresford, Florida*, 1880–97. Dry plate negative, 8 × 10 in. Library of Congress, Prints and Photographs Division, Detroit Publishing Company Collection.

migrants given the state's former reputation as a tangled swamp trailing "a hundred years behind the North."[93] In joining together the visual grammar of the railroad and orange grove, Jackson contributed to the mission of painters, developers, and orange growers in Florida to sell the South to nonsouthern audiences.

ORANGE GROVES, BLACK PICKERS: AFRICAN AMERICAN FREEDMEN AND CITRUS LABOR

While many photographs from Jackson's Florida series display scenic views empty of people, a number of his orange grove photos show the workers of the region (fig. 22). One particularly candid shot from Ormond, Florida, shows a wide-frame view of workers tending to a fruit tree underneath palm fronds and leafy branches that bend dramatically across the picture plane over a grass hut. Jackson's picture is divided into two sections by a makeshift ladder with slender poles that draws the viewer's eye up toward the tree. A black man stands to the left of the ladder, casually leaning his left arm on its steps. To the right, another man stands smoking a pipe, watching over two black workers seated on the ground, packing fruit in a crate. In contrast to laborers on the right, a group of men and one woman behind a wire fence on the left appear at leisure. Their hats, ties, and finer clothing indicate a higher social status than that of the laborers packing fruit on the ground. One of these observers holds an orange as if he is about to bite into the fruit, conveying the hierarchical difference between those who pick the fruit and those who consume it. In contrast to many illustrations that show generic orange pickers half hidden by trees, Jackson's photograph demystifies the work of citrus laborers without disturbing deceitful fantasies that orange picking was easy and picturesque.

Jackson captured a scene of both labor and leisure, but the primary interest of his composition is black workers—a testament to the visibility of African Americans in the Florida orange grove. The workers look clean and relaxed and far from the wide-eyed, smiley buffoons drawn in mainstream caricatures in this period. Photos of black orange pickers were not uncommon, perhaps signaling a comfort with African Americans in the groves that contrasted with disparaging opinions about views of Chinese workers in California's fields. The presence of a woman in this landscape also implies a more inclusive industry and a departure from the South's "old-time intolerances" that fruit industries promised to wash away.[94] The inclusion of a black man in the group of leisurely observers—the figure who is about to bite into an orange—further speaks of a more tolerant industry and the higher status African Americans might have enjoyed in the citrus business. For viewers, this photograph declared that the Florida dream was available to both black and white people and to both men and women. Black viewers seeing this print might have felt especially empowered by seeing African Americans in the citrus industry, persuading them to seek out citrus work. By showing African American workers picking fruit, packing crates, and enjoying the fruits of their

FIGURE 22

William Henry Jackson, *Orange Pickers, Ormond, Florida*, 1880–97. Dry plate negative, 8 × 10 in. Library of Congress, Prints and Photographs Division, Detroit Publishing Company Collection.

labor, Jackson demonstrated that black people played a vital role in Florida's orange industry and dreams of southern abundance.

African Americans were likely attracted to the nascent orange business as they sought new modes of occupation after gaining emancipation. Congress created the Freedmen's Bureau in 1865 to help African Americans in the South secure work—a large initiative given that almost half of Florida's population (165,000 people) consisted of newly emancipated slaves.[95] Two decades later, George Barbour described the presence of black workers in the orange grove in his 1882 brochure, *Florida for Tourists, Invalids, and Settlers,* writing, "negroes . . . perform most of the manual labor and are almost the only attainable domestic help."[96] In contrast to "them yeller fellers," Barbour wrote, "pure blacks are always the best laborers; they work hardest, most willingly, honestly, and efficiently, always performing the most labor in a day."[97] Complimenting African American laborers at the expense of Asian laborers was another tactic

aimed at exalting Florida over California, where fruits were grown and picked by Chinese immigrants deemed filthy. Horticultural expert Ledyard Bill expressed a similar view toward African Americans, writing in the years directly after the Civil War, "there are no people so deserving of considerate and generous treatment from those who were their late masters, as are the negroes of the South."[98] Bill sympathized with African Americans who "dislike, as a rule, to do any labor for their old masters, since that would seem to them very much like the old system which they now have such a horror of."[99] Despite such sympathies, it is unlikely that orange cultivation provided much better conditions than before the war. Freedmen were forced into sharecropping—the tenant system in which plantation land was leased to former slaves—and signed year-to-year contracts that were incredibly limiting to their personal freedom and economic autonomy, much like the conditions of slavery.[100] But according to postwar manuals that were trying to display a rosy view of the South, the rising orange industry offered African Americans alternative opportunities to previous manners of work.

A number of northern sympathizers encouraged African Americans to participate in the citrus business, believing that it could enrich their minds and wallets. Developer and diplomat Henry Sanford was one such advocate. In addition to offering African Americans low-interest mortgages to build schools and churches, Sanford hired African Americans on his ninety-five-acre orange grove near Saint Augustine, believing that an agricultural training could help improve the lives of freedmen in Florida.[101] Edward Daniels pursued a similar mission—building schools, churches, and orange groves. He hired freedmen and taught them the principles of farming as a means of philanthropy.[102] It is meaningful that supporters of emancipation looked to fruit cultivation to uplift Florida's population of African Americans. As altruistic as these actions seem, it is important to acknowledge that Daniels and Sanford were also acting strategically; they built orange groves in the South to capitalize on laws that empowered northerners to take southern land and spread northern influence. They understood that to yield oranges was to yield money and influence. While it is unclear whether their methods of citrus labor were any better than labor systems of the past, Sanford and Daniels purportedly used oranges, in part, to improve the lives of those people previously enslaved.

Harriet Beecher Stowe belonged to this school of thought, organizing African American schools and churches in Mandarin, Florida, and creating orange-picking jobs in her grove for freedmen. She described the positive results in a letter:

> I have started a large orange plantation and the region around will soon be a continuous orange grove planted by northern settlers and employing colored laborers. Our best hands already are landholders of small farms planting orange trees and on the way to an old age of easy independence. It is cheerful to live in a region where every body's condition is improving and there is no hopeless want. You ask if I am satisfied with the progress of Christian civilization in the south. I am.[103]

The progress of Christian civilization, for Stowe, was reflected in the principles of Reconstruction and improvements to black lives that were manifested right in her own backyard—on her orange grove. That some of Stowe's "best hands" had become landowners managing their own small farms suggested that her orange grove contributed to a happier, more autonomous livelihood for African Americans. Stowe, however, obscured the reality for African Americans in the Reconstruction Era who had no choice but to work; they could be convicted for joblessness and punished for vagrancy.[104] Idleness, in fact, was a dangerous offense for African Americans, leading to prison terms or bound labor on plantations. Stowe's writings omit the injustices of contract labor and paternalistically applaud white efforts such as her own for rescuing black people and transforming them into happy, productive workers.[105] In the aftermath of the Civil War, northern fantasies about African American freedom were grafted onto the orange grove.

Paintings of the Florida orange grove by artist Henry Ossawa Tanner, however, kept these fantasies at bay. In the last years of the nineteenth century, Tanner painted an unusual view of orange culture in his canvas *Florida* (fig. 23).[106] He rendered the fruit trees in short impressionistic brushstrokes that reflect his training in Paris just months earlier. This choppy brushwork deviated from the crisp, highly finished pictures of orange groves by his contemporaries. Tanner also departed from tradition by depicting a barren, yellowed ground with icy grass and murky water in place of plowed soil and neat rows of trees. He showed neither fruit pickers nor fruit baskets—the most common elements in pictures of Florida produced for mass markets. Tanner's decision to edit them out seems deliberate since as a painter and photographer working in the South he surely was exposed to the popular rhetoric of the Florida orange grove. In another painting of Florida from the same time period, Tanner also rebuked tradition by focusing on the landscape's moody skies and desolate ground.[107] Tanner's portraits of Florida orange culture clearly diverged from convention.

While frozen ground and muddy puddles in Tanner's painting gave him a chance to experiment with light and texture, they also reflect the condition of Florida in 1894, when it had experienced dangerously low, freezing, temperatures that severely damaged the region's crops. These conditions did not improve months later; in 1895, the front page of the *Jacksonville Florida Times-Union* declared: "Dead, Everything Is Dead."[108] The Great Freeze obliterated the citrus industry in areas such as Mandarin, reducing the sale of oranges in 1895 by 97 percent.[109] It impaired the groves of Harriet Beecher Stowe and countless others. It was the same year—1895—when Martin Johnson Heade stopped painting still lifes of oranges, perhaps because he was unable to find vibrant and healthy fruit as a result of the Great Freeze. Struggling with intermittent freezes, a primitive transportation system, and unregulated fruit production, Florida could no longer compete with the California orange industry. The Great Freeze officially lowered Florida's status below that of California.[110] Despite the blue skies in Tanner's painting, which signaled hope after the Great Orange Freeze, his depiction in

FIGURE 23

Henry Ossawa Tanner, *Florida,* 1894. Oil on canvas, 18½ × 22½ in. Walter O. Evans Foundation.

many ways undercut traditional portraits of Florida by refusing to show this landscape in its fullest and most optimistic expression.

Tanner, an African American artist trained at the Pennsylvania Academy of the Fine Arts, had moved to the South in the 1890s to find a better art market, but conditions for African Americans by then had grown worse.[111] The last years of the nineteenth century marked one of the cruelest periods in African American history, when southern states like Florida passed Jim Crow laws, legalized racial segregation, and abolished the black right to vote. To the satisfaction of many white southerners, many of the Reconstruction Acts and laws from the Civil War promising citizenship to African Americans had been upended by the 1890s. Scholar Marcia Mathews suspects that Tanner experienced the condescension that prevailed in the southern states at this time: "he knew that no amount of talent could break down the rigid barriers of racial prejudice that existed there."[112] One wonders if the bigotry Tanner experienced at that time, and the many riots led by angry white mobs against African Americans in the South, influenced his depictions of Florida that rebelled against picturesque conventions.[113] The industry that offered dreams of improvement to African

Americans after the Civil War was in the last years of the nineteenth century frozen and turned to mud, literally and metaphorically. The dramatic increase in lynchings of African Americans at this time further tarnished the southern landscape where poplar, oak, elm, and dogwood trees—perhaps fruit trees too—were used for hangings. Many years later, in the 1930s, a poem written by Abel Meeropol and recorded by singer Billie Holiday made a direct connection between fruit and lynching in the South in *Strange Fruit*:

> Southern trees bearing strange fruit
> Blood on the leaves
> And blood at the roots
> Black bodies
> Swinging in the southern breeze
> Strange fruit hangin'
> From the poplar trees.[114]

These lyrics turned fruit into a symbol of horror in the Jim Crow South. While it seems meaningful that Tanner, a black artist, painted a stressed southern landscape when the stress of racial tensions and violence was increasing, his picture resisting fantasies of a southern paradise would have been striking regardless of the artist's race and experience in the South. Tanner challenged the optimistic rhetoric surrounding southern fruit and showed a more ambiguous view of Florida's future after the Great Freeze.

CONCLUSION

Tanner's painting provides an unsettling bookend to Stowe's depiction of oranges from years earlier. Stowe's flourishing orange grove after the Civil War offered hope that America's fields would turn into peaceful and fruitful landscapes with the oncoming years of Reconstruction. Stowe, along with northern horticulturists, boosters, and politicians, saw optimism in America's groves, using oranges to restore confidence to the region's economy and persuade northerners to move south to assist in its reconstruction. Still life paintings. photographs, and trade cards were an accessory to this project by advertising Florida's vibrant fruit culture. Images of African Americans working in orange groves also presented a hopeful picture of new opportunities in the South and better conditions for Florida's freedmen. For many artists and viewers, oranges represented ambitions to democratize the South and diversify its resources in the decades after the Civil War.

Although many praised the good intentions of northerners, it is important to bear in mind that northern involvement in the South was not motivated purely by charity. Northerners in the 1860s and '70s realized that transforming southern landscapes into oranges groves was a way to profit from land speculation and sway southern politics.

The more that northerners moved south and established homes and businesses, the more they helped produce a civilizing influence in a region that they perceived to be backward. Orange culture—and its representation in paintings, photographs, and traveling railcars—was simply and plainly an instrument for northernizing the South. While many citrus images supported northern visions of a new South, Tanner's paintings in the last years of the nineteenth century signaled the failure of Florida's orange industry. In the 1890s, hopeful images of the Florida orange were overshadowed by racist images of watermelon that rejected the programs of Reconstruction and Emancipation and ambitions to incorporate African Americans as citizens.

3

CUTTING AWAY THE RIND

A History of Racism and Violence in
Representations of Watermelon

———

WATERMELONS ARE A CHALLENGING subject to paint; they are "cumbrous and ungraceful" but make "very interesting and pictorial subjects for representation," wrote still life painter Andrew John Henry Way in 1887.[1] The watermelon's messy composition, frosty surface, and glassy reflections were difficult to imitate on canvas, serving as a true barometer of an artist's mastery of illusionism. Nineteenth-century paintings of ruptured watermelons, blasted open and fractured in chunks, reflect artists' embrace of this challenge and ambitions to replicate the fruit's cumbersome shape. While watermelons provided an opportunity to experiment with form and texture, on the one hand their messiness concerned etiquette experts— the guardians of dining room culture—who delivered stern advice in manuals and women's magazines on how to properly eat ungraceful foods like watermelon in polite company. Artists, in contrast, relished the inelegance of this fruit, depicting watermelons soaking tables, dribbling juice, and spiked with alcohol. They also used watermelons to make comparisons

with the busty curves, fleshy folds, and the womblike shape of the female body. Artists exploited the watermelon's intemperate qualities discussed in dietary and medical communities to comment on subjects that fell outside the boundaries of polite society.

The watermelon's ungraceful qualities were specifically used for expressing cruel and concocted stories about the impoliteness of African Americans and their ferocious appetite for this fruit. These racist expressions were not only visualized in popular print illustrations and figurines from the twentieth century, as scholars have shown, but also in silverware designs, paintings, and photographs throughout the nineteenth century in both the North and South. This trope was so pervasive that it even infiltrated still life paintings where no black figures were present. Originally an African fruit, the watermelon emerged as a racial trope after the Civil War, when African Americans gained greater civil rights with the abolition of slavery. Depictions of black men devouring watermelons demonized them and cast doubt on whether African Americans could ever become fully incorporated into society as citizens. Trade-card advertisements took this stereotype a step further by showing black bodies morphing into watermelons, using food to make a more direct argument about African Americans as not fully realized humans. Still lifes with watermelons stabbed open and bleeding with juice, on the other hand, may have served as metaphors for and social commentaries on racial violence in the late nineteenth century. Examining representations of watermelons well before the twentieth century, and beyond the print medium, reveals how these depictions were widely produced across various media to promulgate racism and contest the changing status of African Americans in the decades after Emancipation.

Images of watermelon patches were another popular platform for expressing racial stereotypes and anxieties about the integration of African Americans as citizens. Representations of black men stealing fruit from watermelon patches were particularly pervasive, reflecting anxieties over black masculinity and African American men's increasing access to land in the years of Reconstruction. Although some artists pushed back against these anxieties in images that combated racial stereotypes and showed African American people eating watermelon with dignity, images of black men trespassing onto white-owned watermelon patches tapped into feelings of resentment that many white Americans felt over laws giving black men more privileges to purchase southern land managed by the government. Whereas representations of the Florida orange grove advocated for the incorporation of African American freedmen into society, images of the watermelon patch expressed unwillingness to extend land and rights to black people. Into the late nineteenth century, food and the spaces where they were grown continued to form an important site for promoting racial inequalities. No other fruit expressed racial prejudice more clearly and routinely in American visual culture than the watermelon.

SPIT, SPIKE, AND VOMIT: WATERMELONS
AND THE CULTURE OF INDIGESTION

Watermelon, a member of the gourd and cucumber family, is a native of Central Africa, where it was cultivated as a source of food and water.[2] No part of the watermelon was wasted there; every part was repurposed to produce roasted seeds, pickled rind, and livestock feed.[3] After its importation to the United States by Spanish colonizers and African slave ships in the seventeenth and eighteenth centuries, the fruit was used by European colonists to make alcohol, sugar, and mulch.[4] By the late eighteenth and nineteenth centuries, the fruit was well liked by famous American figures. President Thomas Jefferson enjoyed watermelon and cultivated the fruit at his home, Monticello; Henry David Thoreau hosted annual watermelon parties in Concord, Massachusetts; and Mark Twain described watermelon as "chief of this world's luxuries" and "king by the grace of God over all the fruits of the earth." "When one has tasted it," Twain wrote, "he knows what the angels eat."[5] Fit for the appetites of angels and presidents, watermelon was considered a culinary delight. Although the watermelon may not have been indigenous to North America, it gained a strong association with the United States, particularly the South.

Watermelons, like oranges, grow easily in the South because they require a semitropical climate to nourish the vines through the 120-day growing season. The fruit grows most abundantly along the "watermelon belt," which stretched from Florida to South Carolina along the banks of the Savannah River. Georgia was the heartbeat of the watermelon trade in the nineteenth century, shipping between four and five hundred railcars of the fruit a day to markets in the North.[6] The watermelon trade was highly systematized with a bureaucracy of farmers, railroads, dealers, commissioners, and sellers who directed millions of southern watermelons to tables across America. Watermelons, as a result, became a common man's fruit, popularly used in seed-spitting contests and watermelon parties.[7] The fruit was also a central feature in horticultural contests that offered farmers generous rewards for cultivating varieties of record-breaking weight. In 1871, a Mr. Frank Rose grew one of the largest specimens, weighing an astonishing 57 pounds.[8] In the late nineteenth century, watermelons were a mass-produced fruit associated with the South, but common in the North.

Artist Albert Francis King contributed to the watermelon's reputation as a party fruit by showing it carved with a hole for the injection of alcohol (fig. 24). This square window, known as a "plug," provided a place for drinkers to inject, or "spike," alcohol directly into the fruit.[9] King painted the plug in a sharp spotlight, cutting the hole in half with a shadow that shows how deeply alcohol can descend into the fruit. The slice of watermelon removed from the plug sits in the foreground of the table, while a knife lies in the background, its job complete. The meticulous incision left only a few black seeds scattered on the table. The sturdy architecture of the fruit made it a perfect vessel for holding liquid, while the sweet flesh softened the alcohol's bitter taste. Other

Albert F. King, *Still Life with Watermelon and Cantaloupe*, 1895. Oil on canvas, 18 × 24 in. Private collection.

still lifes by King show watermelons with stoneware pitchers and stemmed wine glasses that might have been used for beverages like watermelon wine. These images reflect the vibrant culture of alcohol in King's hometown of Pittsburgh, a region influenced by German immigrants who brought with them pretzels and cheese as well as their mastery of wine- and beer-making. But not everyone appreciated the marriage of watermelons and alcohol; the nation's temperance supporters urged people to avoid "listening to the advocates of brandy or claret soaked melon, and say to yourself such ideas could only emanate from a diseased brain."[10] King did little to curb the fruit's association with intemperance, showing watermelons purging juice and vomiting seeds that foreshadowed what could come from indulging too heavily in a claret-soaked melon.

Still lifes of melons gushing juice and excreting seeds also resonated with the fruit's medicinal function as a digestive aid and laxative in the nineteenth century. The watermelon was touted by writers in medical journals as a "mild aperient" that "will keep the bowels free and easy and prevent chills, fever and ague."[11] Other articles described melons as a cooling, refreshing sedative with diuretic properties that make it "one of the pleasantest medicines we could subscribe."[12] The digestibility of food was a popular topic in the nineteenth century, when indigestion (called dyspepsia) plagued Amer-

icans. The anxiety surrounding dyspepsia cannot be overstated; historically, doctors and dieticians ranked this problem second only to insanity.[13] Etiquette manuals even published digestive timetables that articulated how long a specific food would take to digest. According to *The Home Instructor* by Thomas W. Handford, a food such as broiled turkey took two and a quarter hours to digest compared to roasted pork, which required a long six hours.[14] Watermelons, in contrast, were praised for hastening digestion. Paintings of melons purging seeds and soiling tables evoked the very digestive processes that the fruit promised to produce.

Etiquette experts tried to rein in the very qualities that doctors and artists valued in watermelon. They established strict rules for appropriate times to eat this fruit, the correct room temperatures under which to eat it, and even the suitable clothing in which to consume melons. One expert declared: "The best hour to eat water-melon is eleven o'clock in the forenoon, or between three or four in afternoon, or late at night after the food that has been eaten at the proper intervals, has been thoroughly digested and removed from the stomach."[15] Watermelons also were to be eaten with specially designed knives and spoons. For etiquette experts who dictated how to correctly eat watermelon at the table, pictures of the fruit wetting tables, spilling seeds, and dribbling guts showed a failure to follow societal rules. King's pictures, in particular, displayed the consequences of excessive eating and drinking that etiquette experts and temperance advocates warned against. Perhaps still lifes of watermelons were more appropriate for the bathroom than the dining room as subjects portending the evacuation of food. As much as etiquette experts tried to domesticate this messy and unpredictable fruit, artists such as King disobeyed the rules of decorum in their dining room pictures.

INTERPRETING THE WATERMELON STEREOTYPE ACROSS VISUAL MATERIAL

As embodiments of indulgence, intemperance, and lack of control, watermelons became a useful subject for perpetuating racist stereotypes in the decades after the Civil War, presenting African Americans as an uncivilized people with an uncontrollable appetite for the fruit. A story published in the *Christian Recorder* in 1886 described a black man so obsessed with watermelon that he ate a 46-pound fruit in one sitting, requiring an emetic to save his life.[16] A decade later, an article in *Harper's Weekly* reported how "colored people begged for the watermelon bits broken in transit, eagerly eying the beautiful melons, hoping against hope that one stray melon might fall his way."[17] These stories were not designed to elicit sympathy for impoverished black people, but disdain. Seed companies cemented the racial trope by naming a dark green watermelon variety the "Niggerhead."[18] Few scholars have recognized how the fruit's reputation for intemperance made it adaptable for portraying African Americans as crude and eager for instant gratification. These stereotypes were perpetuated on a national scale at the Columbian Exposition of 1893, when watermelons were

distributed for free on "Colored People's Day," the only occasion when African Americans were allowed to attend this internationally popular fair.[19] African American members on the Columbian Exposition Planning Committee had objected plans to reduce Colored People's Day to undignified stereotypes, wanting it to be "a no watermelon day."[20] In a similar manner of protest, most etiquette books and cookbooks written by African Americans in the nineteenth century noticeably exclude recipes incorporating watermelon, perhaps to avoid perpetuating stereotypes.[21] Like members of the Expo Planning Committee, black cookbook authors understood the watermelon's symbolism in popular vernacular and how the fruit's image was used repeatedly to disparage the character of black people.[22]

The relentless depiction of African Americans devouring watermelons in the most unsophisticated ways makes the stereotype's presence on spoons—a tool of the dining room and symbol of etiquette—all the more striking (fig. 25). A pair of souvenir spoons from New Orleans shows a woman carrying a bale of cotton and a black man eating watermelon on the spoon's handle. His flared nostrils and heavy brows conformed to contemporary ideas about racial inferiority. Though perhaps less widespread than magazine stories and illustrations, silverware pieces were powerfully implicated in disparaging notions of what distinguished "civilized" from "uncivilized" food consumption. Depictions of uncouth black eaters on souvenir spoons designed for well-traveled consumers reinforced social divisions and encouraged them to relish this difference in style. The watermelon spoon was a form of black exclusion from polite culture and representation of a failure to master the codes of gentility. The popularity of such spoons is attested by advertisements in *Godey's Lady's Book*, which described them as "enamelled [*sic*] with a slice of watermelon in the luscious red of the ripe fruit. . . . The handle is tipped with a negro's head in relief, in dead black enamel, while below appears a tuft of the green leaves of the watermelon."[23] Spoons more popularly showed these depictions rather than forks or knives because they offered better surface area for decoration. The use of color reinforced the cruel portrayal by highlighting the bright red color of the fruit against the silver utensil. An object as small as a watermelon spoon provided consumers another opportunity to see and accept racial prejudice by consuming this stereotype with a spoon.

Even in still life representations where no black figures were present, artists depicted the racial trope. In 1896, the American Lithographic Company turned John Edmund Califano's still life painting of watermelon into a print (fig. 26). This was a standard practice throughout the nineteenth century, when lithography firms reproduced paintings with mass appeal in the form of cheaper prints for display in homes and scrapbooks. The print edition of Califano's painting displayed an enormous watermelon, which, despite being cut in half, towers over the red and green tomatoes by its side. The watermelon half in the foreground presents a steep cliff with a valley of seeds, akin to the rugged landscapes for which Califano was best known.[24]

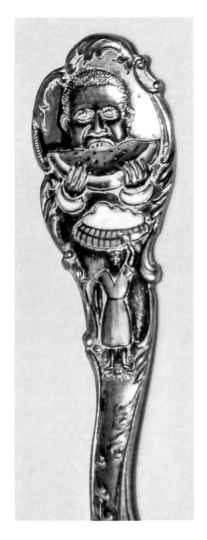

FIGURE 25

New Orleans Souvenir Spoon, June 25, 1900. Sterling silver, 5½ in. Private collection.

Califano flaunted his skill by capturing watery reflections in the knife's shiny blade—a reflection so illusionistic that the knife is nearly camouflaged with the watermelon it sits in between. This translucent effect in his painting was not lost in print reproductions that might have otherwise flattened this artistic accomplishment.

A noteworthy deviation from Califano's painting to print was the title, which the lithographer changed from the more succinct *Watermelon* to *Oh, Dat Watermelon!*, echoing racist poems, minstrel songs, and Currier and Ives prints from the period similarly titled "Oh! Dat Watermelon" and "Give Me Dat Sweet Watermelon."[25] The lithograph's title specifically mirrored a poem published by *Harper's Weekly* in the same year:

FIGURE 26

John Edmund Califano, *Oh, Dat Watermelon!*, 1896. Printed by the Amlico Publishing Company. Based on an original titled *Watermelon,* oil on canvas, 14 × 20 in. Library of Congress, Prints and Photographs Division, Washington, DC.

Oh, see dat watermillion a-smilin' thew de fence!

How I wish dat watermillion it was mine!

De white folks must be foolish to lef' it dar alone,

A-smilin' at me from de vine.[26]

In alluding to popular minstrel songs and poems about black men tempted by "dat watermillion" in the white man's garden, the print's modified title perpetuated stereotypes about black people's desire for the fruit. Evidently, the racial charge of watermelon was so strong that images needed not even visualize a black figure to conjure up the trope. The reproduction of this stereotype in a still life print designed for the masses helped to normalize this disturbing stereotype in dining rooms across the country. A mere title turned this still life of watermelon into a racist prop, showing how no genre of art was excluded from the canon of prejudiced watermelon imagery.[27]

The watermelon trope was not limited to still life representations; higher-end genre paintings more explicitly paired the fruit with African American eaters. Thomas Hovenden's *I Know'd It Was Ripe* from 1885 shows a young black man holding a watermelon in a grimy interior—not the clean and proper dining room described by etiquette experts (fig. 27). Hovenden emphasized the grittiness of this scene by layering gray

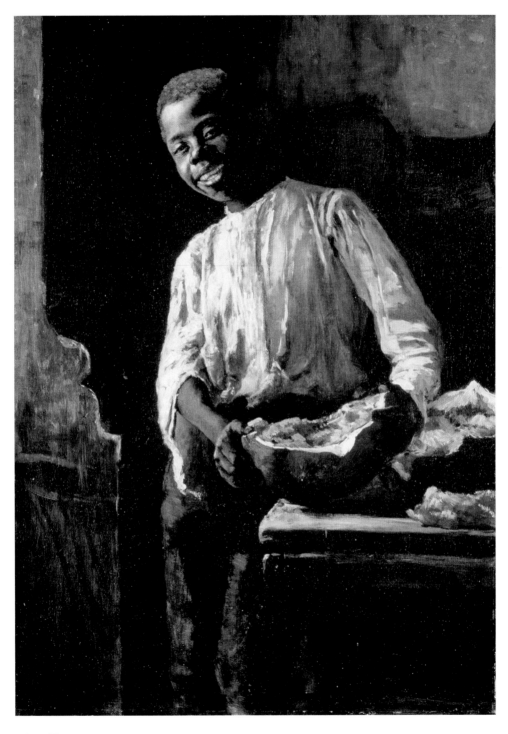

FIGURE 27

Thomas Hovenden, *I Know'd It Was Ripe,* ca. 1885. Oil on canvas, 21 15/16 × 15 7/8 in. Brooklyn Museum of Art, New York, Gift of the Executors of the Estate of Colonel Michael Friedsam / Bridgeman Images.

paint in thick impasto onto the canvas. The absence of silverware in this picture reinforced stereotypes about the incivility and laziness of African Americans, who were thought to naturally prefer foods they could eat with their hands, explains Patricia Turner.[28] Rather than using a specialized watermelon knife, the boy cradles a watermelon that has been broken into chunks on the wooden table. It appears that he has taken a bite from the fruit, for his lips are shiny with the juice. A spotlight traveling from the boy's lips to the flesh of the watermelon emphasizes his lustful desire for the fruit—and the bodily, female flesh that it resembles. Critics remarked on the postcoital tone of Hovenden's painting, noting how the artist "loves to paint boys cutting open watermelons or smoking cigarettes and beaming all over with the satisfaction that comes from the gratification of animal desires."[29] Such interpretations advanced stereotypes of African Americans as excessively sexual people with loose mores. Although Hovenden's original sketch for *I Know'd It Was Ripe* showed the beginnings of a more dignified and individualized portrait of his subject, the artist added weight to the boy's eyelids and a slipperiness to his smile that would have appealed to a broader viewership wanting to see a more stereotypical depiction. Hovenden benefited from these modifications and attracted praise from critics who considered the work "popularly realistic" and one "among the most important" artworks in an exhibition at the New York Artist's Fund Society.[30]

By conforming to racial tropes, Hovenden profited from prejudices about African Americans and particularly black men. It has not been noted before that black men, and not women, dominate stereotypical watermelon imagery.[31] It was fashionable to denigrate black men in this cruel manner because they were considered a threat to many white Americans, especially southerners, who resented the growing power and civil liberties African Americans had recently gained in the previous period of Reconstruction. Pictures demonizing black men eating watermelon and portraying them as unfit citizens who need constant disciplining helped justify their suppression. Anne Maxwell argues that the threat of black masculinity also developed when the virility of white men was perceived to be declining as they led more sedentary lives as clerks and office workers.[32] Anxieties over the corroding physical strength of white men was heightened by the upward mobility of black men in the Reconstruction era and consequent rumors of black men's increasing sexual prowess. Psyche Williams-Forson explains, "the stereotype of the black man as a vicious sexual predator was born out of the gross misperception that all black men had enlarged penises and excessive confidence gained from emancipation."[33] She demonstrates how chicken also expressed these fears in illustrations of black men eating or stealing white meat, which have been interpreted as black men's desires for white women.[34] One wonders if Hovenden's depiction of a black man lusting after pink watermelon under a bright, white spotlight was also intended as a metaphor for interracial lust. While such interpretations might have aroused anxieties over black masculinity, pictures like Hovenden's also dimin-

ished these fears by portraying black figures as smiley, hungry fools whose appetites for cheap foods such as watermelon were a source of humor for white viewers. The boy's tattered shirt and modest dwelling in *I Know'd It Was Ripe* specifically quelled any threat of economic empowerment. The intense focus on black men in images of watermelon shows the intention behind these pictures—to reduce the threat of black masculinity by deriding black men.

The title of Hovenden's painting, *I Know'd It Was Ripe,* also deflated this threat by appropriating an imagined black voice that displays incompetence with the English language. Many artists at the time used the linguistic patterns of lower-class, African American speakers for the titles of their works. *I Know'd It Was Ripe* is one of many titles Hovenden invented that used the painting's black subject as its mouthpiece.[35] Titles borrowing the stereotypic inflections of speech belonged to a larger culture of racial parody that depicted black people as slow and unintelligent, constantly abbreviating, misspelling, or mispronouncing English words as if they were incapable of mastering the language. A character in a sketch from *Godey's Lady's Book* specifically complained about black pronunciations of the word watermelon, saying, "Are they not always watermill *yans,* mill *yins* , or mill*yuns?*"[36] In both literary and visual translations of watermelon, African Americans were ridiculed. Discussions of "watermill yans" in *Godey's Lady's Book,* combined with titles like "I Know'd It Was Ripe," persistently portrayed African Americans as unintelligent, while also relegating them to the lower stations in society.

Sigmund Krausz, known for his full-page photos of "character studies" in Chicago, combined all these tropes and prejudices in his photograph, *Oh Golly, but I'se Happy!* (fig. 28). He captured a black boy eagerly eating a watermelon in a manner that echoed his other stereotyped portraits of an alcohol-guzzling chimney sweeper and an Italian peasant peddler. Like Hovenden, Krausz borrowed stereotypical dialect for his title in order to describe the expression of the sitter, who smiles widely while moving a giant slice of watermelon to his lips.[37] The boy's purposeful gaze away from the camera and exaggerated pause before biting into the fruit suggest that his pose and expression were carefully staged. By instructing the boy to open his mouth in a particular way, Krausz created a visual resemblance between the boy's crescent smile and the watermelon's crescent shape. The sitter displays a "watermelon smile," an expression coined by Tanya Sheehan to describe the goofy grimace and infantile excitement that many pictures of black sitters eating watermelon exhibited.[38] Such expressions looked especially indecorous in the Victorian period, when the mere act of revealing one's teeth in photographs was considered brash. Rendering this stereotype in a photograph—a medium associated with scientific accuracy and honesty—brought validity to this racial fantasy that reduced black people to the objects after which they supposedly lusted. Photographs, paintings, still lifes, and spoons circulating around the country transformed watermelon into a demeaning racial signifier and feature of

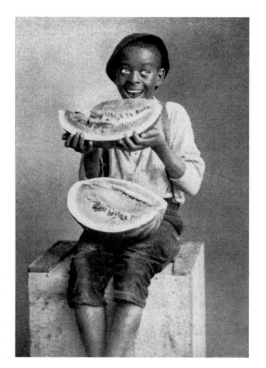

black physiognomy in the nineteenth century. Whether directed at mass audiences or more exclusive circles of viewers, the watermelon stereotype hinged on visual images that belittled black people, specifically men, to reduce their empowered status after the Civil War.

While these pictures clearly aligned with the desires of white southerners who resented the endowment of citizenship and other rights to black people, images of the watermelon stereotype extended far beyond the South. Krausz's photograph was published in Chicago; Hovenden's genre painting was exhibited in New York; and New Orleans souvenir spoons were most likely collected by northern consumers. Desires to deride African Americans in visual culture were not a uniquely southern practice, but a national one. After years of fighting to abolish slavery, it seems strange that northerners would want to see images belittling and vilifying African Americans. The broad consumption of watermelon imagery confirms that northern battles to emancipate enslaved people did not embrace desires to see them achieve full equality. Historian Nina Silber argues that pressures to foster unity between the North and South in the late nineteenth century also produced a declining interest among northerners to help improve the status of black people. Silber explains: "Northern opinion . . . underwent a noticeable change from the 1860s, a period characterized by a certain optimism regarding the position of African Americans to the 1890s, when northerners seemed uninterested, pessimistic, and derisive regarding the status of southern blacks.

Increasingly, northern whites bowed to the racial pressures of reunion, to a process that depoliticized the legacy of sectionalism, overlooked this history of American slavery, and came to view southern blacks as a strange and foreign population."[39] The pressures of reconciliation and fears that African Americans would take jobs away from white northerners exacerbated racial tensions. To viewers all over the country, images of black watermelon eaters as lazy, lustful brutes made African Americans seem less competitive and ultimately less powerful.

"YOU ARE WHAT YOU EAT": CONSUMING RACISM ON TRADE CARDS OF FOOD

As if the watermelon stereotype was not pervasive enough in prints, paintings, photographs, and silverware, one of the most widespread and disturbing uses of the watermelon stereotype appeared in chromolithographic trade cards: small, rectangular advertisements the size of a postcard. Trade cards were made possible with the invention of chromolithography, a printing process that used several stone slabs divided by different colors to produce a multicolored effect. In contrast to pre-Civil-War-era lithographs that were bound by a single-color printing process, trade cards of the late nineteenth century were wildly colorful and produced on a mass scale.[40] They were printed with the names and addresses of retailers selling the advertised product, helping to improve their brand recognition. Businesses wanting to advertise on trade cards, however, had only a limited inventory of illustrations to choose from in the early years of this new invention, so trade cards advertising vastly different products often shared the same pictures. Nevertheless, trade cards were widely distributed in markets, stores, and in product packaging by door-to-door salesmen, and they were also widely collected. Historian Robert Jay asserts that "at the height of its popularity in the 1880s, the trade card was truly the most ubiquitous form of advertising in America."[41] Because of their extensive circulation and broad appeal, trade cards became a highly visible form of expression, offering useful insight into mainstream American visual culture.

Eerie pictures of African Americans eating watermelon or transforming into the fruit were a common subject on trade cards selling a range of products, from fertilizer to cough syrup. A trade card for the Boston Dental Association, for example, showed a black man's face with the green, waxy complexion of a watermelon and a mouth filled with the fruit's red interior and white rind in place of teeth (fig. 29). Black sitters on trade cards were not merely consuming the fruit, but were being consumed by it. The company might have chosen this picture because the gummy, toothless man could advocate for the importance of dental care by not eating sugary foods ruinous to teeth. The figure's head is deliberately tilted at the same angle as the watermelon slice it holds, forging a likeness between the fruit's wide, crescent shape and the figure's obscenely wide smile. The white dog at the center of the composition, with closed lips and discerning eyes, shows more self-control than the black figure. White figures, too,

WHAT-ER-MELON

BOSTON DENTAL ASSOCIATION,
DENTISTS,
281 Main Street, HARTFORD, CONN.
OVER

FIGURE 29
Boston Dental Association trade
card, late nineteenth century.
Lithograph. Jay T. Last Collection
of Horticulture Prints and
Ephemera, 1840–1933, priJLC_
HORT. The Huntington Library,
San Marino, California.

were transformed into watermelons, but depicted with greater dignity in their faces
(fig. 30). They generally stand tall with more controlled expressions, in contrast to
black men whose faces were often so caricatured that they appear less than human.
Here, white watermelon bodies appear as a positive attribute—a promise of fertility
due to their placement on advertisements for fertilizer—while black images of
watermelon show the negative results of indulging too heavily in the sweet fruit. On

FIGURE 30
Bay State Fertilizer trade card, late nineteenth century. Lithograph, ??. Jay T. Last Collection of Horticulture Prints and Ephemera, 1840–1933, priJLC_HORT. The Huntington Library, San Marino, California.

mass-produced trade cards that permeated the nation's visual consciousness, images of black faces and bodies morphing into watermelons served to dehumanize African Americans, literalizing the watermelon stereotype for viewers.[42]

By repeatedly manipulating the human form into foods, trade cards maintained the widely held belief that "you are what you eat," a theory that American dietary reformers endorsed in manuals, school programs, and settlement houses to uplift one culture

over another. Writers such as Francis Grund believed that what a person ate directly shaped his or her mental and physical constitution, writing, "what one eats assimilates with us, becomes our own flesh and blood, and influences our temper." Grund regretted that her fellow Americans "are made up of potatoes, raw meat, and doughy pie-crust! The very thought of it is enough to lower our self-respect."[43] Food, in Grund's case, was not just used for criticizing African Americans, but all Americans. Most often, social reformers used this reasoning to denigrate the diets of immigrants and people of color while elevating a North American diet that promised to produce healthy, virtuous bodies. They criticized the rice-heavy and meat-impoverished diets of Chinese immigrants, for instance, whose cuisine was thought to create unmanly, un-American bodies in the nineteenth century.[44] Dietary reformers also targeted Mexican foods, declaring that salsa and tortillas created weaker bodies in comparison to white bread, which fortified strong men and women.[45] Social workers whitened immigrant meals with cream sauces and fresh milk as part of the larger project of perfecting American society.[46] Experts worried that the failure of nonwhite eaters to embrace Euro-American diets signaled a dangerous refusal to assimilate to American culture. Food's capacity to not only reflect but also shape society played a part in debates about who can and should become a citizen.

Indeed, ideas about food and citizenship were embedded in American political thought, with words such as "assimilation," "digestion," and "consumption" used frequently to describe people's status in American society. Melanie DuPuis explains, "In the body metaphor of society, ingestion represents belonging, digestibility represents assimilation, and inedibility becomes the metaphor for social exclusion."[47] According to this logic, trade cards that turned African Americans into tasty watermelons might make them seem "edible" and therefore "digestible" to the national body. Kyla Tompkins explains the paradox of combining racism with constructs of digestibility, writing, "to be socially degraded and considered nonhuman is one of the conditions to be edible."[48] In that case, African Americans on trade cards may have looked physically edible, but they were socially indigestible as citizens in society. In contrast to paintings that showed African Americans devouring watermelon, trade cards displayed them *becoming* watermelon and, therefore, becoming less human. In a culture where people and their station in society were likened to the digestive stages of food, edible black figures on trade cards presented them as enticing commodities but undesirable citizens.

That trade cards were inexpensive, everyday objects that permeated American life is precisely what made them so dangerous; their dehumanizing images that registered as frivolous, funny, or amusing to many viewers served to naturalize stereotypes and make them more acceptable across a wide population. The cards' jovial colors and the characters' comical expressions also may have softened the harsh reality of racial discrimination for white viewers. Kyla Tompkins's scholarship on the subject acknowledges the racism on trade cards and demonstrates their influence from

derogatory minstrel theater and vaudeville performances, yet she also urges scholars to resist seeing these images as only "a sign of racism to be condemned."[49] Tompkins wonders how the rising population of black consumers, with a claim to both "commodity pleasure and political citizenship," might have encouraged trade-card advertisers to become cognizant, even welcoming, of a black market.[50] The author also contemplates how trade cards featuring people of color might have expanded the perspective of white viewers, asking them to see themselves through the eyes of a black person featured on a trade card, since advertisements ask consumers to trade places with the model.[51] While it is valuable to consider how trade cards carried multiple connotations for a diversity of viewers, it is challenging to fathom how racist trade cards of watermelon might have encouraged empathy in this way. The purpose of stereotyped watermelon imagery on trade cards was to denigrate black people. That is why African Americans fought so hard to dismantle the watermelon stereotype by, for instance, refusing to sell the fruit on "Darkies Day" at the Columbian Expo. Differences between trade cards of black and white watermelon consumption especially highlight the racist intentions behind such imagery. Although Tompkins rightly calls on readers to investigate how black viewers might have changed the trade card industry or devised strategies to "bite back" and "refuse to be consumed" on trade cards, it seems just as likely that they would have challenged racist trade cards by avoiding them altogether.[52]

WATERMELON VIOLENCE AND RESISTANCE IN ART

In searching for modes of resistance to the watermelon stereotype, scholars should consider the possibilities of nineteenth-century still life painting. While some reinforced stereotypes, a number of still life paintings seem to comment on racial violence in images of watermelons stabbed, smashed, and bleeding with juice—a level of abuse and aggression not typically reserved for other fruits. The violent nature of watermelon still lifes in American art can be traced back earlier in the nineteenth century to 1813, when Philadelphia artist Raphaelle Peale painted a cavernous watermelon with its guts carved out from the insides.[53] Decades later in 1862, Edward Edmondson painted a ravaged watermelon, chewed down to its skeletal rind. He glued chunks of glass to his painting, creating an unsettling, even dangerous texture.[54] These still lifes of "watermelon violence" anticipated paintings like *The First Cut* by Fall River school painter Robert Spear Dunning (fig. 31), who depicted a watermelon pierced by the sharp edge of a knife in 1889.[55] Dunning's painting is intensely cropped so that viewers only see a watermelon on a tabletop and not the ornate crystal and glassware that he typically included in his artwork. By excluding decorative objects from *The First Cut,* Dunning focused on the stark, shallow foreground of the painting where a piece of pink watermelon has fallen onto the table. The knife does not rest casually on the fruit as it does in Califano's still life (see fig. 26), but plunges into the tender wound of the fruit, exposing a bloody gash. The deepest part of the wound

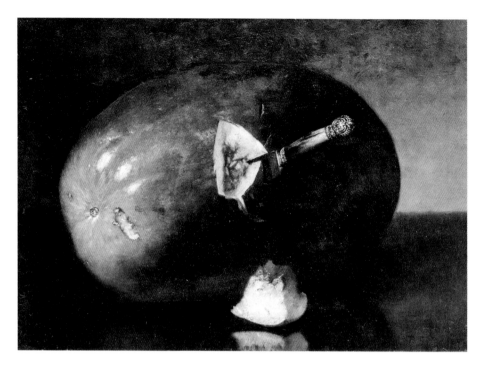

FIGURE 31

Robert Spear Dunning, *The First Cut*, 1899. Oil on canvas, 12½ × 17¼ in. Richard York Gallery records, circa 1865–2005, Archives of American Art, Smithsonian Institution.

shows the deepest hue of red, resembling the bloody shades of a human cut. The insides of the fruit look fleshy, not watery, further likening Dunning's watermelon to wounded skin.

In picturing a knife penetrating the flesh of a watermelon, Dunning may have used the fruit to hint at racial violence. After all, the watermelon was a constant proxy for African Americans and a staple in depictions of racism from the late nineteenth century. Still lifes such as *Oh Dat Watermelon* demonstrate how it was nearly impossible to separate the fruit from its associations with black people. In a society where some watermelons were even known as "niggerheads," a picture of a watermelon punctured by a knife could have certainly represented an outlook on violence against this community.[56] Dunning's picture could have been suggestive of sexual violence as well in depicting a knife penetrating a fruit known for resembling the fleshy folds of the female body. There were many stories in the late nineteenth century that connected watermelons with violence, including one article in the illustrated journal *Gleason's Pictorial Home Visitor* that told of a man who made a watermelon incision so long and deep that he swore he heard the fruit scream "Murder!"[57] Due to the inherently aggressive nature of thrusting and splitting open watermelons with sharp knives, it is pro-

ductive to consider how this fruit was useful for artists to explore darker themes relating to sexual and racial violence.

While the artist never declared that *First Cut* was a commentary on racial violence, other artists in Dunning's time used the still life genre to address charged political issues. William Michael Harnett, for one, depicted a dead, plucked chicken hanging from a nail on a plank door in his 1888 painting, *For Sunday's Dinner*.[58] The artist, an Irish immigrant, focused on this subject a few years after Irish-led labor strikes, perhaps "a vivid reminder of a long tradition of subsistence and poverty endured by immigrants and the working classes," writes Judith Barter.[59] Barter identifies more overt political commentary in a still life painting by De Scott Evans who depicted two potatoes hanging by their necks and tacked to a door pinned with the note, "The Irish Question" (fig. 32). The potatoes are suspended by a white string, recalling the hangings of Irish protestors in 1880s England that impelled many Irish people to flee the country. Potatoes were a fitting subject for addressing the well-known Irish Question since they were closely associated with Irish identity and the earlier potato famine of the 1840s, which led thousands of struggling farmers to immigrate to America.[60] Symbolizing politically loaded topics with everyday foods in still life paintings known for quietude and a lack of figures was a clever strategy used to address sensitive content that may have been too controversial to depict more overtly.[61] Still lifes of food, in this way, were allegorical images, enabling artists to convey complex topics such as racial violence and social injustice. If still life paintings of mutilated chickens and lynched potatoes pointed to larger conflicts in society, it is possible that pictures of stabbed and wounded watermelons might have tackled similarly challenging issues.

The potential of still life paintings to confront racial violence encourages a reconsideration of watermelon paintings by artist Charles Ethan Porter (fig. 33). As an African American artist, Porter faced many obstacles in the art world; it was challenging to find jobs, patrons, and studios since black artists were largely prohibited from renting spaces in downtown New York.[62] Porter, however, overcame some of these barriers and was one of the first black artists admitted to the National Academy of Design. While living in the YMCA building with other famous white artists, he took life drawing classes, which were historically forbidden to black artists, and studied fruits, flowers, and bugs for still life paintings, which were considered an acceptable genre for women and artists of color.[63] Porter painted a wide spectrum of fruits throughout his career, but it appears that he only painted two still lifes of watermelon. He depicted this fruit in 1884 and 1890, taking advantage of its pregnant shape and messy flesh to experiment with form and texture. His images anticipated the advice of still life artist and teacher Andrew John Henry Way, who wrote in an 1887 issue of the *Art Amateur*, "Get a watermelon . . . not over ripe, and of a rich carnation interior. Do not cut it, but *break* it, if possible, into three parts. Let this be the centre of your picture—the point of attraction."[64] This is precisely what Porter did: his watermelon is broken into several pieces and placed in a focal point of the composition.[65] His predilection for diffuse lighting

FIGURE 32

De Scott Evans, *The Irish Question*, 1880–89. Oil on canvas, 12 × 10 in. Art Institute of Chicago, Restricted gift of Carol W. Wardlaw and Jill Burnside Zeno; Roger and J. Peter McCormick Endowments, 2004.3.

and impressionistic brushwork garnered praise from critics, who admired Porter's pictures for their "soft effects of light and true coloring [that] give much satisfaction."[66] The artist's attention to detail and ability to combine an impressionist sensibility with the scientific accuracy of a Ruskinian painting brought Porter recognition.

Porter's soft, impressionistic treatment of watermelon, however, shows a degree of violence not seen in his other depictions. The watermelon flesh looks torn apart and

FIGURE 33
Charles Ethan Porter, *Broken Watermelon*, 1884. Oil on canvas, 20 × 24 in. Private collection.

ravaged, with white seeds scattered like knocked-out teeth. Round watermelon chunks in the background look like a cranium, or skull, that has been smashed open and beaten to a bloody pulp. The ominous shadow looming over the left side of the picture might represent the human or animal responsible for the fruit's ravaged condition. While critics praised dining room pictures that looked "good enough to eat, feast on," and "furnish both good appetite and good conversation," Porter's painting does not look so savory.[67] His battered watermelon has more in common with still lifes of plucked game, which artists like De Scott Evans and William Michael Harnett used to represent political conflict. Although Porter eventually softened his depiction of a watermelon in his later still life of 1890, his depictions of cracked and broken watermelons raise similar issues of violence as Dunning's stabbed fruit. Still life painting was an especially strategic place to insert social commentary since it was widely known as a trivial and marginal genre of art, available to artists who were themselves marginalized in art and society, namely, African Americans and women. Viewers did not expect to confront charged political issues in dining room decorations, yet this is exactly where representations of food often required of viewers to tap into larger debates over the

people who labored for and consumed these foods. Scholars should more seriously consider how still life representations might have been one of the only safe spaces in the fine arts for artists to express commentaries too controversial to voice elsewhere.

As an African American artist, Porter must have contemplated the implications of painting a fruit so closely tied to issues of race. Other African American artists at the time negotiated racialized objects on canvas, including Henry Ossawa Tanner who tackled the heavily stereotyped banjo.[68] Images of black banjo players were as caricatured as watermelon eaters in pictures that showed musicians as buffoons who nearly fall off their stools from wildly strumming the instrument. Tanner, however, brought humanity to the banjo player by depicting an elderly black man sharing a music lesson with a young boy in the 1893 painting *The Banjo Lesson*.[69] Frustrated with mainstream depictions of African Americans, Tanner lamented how "many artists who have represented Negro life have only seen the comic, the ludicrous side of it and have lacked sympathy with an affection for the big heart that dwells within such a rough exterior."[70] Tanner saw this firsthand as a student of Thomas Hovenden, who perpetuated racial stereotypes in paintings like *I Know'd It Was Ripe* (see fig. 27). At a time when racist interpretations of banjos and watermelon were so ubiquitous, artists, specifically African American artists, must have felt pressure to cautiously negotiate these objects on canvas. Perhaps that is why Porter only depicted the racially charged watermelon twice during his robust still life career, wanting to avoid the stereotype and all of its harmful consequences.

WATERMELON THEFT: DEBATES OVER LAND AND ACCESS IN THE WATERMELON PATCH

The racial violence lurking in still life paintings of watermelon rose to the forefront in depictions of watermelon patches. Magazines and journals published numerous, violent stories about theft that took place there. No thief was spared punishment in these stories, including a black bride who was reportedly attacked by her father-in-law for illicitly entering his watermelon patch.[71] Another newspaper reported a story about a watermelon "massacre" in which ninety black convicts escaped prison to ravage a melon patch. They ate the fruit so ferociously that "no mortal man could tell where the nigger began and the melon left off."[72] Such stories brought to life the anthropomorphic images on trade cards that showed black bodies transformed into fruit. To combat watermelon theft, one writer advised farmers to protect patches in areas "where there was an excess of colored citizens." He suggested that farmers "station a man by each melon from the time it was the size of a hen's egg until it ripened."[73] In his opinion, African Americans in the proximity of watermelon patches could not be trusted. Punishment for watermelon theft could be severe; it was considered an act of larceny, punishable by fines and, in some cases, imprisonment. The watermelon violence depicted in still life paintings might be a metaphor for the devastating consequences of thievery on the watermelon patch.

Strohmeyer and Wyman, *Jinks! I could'a sworn I saw a leetle darkey in the melon-patch,* ca. 1897. Stereograph card.
Library of Congress, Prints and Photographs Division, Washington, DC.

The anxiety over watermelon theft permeated prints and photographs that showed white vigilantes guarding their patches from black intruders.[74] One photograph was particularly sinister, showing a white farmer pointing a rifle at a scarecrow that he has mistaken for a "leetle darky in a melon patch"(fig. 34). With his eyes on the target and a finger near the trigger, the white man in this image warned farmers to be on guard and ready to protect their land from intruders. His failure to correctly identify a black trespasser was a caution for farmers to sharpen their vision and maintain surveillance over boundaries that were being tested by African Americans in this period. The wooden fence enclosing the watermelon patch in the foreground of the photo was not just a compositional device to stabilize the receding picture plane, but an allusion to the larger social boundaries dividing black and white men. The scarecrow was also a meaningful inclusion in this photo because black men were viciously likened to black crows in the late nineteenth century and were shown circling watermelons like ravenous birds, which scarecrows were designed to stave off on fields. The antebellum minstrel character "Jim Crow," after whom the era was named, had long associated black people with this noisy bird known for its destructive appetite. Picturing black people as scarecrows, with arms outstretched in surrender, reflected racist desires in the time period for black people to submit to white power and stop encroaching on the land and resources that once belonged only to white citizens.

While there is no shortage of images vilifying African Americans on the watermelon patch, Winslow Homer's painting *Watermelon Boys,* from 1876, shows an unusually sympathetic view of black boys eating the fruit (fig. 35). As part of a series documenting life in the Reconstruction South, Homer's painting showed a black and a white

FIGURE 35

Winslow Homer, *The Watermelon Boys*, 1876. Brush and oil on canvas, 24¼ × 38½ in. Cooper-Hewitt, National Design Museum, Smithsonian Institution, Gift of Charles Savage Homer Jr., 1917.14.6. Photo: © Boltin Picture Library / Bridgeman Images.

youth congenially sharing slices of watermelon outdoors. While two boys recline on their stomachs, one black boy in the center of the composition sits upright, casting a watchful gaze over the broken fence they have likely trespassed. The concerned expression on his face is warranted given that he would likely suffer a more severe punishment for watermelon theft than his white counterpart. His gaze differs from typical images depicting African Americans as smiley, glassy-eyed buffoons intoxicated by watermelon juice. The boy's upright posture and central placement also diverges from pictures that relegated black figures to the lower register of the picture plane. By elevating the black boy to a prominent position in his painting, Homer endowed him with greater dignity. As an illustrator for popular magazines, Homer was very familiar with the period's racist rhetoric, yet, in the years after the Civil War when America's leaders were looking to reunite the country, his painting offered a more compassionate look at African Americans and the uneasy race relations in the South.[75]

Many admirers praised Homer's "negro studies" for showing "total freedom from conventionalism" and a "sensitive feeling for character," but other critics missed the subversion of pictures such as *Watermelon Boys* by applauding the artist for his depiction of "little darkies eating their watermelon."[76] Perhaps this is why Homer was allegedly embarrassed by the popularity of *Watermelon Boys*, which seemed to strengthen, rather than challenge, stereotypes about African Americans for many viewers.[77] For an article on Homer two years later, the *Art Journal* turned his painting

FIGURE 36
Winslow Homer, *Water-Melon Eaters,* 1875. Wood engraving on paper, 5⅛ × 7 in. The Museum of Fine Arts, Houston, The Mavis P. and Mary Wilson Kelsey Collection of Winslow Homer Graphics, 75.821.

of watermelon into an engraving, verging further into the realm of stereotype by show-ing the boys with cruder facial expressions and exaggerated eyebrows and lips (fig. 36).[78] Homer's original title was also changed from "Watermelon Boys" to "Water-Melon Eaters," reducing the sitters to their appetites. Like the retitling of Califano's painting, the modification of Homer's title transformed his sympathetic depiction into a racial stereotype. The most significant deviation from Homer's original painting is the engraving's inclusion of a man behind the wooden fence, which is no longer broken. This standard feature in images of white farmers defending watermelon patches from black intruders firmly separates the boys from the man, who angrily waves his staff in the air to chastise the thieves for trespassing onto his property. The inclusion of the watermelon patch owner raised the stakes of Homer's original painting and amplified the dangerous consequences of white, and especially black, boys' theft.

Depictions of black watermelon thieves emerged during the era of Reconstruction and intensified through the rise of Jim Crow, reflecting a moment when African Amer-ican rights to land were being fiercely debated. In the time period of Reconstruction, African Americans were legally empowered to purchase land in the South as a result of

laws such as the Homestead Act, which allowed newly freedmen as well as women to purchase southern land at cheap prices after the Civil War.[79] These laws disenfranchised southerners whose land, originally stolen from Native Americans, was now put up for sale by the government to transfer its ownership to northerners and those deemed loyal to the Union. This was a strategy to punish ex-confederates and keep them in an inferior position by confiscating their property and preventing them from acquiring new properties.[80] African Americans in this period gained other profound rights as well—namely, the ratification of the 14th Amendment in 1868 granted them citizenship and due process of the law, and the ratification of the 15th Amendment in 1870 gave them the right to vote. African Americans living in the antebellum South could now be legal citizens of their states and the broader nation. In the Reconstruction era, when a Republican majority attempted to make American citizenship more inclusive, pictures of watermelon theft expressed a reluctance to embrace this inclusivity.

The expanding role of African Americans in society produced resentment among many white southerners who did want to see the Constitution extend rights to former enslaved people. Landowning, upwardly mobile African Americans threatened to change traditional relationships between white and black people and destabilize the racial hierarchy that had been in place a century before the war. Not wanting to give African Americans the right to vote, own land, serve on grand juries, or run for office, many white southerners called for a return to previous hierarchies in which free blacks were not citizens.[81] By the 1880s and '90s, a Democratic South gained more influence in the government and reversed Republican legislation by passing Jim Crow laws, or "black codes," which repealed many of the civil rights African Americans had gained during Reconstruction.[82] Laws in the Jim Crow era supported the economic exploitation, voting disfranchisement, and legal segregation of African Americans, overturning all of the progress accomplished in the previous years. Racist depictions of the watermelon patch that showed African Americans craving and searching for resources in many ways celebrated their disenfranchised status in the last decades of the nineteenth century. Unlike depictions of orange groves that communicated a story of inclusion and improvement for freedmen during Reconstruction, depictions of the watermelon patch communicated their exclusion.

Depictions of black men loitering and trespassing onto the landscape supported black codes that were designed to punish begging, vagrancy, and unemployment. Punishments for vagrancy were severe—resulting in imprisonment or bondage—because nonworking African Americans threatened to stall and worsen the southern economy that relied on their labor.[83] Such laws helped preserve a system akin to slavery after the Civil War and force African Americans to work, whether free or convicted. Idleness was also a threat to white Americans in the South because they recognized that idle time allowed for the possibility of black people to organize and revolt. In the late nine-

teenth century, when the country softened and then hardened laws that took away landowning privileges and other freedoms from African Americans, images of black men drifting, wandering, and stealing fruit from watermelon patches reflected anxieties about their new independence and white desires to take them away.

The watermelon patch was a powerful symbol that represented the disenfranchised status of black people because, previously, the cultivation of watermelons in slave gardens reflected black land and power. Before the Civil War, African Americans widely cultivated watermelons on plots of land in slave gardens that Dell Upton describes as sites of empowerment where enslaved people could grow their own food and medicine, and thus exercise control over their own diets and bodies.[84] This was meaningful at a time when many black people and landscapes were the subjects of white ownership. Cultivating watermelon—a fruit indigenous to Africa—was also a way to maintain a link to an ancestral continent in a country that encouraged cultural erasure. The watermelon's location in the gourd family further linked it to black independence since "the drinking gourd" was a metaphor for the Big Dipper, the constellation slaves used to guide them as they traveled north to freedom on the Underground Railroad.[85] While watermelon had been a symbol of black power and agency in the years before Emancipation, eventually the fruit's symbolism was co-opted by image makers to diminish black people. Portraying African Americans with an infantile desire for watermelon rather than a horticultural mastery or ancestral connection to the fruit suppressed its formerly empowering symbolism. Perhaps this is why so few images of watermelon from the late nineteenth century show African Americans actually cultivating the fruit. While previous images in the Reconstruction era showed black people as industrious fruit pickers making a positive contribution to the South, by the Jim Crow era, pictures of black men stealing and consuming fruit served efforts to raise alarm and mobilize fear around their improved status in society.

FRUITFUL REVENGE: CONTEMPORARY RESPONSES
TO THE WATERMELON TROPE

Although the watermelon stereotype has not gone away, several artists from the late twentieth and early twenty-first centuries have challenged the trope in their art. Carrie Mae Weems, for instance, created the 1987 photograph *Black Man Holding Watermelon* (fig. 37) almost a century after the photo *Golly, but I'se Happy* (see fig. 28). Weems rejects old formulas by showing an older boy looking intelligently at the camera without the wide eyes or exaggerated smile of sitters past. He stands tall, his height spanning the entire length of the picture plane, and does not hover over the fruit with grabby hands. He also does not eat the watermelon, but holds it, uncut, refusing to physically or theoretically open up the fruit to stereotypical interpretations. The uncut watermelon is without a crescent shape, which artists had used to emphasize the infantile, crescent smiles fixed on African American figures. Weems

FIGURE 37
Carrie Mae Weems, *Black Man Holding Watermelon,* 1987–88. Vintage gelatin silver print. © Carrie Mae Weems.
Courtesy of the artist and Jack Shainman Gallery, New York.

further rebuked tradition by foregoing the broken English used in titles to belittle figures of the past. Her title instead describes the subject plainly and directly—"black man holding watermelon"—leaving little room for misinterpretation or derision. In departing from earlier photographs that invited viewers to look with disrespect at black people eating watermelon, Weems demands that viewers look at the black sitter *not* eating the fruit. What is not shown here is more important than what is shown. Through these visual strategies, Weems rejects stereotyped depictions of watermelons in all ways.

The greatest success of Weems's photograph is how she makes the viewer acutely aware that this image is carefully staged. Viewers see a sharp spotlight shining on

Joyce J. Scott, *Man Eating Watermelon*, 1986. 2 × 8 × 3 inches. Collection of Linda DePalma and Paul Daniel, Baltimore, MD. Photo courtesy Goya Contemporary Gallery, Baltimore.

the watermelon and creases in the wrinkled backdrop that clue viewers into the artifice of this photograph and how earlier images like *Golly, but I'se Happy* were also carefully staged. Weems does not hide the mechanics of the photographic process but exposes them to reveal how photographs are manipulated to present a tailored view of reality. She shows how racism operates through visual images, while also challenging the visual images that helped establish racist stereotypes. By responding to the watermelon stereotype with the same medium that disseminated it, Weems demonstrates how visual images are so important to dispelling and dismantling racial tropes.

Artist Joyce Scott, too, uses the watermelon's symbolism to combat racial prejudice. In her sculpture *Man Eating Watermelon* from 1986 (fig. 38), Scott created a small, beaded figure of a man caught in the grip of the fruit. He desperately claws his way in the opposite direction in an effort to escape. The symbolism here is clear: the watermelon is dead weight from which the man struggles to free himself. By showing a black man trying to escape from, rather than eat, watermelon, Scott's sculpture deliberately contradicts its title. He opens his mouth not to eat the fruit or form a watermelon smile, but to express anguish at being tethered to the stereotypes that it bears. This is expressed clearly by the man's ankles, which are shackled to the fruit, unable to find freedom from the stereotype. The watermelon, here, is a form of oppression rather than obsession. Portraying this subject in glass beads, a medium typically used to make jewelry and decorate objects, reminds viewers how this ugly narrative has been encoded in pretty things, from paintings to decorative spoons. Scott's bejeweled watermelon is a unique commentary on the ways in which racial stereotypes have enslaved African Americans.

Artist Valerie Jean Hegarty treated the subject of watermelon more recently in her 2012 series *Alternative Histories*, a commentary on racism and colonialism in the United

FIGURE 39

Valerie Hegarty, *Alternative Histories* in The Canes Acres Plantation Dining Room, The Brooklyn Museum. Still Life with Peaches, Pear, Grapes and Crows, Still Life with Watermelon, Peaches and Crows, Table Cloth with Fruit and Crows, 2013 (detail). Canvas, stretcher, paper, acrylic paint, foam, papier-mâché, wire, glue, gold foil, epoxy, fabric, thread, dimensions variable. Courtesy of the artist.

States. In this cycle of work created for the Brooklyn Museum, Hegarty manipulated the institution's permanent collection by making dramatic revisions to the museum's period room, the South Carolina Cane Acres Plantation (fig. 39). She transformed the plantation's elegant dining room into one haunted by black crows, which viciously attack a still life painting of peaches and watermelons on an adjacent wall. The crows peck furiously at the painted fruit, causing watermelon juice to splatter on the frame and chunks of canvas to explode from the wall. What was once a quiet still life of American abundance has now become a scene of savagery. While Hegarty's installation brings to life the myth of ancient Greek artist Zeuxis, who painted a

still life so realistic as to compel birds to peck at the image, the crows in Hegarty's installation are far more aggressive. They attack the still life and the dining room table below, clawing apart the white tablecloth and staining it with fruit juice. Another watermelon has exploded on the floor beneath the table, adding to the riot of feathers and color.[86] Hegarty's installation has ripped this dining room to shreds and wreaked havoc on a model of fine dining that hierarchically separated the haves from the have nots.

These revisions to the Cane Acres Plantation do more than reject dining room etiquette; they seek to destroy the southern plantation ideology that kept communities like African Americans powerless. Hegarty performs this act with black crows, which were analogized to black men in the nineteenth century, shown circling and feasting on watermelons that were used to dehumanize black people. By unleashing crows in the dining room of a southern plantation—sites that were at the center of debates about the status of enslaved African Americans—Hegarty criticizes the racial tropes of pictures past and the culture that first distorted objects like watermelons and crows into racist signifiers. Hegarty's depiction of watermelon is even more resonant given its close proximity to Thomas Hovenden's painting of a black man eating watermelon in *I Know'd It Was Ripe,* which is also housed in the Brooklyn Museum (see fig. 27). By sharing the same institution as Hovenden's black figure eating watermelon, Hegarty's installation provides a truly *Alternative History* to depictions of watermelon and a powerful use of still life painting as a vehicle for social commentary.

CONCLUSION

Watermelon, in sum, was and continues to be a subject propelled by racism.[87] Image makers found the fruit useful to portray African Americans as unruly people because, in part, the fruit was itself unruly, soiling tables and splattering seeds on whatever surface it touched. This messy fruit threatened the values of cleanliness, temperance, and decorum preached by etiquette experts in the late nineteenth century. The watermelon's use in alcohol consumption, seed-spitting contests, and diuretic treatments further portrayed it as a deviant fruit in a society that sought to establish strict rules of decorum. For Americans who believed that "you are what you eat," watermelons, in some respects, were considered as uncontrollable as those who indulged in them. These attitudes made watermelons apt and especially cruel devices for denigrating black people. As a symbol of black agency and independence before the Civil War, watermelons were then deployed after the war as weapons of racist attacks by those who opposed Emancipation and new rights for former enslaved people in the era of Reconstruction. The frequency with which the watermelon stereotype was reproduced across high- and low-brow art forms reveals how urgent it was—for Americans in both the North and South and beyond—to constantly visualize black inferiority and diminish the status of black people.

Representations of the banana and pineapple that follow the Jim Crow watermelon continued to express this message and discourage the extension of land and citizenship to "the darker races." As American fruit businesses grew into large corporations that set their sights on land and resources far past the borders of the United States, domestic debates over "racial others" extended to Central America and the Pacific Islands. Fruit companies wrestled with ways to advertise their products grown in those regions without addressing the people who lived there and cultivated the fruit for American businesses. They adapted strategies that harkened back to the Reconstruction era to justify colonial intervention and endorse the incorporation of new territories abroad where businesses operated fruit production. In the following period of domestic and international expansion in the twentieth century, artists and advertisers had to create flexible images that satisfied competing viewpoints on the conquest of new fruit-growing frontiers and the people who lived there. Images of watermelon, meanwhile, remained unambiguous in their racist messaging: the benefits of citizenship should not be available to everyone, especially to African Americans.

4

SEEING SPOTS

The Fever for Bananas, Land, and Power

I N 1871, **THE LITHOGRAPHY COMPANY** Currier and Ives published the still life print *Fruits of the Tropics* (see fig. 1). The picture reads like a balancing act: grapes are perched on top of a pineapple that leans precariously on a pile of bananas, which squeeze in between oranges and lemons that roll into the margins of the picture plane. To remove one fruit from the picture plane threatens to dismantle the entire composition. It is significant that at the center of the composition are red and yellow bananas, a rare fruit in the 1870s, when only one of every ten thousand residents in the United States had ever seen it.[1] Indeed, Americans may have first learned about bananas from seeing them in this lithograph. North Americans had only occasional encounters with the banana in the 1700s, when this fruit—originally from the equatorial climates of Asia and the Mediterranean—was distributed to the Americas by Asian mariners, Arab traders, and European colonists.[2] After several unsuccessful attempts to cultivate bananas in the semitropical climates of Florida, Louisiana, and California, growers in the United States realized that it was more practical to

import the fruit from Central America and the Caribbean, where the banana grew far more easily. Because North American consumers in the nineteenth century more likely encountered the banana in illustrations, cookbooks, and world's fair exhibits than in markets or in nature, the fruit's visual representation is vital to study. In these instances, sight led the way before taste and shaped US perceptions of the banana.

While nineteenth-century artists showed the banana as an exotic fruit as well as a humorous one informed by tales of slippery banana peels, they offered little information about the fruit's laborers. Information about food labor was particularly important to abolitionist consumers who launched boycotts against tropical fruits produced by enslaved people in the Caribbean in the years before and during the Civil War. After the war, artists continued to remove tropical references from their paintings and traditions of eating bananas in regions that were considered inferior and unsophisticated by North Americans. In the same way that African Americans were perceived as ferocious eaters biting into watermelons without knives or napkins, people in a wider Latin America were portrayed as lazily plucking the fruit and eating it directly from the tree without any decorum. North American housewives helped elevate the banana to the realm of "civilized" habits by displaying bananas on glass stands in the dining room, hanging still life pictures of the fruit in homes, and baking bananas into American recipes. It was women—and not just the "banana cowboys" and "banana men" of fruit companies—who normalized the banana in American homes.[3] Little-studied objects such as the banana boat need to be added to the pantheon of devices that helped sanitize foreign goods in the home.[4] The Americanization of the banana was a form of conquest shaped by artists and housewives who folded this fruit into American domestic culture.

The nineteenth-century strategies that naturalized bananas in American homes were used in the twentieth century to advertise United Fruit bananas. Established in 1899, the United Fruit Company was one of the nation's largest banana distributors, systemizing the banana's production on large-scale, corporate-controlled plantations in Central America and the Caribbean. While most scholarship has focused on the company's foreign policies, land monopolies, and labor practices, few scholars have considered the role of visual images in supporting the company's economic expansion. United Fruit developed a robust visual program, using illustrated cookbooks, maps, and brochures to make the banana's exoticism safe for American consumers while justifying the company's deep infiltration in Central America and the Caribbean. Illustrators for the company modeled their advertisements on trends in the fine arts to elevate the banana in the American imagination and link the fruit to ideas about progress and modernization, which advertised United Fruit's positive influence abroad. The company's influence, however, was not positive abroad; through theft, bribery, and deadly coups, United Fruit amassed a dangerous monopoly over the banana trade and a strong foothold in Central American politics. The history of the banana, therefore, is a story of American corporatization and the ethics that were

sacrificed in the process of political and economic expansion. Contemporary painters such as Moisés Barrios still grapple with its divisive legacy in the twenty-first century by using art to critique the intervention of US banana companies in Latin America. A closer study of the banana reveals how representations of fruit continued to communicate the racial and exclusionary politics of national expansion in the twentieth century as the United States started to invest more in territories abroad.

FIELD TO TABLE: CULTIVATING AND CONSUMING THE NINETEENTH-CENTURY BANANA

Knowledge of the banana in the United States expanded around the time of the Civil War. In 1864, consumers learned about the fruit through prints as well as popular journals like *Godey's Ladies Book,* which reprinted the words of Alexander von Humboldt, a German explorer in South America, who doubted "whether there is any plant on the globe which, in so small a space of ground, can produce so great a mass of nutriment." Humboldt marveled at the banana that "will furnish subsistence for fifty individuals, which, in wheat, would not furnish food for two."[5] *Godey's* published Humboldt's opinion in the last year of the Civil War, when the embargo prohibiting goods from entering ports in the South would soon be lifted. The end of the Civil War led to the lifting of restrictions on navigation, allowing fruit entrepreneurs and merchants to return to their Caribbean and Central American trades.[6] The dissolution of the embargo helped advance the banana trade and enabled more shipments of the fruit from Cuba, Honduras, and Jamaica to the southern ports of New Orleans, Birmingham, and Mobile. Innovations in refrigeration also enabled shipments to reach ports as far north as Boston and New York; thus, it makes sense then that the banana appeared in the 1871 print by Currier and Ives (see fig. 1), a lithography firm based in New York City, a major port for the shipment of tropical fruit.

Saint Louis, Missouri, might have been another destination for the shipment of bananas, since they are depicted in one of the earliest American still life paintings of the fruit by artist Hannah "Harriet" Brown Skeele (fig. 40). Little is known about Skeele, who may have been influenced by artists of the iconic Peale family who exhibited fruit pictures regularly in the same city.[7] Skeele's 1860 painting *Fruit Piece* shows three elegant vessels, two loaded with fruit and a third with sugar, placed on a white tablecloth. The basket in the center holds tropical fruit, including an orange, a pineapple, a lemon, and two bananas—fruits that came from climates and geographic regions far outside Missouri. This luxurious collection of fruit is complemented by a bowl full of strawberries at left and cubed sugar in a filigree bowl at right—another product of tropical lands. The sugar is so delectable that it attracts a fly, hovering over one of the cubes. Skeele would have witnessed a vibrant food trade in Saint Louis, which was situated between the North and the South along the Mississippi River. Skeele's still life celebrated wealth in foods like the banana; she won many awards in Saint Louis for her vibrant fruit still life paintings.[8]

FIGURE 40

Hannah Brown Skeele, *Fruit Piece*, 1860. Oil on canvas, 20 × 23⅞ in. (50.8 × 60.6 cm). The Art Institute of Chicago. Restricted gifts of Charles C. Haffner III, Mrs. Harold T. Martin, Mrs. Herbert A. Vance, and Jill Burnside Zeno; through prior acquisition of the George F. Harding Collection. 2001.6.

Skeele's celebration of tropical bounty in 1860, however, would have agitated abolitionists who urged consumers to boycott bananas, pineapple, sugar, and other slave-produced foods from the Caribbean. Abolitionists hoped that protests against slave-labored commodities would handicap industries reliant on slavery by diminishing their profits. Renowned supporters of slave-free food included Harriet Beecher Stowe, Frederick Douglass, and the Grimké sisters, one of whom famously served "free-sugar" desserts at her wedding.[9] Abolitionists detailed the evils of slave-labored foods, urging supporters in poems and newsletters "*never* to taste or wear any more of the sugar or cotton, in the production of which Slaves have wept, groaned, and been scourged."[10] These verses encouraged readers to consider the human costs of their food. A few artists even painted honey and maple sugar—more ethical alternatives to slave-made goods—in support of the free-produce movement.[11] Skeele's painting, on the other hand, brimmed with foods vilified by antislavery poets who explicitly related the consumption of tropical fruit to the blood and tears shed by those in bondage.[12] The

luxuriousness of her table in 1864 also would have stood out during a time of mounting tensions and a restriction of resources for the Civil War. Bananas did not share the unifying symbolism of grapes and oranges during wartime; for abolitionists, they were reminders of contentious debates and the enslaved people who harvested them.

By 1875, a decade after the Civil War, *Godey's Lady's Book* claimed that the banana was "fast rivaling the orange in popular use."[13] The fruit was in such high demand by 1876 that when it was displayed in the Horticultural Hall at the Philadelphia Centennial, security guards were required to prevent visitors from stealing bananas off the trees![14] The banana's sweet taste and easy consumption were in large part responsible for its popularity; a writer in 1892 explained: "Too much cannot be said of this right royal fruit. No knife is needed in getting it ready for eating. Its soft golden skin is ready at a moment's notice to part from the fragrant meat; it comes away without an effort, leaving no stain, and the most fastidious lady needs no handkerchief in eating a banana, for it is most emphatically a 'kid-glove' fruit."[15] The peel-and-go banana was attractive to many Americans, especially housewives, who preferred foods that eliminated the labor of cooking. This effortless "kid-glove" fruit was also appealing to women who were self-conscious about eating messy foods in public. Dozens of etiquette manuals warned readers about the chaos of fruit seeds, pits, and peels, offering advice on how to handle fruit at the dinner table. That the "most fastidious lady need no handkerchief" when eating the banana was a boon for eaters and distinguished the banana from messier fruits. This advantage, however, was diminished by the banana's phallic shape, which was so suggestive that nineteenth-century fruit peddlers purposely sliced and wrapped the banana in foil to obscure its provocative figure.[16] Whether wrapped in foil or sold in its natural form, the banana appealed to North American consumers for its effortlessness; it also seemed to have lost any toxic association with the stain of slavery by the end of the Civil War.

Artist John George Brown captured the excitement of Americans discovering bananas for the first time in his undated painting *Banana Boy* (fig. 41). A young bootblack seated on a stool excitedly inspects a banana. Bananas cost between ten and twenty cents apiece in the 1880s—a treat for the bootblack.[17] Getting hold of the banana seemed like a joy as well as a challenge: the boy clutches the fruit upside down, incorrectly pointing the top nub toward the ground. Consumers unfamiliar with bananas often confused the fruit with other foods, prompting cautionary tales in *Godey's Lady's Book* that warned: "BROWN *bananas* don't look unlike sausages. The mistake was made by a German a few days since."[18] Although this warning was told at the expense of European immigrants (many of whom were bootblacks and fruit peddlers in New York City), it was not so outlandish for people to mistake a banana for a sausage, since consumers in the late nineteenth century ate the Gros Michel variety, a thicker and stouter banana compared to the leaner Cavendish variety we eat today. Shippers favored the Gros Michel, known colloquially as "Big Mike," for its sturdiness and imperviousness to bruises.[19] Pictures of Gros Michel bananas in the hands of

FIGURE 41

John George Brown, *Banana Boy*, the date is unknown but it is at least post-1860. Oil on canvas, 24 × 16¼ in. Private collection.

curious consumers displayed the delight characterizing early North American encounters with this fruit.

The yellow peel that lies on the ground in Brown's painting echoed humorous tales in journals, trade cards, and song sheets from the late nineteenth century of people sliding on banana peels. It was often excited boys who suffered such falls. An article in *Arthur's Home Magazine* from 1868 regaled readers with a story about a boy who caught sight of a one-cent banana.[20] Drawn by the unusually cheap price, he bought the banana, ate it, and put the empty peel into his pocket, which escaped moments later, causing him to slip on it and fall on the doorstep of his house. What had only cost a cent now cost the boy and his family much more in medical bills, the writer explained. The consequences of slipping on a banana peel were costly and dangerous.[21] Moreover, narratives about the banana peel were lessons on temptation and the need to control one's appetite. Viewers might have read this morality tale in Brown's painting of an eager bootblack whose feet stand dangerously close to a banana peel that anticipates the boy slipping and falling.

Although the banana represented the boisterous and rowdy behavior of consumers in some instances, the banana's importation from far-flung frontiers was also a symbol of sophistication for North Americans. It was an incredible feat to grow bananas and import them from Central to North America. First, regions such as Guatemala and Costa Rica required a complete transformation of the landscape for transporting bananas from jungle to coast. Trees had to be cleared and railroads constructed to haul the fruit across long distances. Once a banana grove matured over several months, laborers quickly cut, washed, wrapped, and loaded the fruits onto railcars.[22] Loading bananas was one of the most strenuous tasks: workers lifted banana bunches weighing up to 100 pounds in scorching temperatures and then rushed the fruit to air-conditioned cabins on ships docked close to railroad hubs.[23] Bananas rot quickly, so their distribution had to be completed as rapidly as possible across the three-week journey to the United States. Fruit companies wanting to expand their business into Central America and the Caribbean used these challenges to justify their intervention in the region, claiming that the conversion of swamps into banana plantations was a heroic reclamation of wilderness for the greater good of civilizing the tropical frontier.[24] This language resonated with the expansionist rhetoric of earlier horticulturists, who similarly claimed that the establishment of vineyards in California and orange groves in Florida helped civilize uncultured borderlands.

Major innovations in refrigeration helped banana growers ship their harvest to North American consumers. Advancements in refrigerated icebox technologies helped delay the bananas' ripening during its cross-country voyage on sail-driven schooners and continued to preserve the fruits once they arrived in the United States on refrigerated railroad cars.[25] There, bananas were chilled in cold storage warehouses with blocks of ice until ready for sale. Ice was considered "big business" at the turn of the century, and it completely overhauled the food industry. With ice and other

innovations, shipments of fresh fruit increased fifteen-fold between 1880 and 1895.[26] By the late nineteenth century, food was accessible from the grocery store, which increasingly supplanted homegrown foods that depended on seasons and climate.[27] Refrigeration ushered in a new era in banana production, delivering the fresh fruit from faraway regions and making it available to American consumers at distances that once seemed unimaginable.

Bananas symbolized the United States' technological ingenuity to make the fruit available from regions far away, but in popular culture, they also reflected "the lazy Tropics," where fruit was thought to grow effortlessly and without the establishment of organized agriculture. Horticulturist Andrew Jackson Downing, for one, believed that life was simple and easy in the tropics, where people were "indolently seated under their shade, and finding a refreshing coolness both from their ever verdant canopy of leaves, and their juicy fruits." "It is not here," Downing concluded, "that we must look for the patient and skillful cultivator. But, in the temperate climates, nature wears a harsher and sterner aspect."[28] An earlier article from 1866 painted a similar portrait of people in Brazil, declaring:

> [The banana] takes about a year for stalk and fruit to mature from the first planting, but then there is never any more trouble with the crop, scarcely any hoeing or weeding, no culture, only "slay and eat." . . . Certainly it is the greatest boon ever bestowed on the indolent tropics. A native swinging in his hammock, with a bunch of ripe bananas hanging in reach on one side, and a smoldering fire on the other, by which he may light his little cigar without getting up, is a most perfect picture of contentment.[29]

In this perspective, Brazilians had only to "slay and eat" their food, while neighbors to the North had to diligently produce food in less hospitable environments. Stereotypes about the lazy tropics were so pervasive that the banana itself was described as languid, with "broad leaves waving in the breeze and fanning in lazy repose."[30] The very term—"the Tropics"—was lazy, conflating a diversity of countries and a wide spectrum of indigenous, African, Asian, and European cultures in Central America and the Caribbean under one simplistic category. Like other fruits in the nineteenth century, the banana was a measurement of progress as much as it was a marker of racial identity used to elevate one culture over another.

THE RAW AND THE COOKED: ASSIMILATING BANANAS IN NORTH AMERICAN HOMES

Pictures focusing on the banana's consumption in the United States rather than its cultivation in Central America and the Caribbean helped assimilate this fruit and distance it from the so-called primitive tropics. Nowhere in popular prints, paintings, and magazine stories did viewers see hints of the laborers who grew, harvested, or transported bananas. Any allusions to labor, or the struggles of workers on banana planta-

tions, were edited out of depictions that showed bananas without their branches, crates, or packaging. By placing bananas in the dark, shallow spaces of still life paintings, artists especially erased the labor and profound distances that bananas traveled. The still life genre lent itself naturally to such de-contextualization by seeming to put life on hold in quiet arrangements of inanimate objects that omit human figures. Obscuring the banana's journey from jungle to table focused viewers on the dining room tables of imagined consumers who could afford to purchase the imported good. By picturing the banana next to grapes, apples, and peaches—fruits long eaten in the United States—still life artists helped further assimilate the tropical fruit into the American mainstream. The display of bananas on tabletops with dessert knives and silver vessels not only naturalized the banana but also elevated it. Even if artists in the United States did not set out to deliberately assimilate the banana in American homes, their still life pictures of fruit in refined, domestic settings—the very places where these pictures were hung—performed this work for them. The growing distribution of banana imagery, specifically inexpensive still life prints, normalized the banana before bananas themselves had become everyday fruits.

Still life paintings from seventeenth-century Holland had achieved this effect first. Dutch still lifes worked to transform remote and costly commodities into objects that seemed immediate and available. Dutch explorers in the sixteenth and seventeenth centuries had increased access to tropical goods by expanding trade routes to the Mediterranean as well as to Venezuela, Suriname, and Brazil. Artists celebrated the abundance of tropical goods in paintings of fruits, shells, and tropical birds crowding tables. While some Dutch artists focused on bruised and rotting foods to comment on the transience of life, others highlighted the mouthwatering produce that filled Dutch tables thanks to domestic industry and foreign trade. Such pictures were a form of "pictorial capitalism," asserts Julie Hochstrasser.[31] She writes, "We are witness here to a language of commodities through which these painters register powerful economic forces that drove daily life in the Dutch universe of commerce."[32] No part of this language included the enslaved laborers of tropical goods and the indigenous people who were removed for the establishment of Dutch plantations.[33] Hochstrasser urges viewers to recognize the horrific aspects of food production that are absent from the lush tables in Dutch still life paintings. This call to action is also necessary in studies of American still life paintings since artists in the United States were looking back to Dutch paintings and lifting visual tropes from them to showcase their own nation's prosperity that came with the hidden cost of others' suffering.

Artists were not the only actors to help assimilate bananas in American homes; housewives and domestic experts were also vital to the domestication of tropical bananas. As homemakers whose selection and preparation of food was thought to define the character of the American family and larger national citizenry, housewives were responsible for creating a stable home free of "alien" influences. With foods such as the banana that were still considered unfamiliar in the last decades of the nineteenth

century, housewives helped integrate them into North American homes by incorporating the fruit into such recipes as ham rolls, fritters, salads, banana trifle, and banana Jell-O. Whereas "primitive" people were perceived as simply plucking the banana from a tree and eating it plainly, housewives in the United States were advised to cook, bake, and sauce the fruit in French and American styles that added more labor to this fruit known for its effortlessness. Cooking the banana also helped improve its likeability in the United States, where people had long distrusted the digestibility of raw fruit.[34] Anthropologist Claude Lévi-Strauss explored the social importance of cooking food in "The Raw and the Cooked" chapter of his 1969 book, *Mythologiques*.[35] After examining food traditions across the world, he concluded that cooking food for many cultures is a socializing process in which the cook, a cultural agent, transforms a raw object from the natural world into a cooked item for society. The acts of cooking, grilling, roasting, baking, and boiling constitute processes of socialization that ensure that raw and "natural" foods become not merely cooked, but refined.[36] According to this logic, housewives who incorporated bananas into American recipes helped to transform this raw, tropical fruit into a refined food for "civilized" eaters. Women's role in preparing food for the family should not be underestimated since their management of food contributed greatly to the assimilation of influences deemed foreign.[37]

This desire to elevate raw fruits explains the emergence of several new utensils for fruit consumption in the late nineteenth century. A range of new products entered the market between 1865 and 1890, including orange peelers, watermelon knives, grape scissors, and banana boats that could be purchased by middle- and upper-class consumers from catalogs or door-to-door salesmen. While many of these tools were practical, assisting in the removal of fruit pits and seeds, the banana boat was designed mainly to showcase the fruit (fig. 42). Glass banana boats were rounded like canoes to display and cradle the fruit without compromising its curved shape. The fruit also stood on these pedestals to separate it from other foods thought to ripen more quickly in its company.[38] Eating the banana from a bowl, as opposed to a tree, distinguished those who "dined" from those who "ate" and represented a higher form of eating that superseded the consumption of food for mere sustenance. An etiquette expert from 1891 explained, "It has been said that [man] is the cooking animal; but some races eat food without cooking it . . . creatures of the inferior races eat and drink; only man dines."[39] Placing bananas in elevated bowls physically and symbolically elevated them in American homes. The banana boat was an assistant to this civilizing project because it ensured that the fruit was not merely picked from a tree or a pile of fruit; it was displayed on a glass vessel that reflected the good taste and manners of American diners.

Women were at the center of implementing these civilizing rituals as directors in charge of maintaining a healthy home and family. By baking bananas into American recipes, displaying them on boats and stands, and decorating dining rooms with still life representations of this fruit, women were indispensable to naturalizing this foreign import. In her seminal essay, *Manifest Domesticity*, Amy Kaplan advises scholars to

FIGURE 42
Fruit stand, 1900. Colorless
nonlead pressed and tooled glass,
24 × 26.2 cm. Collection of the
Corning Museum of Glass,
Corning, NY. Gift of Mrs. Mary
Allyene McKinley, 79.4.119.

more seriously consider women's actions in the domestic sphere as crucial to the empire-making process.[40] Divisions between the domestic and public spheres of empire are not as rigid as scholars originally thought, Kaplan asserts. "When we contrast the domestic sphere with the market or political realm, men and women inhabit a divided social terrain, but when we oppose the domestic to the foreign, men and women become national allies against the alien, and the determining division is not gender but racial demarcations of otherness," Kaplan writes.[41] Put plainly, white women were united with white men in treating "alien" people and objects deemed unfit for the American home. Although Kaplan does not squarely cite women's work with food as an example of this national exercise, the banana's history in the United States clearly demonstrates how women, through food and its visual presentation, played a "major role in defining the contours of the nation and its shifting borders with the foreign."[42] While men may have imported the banana, it was women who incorporated it into the American mainstream.

"EL PULPO" AND THE RISE OF THE UNITED FRUIT COMPANY

America's largest banana distributor, the United Fruit Company, drew from this arsenal of strategies to naturalize bananas in American homes. The company was

established in 1899, when Andrew Preston and Lorenzo Baker Dow, founders of the Boston Fruit Company, consolidated their business with Minor Keith, a prominent landowner and banana entrepreneur in Central America.[43] At the turn of the century they capitalized on lenient extradition laws and new transportation technologies to build a transnational banana business. The United Fruit Company emerged alongside other tropical fruit brands, such as Sunkist Oranges and Dole Hawaiian Pineapple, which similarly took advantage of the friendly trading climate in the early twentieth century. Unlike the nineteenth century, when the fruit market was controlled by smaller-scale farmers and merchants, the twentieth century marked a new era in which larger companies streamlined the process of fruit production with support from the government and Wall Street, which supplied capital for the reorganization of food industries. At this time, manufacturers became more powerful, producing goods at lower costs and in bulk for the rising middle class. The corporatization of fruit also was enabled by technological advancements in transportation that replaced slow, sail-driven schooners with faster, steam-powered ships that could carry between 13,000 and 19,000 bunches of bananas.[44] By the end of the 1920s, food conglomerates grew so big and drew in so much money that they surpassed some of the country's largest manufacturing industries, such as iron, steel, and textiles.[45]

The political climate of the early years of the twentieth century was particularly conducive to growing US fruit businesses abroad. With the recent victory of the Spanish-American War in Cuba in 1899, and the invasions of regions from Puerto Rico to the Philippines, many Americans felt empowered to spread their influence to new regions in Central America and the Pacific and open new military bases and commercial markets that would strengthen their economy. This goal was a shared one among northerners and southerners who, once fighting each other in the Civil War, now were bonded together in the last years of the nineteenth century to fight the Spanish-American War. The participation of African Americans in the war, however, did not foster much reconciliation in this time period of lynching and segregation back home.[46] The racial hostility of the Jim Crow era heightened debates over whether or not to annex countries in Central America and incorporate what many Americans perceived as an exotic population.[47] While the failures of Reconstruction and racist attitudes toward people of color during the Jim Crow era deterred many people in the United States from wanting to intervene in Latin America, the allure for some to expand US businesses abroad was too tempting. Descriptions of banana barons as cowboys overthrowing colonial oppressors and domesticating the wild terrain of Central America drew on long-standing ideas about American masculinity to make US involvement abroad seem more attractive.[48] In a time period of national expansion yet intense xenophobia, Americans tried to devise ways to control affairs in banana-growing countries like Guatemala and Colombia without the controversy of incorporating them or their populations.

This mission of economic expansion was communicated by women authors, to women consumers, with images of women—revealing how central women were to

translating United Fruit's agenda abroad to domestic consumers. The company launched several advertising and cookbook campaigns aimed at middle- and upper-class women in the early twentieth century, including its first cookbook, published in 1904, *A Short History of the Banana and a Few Recipes for Its Use*. This cookbook was written in partnership with Janet McKenzie Hill, an instructor for the Boston Cooking School.[49] Under the leadership of culinary reformer Fannie Farmer, the Boston Cooking School helped professionalize women's work in the home by creating cooking courses and nutrition laboratories for the study of domestic science.[50] The creation of healthy meals was serious business. Healthy cooking was thought to reduce poverty, alcoholism, and crime. Reformer Maria Parloa, for example, believed that "dirty homes and improper food fill our prisons and almshouses with drunkards and criminals," and cooking schools would be the solution to such woes.[51] Catharine Beecher and Harriet Beecher Stowe agreed that only with a woman's proper cooking can "our children become educated and so that our men don't complain and run off to taverns and clubs."[52] Hester Poole put it more plainly, "could the man have a good savory meal he would forget the liquor, since his craving would be satisfied in the only natural and wholesome way."[53] Repeated concerns about inadequate meals driving up crime and alcoholism reveal how a woman's mastery of food preparation was thought to have direct consequences on the stability of the home and society at large. As the nation's purchasers of food and authorities on the home, women were important allies to the United Fruit Company and valuable to the mission of assimilating the foreign banana for American consumption.

Janet McKenzie Hill was a natural choice for collaborating on the United Fruit cookbook because she had already written an article on the usefulness of the banana for the *New England Kitchen Magazine* in 1894.[54] Hill was also a savvy advertiser, integrating the Boston Cooking School into branding campaigns for Knox gelatin and Baker's brand chocolate. Hill's combined experience in cooking and marketing would have been attractive to the United Fruit Company, which faced the challenge of selling a still-unconventional fruit to audiences in the United States. This was no easy task. Throughout history, Americans did not easily embrace foreign fruits. In the 1840s, President Martin van Buren famously complained that pineapples were "too decadent" and aristocratic. Andrew Jackson Downing described pears as "pompous" fruits. The apple, in contrast, was considered "beyond all question, the American fruit" and a "genuine democrat" according to preacher Henry Ward Beecher.[55] These reactions demonstrate how food in the eyes of Americans was not merely a nutritional object but a cultural signifier that expressed national identity. To win approval for the banana, Hill crafted several recipes incorporating it for the United Fruit cookbook, including "Lamb Croquettes with Baked Bananas," "Escalloped Bananas," and "Richelieu Sauce"—all meals with noticeably French antecedents.[56] By inserting the banana into French dishes, Hill capitalized on America's reverence for French cooking, the gold standard for elevated taste. Cookbook illustrations showing the fruit in banana boats

and with Victorian silverware also raised the banana's status and provided a model on how to display the fruit on American tables. Hill's recipes, and the housewives who prepared them, continued to naturalize the tropical banana and place it in the culture of Euro-American civilized dining.

Although many of these strategies were designed to Americanize the banana, the first page of United Fruit's 1904 cookbook displayed an image of Latin American women that turned consumers' attention back to the tropics (fig. 43). The introductory page showed a banana, at center, posed against the company's green and gold starred logo, and beneath the United Fruit's red, white, and blue crest. The fruit, given pride of place and ennobled by its heraldic framing, is flanked by two allegorical figures—one representing Central America, the other South America, with the West Indies referred to in the center. The composition draws on a long tradition using racial stereotypes and women as allegories of territorial expansion. The lighter-skinned Central America is classically dressed and engaged in the act of writing, while the darker-skinned South America wears a less classical dress and hood and engages in no intellectual activity. The allegorical representation of South America with heavy brows and flared nostrils echo contemporaneous depictions of savage people, yet she also directs her gaze toward the white woman representing Central America and her big book, suggesting a willingness to learn. South America is depicted in the same way as victims of Orientalism: primitive and exotic, awaiting the lessons of civilization. The illustrator's choices were deliberate. Paradoxical views of the tropics enabled the United Fruit Company to exploit the feminine exoticism of the banana while asserting the fruit's safe, whitened status for North American consumers.

An illustration of a woman at the end of the cookbook more directly articulated United Fruit's desire to consume the tropics (fig. 44). On this last page mapping the company's steamship activity between Central America and the United States, a blond mermaid rides a dolphin, steadying herself with one hand on its fin and pointing the other toward the horizon. The outstretched arm was a prominent feature in art associated with America's territorial expansion. In one of the most famous examples, Emanuel Leutze's painting *Westward the Course of Empire Takes Its Way* (fig. 45), the explorer Daniel Boone extends his hand toward the San Francisco Bay as he and a band of pioneers approach the threshold of the Rocky Mountains, ready to fulfill what many nineteenth-century Americans believed to be God's plan for national expansion and the conquest of indigenous territory. Boone's gesture would have been immediately recognizable to period viewers as a sign of white heroism and white Americans' divine right to conquer the continent. Just like Leutze's pioneer who points toward the western frontier, the white-skinned mermaid in the United Fruit cookbook points symbolically toward the tropical frontier it wants to control. The use of this visual vocabulary on a map of United Fruit's trade routes was more than a way to artistically elevate the banana; it was a clear endorsement of the company's expansion to countries in Central America where it wanted to secure railroad and land monopolies to benefit the

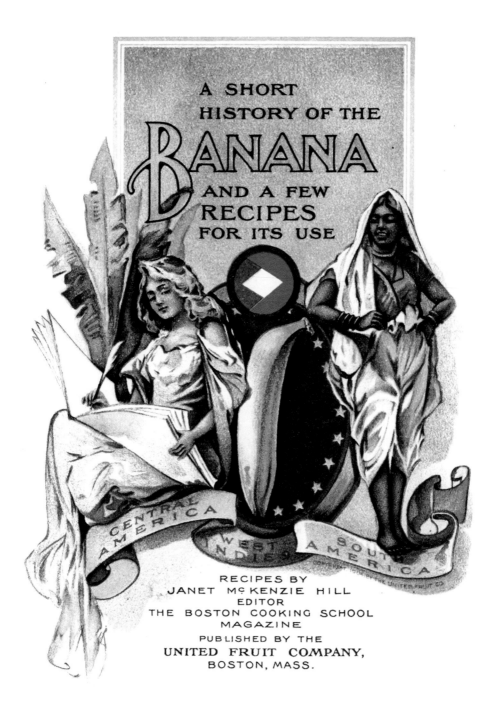

A SHORT
HISTORY OF THE

BANANA

AND A FEW
RECIPES
FOR ITS USE

CENTRAL AMERICA

WEST INDIES

SOUTH AMERICA

RECIPES BY
JANET McKENZIE HILL
EDITOR
THE BOSTON COOKING SCHOOL
MAGAZINE
PUBLISHED BY THE
UNITED FRUIT COMPANY,
BOSTON, MASS.

FIGURE 43

A Short History of the Banana and a Few Recipes for Its Use, 1904 (title page). Recipes by Janet McKenzie Hill. Published by the United Fruit Company, Boston, MA. HathiTrust Digital Library, digitized by Google, original from University of California.

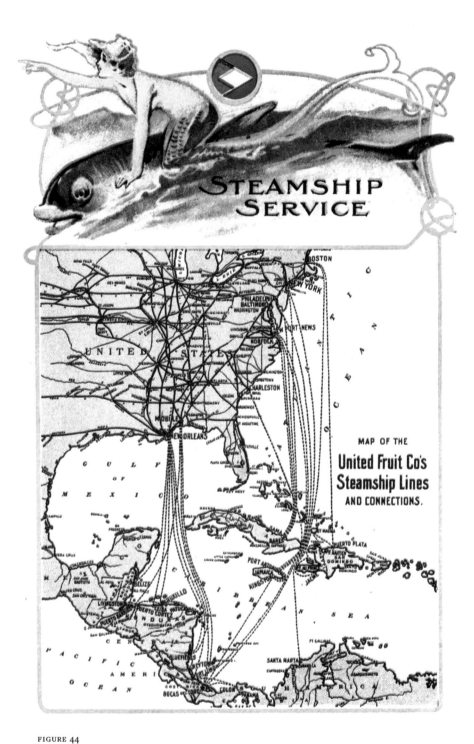

FIGURE 44

A Short History of the Banana and a Few Recipes for Its Use, 1904 (page 30). Recipes by Janet McKenzie Hill. Published by the United Fruit Company, Boston, MA. HathiTrust Digital Library, digitized by Google, original from University of California.

Emanuel Gottlieb Leutze, *Westward the Course of Empire Takes Its Way,* 1861 (Mural study, US Capitol). Oil on canvas, 33¼ × 43⅜ in. Smithsonian American Art Museum, Washington, DC / Art Resource, NY.

banana trade. The company's desire to conquer the tropics inspired United Fruit's nickname, "el pulpo," the Spanish word for octopus, implying that the company had tentacles extending well into Latin American economics and politics.[57] Company cookbooks for "el pulpo" literally pointed to the land it wanted to incorporate, revealing how the visual program of the United Fruit Company not only advocated for the assimilation of the banana but also the assimilation of the lands on which it grew.

"THE GREAT WHITE FLEET" AND THE PROJECT OF CIVILIZATION

United Fruit's mission to expand into Latin America was ultimately successful. By the 1920s and '30s, it had a stranglehold over the banana industry, owning more than three million acres of land and employing ninety thousand people in Central America and the Caribbean. United Fruit "became the un-starred state on the U.S. flag," according to historian Peter Chapman.[58] The company secured land for its large-scale, corporately owned plantations by repeatedly intervening in Latin American politics and

forcefully controlling the systems of land distribution. United Fruit was merciless in its pursuit of profit, acquiring land through economic strategy and more violent methods of intimidation, bribery, and physical aggression.[59] Many laborers contested the company's unethical practices, organizing strikes in countries such as Guatemala throughout the 1920s that threatened United Fruit's stability.[60] The rising isolationist policies of the United States after World War I, in combination with the economic turmoil of the oncoming Great Depression, also threatened to dismantle United Fruit's deep involvement in affairs abroad. To maintain a clean image for the public, United Fruit's Publicity Department produced pamphlets, tours, and other programming that claimed its intervention in Latin America helped modernize conditions in the region.[61] While they were truthful in stating that the United Fruit Company brought technological advancements to regions in Latin America, they, as expected, did not advertise the company's violent takeovers, mistreatment of workers, and primary objective of transforming Latin American regions to gain vast profits.

No project more clearly demonstrates the company's imperialist agenda than its line of steamships launched in the 1920s and '30s, called "the Great White Fleet": a collection of one hundred white steamships that surpassed in size and speed the earlier sail-driven schooners. The Great White Fleet shared its name with the battleships ordered by President Theodore Roosevelt in 1907, which he sent on a fourteen-month voyage around the world to flaunt America's naval power. Likening itself to that enterprise, United Fruit marketed their ships as the "newest and finest vessels sailing to the Caribbean."[62] The company promoted this steamship line to tourists, wanting to profit from carrying both fruit and passengers to and from the tropics. United Fruit offered two- to three-week roundtrip cruises leaving from Boston, New York, and New Orleans. The cost per passenger on the Great White Fleet ranged from $240 to $350. The popularity of the cruises led the company to expand further by purchasing two hotels on the island of Jamaica: the Myrtle Bank Hotel in Kingston and the Titchfield Hotel at Port Antonio. Tourist ventures were a natural outgrowth of the company since tropical fruit contributed powerfully to tourist fantasies of a tropical paradise.

On the Great White Fleet, visitors could take a tour called "Following the Conquerors through the Caribbean," a promotional venture that shuttled passenger to historic sites conquered by European explorers (fig. 46).[63] The "Conquerors" tour offered visitors an opportunity to see the crumbling ruins, time-worn cannons, and relics marking the end of Spanish dominance in "the New World." Promotional booklets from the 1920s described this tour as a celebration of the "heroic" struggles and "discoveries" of European colonizers to modernize the region, ignoring the bloodshed and wipeout of indigenous populations that resulted from this conquest.[64] The United Fruit Company applied this interpretation of history to its own work in the Caribbean and Central America, where it claimed to be modernizing primitive cultures centuries later. Booklets advertising the "Conquerors" tour specifically advocated for intervention in Guatemala, reporting that:

FIGURE 46

United Fruit Company Steamship Service, *Following the Conquerors through the Caribbean: Great White Fleet,* [New York?] [192-?]. Courtesy the Winterthur Library, The Saul Zalesch Collection of American Ephemera, RBR AA113098.

There is so much potential wealth, so many natural resources undeveloped in Guatemala that the situation is like a man with great assets who has failed to realize that his apparent condition is in sharp contrast to his actual financial stability and to the brilliant future which he cannot by any mischance escape. . . . Due to the long coast lines, the proximity of new trade routes, the nearness to the markets of the United States, Central America is literally the most accessible, the most varied and the richest of the tropical regions awaiting development.[65]

Such descriptions were not unique to Guatemala. Repeated discussion in brochures about the "agricultural possibilities" and "unequaled opportunities" in Central America were used to justify United Fruit's aggressive interference in the region and cast the company in a positive light as a guardian of Central Americans, guiding those ignorant of their natural wealth to development. For an American company credited with civilizing the "swarthy savages" of the tropics, there was no more appropriate name for the United Fruit's cruise line than "The Great White Fleet."[66] Although the 1920s saw a rise in labor strikes, United Fruit's display of "Great White" ships and tours of "great white" explorers positioned it as an inheritor of Europe's civilizing mission to exploit the resources of Central America.

Earlier in 1914, United Fruit biographer Frederick Upham Adams saluted the company for having "awakened the slumbering nations bordering on the Caribbean with the quickening tonic of Yankee enterprise."[67] This language harkened back to the patronizing rhetoric of Reconstruction, when Yankee farmers in the North moved south after the Civil War to civilize the South's wild landscape and backward population. The United Fruit Company employed a similar argument, declaring that its involvement in Latin America helped civilize rural towns with electricity, railroads, hospitals, and harbors. Similarities between the colonial program of the American South and Central America are not coincidental; North American developers in the early twentieth century were looking to the Reconstruction South as a model for acquiring and exploiting plantation economies in the Caribbean and Pacific.[68] The lessons of Reconstruction were helpful to developers more than fifty years later because they showed how to justify American intervention for reasons that appeared to be more altruistic than pure economic gain. Peter Schmidt confirms that Reconstruction had "what is surely one of the strangest afterlives of any major U.S. reform movement: it became *the* prime model for U.S. colonial practices abroad."[69] In materials promoting United Fruit bananas, cruise lines, and tours, the United Fruit Company recycled earlier narratives from the Reconstruction era to justify its dominance in Central America and the Caribbean.

THE ART OF ADVERTISING: UNITED FRUIT, CHIQUITA BANANA, AND MODERNIST AESTHETICS

By the mid-twentieth century, United Fruit shifted focus away from the company's operations in Latin America back to images of women and domesticity. This time

period inspired the creation of Chiquita Banana, a cartoon created by illustrator Dik Brown for United Fruit in 1944 that showed long eyelashes, a ruffled *chaquetilla*, and a fruit-hat modeled after that worn by Brazilian samba singer Carmen Miranda. Chiquita appeared in advertisements, cookbooks, and radio and television campaigns to educate North American consumers on how to eat and prepare the banana. She represented the United Fruit brand through conventional ideas about femininity and racial typology, a strategy first seen in the company's 1904 cookbook, where feminine allegories of Central and South America helped situate and advertise the banana. The girly Chiquita also recalled 1920s dancer Josephine Baker, who famously danced topless in a banana skirt at Paris's Folies Bergère, capitalizing on stereotypes of an exotic and erotic tropicality. Once again, United Fruit struck a unique balance by portraying the banana as an exotic yet familiar fruit, with foreign qualities made acceptable by Chiquita's sexy femininity. Historian John Soluri confirms that Chiquita was essential to Americanizing the tropical banana by bringing "a nonthreatening form of tropical exoticism to North America."[70] Chiquita, however, was not the first display of "tropical exoticism" for the company; she was a reincarnation of images past that played to long-standing American fantasies of the tropics.

Chiquita played a prominent role in print advertisements, radio commercials, and mainstream booklets for the company, but her presence was noticeably reduced years later on the company's 1960s cookbook cover, which displayed a picture of a dozen banana fingers balancing on a glass pedestal (fig. 47). The yellow fingers are fanned out like rays of the sun, an image that United Fruit may have used to deliberately compete with businesses like Sunkist that employed sunny metaphors in advertising its oranges. Arranging bananas on a glass stand turned the fruit into an object of veneration, the same mission that glass stands were designed to accomplish in the earlier nineteenth-century dining room. United Fruit paid homage to this Victorian tradition, acknowledging that the inspiration for its 1960s cookbook cover was the glass-pressed banana stand that "came into popular use in America in the 1890's . . . [and] can be found in antique and decorator shops today."[71] By once again elevating bananas on a pedestal, the fruit embodied an elevated taste—the initially desired accomplishment of bringing this tropical fruit into American homes. The exotic Chiquita, in this instance, was less central to the company's image; the 1960s cookbook relegated her to a tiny circular logo and focused the reader's attention instead on the elegant fruit itself, a more suitable image for the expensive, hardbound cookbook. Whether communicated through Chiquita Banana in mainstream commercials or the Victorian banana stand on fancier cookbooks, United Fruit's message was the same in the 1960s as it was in 1904: to make the banana's tropical qualities familiar and pleasing for North American consumption.

The United Fruit Company may have borrowed its cookbook cover image from a photograph by the influential photographer Edward Weston, who created nearly the same composition in his 1927 photograph *Still Life with Bananas* (fig. 48). Weston presented a dozen banana fingers fanning out in a semicircle, extending from an orange

at its center. He often found inspiration in everyday objects, writing in his daybook, "I was awake at 4, with my mind full of banana forms! How exciting they are to work with! I have two new loves: bananas and shells."[72] He was delighted to find an "unusually curved" banana bunch that provided "endless possibilities."[73] Weston and his peers experimented with the formal qualities of a given object by shifting its perspective, manipulating its color, and reorganizing objects in ways that obscured their original function. He achieved this in *Still Life with Bananas*, staging the fruits in a shallow space against a plain backdrop of a black clay pot that highlighted the bananas' soft, curving lines. The photo's economy of line and play with perspective reflected modern art's reinvention of still life representation and experimentations in pictorial abstraction. Weston transformed the banana into an art form, which United Fruit may have used to further elevate the fruit in consumers' minds.

It is very possible that the United Fruit Company borrowed Weston's design, since the artist was well established in this time period, when more artists were contributing to advertising campaigns.[74] This trend was prompted by the rise of the art director, a new role in companies that used the cultural status of art to strengthen brand recognition in marketing campaigns.[75] In the world of fruit, the Dole Hawaiian Pineapple Company led this movement, hiring prestigious artists such as Georgia O'Keeffe and

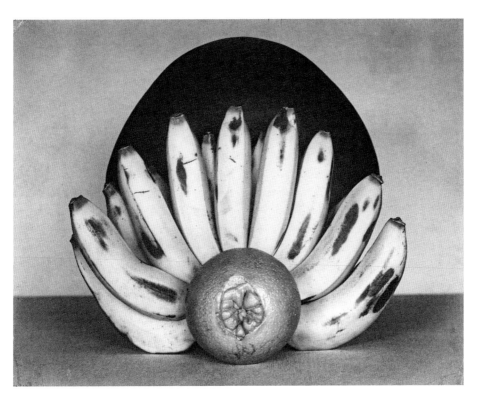

FIGURE 48
Edward Weston, *Bananas and Orange,* April 1927. Gelatin silver print, 7 $\frac{7}{16}$ × 9 $\frac{5}{16}$ in. The J. Paul Getty Museum, Los Angeles. © Center for Creative Photography, Arizona Board of Regents.

Isamu Noguchi to apply the high aesthetic standards of art to advertisements for pineapple juice in the 1930s and '40s. The growth of publicity departments, art director roles, and advertising budgets in the mid-twentieth century transformed the way foods were marketed to the public and created new professional opportunities for artists in commercial businesses. Although there is no confirmation that United Fruit's marketing team worked with Edward Weston in the manner that Dole worked directly with O'Keeffe and Noguchi, United Fruit surely could have hoped that borrowing Weston's artistic design for its cookbook would elevate the banana's reputation.[76] The company edited out many elements of Weston's photograph—eliminating the orange, the bruises on the banana, and the monochrome palette—but maintained his overall design, which embodied the elegant simplicity of the modernist aesthetic. The artistic treatment of this fruit was a calculated move away from the tropical primitiveness of Chiquita Banana and an attempt to position the banana as an art form. The United Fruit Company carefully crafted images inspired by domestic and artistic ideals that colonized the tropical characteristics of the banana and transformed the aesthetics of its consumption.

By borrowing conventions from the fine arts and positioning the banana as a domestic jewel, the United Fruit Company removed the banana from the realities of its production in Central America and the Caribbean, where it was inserting itself forcefully and violently into Latin American politics. One of the most unsettling examples was the company's role in the 1954 coup to overthrow Guatemala's democratically elected president, Jacobo Árbenz. The election of Árbenz in 1951 constituted a threat to United Fruit's agenda, since the new president sought to promote greater economic equality by implementing an agrarian reform that would redistribute large land holdings from the United Fruit Company to local peasants.[77] Although the majority of this land was unused and held by the company in reserve, the passing of agrarian reform threatened to remove this land from company control and put millions of dollars at risk for United Fruit.[78] To prevent the passing of the agrarian reform and secure North America's control in the region more broadly, the CIA, backed by the United Fruit Company, used military force to overthrow Árbenz's rule in 1954. The CIA considered United Fruit a political ally and hid the company's motive from the public, claiming to intervene in Guatemala to stop the threads of Communism that were spreading throughout the country.[79] The effects of the coup were devastating, causing the mass displacement of peasants and farmers whose land was taken over for conversion into banana plantations. Many more were imprisoned, killed, or "disappeared" at the hands of the CIA, which sought to eliminate any political enemies expressing a rejection of US policy. These killings were performed by off-duty, ex-military men known as the "White Hand," a name that eerily resembles United Fruit's "White Fleet."[80] Not surprisingly, this political tumult was edited out of United Fruit promotional materials, which focused narrowly on the fruit in domestic contexts.

The United Fruit Company and the CIA hoped to garner support for the intervention through a twelve-minute film from 1953 called *Why the Kremlin Hates Bananas*.[81] Narrated by journalist Edward Tomlinson, the film warned viewers that Communist Russia was attempting to destroy United Fruit bananas and the free enterprise for which United Fruit stood. United Fruit was a Communist target and "enemy of red leaders," according to the film, because it was a symbol of "the free world" that helped install hospitals, schools, and housing in Central America. Footage of Guatemalan workers studying at colleges and training in farming techniques demonstrated the positive influence of the United States in the region and conjured up long-standing ideas about the merits of American colonial projects abroad. Support for the banana in Central America became a sign of support for the US mission there and an expression of patriotism that stood in opposition to the Kremlin. After fifty years of trying to Americanize the banana and incorporate it into US homes through cookbooks, banana stands, and illustrations, this film solidified the fruit's status as a bastion of American civilization and democracy.

The success of the United Fruit banana, however, came at a terrible cost for local populations. The coup United Fruit orchestrated in Guatemala resembled earlier

events the United Fruit Company organized in Ciénaga, Colombia, in 1928, when the company paid the Colombian army to squash laborers protesting the unfair wages and unethical practices that resulted in as many as two thousand deaths and injuries. The company's political interference also extended to Honduras, Belize, Jamaica, and Cuba, producing political consequences in each of these regions. According to historian Peter Chapman, United Fruit "possibly launched more exercises in 'regime change' on the banana's behalf than had ever been carried out in the name of oil."[82] This hold on power was not accomplished by tyrannical policies alone; domestic cookbooks, illustrations, and advertisements also helped the company's economic expansion by naturalizing the banana in American homes, endorsing the company's intervention in the tropics, and obscuring its bloodshed abroad. Advertisements and cookbooks were a form of soft power that boosted US authority in Latin America through nonmilitary means.[83] Although not as forceful as a coup, using these materials, which were ubiquitous, mass-produced objects and a part of daily life, effectively justified or obscured the company's actions abroad. Similar to nineteenth-century pictures that erased the labor and origins of the banana industry, pictures in the twentieth century belied how banana corporations were deadly institutions, standing at the center of coups co-organized by the CIA.

BLACK AND BRUISED: HEALING FROM THE AFTERMATH OF THE BANANA WARS

Around the same time that the United Fruit Company depicted the banana as an emblem of artistic and Victorian virtue on its cookbook, the company was undergoing major shifts internally. After decades of struggling with political unrest and low profits in the 1950s, the United Fruit Company was dismantled in the 1960s and was eclipsed by competing fruit corporations. The US government, which once fiercely supported United Fruit and inflated its role in the first half of the twentieth century, later attacked the company for violating antitrust legislation in the 1960s. This shift in regulation forced United Fruit to divest many of its landholdings, putting more control in the hands of local subsidiaries and independent growers. United Fruit grew weaker as labor unions grew stronger, pushing for local growers to receive greater control. Equally damaging to the United Fruit Company were invasive viruses such as the Panama disease, which threatened to infect an alarming amount of its farmland and crops. The 1960s marked the twilight of the United Fruit Company, culminating in the suicide of its largest stakeholder, Eli Black. Even though United Fruit was praised for bringing jobs, stores, railroads, harbors, and electricity to the places where they established plantations, scholars like Mark Moberg and Steve Striffler acknowledge how this "rarely led to enlightened labor relations or democratic forms of governance."[84] The optimistic image of a mermaid driving toward the horizon of the tropics in the 1904 cookbook lost power by the early 1960s, when United Fruit struggled with sinking sales and eventually became incorporated into another company, United Brands.[85]

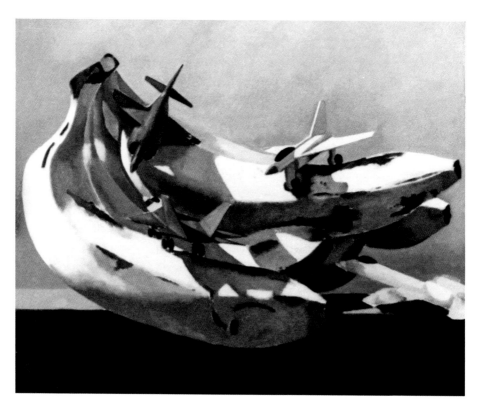

FIGURE 49

Moisés Barrios, *Mosquitos,* 1998. Oil on canvas, 110 × 150 cm. Private collection.

The reign of "el pulpo" may have been over, but by the 1990s, artists such as Moisés Barrios illustrated how the effects of United Fruit operations were still felt in the countries it occupied. Barrios is one of many artists in the late twentieth and early twenty-first centuries who has looked back to United Fruit's legacy to critique the company's violent impact on Central America.[86] In 2003, Barrios painted *Mosquitos,* (the term for a World War II bomber jet) which shows three toy fighter jets defending a cluster of large-scale bananas (fig. 49). The airplanes' noses are pointed in different directions, ready to protect the yellow territory on which they stand. Although Barrios employs traditions of still life painting with a shallow perspective of uneaten fruit on a table, he does not capture the dining room quietude of pictures past. Barrios's use of toy planes, bright colors, and exaggerated scale points to the absurdity that so many lives were destroyed over such a bright and sunny fruit. The toys' defensive postures and mechanical movements highlight their role as tactical accessories of the domineering US government and a multinational corporation. Planting these toy planes on the yellow terrain of a banana is an explicit commentary on United Fruit's occupation in Central America. The large scale of the bananas relative to the fighter jets in Barri-

os's painting speaks to the immense importance of this fruit, akin to sugar, petroleum, and other resources that have become political battlegrounds throughout history.

In another series of paintings, Barrios tackled the Banana Republic clothing company founded by US designers Mel and Patricia Ziegler in 1978. The first seasons of the clothing line featured safari jackets, panama hats, and outback pants that conflated fantasies of tropical expeditions around the world and married comfort with "imperial style"—in the words of the company's founders.[87] The designers described a specific moment of inspiration they experienced in remote pockets of Central America, writing: "Once we've settled in, relearned the knack of guiltless relaxation, and begun to let the spirit of the place wash over us like a body-temperature, slightly saline bath. Only then—ensconced, perhaps, in a sisal hammock, with a half-peeled mango lying forgotten at our side—do we cease being pallid gringos who talk too fast, and become sojourners who have grasped the tropical lesson that one can only triumph by sweet surrender."[88] This description shores up age-old stereotypes of Central America as a primitive paradise and reflects the founders' goal to create a clothing line that embodied fantasies around the idleness of the "lazy tropics." Their book on the history of the fashion brand also perpetuated stereotypes by coupling Banana Republic clothes with reproductions of paintings by Henri Rousseau and Paul Gauguin, nineteenth-century French artists famous for their exoticization of African and South Pacific cultures.[89] The company's very name was also problematic; the author O. Henry coined the term "Banana Republic" in his 1904 novel, *Cabbages and Kings,* which disparagingly portrayed banana-growing societies as politically unstable, economic failures operating under corrupt rule.[90] The designers did not address this derisive term or disturbing history, relying instead on well-worn tropes about the vegetative tropics established earlier in art and literature.

Barrios responded to the prejudices underpinning the Banana Republic brand in *Vitrina Banana Republic,* a series of paintings that show the store's display windows on New York City's Fifth Avenue. In one tightly cropped painting, Barrios depicted three headless mannequins posing stiffly in Banana Republic clothing (fig. 50). All posed identically, with their hands pinned to their hips and cocked to the right, the mannequins model sports jackets, crisp shirts, and tailored slacks that exhibit a more corporate look owing to the company's acquisition by The Gap in 1983. These outfits, however, are obscured by a dramatic reflection in the window of fruit for sale on an outside table—a deliberate juxtaposition between the sale of bananas for edible consumption against the sale of bananas for material consumption. The street vendor selling the fruit is difficult to see in the window's reflection, yet he is standing to the right, underneath a bus advertisement depicting Minnie Mouse, another symbol of American imperialism that reoccurs in Barrios's work.[91] Like the unseen laborers in historic images of American bananas, the street vendor is barely visible in Barrios's painting and society at large. The artist urges viewers to become more conscious of how those who grow and sell bananas might relate to those who buy Banana Republic clothing and contribute to fantasies masking the reality of banana-growing regions. By

FIGURE 50

Moisés Barrios, *Vitrina Banana Republic*, 2003. Oil on canvas, 59¼ × 43 in. (200 × 150 cm). Private collection.

rendering this subject in a photorealist style, Barrios's paintings are easily mistaken for photographs, another game that the artist plays with the viewers' vision and ability to see the unseen in the fruit industry. The many reflections in Barrios's painting encourage the viewer's self-reflection about the need to consider what the Banana Republic brand truly represents and at whose expense.

Barrios's *Ropa Americana* provokes the viewer to question why the Banana Republic brand finds inspiration in a history of corruption. "Banana republics" symbolize the political upheaval caused by US fruit companies that profited from deadly coups, the forced removal of indigenous farmers, and the mistreatment of workers on plantations. The term *banana republic* also represents the outcome of a lopsided economy in which banana companies have dangerously directed national products away from local resources, forcing these regions to rely on the exportation of a single commodity. Furthermore, banana republics caused deforestation and soil erosion as a result of the clearing of land for this mono crop and laying of railroad tracks to transport it to faraway consumers. Environmental damage affected local waterways, filling rivers with silt and contaminating them with pesticides that devastated both banana workers and the fruits they harvested.[92] Given the social, economic, and environmental wreckage caused by American banana companies, why would a clothing brand want to appropriate this troubling and violent history for its identity? Such systems of oppression should not be fashionable. Barrios criticizes the romanticization of "banana republics" and the failure to acknowledge US companies' deadly impact on people and natural resources.

Barrios also wrestled with this subject in the painting *Banana Liberty,* a picture that resembles the 1960s United Fruit cookbook cover possibly adapted from Edward Weston's 1927 photograph (fig. 51). This was part of his series *Contaminaciones,* in which he covered strollers, clothing, and other objects associated with the comfort of home in banana spots and bruises. He used the fruit as a symbol of contamination, which the American government once attributed to "the virus of Communism" in Latin American countries.[93] For the still life painting, Barrios deviated from earlier versions by showing the banana cluster in a faded yellow color, tipped with green and brown spots that radiate outward into red and yellow stripes. The broad stripes and urgent colors call to mind protest posters, an association reinforced by the text underneath the bananas that declares in all capital letters: "LIBERTY"—a call for freedom in banana-growing regions that have been rife with colonial conquest and war. The word "liberty," coupled with the rays surrounding the banana cluster, also resemble the Statue of Liberty with its radiant crown, highlighting the contradiction that the United States, which promotes the principles of freedom and diplomacy in plans such as the Good Neighbor policy, has refused to grant the same to many of its neighbors. The decision to write "liberty" in English, the language of the oppressor, also seems intentional. Barrios's painting communicates political urgency in a way that the picture's original referents did not. With this larger series, Barrios illustrates how US consumers have been enjoying Central American goods at the expense of Guatemalans whose government was toppled to foster US economic expansion. Making this declaration in a still life painting seems especially deliberate since this genre of art historically obscured the politics of fruit labor. Artists like Barrios are confronting the company's actions after a century of oppression, reconfiguring banana fans and banana stands in ways that visualize the political unrest made invisible in earlier images.

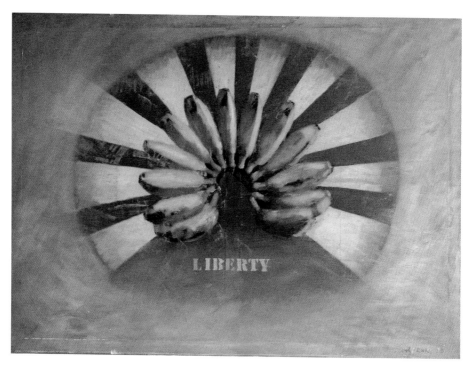

FIGURE 51

Moisés Barrios, *Banana Liberty*, 1998. Oil on canvas, 110 × 150 cm. Private collection.

While Barrios's *Banana Liberty* recovers the disturbing histories written out of earlier images, his painting might actually share political themes in common with Weston's original photograph of bananas (fig. 48). According to photo historian Ellen Macfarlane, Weston's photographs of fruits and vegetables possibly demonstrate the artist's awareness of agricultural strikes taking place in Northern California throughout the 1930s.[94] Weston photographed cabbage leaves and artichokes ripped from their plants and lying on beds of dirt at a time when agricultural farmers were protesting the physical mistreatment of workers and unfair wages for workers. Even if Weston's photographs of fruits and vegetables were not overtly political, Macfarlane argues that they at least reminded viewers of which foods were accessible during ongoing labor strikes.[95] If Weston's photographs of beaten and bruised foods acted as metaphors for the mistreatment of workers and larger agricultural strikes, then perhaps the banana fingers in Weston's photograph stand in for similar subjects, particularly the bruised bodies or hands of workers. Weston's artistic interest in labor disputes was likely influenced by his residence in postrevolutionary Mexico between 1923 and 1926, when he would have seen the government-supported murals and public art projects that celebrated the poor agricultural worker over the bourgeois capitalist. The potential commentary on labor disputes in Weston's photographs makes their later borrowing by

the United Fruit Company incompatible with the its own role in the mistreatment of laborers. Instead, Weston's photograph falls more in line with Barrios's mission for *Banana Liberty*, which condemns the oppressive practices of agricultural companies. In voicing the atrocities silenced by pictures of the past, Barrios's painting reasserts the political stakes of the banana and refuses to obscure the violent history of controlling food systems for economic gain.

CONCLUSION

The fraught history of the banana demands more careful examination of historic cookbooks, advertisements, and other visual and material objects that supported US economic expansion through food. While historic images by Currier and Ives, Hannah Brown Skeele, and John George Brown expressed consumers' admiration for fruits such as the banana, the actual trade of bananas produced bitter results for those who cultivated it. The conditions that characterized the banana industry were purged from paintings, cookbooks, and advertisements that celebrated fantasies of banana-growing regions while promoting an agenda to control the very regions at the center of these fantasies. These messages were communicated in domestic materials authored by women, targeting women, and showing representations of women, who were vital to naturalizing bananas in American homes and endorsing banana companies' influence abroad. These domestic histories are often excluded from studies of empire, yet, something as seemingly mundane as a United Fruit cookbook contributed to campaigns of national expansion. Although it is well known that the United Fruit Company set out to dominate regions in Latin America through labor practices and foreign policies, more investigation needs to be paid to how domestic objects, and the women who used and shaped them, also expanded United Fruit's power.

Banana companies shared much in common with twentieth-century Hawaiian pineapple companies, which also set out to Americanize tropical goods and control the landscapes where these goods were produced. Leaders of the Hawaiian pineapple industry produced colorful images in the most popular magazines to sell the American public on Hawaiian pineapple and, more generally, the incorporation of Hawai'i into the United States. When distributing the Hawaiian pineapple and Central American banana in the United States, visual images played a powerful role in co-opting tropical fruit and tropical lands. Artists today, however, remember the United Fruit banana for the violent coups and deadly disasters it precipitated. The banana, for these artists, does not deliver dining room inspiration or fantasies of a tropical paradise, but dark reminders of how the bananas we eat and the Banana Republic clothing we wear carry social consequences.

5

PINEAPPLE REPUBLIC

Representations of the Dole Pineapple from Hawaiian
Annexation to Statehood

IN 1954, AN ADVERTISEMENT FOR the Dole Hawaiian Pineapple
Company declared: "It's Hawaiian Party Time" (fig. 52). For
this color photograph, shot by commercial photographer
Anton Bruehl, generations of people gather around a pineapple
feast. Men and women wear leis around their necks and colorful
flowers in their hair that announce their Hawaiian-ness according
to popular tropes of the time. A woman on the far left parts her
lips, preparing to consume the slice of pineapple in her hands.
Others around her smile at the abundance spread out before
them, making Hawai'i seem like a perpetual party without the
worries or chores of daily life. Sunny-colored pineapples contrib-
ute to this ambience; in the foreground, closest to the viewer's
vantage point, the advertisement shows cans of Dole pineapple
sliced in circles, spears, chunks, and crushed. Below the cans, a
banner of text reads: "It's Hawaiian Party Time with Dole: Hawaii
greets you with a feast of flavor from DOLE'S own sunny pineap-
ple fields." Yet, nowhere in this tightly cropped picture plane
do viewers see the vast pineapple fields or the labor needed to

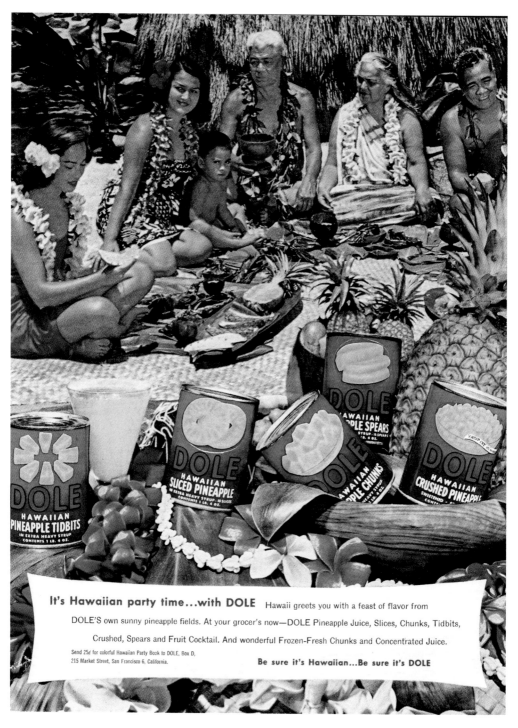

FIGURE 52

Anton Bruehl for Dole Hawaiian Pineapple Company, *It's Hawaiian Party Time,* advertisement, 1954. Ink on paper, 14 × 10½ in. Private collection.

cultivate the fruit. Instead, the advertisement focuses on the consumption of pineapples, proclaiming, "At your grocers now . . ." all of these products are available. This ad belonged to the "Be sure it's Hawaiian—Be sure it's DOLE" campaign in the 1950s, a celebration of Hawai'i just five years before it became an official state in the Union.

It seems no coincidence that the prominent display of Hawaiian people in Hawaiian Pineapple Company advertisements occurred in the years before statehood, when Hawaiians would officially become citizens in the American union. Leaders of the Dole Hawaiian Pineapple Company campaigned for Hawaiian statehood in the 1950s, as it had done for annexation in the 1890s, when the United States sought to incorporate the Hawaiian Islands for their militaristic and economic advantages. James Dole had established the Hawaiian Pineapple Company in Honolulu in 1901, three years after Hawai'i officially became American territory; he stood to benefit from the US government's expansionist agenda by purchasing cheap land, while the government was poised to benefit from Dole's economic expansion into Hawai'i by growing America's influence in the Pacific and providing access to the Islands' resources. Hawaiian annexation was a family affair for James Dole, whose cousin once removed, Sanford, helped establish America's first government there. Dole also took advantage of improvements in refrigeration and canning technologies that revolutionized the processing of pineapples and enabled their mass distribution to the United States. The political and economic climate of the late nineteenth century allowed Dole and his competitors to build a pineapple business in Hawai'i, working closely with the American government to promote American investments in the Pacific.

Politicians, fruit company owners, and image makers who advocated for Hawaiian annexation and later statehood recognized the role that visual images of pineapples could play in expanding US investments in Hawai'i. Similar to how images of grapes, oranges, and bananas endorsed the development of fruit-growing regions in California, Florida, and Central America, representations of the pineapple helped garner support for America's development of Hawai'i. But unlike fruits such as watermelon, which became synonymous with racial exclusivity and the costs of incorporating people of color as citizens, the Hawaiian pineapple was marketed as a symbol of racial inclusivity, in which laborers of all races worked harmoniously together in the pineapple cannery. Interestingly, this portrayal emerged at a time when racist policies were in place to prohibit the entrance of Asian immigrants, the pineapple industry's main source of labor. Always attuned to the persuasive power of images, the Hawaiian Pineapple Company used several strategies to manage anxieties about race and immigration in its advertisements: whitewashing, allegorizing, exoticizing, or omitting immigrants and indigenous people from print ads and world's fair exhibits. By the 1940s and '50s, advertisements like "It's Hawaiian Party Time" placed an emphasis on Hawaiian people as a friendly, nonthreatening community in anticipation of their invitation to statehood. Because the Hawaiian pineapple and its visual image were so closely tethered to America's imperial ambitions in the Pacific, its repeated

representation is vital for investigating national expansion and period conversations about the incorporation of Hawaiian land and people.

THE FAILURES OF AMERICAN HOMESTEADING IN HAWAIʻI

The pineapple, which has become synonymous with Hawaiʻi, is not actually indigenous to the Islands. Scholars believe that the pineapple originated in Brazil and Paraguay and emerged in Europe after the invention of hothouses and greenhouses.[1] To Europeans, the fruit resembled pine cones, so European explorers named it the "pineapple."[2] The fruit's crown gave it a regal appearance and its moniker: the princess of fruits.[3] Pineapples became a symbol of hospitality in Europe and America, where they were engraved on objects associated with entertainment and socialization—such as doorposts, plates, and mirrors—including one owned by George Washington at his Mount Vernon estate.[4] While George Washington enjoyed pineapples when he first tasted them in Barbados, and Thomas Jefferson declared his favorite dessert to be pineapple pudding, the American public did not gain access to the Hawaiian pineapple until the 1880s, when Captain John Kidwell brought over the Smooth Cayenne variety to Hawaiʻi and James Dole began exporting it to the United States.[5] Even though it might have been more logical for Dole to invest in a Caribbean or South American pineapple industry since the fruit was indigenous in those regions, he recognized the economic potential of establishing a fruit business in Hawaiʻi—another region that the United States wanted to control at the turn of the twentieth century.[6]

The Hawaiian Kingdom had been a sovereign nation recognized by international powers for most of the nineteenth century, until the hostile takeover of the region by the United States. The forced annexation of Hawaiʻi promised to benefit the American nation in many ways; situated in the middle of the Pacific Ocean, between North America and Asia, Hawaiʻi was strategically located for economic trade. A number of congressmen pushed for the conquest of Hawaiʻi, including representative Elijah Ward, who spoke before Congress on March 4, 1876, asking for extended treaties with the Hawaiian Islands in order to gain easier access to Asian markets. Ward believed that greater interaction with Hawaiʻi would solve unemployment in the United States and improve the businesses of American sailors, ships, and our "fellow citizens of the Pacific coast."[7] He explained, "China and Japan are among the chief fields for our commercial and manufacturing enterprise . . . [so] it is of the utmost importance that we should possess adequate naval stations in the Pacific Ocean."[8] Worried that Hawaiʻi would fall into the hands of another world power, Ward also tried to convince Congress of the region's numerous defensive advantages by being in close proximity to Asia. Ward and other advocates saw the colonization of Hawaiʻi as "an impetus to our national progress" that should be included alongside contemporaneous expansionist efforts in Latin America.[9]

While Ward's arguments would have been compelling to congressmen who favored expansion, many others chafed at the idea of annexing Hawaiʻi. In addition to worry-

ing about the capital needed for protecting islands of such a far distance, dissenters expressed another major concern to Congress: they were anxious about the racial makeup of the islands, declaring that Hawai'i's "population is not racially, nor religiously, nor otherwise homogenous to our own."[10] The racial composition of Hawai'i was a source of worry for many Americans in the late nineteenth century, particularly for southerners, who were engaged in their own race wars on the home front. At a time when African Americans were lynched, Chinese immigrants were barred from entering the country, Native Americans were massacred at Wounded Knee, and Spanish armies were at war with North Americans in the Spanish-American War, the incorporation of Hawaiian people seemed an unwelcome prospect to many. Similar to the way Native Americans were denigrated in the United States, Native Hawaiians had perpetually been seen as "savages" who did not wear clothing, practiced human sacrifice, and freely exchanged husbands and wives.[11] Although missionaries felt that the racial inferiority of Hawaiians warranted American intervention in the region, politicians wondered how Hawai'i, a territory so racially and culturally different from the United States, could be successfully incorporated.

In January 1893, John L. Stevens, minister to Hawai'i, overthrew Hawai'i's ruler, Queen Lili'uokalani, and ordered a camp of US Marines to take control of the Hawaiian capital, where they imprisoned the queen on the second floor of the 'Iolani Palace for nearly a year. Stevens ousted the indigenous government and set up an interim one with the US Minister of Foreign Affairs, Sanford Ballard Dole, James Dole's cousin once removed. A year later, in 1894, the interim government announced itself as an independent republic without support from President Grover Cleveland. It was not until the presidency of William McKinley that the US government supported Sanford as Hawai'i's first governor, passing an official resolution to annex the region. The invasions of Cuba and Puerto Rico, the annexation of the Philippines and Guam, and the impending victory of the Spanish-American War changed the political climate in the country in favor of expansion. Intoxicated by these victories and the prospects of national expansion, McKinley's administration annexed Hawai'i in 1898 and officially made it a US territory in 1900.

James Dole capitalized on the new, American regime in Hawai'i. With his impeccable timing, political connections, and opportunity to avoid tariffs on Hawaiian goods shipped to the United States, Dole used his degree in horticulture from Harvard University to start the Hawaiian Pineapple Company on sixty-one acres of land outside of Honolulu.[12] One photograph shows a man of the white mercantile elite, possibly Dole, holding a pineapple on a sprawling landscape that stretches to the horizon (fig. 53).[13] The man stands alone, emphasizing his role as a leader of the pineapple industry. The vast fields, with small settlements in the background, romanticize the pineapple business, which was spun as a heroic venture in the first years of the twentieth century, when only a few American merchants had the sense of adventure to start a new life in Hawai'i. This photograph of the entrepreneur holding a pineapple like a trophy

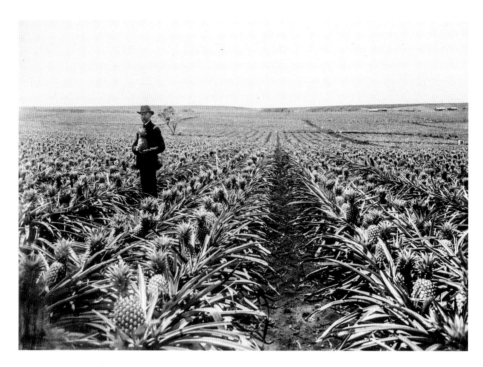

FIGURE 53
Pineapple Fields, n.d. Hawai'i State Archives, Photograph Collection, PP-85-10-012-S.

provided visual assurance to potential US entrepreneurs and signaled the promise that the pineapple industry could yield rich rewards. A path running through the field underneath clear skies served as another metaphor and invitation for viewers to pave their own path to success in Hawai'i. This "path to success," however, was paved on lands stolen from indigenous Hawaiians whose communities were violently displaced. Members of these communities were forced into indentured servitude by American companies, condemned for speaking native languages and practicing rituals, and reduced in number as a result of US invasions. The indigenous population in Hawai'i shrunk profoundly from one million in 1778 to forty thousand in the years of annexation, a result similar to the genocide of Native Americans in the central United States.[14] Scholar and activist Noenoe K. Silva writes, "step by step, the religion, the land, the language, and finally the government were overtaken by the drive for imperial domination."[15] Photographs of American entrepreneurs in pineapple fields elided this violent history in support of the larger mission to increase US migration to Hawai'i.

Upon forming the Hawaiian Pineapple Company in 1901, James Dole shared a vision with his cousin Sanford of transforming Hawai'i into an American republic operated by white, small-scale farmers. He, along with a group of American developers, collaborated with the Hawaii Promotion Committee and used pineapples to entice white homesteaders. In their pamphlets they reported: "The pineapple industry is now

regarded as offering the best opportunities for the white settler."[16] Minister of Foreign Affairs Francis M. Hatch also assured readers that Hawai'i "possesses opportunities to the American home-seeker under laws and conditions harmonious with those on the main land."[17] He cited the need for "sturdy New England principles" and "industrious American workers" in a region where there are "too many idle Hawaiians."[18] Hatch used the same language as northerners after the American Civil War, calling on New Englanders to move south and inculcate northern ideals in what they viewed as a backward wilderness. The Hawaiian pineapple industry was closely aligned with land speculation, indigenous removal, and the mission to transform the region into an American republic.

Although photographs showed the promise of Hawai'i as an American republic, developers struggled to recruit American migrants to Hawai'i. In 1897, James Bryce, author of "The Policy of Annexation for America," worried that "men of Teutonic stock cannot do field labor under so hot a sun."[19] Others expressed anxieties about the dangers of "becoming Orientalized and un-American" in the Hawaiian tropics.[20] Almost a decade after annexation, Minister Hatch delivered a dismal report in 1906 about unsuccessful efforts to recruit American migrants to Hawai'i: "It was hoped that following the flag would come an immigration of farmers from the main land, who would take up the public lands, and who, in addition to brawn and muscle, would bring into the country sturdy qualities of character which would strengthen our electorate as well as build up the country. To our great disappointment any considerable immigration of this nature has not been obtained."[21] The failures of American immigration were apparent in the minority of white people (also known as "haole") employed as laborers on pineapple plantations in 1915, with only three white Americans working there alongside 632 Japanese, 312 Chinese, and 223 Filipino workers.[22] Native Hawaiians constituted only a small minority in the pineapple industry. Their population had been profoundly devastated as a result of US conquest, which impelled American companies to import laborers from Asia. Historian Richard Hawkins reports that by the 1920s, 95 percent of workers in the pineapple industry were Asian.[23] American companies brought vast numbers of laborers from Japan, China, Korea, the Philippines, and Portugal and Puerto Rico, moving further away from the conception of Hawai'i as a small, white American farming community. A decade into the twentieth century, sugar and pineapple moguls relinquished any hopes of whitening Hawai'i and settled for controlling it economically and politically.[24]

"THE PERFECT SERVANT": RACE, HYGIENE, AND GINACA CANNED PINEAPPLE

While political ambitions to infiltrate the Pacific helped jump-start the Hawaiian pineapple industry, it was the invention of canning that made the industry possible. Canning increased in popularity during the Civil War, when soldiers needed packaged foods that would not spoil on the battlefield.[25] The canning industry continued to

grow after the Civil War, as the nation expanded its physical borders to faraway regions with "new" and exciting foods that merchants desired to sell. The invention of canning helped companies overcome the obstacle of transporting foods from distant locations, such as the Hawaiian pineapple, whose closest port was San Francisco, two thousand miles away. This was a significant distance given that pineapples needed to be picked ripe and could easily spoil on the lengthy trans-Pacific journey. The establishment of the American Can Company in Hawai'i in 1906 emerged alongside the extension of the Island Railroad Company in the same year, enabling businesses to connect remote pineapple plantations to the heart of Honolulu for eventual shipment to the west coast of the United States.[26] These changes accelerated the pineapple industry, enabling companies to deliver canned products to consumers at faster speeds and farther distances than ever before.

At the start of the pineapple canning industry, Hawaiian fruits were sliced by slow, clunky grating machines that processed no more than four fruits per minute.[27] Mechanical slicing removed the pineapple's prickly shell and spiky spine, a huge convenience for consumers who wanted a "ready-made," "peel-and-go" fruit similar to the banana. By 1911, the slicing of pineapples radically improved with the introduction of the motorized Ginaca Automatic Pineapple Machine, an invention of engineer Henry Gabriel Ginaca. The machine's distinguishing feature was a tubular slicing knife that could cut an astounding one hundred pineapples per minute. The coring and peeling were all performed in the interior of the machine, diminishing the danger for cannery workers. Eventually, the Ginaca not only cored, peeled, and sliced the fruit into neat squares but also sized it to fit the diameter of the can. According to one advertisement, James Dole "gladly" paid $50,000 for the concept.[28] The invention of the Ginaca machine was transformative for the Hawaiian pineapple industry, superseding machines that had been invented only a few years prior.

The Hawaiian Pineapple Company wasted no time in showcasing Ginaca machines; some of its earliest print advertisements incorporated photographs that showed the machines at work in the cannery (fig. 54). A 1928 advertisement presented a bird's-eye view of the white Ginacas, with pineapples descending down their long conveyor belts. The elevated perspective revealed how Ginacas were not the dense and bulky contraptions of the past, but were slender and graceful machines that gave a semblance of an airy openness. Cannery buildings themselves were designed to provide plenty of air and light, producing an environment that seemed "entirely open," according to one writer.[29] The Ginaca machines were the pineapple industry's highest achievement, bringing ideas about modernism and cleanliness into a model of hygienic design. Homogenized and mechanized, Ginaca machines contributed to the visual harmony of the pineapple cannery that businesses like the Hawaiian Pineapple Company advertised to consumers.

Advertisements praised the Ginaca machine, dubbing it "the perfect servant" for its intelligent design and success in minimizing human labor. The company's 1928 adver-

WORLD'S LARGEST GROWERS AND CANNERS OF HAWAIIAN PINEAPPLE

A group portrait of our 24 "perfect servants"—the marvelous Ginaca machines which help to speed the fresh-picked fruit from field to can. Without them we might still be slowly and wastefully peeling and coring pineapples by hand. Instead, these 24 magical machines calmly prepare as many as 1,000,000 pineapples a day.

The "perfect servant" lives
◄ ◄ ◄ *in Honolulu*

IN this great kitchen of ours, the world's largest fruit cannery, there is a most amazing servant—a servant that does what human hands can do, faster than human eyes can follow. A "perfect servant"—a magical machine named Ginaca.

And what does "Ginaca" do? It peels and cores pineapples. If you have ever tried it you know what a laborious task that is. Yet this marvelous servant thinks nothing of peeling and coring as many as 80 pineapples a minute—sometimes nearly 100,000 in 24 hours.

Long lines of the fresh, ripe fruit speed to its magical, knife-like hands. Swift blades whisk off each prickly shell. Zip!—and away with each top and bottom! Out whirls the fibrous core! And there, lying before you, is the golden meat of a perfect pineapple. All this in less than a second.

Because it would save precious minutes, James D. Dole, head of the Hawaiian Pineapple Company, gladly paid $50,000 for the idea of the undeveloped Ginaca Machine—then spent much more to perfect it.

Costly? Yes! But speed is vital! That elusive field-flavor of plant-ripened Hawaiian Pineapple must be captured. It is—thanks to the help of 24 such "perfect servants" in our kitchen.

You Can Thank "Jim" Dole for Canned Hawaiian Pineapple

30 New tempting recipes . . and a charming little romance *free*

Both—in our books, "The Kingdom That Grew Out of a Little Boy's Garden." There's a lot of enthusiasm about the recipes. They appear nowhere else. They were prepared for us by three of America's leading culinary experts. The romance is the story of Hawaiian Pineapple and the man who has brought this delectable fruit to your table—the intimate story of James D. Dole.

Mail to: Hawaiian Pineapple Co., Dept. 8-58, 215 Market Street, San Francisco

Send me free, "The Kingdom That Grew Out of a Little Boy's Garden"—and the 30 new Hawaiian Pineapple Recipes.

NAME

STREET

CITY STATE

SLICED
CRUSHED
TIDBITS

HAWAIIAN PINEAPPLE

Honolulu HAWAII · HAWAIIAN PINEAPPLE COMPANY · *Sales Office:* 215 Market Street San Francisco

FIGURE 54

Dole Hawaiian Pineapple Company, *The Perfect Servant Lives in Honolulu*, 1928. Ink on paper, 35 × 27.5 cm.

tisement claimed that the Ginaca "does what human hands can do, but faster than human eyes can even believe."[30] It applauded the Ginaca for opening pineapples with "its magical knife-like hands" and whisking off prickly shells in less than a second. The ad flaunted the sheer speed of the machine that canned as many as one hundred thousand pineapples a day.[31] Pineapple canneries were, in a literal sense, power plants. Describing the Ginaca as "the perfect servant" diminished the role of human laborers in the canning process, even though human involvement was still necessary. Cannery workers known as "tray boys," for example, sealed and collected the finished canned pineapple, while women trimmed, cleaned, sorted, sized, and packed the fruit into cans.[32] Advertisements for the Hawaiian Pineapple Company showed a number of women as operators and trimmers in the cannery, but the aerial view of the long, white machines extending far into the distance conveyed to the nation that the future belonged to the Ginaca.

Advertisements that focused on machines and limited human contact in pineapple productions emphasized the cannery's efficiency and cleanliness. Articles on the pineapple cannery validated this point by reporting that the modern, well-ventilated rooms were "stainlessly clean."[33] They also described how "rubber gloves, clean white aprons and caps are worn by every worker," making sure that "bare hands never touch the golden fruit."[34] The same article even offered the detail that women canners laundered their clothing every day.[35] Booklets continuously stressed that "no human hand touches the fruit," and "from the time it is peeled, the rubber gloves of the sorters being the nearest approach to it."[36] Ads accentuated ideas about the purity of canned pineapples by showing photographs with women in white rubber gloves and white smocks not touching, but supervising, the fruit's slicing. These women were models of sanitation, maintaining the highest standard of cleanliness with uniforms unsullied by either a chunk of fruit or a speck of juice. Print advertisements and promotional booklets reveal that the cleanliness of the pineapple cannery was as important as the product it canned.

This obsession with cleanliness reflected mounting concerns at that time about contamination in the canning industry. While concrete floors were lined with drains and gutters to keep factories sanitary and dry, the floors were not always good for employees working long hours, standing at trimming and packing tables seeped in juice.[37] Workers also suffered injuries, specifically bruised knuckles and open sores, from trimming and packaging pineapples. Gloves were one preventative measure to protect a canner's hands from the acidity of the pineapple, but gloves did not always help.[38] Concerns about contaminated food had existed for decades, leading to the Pure Food and Drug Act, which passed in 1906, mandating that the government regulate the food conditions gruesomely described in books like Upton Sinclair's *The Jungle*. Two decades later, Dole's Hawaiian Pineapple Company still felt the pressure of activists who advocated for greater sanitary infrastructure and policies. The company would have been especially interested in presenting a clean view of their canneries since

pineapple competitors like Libby, McNeil, and Libby boasted in advertisements their "famous white enameled kitchens" that "conformed to the highest standards of sanitation."[39] Although the Hawaiian Pineapple Company remained one of the largest producers of Hawaiian pineapple alongside Libby, it created competing ads of pristine factories to temper anxieties about sanitation.

Few scholars have considered how worries about contamination were inflated by fears of foreign contamination in the pineapple cannery by the industry's immigrant workers. Since the late nineteenth century, Americans expressed vicious complaints about Asian food workers being filthy and loathsome. In the 1870s, consumers distrusted the purity of sugar produced by "heathen Chinamen" standing ankle-deep in syrup.[40] In the 1880s, consumers protested California wine made from grapes treaded by the bare feet of "celestials."[41] By the 1900s, food companies were so determined to eliminate Chinese laborers from the fish industry that they invented the "iron chink," a machine that cleaned and canned fish without human intervention. Using a racial slur for this invention highlights the bigotry toward Chinese laborers and desires to create mechanical surrogates for them.[42] The industry's Japanese and Chinese workers were considered a threat to consumers, their un-American status and habits polluting the purity of America's foods. Melanie DuPuis explains that the Food and Drug Act was prompted in part by "a health panic about germs and genes [which was] linked to a moral panic about social virtues and a hope that government could better both health and morals through policies that sanitized and purified American society."[43] Dole's Hawaiian Pineapple Company was aware of these concerns and had to win public trust for its immigrant workforce in the face of decades of discrimination against them.

Hostile attitudes toward Asian immigrants likely influenced depictions of idealized and sanitized pineapple canneries. For example, the 1928 advertisement presents clean employees standing tall and confident, conducting their work with integrity. The workers' uniforms were as white as the spotless Ginacas, thus working to assuage prejudices about the filth of immigrant workers. Showing them in white clothes among white walls in white canneries literally whitewashed workers and defused the threat of immigrant laborers in factories, whose placement next to machines spoke directly to the minimal contact between workers and pineapples. These images were a visual testament not only to the cleanliness of the workers and the purity of the fruit they processed but also to the broader industrial progress of the region. Fruit's reputation for civilizing landscapes remained strong well into the twentieth century. The Hawaiian Pineapple Company could have edited out immigrant workers from its advertisements, but it chose to foreground them, declaring that they had an important role to play in the pineapple industry. Placing them in the foreground also declared that the Hawaiian Pineapple Company had regulated and thus controlled its workforce, which many viewed with suspicion and hatred.

Because pineapple and sugar companies relied so heavily on Asian laborers, they lobbied for modifications to the 1882 Chinese Exclusion Act and 1924 Asian

Exclusion Act so as to increase Asian immigration in Hawai'i. The pineapple industry argued that Asian people were willing to do the unpopular, difficult work that most white Americans shunned. One supporter wrote: "I am convinced that the ordinary field work of the sugar plantations and pineapple fields can not be, and never will be, done by white American labor. . . . I am convinced that our only salvation from the present dire shortage of the field labor is the importation of Oriental laborers."[44] Others wrote: "Our experience shows that the Japanese make the best pineapple growers of any of the nationalities amongst us, and they are also efficient help in the cannery work. Chinese have also proved most efficient cannery workers and are very well adapted to this work in general."[45] No longer hoping to transform Hawai'i into a white homestead, sugar and pineapple industry leaders were eager to recruit more immigrants who they could hire cheaply as contract laborers.[46] But at the same time that the Hawaiian Pineapple Company challenged racist policies and advocated for immigration reform, it also disenfranchised its workers by offering them low wages and few benefits, pitting immigrant communities against one another and against indigenous people in the competition for jobs. Their living conditions were also dismal; Dole employees on the island of Lāna'i had no running water, electricity, gas, or indoor bathrooms, compared to Dole's white employers who lived much more luxuriously in larger homes separated from the workers' quarters.[47] Advertisements glossed over this reality, instead presenting a visual rebuttal to federal laws prohibiting the immigration of Asian laborers.

In fact, reports about the Hawaiian pineapple industry praised canneries for fostering racial harmony. Pineapple promoters flaunted the industry's tolerant environment, stating, "it is a common sight to see women of four or five different races working side by side on a packing table. Race prejudices are rarely in evidence in the cannery—Japanese, Chinese, Koreans, Hawaiians and Portuguese all working peacefully together under foremen of different nationalities." The writer continued, "we daresay that nowhere else in the world will one find so many races and mixtures of races gathered together in one plant as are found in a pineapple cannery in Hawai'i."[48] At a time of intense racism and xenophobic immigration reform that virtually banned all immigration from Asian nations, the pineapple cannery was marketed as "a multiracial nirvana," hailed for its racial diversity and opportunities for upward mobility.[49] Promotional materials applauded racial harmony in canneries, silencing the tensions brewing between laborers of different nationalities and between laborers and their employers. The notion that pineapple canneries were racial paradigms silenced another undeniable reality worth mentioning again: that the Hawaiian pineapple industry was built on the historic theft of indigenous land and subjugation of indigenous people that benefited white, and later Asian, Hawaiians. Presenting the pineapple cannery as a model of racial equality refuted the negative image of Asian immigrants while paradoxically diminishing their role by highlighting Ginaca machines, the industry's "perfect servant."

HAWAI'I ON EXHIBIT: PINEAPPLE DISPLAYS AT AMERICAN WORLD'S FAIRS

Although Hawaiian pineapple companies failed to attract American laborers, they still needed to attract American consumers. Business owners partnered with politicians on promotional boards to organize exhibits at world's fairs that would increase US tourism and investment in Hawai'i. World's fairs were a promising venue for a business like the Hawaiian Pineapple Company since they had long advertised new foods; for example, Heinz ketchup was introduced at the Philadelphia Centennial of 1876 and Aunt Jemima Pancake Mix made its debut at the Columbian Exposition of 1893. Hawaiian pineapple businesses continued this tradition by using exhibition space in the Hawai'i Building at the 1909 Alaska-Yukon Exposition in Seattle to sell their product alongside an impressive installation of a towering, two-story sculpture of a pineapple made from hundreds of pineapples (fig. 55). The sculpture reached between 15 to 30 feet high with its top full of palm fronds to imitate the fruit's spiky crown.[50] Viewers were accustomed to seeing quirky food sculptures at world's fairs, including the famous display of California oranges shaped like the Liberty Bell at the Columbian Exposition (see fig. 2). The importance of these exhibitions should not be underestimated; in an age when few people could travel as far as Hawai'i, such installations offered consumers a taste of the nation's far-flung regions. Relying on the old but popular formula of food sculptures, exhibitors like the Hawaiian Pineapple Company organized the construction of a towering pineapple that portrayed this fruit as exotic yet available.

Fairgoers could sample the Hawaiian pineapple in a section next to the pineapple tower, where Native Hawaiian girls sold slices of the fruit for ten cents a plate. According to one writer, the Hawaiian girls were "in themselves an excellent exhibit for Hawai'i, for their beauty, amiability, and lady-like demeanor and gave visitors a favorable idea of the cultivation of the better class of the natives."[51] The girls were as much on display as the pineapple they sold. The display of "amiable" and "lady-like" Native Hawaiians disguised the crushing overthrow of indigenous power, instead portraying a Native population friendly to Americans, specifically American women who may have been impressed by the "civilized" etiquette of Hawaiians. The Hawaiian Pineapple Company would later publish several print ads in *McClure's* and *Ladies' Home Journal*, recognizing that one of the most effective ways to increase pineapple consumption was through female consumers, the ones purchasing food and preparing it in the home. The display of girls selling pineapple in the Hawai'i exhibit further naturalized colonial settlement and encouraged US investment in Hawai'i, its products, and its people.

The Hawai'i Building in the Alaska-Yukon fair was a good trial run for the Panama-Pacific Exposition six years later in 1915. The Hawai'i exhibit at the Panama-Pacific was much more elaborate, containing a tropical garden, a reproduction of the Kīlauea volcano, and an aquarium with fish and octopi in tanks of seawater brought from the Farallon Islands off the San Francisco coast.[52] The exhibit was tremendously popular, visited by 34,000 people a day, according to one record.[53] When ground broke for the Hawai'i

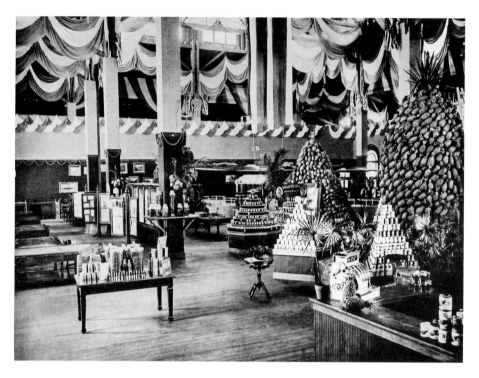

Building, the Hawaiian flag was raised by the granddaughter of the first American military commander of Hawaiʻi, while the wife of the commander of the US cruiser *St. Louis* christened the ground with pineapple juice.[54] Wives connected to the military and steamship personnel presented Hawaiʻi as a family-friendly destination, at the same time that the presence of Native Hawaiian girls highlighted the region's exotic allure. Noticeably absent from the exhibit were Asian immigrant women who had been canning the Islands' pineapple. In their place, viewers learned about canning from the nearby Palace of Horticulture, where a gold medal was awarded to the Ginaca Automatic Pineapple Machine. This award was especially meaningful at the Panama-Pacific Exposition, which, for the first time in fair history, devoted an entire building to the display of food technology in its "Palace of Food." By the end of the Panama-Pacific Exposition, five thousand cans of pineapple were sold to visitors, a landmark sale in the history of the fruit.[55]

The Panama-Pacific Expo was an important venue for promoting the economic expansion of the Hawaiian pineapple industry and Hawaiʻi more broadly. In a speech at the fair, Hawaiʻi governor Lucius E. Pinkham asserted the importance of Hawaiʻi for the

United States, declaring, "she exists for the protection of your Pacific Coast—your cities, your commerce and trade, and the mighty material and political progress of the United States of America."[55] There was no better platform to make this declaration than at this fair in San Francisco, one of the closest neighbors to Hawai'i. Albert P. Taylor, secretary-director of the Hawaii Promotion Committee, explained how the fair's Hawai'i Building could be profitable for tourism, saying, "The whole idea of Hawaiian representation at the Exposition was to gain more publicity for the islands, publicity which would attract the traveler, make the islands better known, and better understood, and cause them to become the tourist mecca of the travel world. It is a business proposition which was placed before the legislature of 1913, which appropriated $100,000 for Hawai'i's representation at the Exposition." Taylor assured Americans of its success, proclaiming, "From getting Hawai'i better known, and better understood as a modern, up-to-date insular community, the results have been fifty-fold more than for the larger expenditures made by other states."[56] Through displays at world's fairs, businesses put forth a seductive image of Hawai'i as both modern and exotic to consumers who had little knowledge and even less access to Hawai'i in the first decades of the twentieth century.

The Hawaiian Building at the Panama-Pacific Expo carried even greater national significance in 1915, the second year of World War I, when pineapple sales were declining. While the militarization of Hawai'i and opening of the Panama Canal in 1915 expanded trade routes that benefited the pineapple trade, Hawaiian fruit companies endured significant losses as a result of the war. Pineapples were transported far less frequently on ships that prioritized space for weapons and other war goods. Dole's Hawaiian Pineapple Company survived this tumultuous time due to its contract with the US Navy, which purchased 180,000 cases of canned pineapple.[57] In fact, the Hawaiian Pineapple Company profited so much as a result of this contract that James Dole was accused of war profiteering.[58] In his defense, Dole claimed that the company had only raised pineapple prices during the war to sustain the company in an unsteady economy. The navy contract blunted the blow to pineapple sales but did not save sales from shrinking in the general consumer market. The 1915 exhibition of pineapples at the Panama-Pacific Expo was a clever strategy the company used to continue marketing the product in an unstable climate. Emphasizing the pineapple's production in Hawai'i—an important port for shipping vessels, war materials, and Hawaiian soldiers who fought alongside Americans in World War I—was a way to not only sell pineapples but also stir patriotic sentiment. Hawai'i was finally living up to the dream of earlier annexationists who had visions of this region as a commercial gold mine and "Gibraltar of the Pacific."[59]

THE ART OF SEDUCTION: SELLING PINEAPPLE, SELLING PARADISE

After World War I, and in the wake of the Great Depression, the Hawaiian Pineapple Company charted a new path for marketing its product by creating advertisements in collaboration with well-known artists. This new strategy was spearheaded in the

mid-1930s by the advertising firm N.W. Ayer and Son, which launched an aggressive ad campaign for Dole pineapple juice under the art direction of Charles T. Coiner. Coiner was hired by Castle and Cooke, one of the "Big Five" companies in Hawaiʻi, which gained more control as a major stakeholder over Dole's Hawaiian Pineapple Company in 1932.[60] The company told the *Honolulu Advertiser*, "we have planned with the aid of advertising counsel, a very unusual campaign, unlike anything you have ever seen before."[61] Under Coiner's guidance, the Hawaiian Pineapple Company commissioned a constellation of famous artists to collaborate on print advertisements for pineapple juice, a fruit drink that experienced a surge in popularity during the Prohibition era. In 1934, it sold a record-breaking twelve million cases.[62] Several artists created ads for this new product, including Lloyd Sexton, Miguel Covarrubias, and Georgia O'Keeffe, whose ads were published in popular magazines such as *Life* and *Saturday Evening Post*. While fruit businesses such as Sunkist and the United Fruit Company also borrowed from the fine arts, the Hawaiian Pineapple Company worked more directly and consistently with nationally renowned artists. Association with high-status, high-profile talent helped elevate the new Dole product, distinguish it from competitors, and revive the company's reputation after an economic depression.

Lloyd Sexton, an artist and graduate of the Punahou School in Honolulu, produced some of the company's most colorful advertisements, perpetuating stereotypes about Hawaiʻi as a timeless and primitive Eden. His ad for pineapple juice from 1935 shows a topless woman, wearing a skirt, lei, and white flower in her hair as she sits in the midst of an unspoiled paradise (fig. 56). Such tropes were nothing new; they resembled the Hawaiian women on display in world's fair exhibits and native women in paintings made popular by French artists such as Paul Gauguin more than fifty years earlier. The tropes in Sexton's ad were made even more legible with the word "Exotic" printed in large cursive font below the image. The advertisement went on to state: "From those exotic Hawaiian Isles, so rich in color, so startling in contrasts, so enchanting in fragrance, comes DOLE pineapple juice—one of nature's most glamorous drinks. Words cannot describe the spicy aroma, the sprightly flavor, the exhilaration of this pure juice from sun-ripe pineapples. You must taste DOLE pineapple juice for yourself to understand fully its delicious goodness!"[63] Sexual undertones course through this advertisement, which describes the spicy and sprightly exhilaration one gets from drinking pineapple juice. Sexton activated sexual fantasies about the region while also linking the Hawaiian pineapple to admired painting traditions of the past. The world of advertising was impressed by such collaborations; in 1940, Sexton won a New York Art Directors Association Award for this very advertisement.[64]

The Hawaiian Pineapple Company also used tropes of the exotic tropics in its advertisement with the art of Miguel Covarrubias. An ad from the late 1930s shows a white couple against Covarrubias's tropical backdrop, drinking pineapple juice (fig. 57). Everything in the advertisement speaks to the elegance of this well-groomed couple, who have coiffed hair and fashionable clothing, sitting at a table decorated with

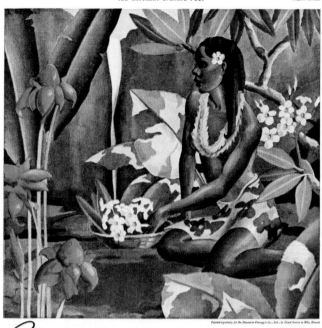

Exotic

From those exotic Hawaiian Isles, so rich in color, so startling in contrasts, so enchanting in fragrance, comes DOLE Pineapple Juice—one of Nature's most glamorous drinks. Words cannot describe the spicy aroma, the sprightly flavor, the exhilaration of this pure juice from sun-ripe pineapples. You must taste DOLE Pineapple Juice for yourself to understand fully its delicious goodness!

Hawaiian Pineapple Co., Ltd., Honolulu, Hawaii. Sales Offices: 215 Market Street, San Francisco, California

FIGURE 56

Lloyd Sexton, *Exotic*, advertisement for Dole Hawaiian Pineapple Company, 1935. Dole Magazine, advert, USA, 1930 © The Advertising Archives / Bridgeman Images.

delicate glassware. The two Hawaiian women in the background, however, possess no such elegant objects. Topless, they stand empty-handed amid lush, tropical vegetation, nearly duplicating Sexton's earlier advertisement. Clearly, these artists were in conversation with one another, responding to the expectations of their client, the Hawaiian Pineapple Company. Covarrubias did not show the women's faces because they were mere accessories in his image, as indexical of the tropics as the palm fronds and flowers in the picture. The women are rendered in a flat, two-dimensional style, their identities flattened and painted like a mere backdrop to the white couple in the foreground. They stand right above the still life of what might be "wang peony" flowers, whose name and phallic stems add to the sexual innuendo of the ad. Cutting across Covarrubias's picture is the word "Recaptured," expressing how pineapple juice captures the exotic essence of Hawai'i for its drinker. The word "Recaptured" also had an unintended resonance for the Hawaiian landscapes that were captured and Hawaiian people held hostage to stereotypes. Such ads filtered Hawai'i through American fantasies about the Islands, making the region's conquest look easy, sexy, and inevitable.

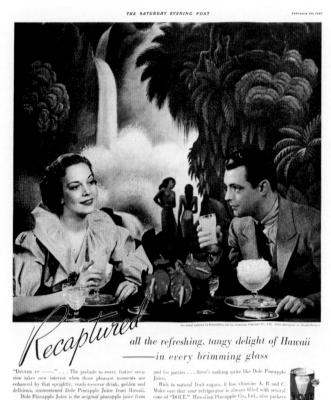

Recaptured all the refreshing, tangy delight of Hawaii
——in every brimming glass

"DINNER AT ——." . . . The prelude to every festive occasion takes new interest when those pleasant moments are enhanced by that sprightly, ready-to-serve drink, golden and delicious, unsweetened Dole Pineapple Juice from Hawaii.

Dole Pineapple Juice is the *original* pineapple juice from Hawaii. The exclusive Dole Fast-Seal Vacuum-Packing Process retains in high degree those important, *natural* food values of fresh fruit. That's why . . . for every meal, between meals,

and for parties . . . there's nothing quite like Dole Pineapple Juice.

Rich in natural fruit sugars, it has vitamins A, B and C. Make sure that your refrigerator is always filled with several cans of "DOLE." Hawaiian Pineapple Co., Ltd., also packers of Dole Sliced Pineapple, Crushed, Tidbits, Gems, and the new Royal Spears. Honolulu, Hawaii, U. S. A. Sales Offices; San Francisco, California.

DOLE PINEAPPLE JUICE from HAWAII

FIGURE 57
Dole Hawaiian Pineapple
Company, "Recaptured, all the
refreshing, tangy delight of
Hawaii—in every brimming glass,"
1937. Ink on paper, 13½ × 10 in.

While Sexton and Covarrubias won national attention and top honors for their advertisements, the content of their pictures was far from inventive.[65] Archetypes of a tropical paradise free from the drudge of daily life had been popular for decades in sheet music, movies, and movie posters about Hawai'i.[66] Patricia Johnston reports that more than fifty feature films, mostly romances, were made in or about Hawai'i from 1920 to 1939.[67] The exotic tropes attached to Hawai'i were revived in the 1930s, a period of economic rebound and increased tourism, when ships sailed by the Matson Navigation Company offered luxury travel from the West Coast to Honolulu. Hawai'i provided not only political and commercial benefits to the United States but also those of leisure. Unlike most regions of interest to the United States in Latin America and the Caribbean, Hawai'i was an annexed territory able to provide a tropical experience on American soil. Dole advertisements showing the Hawaiian landscape told consumers that fantasies of Hawai'i were within their reach.

The women in smocks and gloves touting the industry's Ginaca machines from the 1920s were now replaced in the 1930s by women undressed and mythologized in a tropical Eden. Under the guidance of art directors in the 1930s, artists working for the Hawaiian Pineapple Company took the fruit out of the cannery and into the tropical outdoors to lure consumers with fantasies of Hawaiian women and landscapes.

Compared to Sexton and Covarrubias, Georgia O'Keeffe had a more challenging time crafting an image for the Hawaiian Pineapple Company. In the summer of 1938, Coiner paid for O'Keeffe to travel to Hawai'i and paint pictures for use in company advertisements. He gave O'Keeffe little direction on what to paint, but surely he expected that she would depict the company fruit. After traveling by train from New York to California and then by steamship to Hawai'i, O'Keeffe arrived there in February 1939 and visited the sites with local elites for nine weeks. Wanting a different perspective, O'Keeffe requested to stay in a plantation village with pineapple workers. The company rejected her request because "this was not local custom for white women to live with native workers."[68] O'Keeffe still managed to spend time on a sugar cane field, writing in a letter to her husband Edward Stieglitz: "I went and stayed on a sugar plantation at Hana among the working people and had the best time I had any place on the islands."[69] She was struck by Hawai'i's fusion of Asian cultures, writing, "the sugar town is a town of mixed yellow people . . . so many oriental people make it different than any town I was ever in—Makes me feel I ought to go on to Japan and China when I get this far."[70] O'Keeffe left Hawai'i after more than two months with a positive impression of the region as an exciting collage of different cultures, but she returned to New York without painting a single pineapple, instead submitting a painting of a papaya tree and Heliconia flower.[71]

Many scholars suspect that O'Keeffe's failure to paint a Dole pineapple was an act of revenge for the company's denial of her request to stay with pineapple and sugar workers.[72] The company may have feared that O'Keeffe would witness tensions resulting from the racial segregation of workers in living quarters or the labor strikes that had been brewing throughout the 1930s. The years leading up to World War II were a time of great change in the Hawaiian pineapple industry, where workers of all races, led by New Deal agents, formed powerful unions to protest unfair wages and working conditions.[73] Prior to the intervention of New Deal agents, workers were powerless in the hands of company leaders, and even O'Keeffe noticed how Hawaiian Pineapple Company's investors, Castle and Cooke, "seem to control so many things here."[74] Cannery workers fought corporations in the 1930s with the help of outside agents, eventually winning recognition as a formal union in 1939. Weeks after O'Keeffe visited Hawai'i, pineapple workers secured major benefits in the form of paid holidays and unemployment compensation outside the pineapple season. Articles in the *Star Bulletin* and *Honolulu Advertiser* announced the new labor policy

for pineapple workers, including eight-hour days, forty-hour weeks, vacation time, and overtime pay.[75] Strikes during the 1930s resulted in one of the most successful and racially diverse unions in American history, eventually joining pineapple workers with laborers of other Hawaiian industries as part of the International Longshore and Warehouse Union.[76] Because O'Keeffe visited pineapple and sugar plantations during this pivotal moment, one wonders whether she intentionally excluded the pineapple from her paintings since it, along with sugar, was at the center of labor debates in 1938 and 1939.

When O'Keeffe returned stateside without a pineapple picture, Coiner managed to squeeze another painting out of the artist by flying an enormous budding pineapple plant via a Pan Am Clipper to O'Keeffe's New York penthouse at the Shelton Hotel.[77] O'Keeffe complied and painted the fruit with thick green leaves radiating outward beyond the picture frame (fig. 58). The pineapple bud dramatically emerges from the center of the plant as if birthing a new life. In focusing on the colorful anatomy of the plant, O'Keefe de-contextualized it from the broader landscape of Hawai'i and showed no signposts situating the fruit in an identifiably Hawaiian setting. It is noteworthy that O'Keeffe emptied the canvas of all Hawaiian women, leis, waterfalls, and other stereotypical signifiers used by her peers. While it is tempting to argue that she deconstructed the pineapple to emancipate Hawai'i from age-old stereotypes, the impulse to abstract plants to their most essential forms was simply a hallmark of the artist's work.[78] Rather than adapt her artistic style to highlight the company's product, she honored self-expression in the ad. After all, that is why Coiner hired O'Keeffe: to associate the Dole pineapple with her unique style that represented an elevated, modern art. The Hawaiian Pineapple Company reproduced O'Keeffe's picture for their ad in 1939 and displayed the original painting at its corporate headquarters.[79]

To turn O'Keeffe's painting into an ad, the team at the Hawaiian Pineapple Company added a small vignette of a model white American family below her picture: a husband, wife, son, and daughter smile as they share glasses of pineapple juice. The text underneath encourages viewers to "just try [pineapple juice] for breakfast . . . after shopping or exercise . . . with the children when they come home from school."[80] Few scholars discuss this part of the image, which is much more docile than the topless women in Sexton's and Covarrubias's advertisements. The image of the family of four shared more in common with the messages conveyed in the company's cookbooks, which offered tips and "wife savers" on how to incorporate the pineapple into school lunches and dinner parties. Although the Hawaiian Pineapple Company had been publishing more risqué pictures of topless native women by Sexton and Covarrubias, perhaps they felt a family-friendly image was more appropriate for a woman artist such as O'Keeffe. In the end, all Dole advertisements shared the same goal: to tailor the Hawaiian pineapple to the fantasies of white American consumers. The inclusion of white figures in advertisements not only offered white consumers a model with

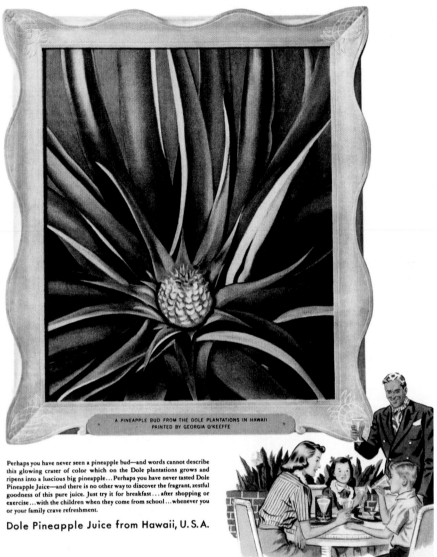

First Showing: A Dole Pineapple Bud from Hawaii

A PINEAPPLE BUD FROM THE DOLE PLANTATIONS IN HAWAII
PAINTED BY GEORGIA O'KEEFFE

Perhaps you have never seen a pineapple bud—and words cannot describe this glowing crater of color which on the Dole plantations grows and ripens into a luscious big pineapple...Perhaps you have never tasted Dole Pineapple Juice—and there is no other way to discover the fragrant, zestful goodness of this pure juice. Just try it for breakfast...after shopping or exercise...with the children when they come from school...whenever you or your family crave refreshment.

Dole Pineapple Juice from Hawaii, U.S.A.

FIGURE 58
Georgia O'Keeffe for Dole Hawaiian Pineapple Company, *First Showing: A Dole Pineapple Bud from Hawaii*, 1941. Private collection.

which to identify—an authoritative model that typically dominates over submissive Hawaiian figures in the ad—but also assurance that they too could consume Hawaiian culture without "going native" and sinking too deep into the tropics. Images of white figures were as safe as the atemporal Hawaiian women in Dole advertisements that allowed consumers to taste and take the tropics without being swallowed by it.

VICTORY PINEAPPLES: THE HAWAIIAN PINEAPPLE
COMPANY DURING WORLD WAR II

Advertisements displaying Hawaiians as exotic native caricatures may have been used to distract from the industry's large base of Japanese workers, whose country of origin was an enemy of the United States during World War II. In 1941, two years after O'Keeffe visited Honolulu, thousands of American servicemen went abroad to fight a war against Japan, Germany, and other foes. During her visit to the Islands before the war's start, O'Keeffe noted the paradox of wearing Japanese sandals and carrying Japanese umbrellas "in spite of what Japan may be doing."[81] The artist left Honolulu a few years before the region was completely transformed into an army outpost bristling with fortifications and barracks. Sugar and pineapple fields were converted into defensive posts, while public buildings were coated in camouflage paint.[82] The Hawaiian Pineapple Company even built splinter-proof bomb shelters for employees in case of an emergency.[83] During World War II, 512 workers from the Hawaiian Pineapple Company enlisted in the armed forces, and by the war's end twenty-two had died.[84] Hawai'i was crucial for the course of the war because of its population of soldiers and strong naval base, but also as a target for Japanese fighter planes, which bombed Pearl Harbor in 1941, killing more than two thousand people and destroying dozens of military aircraft. Prejudices toward Japanese and Japanese Americans were amplified as the war progressed, resulting in the forced relocation of people to internment camps, including one near Pearl Harbor that held hundreds of Japanese prisoners. After the bombing, the country was on high alert, with Hawai'i at the center of US conflict.

The war had major consequences on the sale of Hawaiian pineapples. With Hawaiians under martial law for most of World War II, the American government dominated all operations related to the distribution of food. This included the pineapple, which was restricted by food rationing, one of the first measures enacted by the government after the bombing of Pearl Harbor to ensure that the American army and its allies had enough supplies. When pineapples were not being shipped to soldiers, they, like most canned foods, were available to civilians at an elevated price. The *National Wartime Nutritional Guide* in 1943 shows that pineapples belonged to Food Group Three, costing twenty-four out of the fifty points allotted to each household member per month.[85] A can of the fruit amounted to almost half of one person's monthly allotment. A black market for costly foods thrived despite warnings that pineapple theft was punishable by $1,000 fines.[86] Even though the Hawaiian Pineapple Company managed to survive slipping sales during World War II due to a contract with the army (similar to the navy contract that rescued Dole sales in World War I), the company struggled to make a profit.[87]

In this time of hardship, the timeless paradise represented in earlier ads by Sexton and Covarrubias would have seemed out of touch with the millions of families who had brothers and sons at war and did not have the luxury to fantasize about a vacation in Hawai'i. These ads would have seemed especially incongruent with the realities of World War II, when tourism was prohibited by the US Navy, as cities like Honolulu

had become militarized centers for war. Indeed, Matson luxury steamship liners—the line that had transported O'Keeffe to Hawai'i in 1939—now carried soldiers instead of tourists.[88] While the Hawaiian Pineapple Company continued to publish escapist ads of sun-splashed pineapples and tropical beaches, it also departed from earlier practices by explicitly addressing the political circumstances of Hawai'i. The company took advantage of new laws set by the Treasury Department and War Advertising Council in 1941 that offered tax benefits to businesses that expressed support for the war effort in their advertisements.[89] The Hawaiian Pineapple Company followed suit and devoted all advertisements exclusively to the war effort by 1945. With Hawai'i and Japanese people at the epicenter of World War II, it was more critical now than ever for the company to establish a connection between Hawaiian pineapples and national loyalties in its advertisements.

The Hawaiian Pineapple Company imbued pineapples with wartime patriotism in several ads, including one from 1944 that showed a map of the United States in pineapple yellow (fig. 59). Inside the contours of the country are fruits and vegetables representing the fabric of American agriculture. Though this ad displayed a picturesque image of abundance, its message was more urgent, stating:

> From Hawaii to Maine the nation calls for harvest help. There is still an urgent need throughout the nation for volunteers in the fields, orchards, and canneries. Every fruit, vegetable, and grain must be harvested, stored or processed to meet the requirements of our Armed Forces, our Allies, ad our great civilian population. Already millions of volunteers from cities and towns have performed notably in their vital war work. In Hawaii for example, thousands of men, women, boys, and girls helped pack the Dole Pineapple crop.

These rousing words urged consumers to perform their civic duty by registering with local Farm Labor officers, growing "victory foods" in "victory gardens," and packing pineapples for the war effort.[90] Food production was presented as an opportunity to spread patriotism, from Maine to Hawai'i, presenting the annexed territory as loyal as any American state. Ads capitalized on the many metaphors that food easily provided for wartime, declaring: "turn ripe crops into fighting foods," "plant the seeds of democracy," and "fight our enemies in the fields." The Hawaiian Pineapple Company demonstrated its contribution to the war effort by sending canned pineapple to soldiers, explaining in one ad from 1941 that only a small portion of the pineapple crop would be available to civilians since the armed forces require two thirds of all Dole pineapple and juice.[91] In 1941, the president of the company, Henry A. White, declared in the annual newsletter, "We cannot lose sight of the fact that all canned foods, including pineapple products, are vitally essential weapons of war. It is not merely our business, but our patriotic duty, to produce these weapons . . . until victory is won."[92] Pineapples were not merely tasty treats; they were conceptualized as weapons protecting American values.

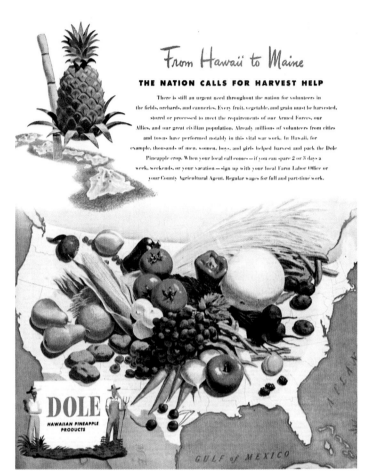

From Hawaii to Maine

THE NATION CALLS FOR HARVEST HELP

There is still an urgent need throughout the nation for volunteers in the fields, orchards, and canneries. Every fruit, vegetable, and grain must be harvested, stored or processed to meet the requirements of our Armed Forces, our Allies, and our great civilian population. Already millions of volunteers from cities and towns have performed notably in this vital war work. In Hawaii, for example, thousands of men, women, boys, and girls helped harvest and pack the Dole Pineapple crop. When your local call comes — if you can spare 2 or 3 days a week, weekends, or your vacation — sign up with your local Farm Labor Office or your County Agricultural Agent. Regular wages for full and part-time work.

DOLE
HAWAIIAN PINEAPPLE
PRODUCTS

FIGURE 59
Dole Hawaiian Pineapple
Company, "From Hawaii to Maine:
The Nation Calls for Harvest
Help," 1944.

Many companies infused their advertisements with patriotic sentiment, but it was particularly crucial for the Hawaiian Pineapple Company to emphasize its loyalty, given that its product was largely canned and cultivated by workers from an enemy nation, Japan. Even in Hawai'i, where Japanese and Japanese Americans made up one-third of the population, and fought in the 100th Infantry Battalion and 442nd Regimental Combat Team for the United States, they were treated by many as foes.[93] Japanese-language schools, Japanese-owned banks, and Japanese newspapers were closed down during World War II.[94] Japanese people were restricted by prohibitive laws and monitored under curfew.[95] The American army specifically targeted religious leaders and business owners, imprisoning pillars of Japanese society. Historians estimate that hundreds of Japanese people and a smaller number of Japanese Americans were interned in more than fifteen camps in Hawai'i, including camp "Honouliuli," which was referred to as "Hell Valley." Removing laborers of Japanese ancestry from the

Hawaiian workforce threatened to hurt the Islands' industries, yet they were still discriminated against with intensity.

Given the discrimination against people of Japanese descent during World War II, it seems purposeful that Dole advertisements from the time focused less on immigrant cannery workers than in previous decades and more on American soldiers and a generalized population of Hawaiians. A company ad from 1943, for instance, declared, "Here in Hawaiʻi, with the help of Island people, we are now harvesting and canning a great crop of Dole-grown pineapples."[96] Using the generalized term "Island people" blurred the racial identities of the industry's labor force and conflated the complexities of Hawaiʻi's diverse population. Consumers most likely interpreted "Island people" as Native Hawaiians, who comprised a small percentage of pineapple workers. Yet, wartime ads emphasized the "Hawaiian-ness" of its workforce by quoting laborers with Hawaiian sayings and showing them with Hawaiian flowers in their hair. At a time when Asian—specifically Japanese—people were viewed as war criminals and Native Hawaiians were considered docile and alluringly exotic, Dole advertisements during World War II likely evaded the former and emphasized the latter to negotiate the public perception of its product and worker during wartime.

THE PINEAPPLE INCORPORATED: DOLE AND HAWAIIAN STATEHOOD

American perceptions of Asian Hawaiians and Native Hawaiians changed after the war's closing as Hawaiʻi progressed toward statehood. A new class of Chinese and Japanese workers in Hawaiʻi capitalized on GI bills, educational opportunities, and citizenship offers as young veterans of the war.[97] They took advantage of revised immigration laws in the 1950s, which enabled more Asian immigrants to become naturalized citizens with voting rights. Empowered by their new status, a rising labor class of Asian veterans in Hawaiʻi formed an influential and multiracial Democratic party that demanded better pay and improved working conditions, a continuation of the work unions began in the 1930s.[98] Although pineapple laborers continued to strike after World War II, the industry benefited from the postwar boom and growing tourism, which brought more money and interest to the pineapple industry on the Islands. By the 1950s, sugar cane and pineapple plantations accounted for more than 90 percent of field crops, employing nearly one-third of Hawaiʻi's labor force.[99] The industry was responding to the growing demand for pineapple in 1950, when Americans consumed, on average, 31 pounds of the fruit annually, just a few pounds behind the national consumption of peaches.[100] Wanting to maximize the postwar upswing, deliver Hawaiian products to a growing base of American consumers, and enjoy rights as citizens for a country that many Hawaiian veterans had fought for during World War II, a contested majority in Hawaiʻi supported efforts to make the Islands an official part of the United States.[101] The period following World War II marked a time of political ascendency for people of Asian descent in Hawaiʻi, who, after enduring a long

history of oppression under the US regime, now benefited from US development in the region and the legacy of settler colonialism.[102] With the growing acceptance of Hawaiians—namely, Hawaiians of Asian ancestry—the territory received a formal invitation from the United States in 1959 to join the Union as the fiftieth state.

In the years leading up to statehood, the Hawaiian Pineapple Company published color photographs featuring Hawaiian actors in ads such as "It's Hawaiian Party Time" for the "Be sure it's Hawaiian—Be sure it's DOLE" ad campaign (see fig. 52). New York commercial photographer Anton Bruehl shot this and other ads that incorporated well-known Hawaiian actors including professional hula dancer Pualani Mossman.[103] Although Bruehl shot many of these photo campaigns in his studio, he photographed "It's Hawaiian Party Time" on location in Hawai'i, posing actors around pineapples sliced in halves and crescents. By showing many generations enjoying the pineapple, the Dole Company presented a new model family, replacing the white American family placed next to Georgia O'Keeffe's picture from fifteen years earlier. The display of smiling, happy Hawaiians did not conjure up the Japanese immigrant workers who were treated as recent enemies and prisoners of war or the indigenous communities who had been devastated by American conquest and its aftermath. Rather, the display of smiling actors in Dole advertisements showed that Hawaiian culture was alive and nonthreatening as its people were about to become American citizens. Haunani-Kay Trask, a highly regarded educator and advocate of indigenous rights, explains how the "tourist poster image of my homeland as a racial paradise with happy Natives waiting to share their culture with everyone and anyone is a familiar global commodity."[104] She describes these images as false and predatory, disguising the ugly truths about the real conditions of Native Hawaiians.[105] Leaders of the Hawaiian Pineapple Company reproduced these tropes in advertisements, selling American consumers on the idea of Hawaiians as citizens with their own star on the American flag.

The company recognized the mutually beneficial relationship of pineapples, pictures, and statehood; it hoped that full-color ads would lead to a greater emotional interest in Hawai'i and "a more favorable climate for Mainland investment in the newest state."[106] It specifically looked forward to Hawaiian statehood in its "Be sure it's Hawaiian—Be sure it's DOLE" campaign, declaring that Hawai'i's pineapples were America's pineapples. When Hawai'i was officially anointed a state in the Union, a Dole company newsletter from 1959 applauded its new ad campaign incorporating Hawaiian people and landscapes, stating, "In the year ahead, the most powerful advertising campaign we have ever put behind Dole . . . [will emphasize] the unique three-way association between the DOLE brand, pineapple, and Hawai'i, now our 50th state, the campaign will feature our products against striking, full-color Hawaiian backgrounds."[107] The incorporation of Hawaiian people in company ads mirrored the incorporation of Hawai'i into the United States, revealing how the pineapple's depiction was not only a reflection of but also a promotion of American expansion.

At the same time that Dole advertisements celebrated the incorporation of Hawaiians as American citizens, they also fortified perceived cultural differences between Hawaiians and Americans. By depicting Hawaiians eating fruit outside on the ground without tables, chairs, or silverware, such images shored up earlier stereotypes of Hawaiians as an unsophisticated race. Their manner of eating would have been read by many American viewers as signals of racial difference and inferiority. The perception of Hawaiians as so culturally different from people in the United States continued to challenge congressmen who questioned how Hawaiians could be integrated as American citizens. The absence of chairs and silverware in Bruehl's photo was a particularly long-standing device for portraying marginalized people's inability to assimilate American values. For many Americans, the Hawaiian actors' manner of eating and dressing in Dole ads would have signaled "otherness" and a timeless culture incapable of modernizing.

In the mid-twentieth century, congressmen still had trouble imagining Hawaiians as American citizens and disliked the notion of giving citizenship to a population "so preponderantly Oriental."[108] The ongoing labor strikes in Hawai'i throughout the 1950s also triggered fears about a Communist influence pervading Hawai'i.[109] The president of the Hawaiian Pineapple Company assured worried senators that "these Islands have taken quick and decisive steps every time any suggestion of communism has arisen. Our record is clear—and emphatically—American."[110] That the president of the Hawaiian Pineapple Company fielded congressional concerns signals once again how closely the pineapple industry was attached to US ambitions in the region. Furthermore, a number of southern congressmen feared that the incorporation of Hawai'i and election of Hawaiian congressmen would shift the balance of power to Democrats in the American government and lead to the passing of civil rights legislation.[111] Debates about Hawaiian statehood took place around the same time as the civil rights movement, inspiring strong opinions about how power and citizenship should be distributed. A contingent of southern congressmen stalled the statehood proposition for several years, but the commercial benefits of incorporating Hawai'i were too enticing to be curbed, and legislation for Hawaiian statehood passed through Congress in 1959.

As in the earlier annexation period, pineapple imagery played an important role in empire building by lobbying for Hawaiian statehood and mitigating anxieties about incorporating Hawai'i's diverse population. In addition to the Dole Hawaiian Pineapple Company, the Hawai'i Statehood Commission used pictures of pineapple toward this goal, working between 1947 and 1959 to lobby congress and conduct national advertising campaigns that "actively support and press the movement for statehood."[112] No publicity campaign was too elaborate for the commission, which sent two hundred fresh pineapples individually wrapped in cellophane bags to Washington, DC, for congressmen to enjoy in the Capitol Building's Senate Dining Room.[113] Around the same time period, the Statehood Commission also sent Hawai'i's "Pineapple Queen," Doris Berg, to march in President Truman's inaugural parade.[114] Under the

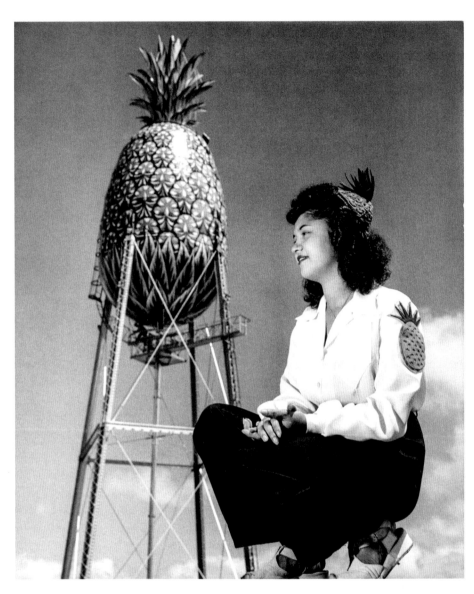

FIGURE 60

Hawai'i State Archives, Photograph Collection, PP-85-4-011-S. Pineapple—Canneries, Hawaiian Pine Co. Pineapple Guide, Statehood Commission photo—Rec'd July 1959. Photograph by Photo Hawaii (408 Castle and Cooke Bldg., Honolulu, HI USA).

Hawai'i Statehood Commission, the Hawaiian pineapple had a unique presence in Washington, DC, where legislation about Hawaiian statehood was debated in the Capitol throughout the 1950s.

In collaboration with the Hawaiian Pineapple Company, the Statehood Commission distributed hundreds of photographs showcasing the pineapple industry in magazines,

newspapers, and postcards. One photo displayed a woman wearing a hair clip in the shape of a pineapple crown and a pineapple patch sewn to her left sleeve, proudly wearing the fruit like a badge of honor (fig. 60).[115] In the distance stands what was once Dole's famous landmark in Honolulu: the pineapple-shaped water tank that once distributed thousands of gallons of water to nearby pineapple fields and canneries. The woman kneels before the water tower, displaying reverence to the pineapple company's presence in Hawai'i. Such images proclaimed Hawaiians ready for statehood as citizens of the Dole nation—a company that over and over again displayed its allegiance to the United States. Decades after the portraits of merchants in a pineapple field (see fig. 53), this photograph of a Hawaiian woman posing in front of another indigenous resource colonized by the United States—water—continued to celebrate the US conquest of Hawai'i's landscape.[116] Photos from the Hawaiian Statehood Commission declared once and for all that Hawai'i was Dole, and by extension, American, territory.

While Hawaiians enjoyed a boost in American investment and new membership in the Union by 1959, in the central United States, African American citizens were still barred from some of the most basic civil rights. Indeed, Hawaiian incorporation occurred alongside the nation's battles over African American equality in the 1950s, when the nation wrestled with explosive debates over segregation, bus boycotts, and Emmet Till, a young boy who was murdered for addressing a white woman in a store. The United States was mired in racist policies and attitudes, but promoters of Hawai'i praised pineapple companies for their racial inclusivity, reviving the same narratives from advertisements of thirty years earlier that saluted the "different races working side by side on a packing table."[117] Ben Adams's promotional book, *Hawai'i: The Aloha State; Our Island Democracy in Text and Pictures*, specifically championed race relations in the pineapple industry, writing in 1959:

> Hawai'i is a human laboratory where old myths and prejudices are constantly being broken down. Who says that East and West can't meet? They do all the time in Hawai'i. Hawai'i's multiracial, multicolored people have demonstrated the ability to get along as civilized human beings. They have had their tugs and pulls, their frictions and resentments. But they live together. They work together. They vote for each other. They mix socially. They intermarry. They respect each other's customs and traditions and religions.[118]

Adams praised Hawai'i for its inclusivity, upholding it as a model of island democracy that "does not have a 'for-whites-only' sign around it."[119] In truth, African Americans were treated just as terribly in Hawai'i and battled segregation and discrimination in the region.[120] Yet, perpetuating fictions of Hawai'i as a racial nirvana was a tool used to elevate the Hawaiian pineapple industry and manage anxieties about whether or not to incorporate Hawaiians as citizens into the American empire. Advertisements and literature distinguishing Hawaiian race relations from those in the central United States portrayed Hawai'i as a paradigm of racial harmony that was simply inaccurate.

CONCLUSION

For many Hawaiians, the portrayal of Hawai'i as a multiracial paradise was not their experience. Only a few years earlier, Honolulu was a site for more than fifteen concentration camps that imprisoned hundreds of Japanese immigrants. The subjugation of immigrant pineapple workers by an elite class of white company owners also contradicted the image of Hawai'i as a model of racial harmony. Clear examples of racial conflict in Hawai'i also date earlier to the violent years of annexation, when American settlers overthrew Hawaiian royalty, stole indigenous land, and prohibited indigenous people from speaking their languages and practicing their ceremonies. Missionaries and businessmen had pleaded for white Americans to migrate to Hawai'i and replace the Islands' native values with "sturdy" American values. By the mid-twentieth century, both white and Asian settlers continued to displace indigenous Hawaiians. All in all, Hawai'i was not the happy meeting ground of people and races that promotional materials about the pineapple portrayed. Scholars identify the historical erasure of racial oppression and settler colonialism as "cultural amnesia," which is designed to cloud the unsettling histories of nation formation.[121] Imperialism, in this way, is doubly perpetrated through the physical violence of colonization and institutionalized acts of forgetting.[122] Fantasies that buried colonial violence in favor of stories celebrating Hawai'i's racial plurality presented an optimistic and unrealistic model of race relations in the 1920s and 1950s, during specific cultural moments when the country was fiercely debating xenophobic laws over immigration, racial segregation, and citizenship. At times when the United States was steeped in debates over racial inequality, pictures of Hawaiian pineapples offered Americans a fantasy of a tropical escape and a racial paradise.

The Hawaiian fantasies attached to Dole pineapple have been so forceful and enduring that many readers might be surprised to learn that Dole's main source of pineapples are no longer produced in Hawai'i. Dole and other companies sold their land to the Hawaiian tourist industry in the 1970s, leaving the region for cheaper land and lower wages in areas like Singapore and Thailand. As a result, pineapple acreage dropped in Hawai'i from 73,000 in 1959 to 33,000 in 1989.[123] The industry also shifted from exporting canned pineapple to shipping fresh fruit, which turned pineapple canneries into artifacts of plantation life. To convey the pineapple's historical importance, the Dole Company has preserved an original fruit stand from the 1950s in Honolulu and transformed it into a tourist site for visitors to learn about the island's history—a history that perpetuates the narrative of US benevolent rule in Hawai'i. Visitors can tour the pineapple canneries on a child-friendly caboose, learn about the origin story of James Dole from labeled signposts, and taste Dole pineapple whip.[124] As it has done so many times in the past, the Dole Company has rebranded its product—now as an American heritage site. Like the company's print advertisements and world's fair exhibits that came before, the Dole Plantation is one more device in a long legacy of

visual and political maneuvers to incorporate Hawai'i and its commodities into the broader American empire. Images of the Hawaiian pineapple supported national expansion similar to images of grapes, oranges, and other fruits, reinforcing how the symbolic fruits of American empire were accomplished by cultivating the literal fruits of new frontiers.

CONCLUSION

New Directions in Scholarship on Food in American Art

IN THE SPRING OF 2000, more than a dozen protestors marched
233 miles from Fort Myers, Florida, to Orlando, carrying a
13-foot-tall replica of the Statue of Liberty (fig. 61). In place of
the statue's iconic torch and tablet, the replica hoisted a tomato in
one hand and a bucket of tomatoes in the other. The artist Kat
Rodriguez, who created this statue, also darkened the figure's skin
and placed her on a platform with the inscription "I, too, am
American." Rodriguez created *Lady Liberty* for the Coalition of
Immokalee Workers (CIW), protesting the unfair wages of tomato
farmers in Immokalee, Florida. Farmworkers in Florida contribute
significantly to the national tomato business by producing almost
half of the nation's $1.3 billion annual crop, yet they struggle with
mistreatment, poor pay, and backbreaking working conditions.[1]
Women of color on tomato farms, in particular, have been victims
of abuse. The march in 2000 was designed to confront major food
corporations in Orlando and demand improvements. At the sym-
bolic center of this protest was Rodriguez's sculpture, which has
since been acquired by the Smithsonian's National Museum of

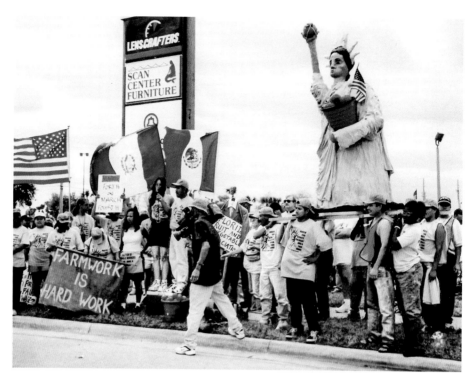

FIGURE 61

Kat Rodriguez, *Lady Liberty*, 2000. Statue is mixed media, 13 ft., and in the collection of the Smithsonian National Museum of American History. Photo courtesy of the artist.

American History in Washington, DC, and displayed in their exhibition *Many Voices, One Nation*. Like the tomato workers who carried her forward, *Lady Liberty* continued a long tradition in American history of artists and activists using representations of food to stimulate public discourse and comment on social inequalities.[2]

In addition to artists who explore how food systems have depended on the subjugation of immigrants and people of color, institutions and scholars, too, are recognizing the importance of critically studying food histories and recovering the stories of farmworkers and communities that have been written out of scholarship. The Smithsonian's National Museum of American History, for one, has embarked on a new initiative to collect artifacts honoring the role of Mexican and Mexican American grape laborers in California's wine industry.[3] Similarly, in Sonoma, California, a memorial was proposed in 2017 to commemorate the Chinese grape workers who contributed greatly to California wine country but have been historically excluded from regional narratives.[4] Culinary activists like Michael Twitty have performed another kind of intervention: Twitty has created plantation tours and cooking demonstrations to educate people on how African American cooks and farmers have influenced southern foodways but have rarely been given credit for it.[5] Histories of African, Asian, Native, and Central

American people in America's food systems have long been overlooked or obscured in the United States, but today a number of artists, institutions, and activists are trying to correct these omissions with redemptive measures inside and outside the arts. This book is part of the effort to correct such major oversights and to illuminate how the edible is political in American art and culture.

Representations of food in the United States are particularly useful for recovering the histories of marginalized people because they demand an examination of the marginalized places where food was produced—places that typically fall outside the northeastern-focused art historical canon. Scholars analyzing representations of hogs and game, for instance, likely would need to analyze advertisements and photographs in the context of Chicago, the biggest producer of meat in nineteenth-century American stockyards. Scholars of seafood imagery would benefit from studying the Chesapeake Bay, a leading producer of oysters and other shellfish favored in the works of many American artists.[6] Some of the most promising yet neglected investigations of food in American art are about food production located in southern cities, including Mobile, Alabama, and New Orleans, Louisiana—the sites of a robust, international food trade due to their relative proximity to the Caribbean and Latin America. Scholars would also benefit from a more rigorous analysis of food imagery at indigenous sites, and how Native American traditions both clashed and converged with non-Native foodways in visual representations of corn and buffalo, for example. Examinations of food, furthermore, should accompany the equally neglected analyses of drink in all areas of the country, where the subject of alcohol inspired artists to comment on both sides of the "temperance question" and prohibition debate.[7] An investigation of food and drink in art, therefore, offers an opportunity to study people and places that have been overlooked in mainstream history.

But one does not need to look far into the past to locate artworks that shed light on the politics of food; a number of contemporary artists are engaging with food in order to explore communities that have been marginalized or enslaved. Kara Walker's 2014 sculpture of *The Sugar Sphinx* in Brooklyn's Domino Sugar Factory and Titus Kaphar's 2016 bust of George Washington filled with rum and molasses are powerful examples of this trend.[8] Artists in contemporary times have also used food to comment on the discourses of ecological farming and environmental sustainability by genetically engineering food and plants in the art gallery space.[9] The lines between museums and farms, and paints and soil, are blurry, showing a need to analyze these objects together. New scholarship exploring the senses in American art also promises to generate new knowledge about food in art, with scholars such as Jenni Lauwrens and Leo Mazow advocating for a "sensory turn" in art history and the examination of taste, sound, and olfactory senses in the field that has to date prioritized vision.[10] Lastly, a deeper study of women artists is crucial to advancing scholarship on art and food since food was one of the few subjects historically available for women to depict. Like nineteenth-century women artists such as Hannah Brown Skeele, who gained acclaim and

visibility for her depictions of fruit and sugar, a century later feminist artists like Martha Rosler and Judy Chicago continued to use representations of food in the kitchen and on the dinner table to honor or challenge women's traditional roles in the home.[11] These threads of research offer new directions in scholarship that will enrich our understanding of the relationship among art, food, and society in the United States.

Food is a natural gathering point for so many conversations about social hierarchies because its representation and cultivation activate dialogues about those who grow, harvest, and consume it. Indeed, food is often a contested process that both shapes and reflects the political direction of the country and reveals the fundamental inequalities wrought by its labor, distribution, and depiction. Because food is a cultural linchpin that touches everyone, whether they have ample or little access to it, food is a crucial lens through which to study history and culture. The centrality of food to any society explains why several texts in recent years have focused on this subject. In just three years—between 2015 and 2018—academic books have been published on the apple, Georgia peach, pork, foie gras, chocolate, salmon, falafel, maple sugar, and cocoa.[12] These texts demonstrate how various foods warrant their own cultural biographies. *The Fruits of Empire* enhances this canon of literature by showing how the visual culture of fruit offers an especially valuable perspective on American society, particularly expansionism, and a glimpse at the people and fruit-growing frontiers that Americans were trying (or trying not) to incorporate. As this study demonstrates, representations of fruit were not mere dining room dressing but were thoughtfully crafted and strategically employed to advance or challenge American empire-building.

This book analyzes images of grapes, oranges, watermelons, bananas, and pineapples as political tools, but stories about national politics also could be told about many other foods. The vineyards, orange groves, and watermelon patches are also key sites for national construction and expansion, so what might scholars find if they turn their attention to images of strawberry fields, coffee groves, or, as the sculpture *Lady Liberty* encourages, tomato farms? While this book focuses on five fruits, it is also intended to point scholars toward other explorations of food, race, and empire. An investigation into indigenous, subaltern, and marginalized perspectives on food in art is particularly necessary and urgent. It is easy to locate images that endorse the conquest of food and people; it is much harder and more meaningful to find historic images that express resistance to America's appetite for conquest. I hope that this book will inspire readers to probe all representations of food more deeply and use them to metabolize questions about where food comes from, who produces it, why it matters, and how visual images obviate or hide the answers to these very questions.

NOTES

ACKNOWLEDGMENTS

1. Simon Schama, *The Embarrassment of Riches: An Interpretation of Dutch Culture in the Golden Age* (New York: Vintage Press, 1997).

INTRODUCTION

1. Commissioner W. T. Coleman, "The Pure American Wines: A Plea for the Use of the Native-Grown Article," *Washington Post*, May 19, 1886, in the "Henry Leslie Lyman Scrapbook," Doc. 1165 v. 1 (1853–93), in the collection of the Winterthur Library, Delaware.

2. Prior to the Civil War, raw fruit was thought by many to be unsavory, difficult to digest, and in some instances, poisonous. Many imported fruits, on the contrary, were treated as luxury objects, accessible only to the elite who could afford it. Fruits, in general, were not considered mainstay foods as a result of their difficulty to grow and preserve over long periods of time. These attitudes changed alongside the growing accessibility of fruit mainly due to advancements in transportation technology. On early attitudes toward raw fruit, see Kathryn Grover, *Dining in America, 1850–1900* (Amherst: University of Massachusetts Press, 1987), 94; Trudy Eden, *The Early American Table: Food and Society in the New World* (DeKalb: Northern Illinois University Press, 2008), 28; Keith Stavely and Kathleen Fitzgerald, *America's Founding Food: The Story of New England Cooking* (Chapel Hill: University of North Carolina Press, 2004), 207. For a short discussion on fruits as imported

indulgences, see Brandon K. Ruud's essay, "Truth to Nature: Still Life, Exoticism, and Gender," in *Poetical Fire: Three Centuries of Still Lifes* (Lincoln: University of Nebraska Press and the Sheldon Museum of Art, 2011), 22, and Susan Williams, *Savory Suppers and Fashionable Feasts: Dining in Victorian America* (Knoxville: University of Tennessee Press, 1996), 82, 85.

3. William H. Gerdts, *Painters of the Humble Truth: Masterpieces of American Still Life, 1801–1939* (Columbia: University of Missouri Press, 1981), 28.

4. Waverly Root and Richard de Rochemont, *Eating in America: A History* (Hopewell, NJ: Ecco Press, 1995), 102.

5. Eden, *Early American Table*, 243; Nancy Siegel, "Cooking Up American Politics," *Gastronomica* 8, no. 3 (2008): 59. See also Lauren Klein, "Dinner-Table Bargains: Thomas Jefferson, James Madison, and the Senses of Taste," *Early American Literature* 49, no. 2 (Spring 2014): 403–43.

6. The Liberty Bell made from oranges even included an indentation for the bell's crack. This was seen in the Horticultural Building at the 1893 Columbian Exposition in Chicago. For more information, see David Boulé's *The Orange and the Dream of California* (Los Angeles: Future Studios, 2013), 75. For the chocolate sculpture of Christopher Columbus, see Michelle Moon, *Interpreting Food at Museums and Historic Sites* (Lanham, MD: Rowman and Littlefield, 2015), 111.

7. Milon Ellsworth, *The Successful Housekeeper: A Manual Especially Adapted to American Housewives* (Harrisburg: Pennsylvania Publishing, 1884), vi.

8. James W. Parkinson, *American Dishes at the Centennial* (Philadelphia: King and Baird, 1874). The full quote reads: "Florida, and California produce admirable specimens of such tropical fruits as oranges, lemons, limes, and figs. Apricots and nectarines grow to a high state of perfection in California. . . . The olive, the citron, and the pomegranate, have lately been transplanted in California, and promise in the near future to equal the best. . . . In pears and peaches, cherries and plums, we equal the best; Also in currants, raspberries and strawberries, persimmons, pawpaws, and cranberries, are exclusively American fruits . . . with the apple, no other country equal . . . or approaches us . . . 'greenings' and 'pippins' from America, are accounted among the most highly-prized dainties at the feasts of kings, queens, and emperors in Europe."

9. Parkinson, *American Dishes at the Centennial*.

10. Lawrence Glickman, *Buying Power: A History of Consumer Activism in America* (Chicago: University of Chicago Press, 2012), 103.

11. Nicholas Hardeman, *Shucks, Shocks, and Hominy Blocks: Corn as a Way of Life in Pioneer America* (Baton Rouge: Louisiana State University Press, 1981), 113; Laura Schenone, *1,000 Years over a Hot Stove: A History of American Women Told through Food, Recipes, and Remembrances* (New York: W. W. Norton, 2004), 34; Eden, *Early American Table*, 77.

12. For more information on the use of food to regulate Native American people, see Schenone, *1,000 Years over a Hot Stove*, 34, 39.

13. Hester Poole, *Fruits and How to Use Them: A Practical Manual for Housekeepers* (Chicago: Woman's Temperance Publishing Association, 1892), 17.

14. For a cultural history of Johnny Appleseed, see Robert Price, *Johnny Appleseed: Man and Myth* (Bloomington: Indiana University Press, 1954), and Michael Pollan, *The Botany of Desire: A Plant's-Eye View of the World* (New York: Random House, 2001), 3–9, 16–19.

15. The description of Israel as a promised land flowing with milk and honey appears in the book of Exodus. For references to this quote in agricultural journals, see Shana Klein, "Cultivating Fruit and Equality in the Still-Life Paintings of Robert Duncanson," *American Art* 29, no. 2 (Summer 2015): 68, 81.

16. Edward Mansfield, *Address Delivered before the Horticultural Society* (Cincinnati: Wright, Ferris, October 4, 1850), 7–8. Cincinnati Museum Center, Pamphlets Collection, Reference Number 635 M287.

17. Eric T. Love, *Race over Empire: Racism and U.S. Imperialism, 1865–1900* (Chapel Hill: University of North Carolina Press, 2004), 3.

18. Love, *Race over Empire,* 3.

19. Roland Barthes, *Empire of Signs,* trans. Richard Howard (New York: Hill and Wang, 1982); Pierre Bourdieu, *Distinction: A Social Critique of the Judgment of Taste,* trans. Richard Nice (Cambridge, MA: Harvard University Press, 1984); Mary Douglas, "Deciphering a Meal," *Myth, Symbol, and Culture* 101, no. 1 (1972): 61–83; Claude Lévi-Strauss, *Mythologiques: The Raw and the Cooked* (New York: Harper and Row, 1969).

20. See Barthes, *Empire of Signs,* 15–18.

21. Douglas, "Deciphering a Meal," 100.

22. Sydney Mintz, *Sweetness and Power: The Place of Sugar in Modern History* (New York: Penguin, 1986); Gary Okihiro, *Pineapple Culture: A History of the Tropical and Temperate Zones* (Berkeley: University of California Press, 2009); E. Melanie DuPuis, *Dangerous Digestion: The Politics of American Dietary Advice* (Berkeley: University of California Press, 2015); Kyla Tompkins, *Racial Indigestion: Eating Bodies in the Nineteenth Century* (New York: New York University Press, 2012); and Psyche Williams-Forson, *Building Houses Out of Chicken Legs: Black Women, Food, and Power* (Chapel Hill: University of North Carolina Press, 2006).

23. See Frieda Knobloch, *Culture of Wilderness: Agriculture as Colonization in the American West* (Chapel Hill: University of North Carolina Press, 1996); Philip J. Pauly, *Fruits and Plains: The Horticultural Transformation of America* (Cambridge, MA: Harvard University Press, 2008); and Steven Stoll, *The Fruits of Natural Advantage: Making the Industrial Countryside in California* (Berkeley: University of California Press, 1998).

24. Kenneth Ames, *Death in the Dining Room and Other Tales of Victorian Culture* (Philadelphia: Temple University Press, 1992); T.H. Breen, *The Marketplace of Revolution: How Consumer Politics Shaped American Independence* (Oxford: Oxford University Press, 2004), and Jules David Prown, "Mind in Matter: An Introduction to Material Culture Theory and Method," *Winterthur* 17, no. 1 (Spring 1982): 1–19.

25. Arjun Appadurai, ed., *The Social Life of Things: Commodities in Cultural Perspective,* Cambridge Studies in Social and Cultural Anthropology (Cambridge: Cambridge University Press, 1988).

26. "The Exhibition of Pictures at the Athenaeum Gallery," *North American Review* 33 (October 1831).

27. L. Donaldson and A.J.H. Way, "Fruit-Painting in Oils," *Art Amateur* 16, no. 1 (December 1886): 10.

28. Bryson writes, "narrative is banished" in still life painting. *Looking at the Overlooked: Four Essays on Still Life Painting* (Cambridge, MA: Harvard University Press, 1990), 61.

29. Gerdts, *Painters of the Humble Truth;* Wolfgang Born, *Still-Life Painting in America* (New York: Oxford University Press, 1947); Bryson, *Looking at the Overlooked;* and Charles Sterling, *Still Life Painting from Antiquity to the Twentieth Century* (New York: Harper and Row, 1981). See also Alfred V. Frankenstein, *After the Hunt: William Harnett and Other American Still Life Painters, 1870–1900* (Berkeley: University of California Press, 1953).

30. Gerdts has written prolifically on still life studies, but the following two texts are particularly enlightening on the topic: Gerdts, *Painters of the Humble Truth;* "The Influence of Ruskin and Pre-Raphaelitism on American Still-Life Painting," *American Art Journal* 1, no. 2 (Autumn 1969): 80–97. Gerdts and Russell Burke, *American Still Life Painting* (New York: First Edition, 1971).

31. Alexander Nemerov, *The Body of Raphaelle Peale: Still Life and Selfhood: 1812–1824* (Berkeley: University of California Press, 2001), and Nancy Siegel, "Cooking Up American Politics," *Gastronomica* 8 no. 3 (Summer 2008): 53–61. See also the following articles on American still life representation: Lori E. Rotskoff, "Decorating the Dining-Room: Still-Life Chromolithographs

and Domestic Ideology in Nineteenth-Century America," *Journal of American Studies* 31, no. 1 (1997): 19–42; Annie V. F. Storr, "Raphaelle Peale's Strawberries, Nuts, &c.: A Riddle of Enlightened Science," *Art Institute of Chicago Museum Studies* 21, no. 1 (1995): 24–34, 73–74.

32. Judith Barter, *Art and Appetite: American Painting, Culture, and Cuisine* (New Haven, CT: Yale University Press, 2013), 34.

33. Krista A. Thompson, *An Eye for the Tropics: Tourism, Photography, and Framing the Caribbean Picturesque* (Durham, NC: Duke University Press, 2006).

34. See Svetlana Alpers, *The Art of Describing: Dutch Still Life in the Seventeenth Century* (Chicago: University of Chicago Press, 1983); Julius Held and Donald Posner, *Seventeenth and Eighteenth Century Art: Baroque Painting, Sculpture, and Architecture* (New York: Harry N. Abrams, 1971); and Simon Schama, *The Embarrassment of Riches: An Interpretation of Dutch Culture in the Golden Age* (New York: Vintage Press, 1997).

35. Julie Berger Hochstrasser, *Still Life and Trade in the Dutch Golden Age* (New Haven, CT: Yale University Press, 2007).

36. Hochstrasser, *Still Life and Trade*, 227.

37. DuPuis, *Dangerous Digestion*, 8, 87.

38. Jeffrey Pilcher, *¡Que vivan los tamales! Food and the Making of Mexican Identity* (Albuquerque: University of New Mexico Press, 1998), 159.

39. Tompkins, *Racial Indigestion*, 3, 7.

40. "Beany" and "brownie" are derogatory terms used to describe people of Mexican descent; "kraut" was a term used after World War II to describe people of German ancestry; and "crackers" have pejoratively described white Americans in the lower classes. Coconut, apple, platano, cheesehead, and oreo are other foods that have been appropriated for derogatory terms.

41. Hochstrasser, *Still Life and Trade*, 8.

42. Andrew John Henry Way, "Fruit-Painting in Oils—Small Fruit, Cherries, Apricots, Wild Fruits," *Art Amateur* 16, no. 5 (April 1887): 104.

43. Andrew John Henry Way, "Fruit-Painting in Oils—Treatment of Pineapples, Oranges, Lemons, Bananas, and Apples," *Art Amateur* 16, no. 2 (January 1887): 32.

44. The most complete history of the apple in American art is Bruce Weber's *The Apple of America: The Apple in Nineteenth-Century American Art* (New York: Berry-Hill Galleries, 1993).

45. Other notable exhibitions include *Poetical Fire: Three Centuries of Still Life* at the Sheldon Art Museum (2011); *Feast: Radical Hospitality in Contemporary Art* at the Smart Museum (2012); *Food: Contemporary Photography and the Way We Eat* at the Houston Center for Photography (2013); *Around the Table: Food, Creativity, Community* at the San Jose Museum of Art (2013); and the Shelburne Museum's *Sweet Tooth: The Art of Dessert* (2017).

CHAPTER 1. WESTWARD THE STAR OF EMPIRE

1. George Husmann, "The New Era in Grape Culture—No. II," *Horticulturist, and Journal of Rural Art and Rural Taste* 2, no. 227 (May 1865): 143.

2. Erica Hannickel, for one, writes that grape growers "proved excellent translators and cheerleaders of national expansion." *Empire of Vines: Wine Culture in America* (Philadelphia: University of Pennsylvania Press, 2013), 28. Other seminal sources on the history of California grapes include Julius L. Jacobs, *Pioneer Wine Families in California* (San Francisco: California Historical Society, 1975); Thomas Pinney, *A History of Wine in America: From the Beginning to Prohibition* (Berkeley: University of California Press, 1989); and Richard Steven Street, *Beasts of the Field: A Narrative History of California Farmworkers, 1769–1913* (Stanford, CA: Stanford University Press, 2004).

3. "Greeley Prize on Grapes," *Horticulturist and Journal of Rural Art and Rural Taste* 21 (1866): 341.

4. Farmers in the South were particularly threatened by competition in the West. For one example, read: "The New South Versus the New West: A New Field for Home Seekers; Extracts from the Speeches of a Few Public Men and Newspapers upon This Subject," in the Henry Leslie Lymon Scrapbook at the Winterthur Museum and Library, Delaware. Missouri vintner George Hus-mann also wrote in his journal, *Grape Culturist,* "Our soil on an average will compare favorably with that of the great Northwest. We can raise a greater variety of fruits and vegetables, whilst our climate is so mild we seldom have snow" (January 1869): 294.

5. Husmann, in *Grape Culturist,* 294.

6. Husmann, in *Grape Culturist,* 294. The jurors of the competition from the Horticultural Association of the American Institute also felt that the premium should have gone to grapes of "a more refined character." *Gardeners Monthly and Horticultural Advertisement* 11 (1869): 120.

7. The black Hamburg grapevine at Hampton Court Palace in Oxfordshire, England, was planted in 1769 by landscape architect Lancelot Brown for King George III and Queen Charlotte at their royal court. It won several prizes at world's fairs. For more information on it, see Andrew Samuel Fuller, *The Grape Culturist: A Treatise on the Cultivation of the Native Grape* (New York: Davies and Kent, 1864), 230.

8. Michael Sarver, *The History and Legend of the Mammoth Grapevine* (Canton: McGregor and Son, 1876), 16–17.

9. Sarver experienced several financial hardships in the process of maintaining and exhibiting the mammoth vine. According to David Myrick, he was exhausted from the venture and died a year after its exhibition. David F. Myrick, *Montecito and Santa Barbara,* vol. 1, *From Farms to Estates* (Glendale, CA: Trans-Anglo Books, 1989), 28.

10. Sarver, *History and Legend of the Mammoth Grapevine,* 7.

11. New York was the epicenter of grape culture, and horticulture more generally, between 1835 and 1865. By the 1860s, Cincinnati emerged as the leading center for grape growing in the West due to the grape experiments of America's richest man, Nicholas Longworth, "father of American wine."

12. "Honors to the Mammoth Grape-Vine," *Pacific Rural Press* 10, no. 10 (September 4, 1875): 153.

13. James W. Parkinson, *American Dishes at the Centennial* (Philadelphia: King and Baird, 1874), 16.

14. Phoebe Kropp explains how some people identified as Californio, Indian (indigenous people), Mexicano (Mexican ancestry), and Spanish (Spanish-speaking, Anglo-European ancestors). Spanish identification was used to distinguish a person attached to European identity from "Mexicano." Katherine Manthorne's seminal book on California Mexicana also discusses the complex racial identifications in California, explaining how this region in the 1860s had the largest population of Chinese people as well. Consult Phoebe S. Kropp, *California Vieja: Culture and Memory in a Modern American Place* (Berkeley: University of California Press, 2006), 10; Katherine Manthorne, *California Mexicana: Missions to Murals, 1820–1930* (Berkeley: University of California Press, 2017), 29, 41, 49–50, 84.

15. Sarver, *History and Legend of the Mammoth Grapevine,* 8. There are many iterations of this tale that vary in the names, dates, and plot of the grapevine's narrative. All incarnations of the story, however, revolve around a tortured romance between a man and woman of two different social classes.

16. Sarver, *History and Legend of the Mammoth Grapevine,* 8.

17. "Legend of the Montecito Grape-Vine," *Overland Monthly and Out West* 9 (1872): 519.

18. Frieda Knobloch, *The Culture of Wilderness: Agriculture as Colonization in the American West* (Chapel Hill: University of North Carolina Press, 1996), 3.

19. Michael K. Komanecky, "Spanish Missions in the American Imagination," in *The Arts of the Missions of Northern New Spain, 1600–1821* (Mexico City: Antiguo Colegio de San Ildefonso, 2009), 190.

20. Hyatt, quoted in Sarver, *History and Legend of the Mammoth Grapevine,* 12.

21. Jacobs, *Pioneer Wine Families in California,* 140.

22. Hyatt also complained that "the soil was entirely neglected and trampled upon by crowds of people, till the earth underneath and around it became as solid as the road . . . it was never cultivated nor loosened in any way." Hyatt, quoted by Sarver, *History and Legend of the Mammoth Grapevine,* 14–15. Another writer complained that Spanish owners of the mission grapevine were doing a disservice to the vine by constructing a dance hall over its roots. The article pleads with citizens "who understand the Spanish language" to "make this matter plain to those who claim the ownership or are in charge of 'the great vine.'" *Sacramento Daily Union,* April 8, 1874.

23. Renowned author Helen Hunt Jackson, for one, discussed "the lack of character" of Mexican and Spanish farmers in the article "Outdoor Industries in Southern California," *Century Illustrated Magazine,* October 1883, 803.

24. The full quote reads, "A whole new country, falling from the hands of an inert race into the possession of a new and energetic people, has been transformed; the results of energy are here pointed out in most energetic language, and in a spirit that has already swept the lazy Spaniard from the soil." "The Way They Talk in California," *Horticulturist* 12 (July 1857): 314–16, cited in Hannickel's *Empire of Vines,* 155.

25. These entrepreneurs were Arpad Haraszthy, J. Gundlach and Company, C. Carpy and Company, and the Napa Valley Wine Company.

26. Exports of American wine in 1882 were listed in the booklet as 1,718,000 and increased to 4,712,000 in 1892. Other statistics in the brochure show that American wine exports profoundly exceeded the sales of brandy exports between 1882 and 1892. See *California Big Tree Joint Wine Exhibit: C. Carpy and Co., J. Gundlach and Co., Arpad Haraszthy and Co., Napa Valley Wine Co.,* San Francisco, World's Columbian Exposition, Chicago, 1893, in the Jay T. Last Collection, Binder 13, at the Huntington Library, San Marino, California.

27. Frederick Jackson Turner, *The Significance of the Frontier in American History, Annual Report of the American Historical Association* (Washington, DC: Government Printing Office, 1893), 197–227.

28. *California Big Tree Joint Wine Exhibit: C. Carpy and Co., J. Gundlach and Co., Arpad Haraszthy and Co., Napa Valley Wine Co.,* San Francisco, World's Columbian Exposition, Chicago, 1893.

29. Judith Barter, *Art and Appetite: American Painting, Culture, and Cuisine* (New Haven, CT: Yale University Press, 2013), 122.

30. Betty A. O'Brien, "The Lord's Supper: Fruit of the Vine or Cup of Devils?" *Methodist History* 31, no. 4 (July 1993): 203–23.

31. Years later at the California Panama-Pacific International Exposition of 1915, there was an entire section devoted to Welch's products in the "Welch's Grape Juice Pavilion." See the Arthur Brown Jr. Papers at the Bancroft Library at the University of California, Berkeley.

32. William Saunders, *Both Sides of the Grape Question* (Philadelphia: J. P. Lippincott, 1860), 72.

33. See Robin Veder's "Mother-Love for Plant-Children: Sentimental Pastoralism and Nineteenth-Century Parlour Gardening," *Australasian Journal of American Studies* 26 (2007): 27.

34. William Chorlton, *Grape Grower's Guide: A Handbook of the Cultivation of the Exotic Grape* (New York: Orange Judd, 1894), 17.

35. Millard, a watercolorist from New York, was asked to paint representations of California grapes for this book sponsored by the California State Vinicultural Association. Arpad Haraszthy was likely one of the text's authors. *Harper's Weekly* also referenced other women participants in California viticulture. Read *Grape and Grape Vines of California* (San Francisco: California State Vinicultural Association, 1877), including a "Mrs. Marfield" and "Mrs. Flood" for owning their own vineyards in Sonoma, California.

36. Borglum was a student of artist William Keith. The following article describes Borglum as "well known for her splendid grape paintings": Kathryn Rucker, "Art Review," *Los Angeles Herald*, February 21, 1909, 9.

37. Edward Roberts, "California Wine-Making," *Harper's Weekly*, March 9, 1889, 197.

38. John Phin, *Open Air Grape Culture: A Practical Treatise on the Garden and Vineyard Culture of the Vine* (New York: Woodward, 1876), 27.

39. Brookes was born in Newington Green, Middlesex, England, on March 8, 1816. He moved to California in the early 1860s after working in Chicago and Milwaukee. In England, Brookes's father was an expert in fruit raising and the owner of a nursery in London. His uncle was a naturalist and a descendent of a bird trainer, according to Lucy Agar Marshall's accounts in the *California Historical Society Quarterly* 36 (September 1957): 193–203, in the Baird Collection at the University of California, Davis.

40. Birgitta Hjalmarson, *Artful Players: Artistic Life in Early San Francisco* (Los Angeles: Balcony Press, 1999), 30.

41. Deakin was born in Sheffield, England, in 1838 and immigrated to the United States in 1856, living in Chicago where his family managed a hardware store. Although he did not have much artistic training, in 1869, he opened a portrait studio in Chicago. He eventually moved to San Francisco in 1870 and transitioned from portraiture to landscape studies in a shared studio with Brookes. It was his pictures of fish and grapes, however, that garnered him acclaim. For more context on Deakin's artwork, read Scott Shields, *Edwin Deakin: California Painter of the Picturesque* (Petaluma, CA: Pomegranate, 2008); Anthony Lee, *Picturing Chinatown: Art and Orientalism in San Francisco* (Berkeley: University of California Press, 2001); Samantha Burton, "'For the California of Today': Visual History and the Picturesque Landscape in Edwin Deakin's Missions of California Series," *Nineteenth Century Art Worldwide* 18, no. 2 (Spring 2019): 52–74; and the Robert Deakin Papers at the Smithsonian Archives of American Art.

42. Arpad Haraszthy was the son of a Hungarian nobleman. He immigrated to the United States and introduced the Zinfandel grape from his homeland. He was a significant advocate for grape culture in California. He, along with Brookes and Deakin, belonged to the Bohemian Club, founded in 1872 to nurture the artistic ambitions of local painters, poets, and writers. In only two years, the club achieved local notoriety and bonded the area's painters, writers, and vintners. For more on Haraszthy's impact, read Philip J. Pauly, *Fruits and Plains: The Horticultural Transformation of America* (Cambridge, MA: Harvard University Press, 2008), 173.

43. Governor John G. Downey anointed Haraszthy as a "special agricultural commissioner" to visit Europe and learn about viticulture. William H. Seward supported Haraszthy's trip to Europe but failed to deliver on his promise. Jacobs, *Pioneer Wine Families in California*, 146; Agoston Haraszthy, *Grape Culture, Wines, and Wine-Making: With Notes upon Agriculture and Horti-Culture* (New York: Harper and Bros. 1862), xv.

44. Undated newspaper clipping, California Historical Society Library, cited in Janice Driesbach's *Bountiful Harvest: Nineteenth-Century California Still Life Painting* (Sacramento: Crocker Art Museum, 1991), 33.

45. As recorded in Pliny the Elder's *Natural History*, the author described a competition wherein Zeuxis painted a portrait of grapes so true to nature that it caused birds to peck at the fruit on the canvas. Parrhasius, in turn, painted such a realistic portrayal of a curtain that Zeuxis asked the artist to peel it back, believing this depiction to be real. Because Parrhasius fooled the eye of an artist and not merely an animal, he was crowned the better painter.

46. Pauly, *Fruits and Plains*, 53.

47. Pauly, *Fruits and Plains*, 53.

48. See Beth Fowkes Tobin's chapter, "Imperial Designs: Botanical Illustration and the British Botanic Empire," in *Picturing Imperial Power: Colonial Subjects in Eighteenth-Century British Painting* (Durham, NC: Duke University Press, 1999), and Daniela Bleichmar's *Visible Empire: Botanical Expeditions and Visual Culture in the Hispanic Enlightenment* (Chicago: University of Chicago Press, 2012).

49. Robert L. Hewitt, "Edwin Deakin: An Artist with a Mission," *Brush and Pencil* 15 (January 1905): 3; "The Art Exhibition," *San Francisco News Letter and California Advertiser,* April 22, 1882.

50. "Art Notes," *Overland Monthly* (1874): 92–93, in the archival files on the artist at North Point Gallery, San Francisco.

51. Kropp, *California Vieja,* 47.

52. Burton, "For the California of Today," 58.

53. Hewitt, "Edwin Deakin: An Artist with a Mission," 4.

54. Shields, *Edwin Deakin: California Painter of the Picturesque,* 4. He also built a mission-style home and studio in Berkeley, California, in 1890, according to the website of the Laguna Art Museum, which holds work by Deakin in their collection. https://lagunaartmuseum.org/artist/edwin-deakin/.

55. Kropp, *California Vieja,* 47.

56. Paul Shoup, "An Old Story in Crumbling Walls," *Sunset* 4 (April 1900): 244–45, cited by Shields on page 74. Years later, in 1947, the California State Senate Finance Committee also passed on purchasing the artist's mission paintings.

57. *San Francisco Call,* December 25, 1904. Clipping found in the Edwin and Robert Deakin Papers at the Smithsonian Archives of American Art, Washington, DC.

58. For information on the display of Deakin's work in the Palace Hotel, see Shields, *Edwin Deakin: California Painter of the Picturesque,* 74.

59. *San Franciscan* 4, no. 3 (November 22, 1884), Deakin Papers.

60. "Among the Artists," *San Francisco Chronicle,* December 28, 1884, 8, Deakin Papers.

61. "Among the Artists," *The Gazette,* March 25, 188-, Deakin Papers.

62. "San Francisco Art," *Daily Examiner,* January 26, 1889, Deakin Papers.

63. Climate theory, or environmental determinism, was a European invention that claimed each climate zone affected the character of its regional inhabitants. See Gary Okihiro, *Pineapple Culture: A History of the Tropical and Temperate Zones* (Berkeley: University of California Press, 2009).

64. Hyatt, quoted in Sarver, *History and Legend of the Mammoth Grapevine,* 24.

65. Haraszthy, *Grape Culture, Wines, and Wine-Making,* xv, xvii.

66. Roberts, "California Wine-Making," 197.

67. "The Wine Business of California," *Moore's Rural New-Yorker* (October 19, 1876): 395. George Husmann also wrote, "A great deal has been said about the importance of age for wines, and the evils of selling California wines too young." *American Grape Growing and Wine Making* (New York: Orange Judd, 1880), 253.

68. John L. Tremenheere, "Art in California," *California Art Gallery* 1 (January 18, 1873): 3. Other articles on the failing art scene in California include, "Art: More Substantial Recognition Needed from Leading Citizens," *Daily Evening Post,* May 1, 1880, and "San Francisco Art: How a Studio Building Might Be Secured," *Daily Examiner* (1889), in the Deakin Papers.

69. "An Art Proposition: Rotary Exhibitions of Representative Paintings," *Salt Lake Daily Herald,* Deakin Papers.

70. Tremenheere, "Art in California," 3.

71. "Samuel M. Brookes" *California Art Gallery* (May 1873).

72. "Art," *Mercury: A Saturday Evening Paper,* Deakin Papers.

73. "Palette and Brush: Our Artists in Pen and Ink," *Daily Morning Call,* November 18, 1884; Haraszthy, *Grape Culture, Wines, and Wine-Making,* xvii. The first full quotation reads: "we were dormant and now we are awake and alive. We have an Art Association, and the artists find patrons. A new picture is a pleasant event, and is gladly welcomed. We have learned to appreciate (some of us), and the rest of us, can at least, enjoy." The second full quotation reads: "I was gratified to find that of all the countries, through which I passed, not one possessed the same advantages that are to be found in California; and I am satisfied that even if the separate advantages of these countries could be combined in one, it would still be surpassed by this State when it's now dormant resources shall be developed."

74. "The Art Galleries, New Paintings by Old and New Artists," Deakin Papers. The artists' grape paintings would have been especially fitting in the collection of railroad tycoon and vineyard owner Leland Stanford, a man who shared deep interests in California grapes, art, and industrialization. Although it is unclear if Stanford owned any grape paintings, many of the ones painted by Brookes and Deakin hang today in the Crocker Art Museum, Stanford's former mansion.

75. Hjalmarson, *Artful Players,* 103; "Palette and Brush," 1884. For more on the California Mechanic's Fair, see Barbara Berglund, "Celebrating the City: Labor, Progress, and the Promenade at the Mechanics' Institute Fairs," in *Making San Francisco American: Cultural Frontiers in the Urban West, 1846–1906* (Lawrence: University Press of Kansas, 2007), 131–70.

76. A grape painting by Deakin also hung in the office of Supreme Court justice Anthony Kennedy, who was born in San Francisco and served as a judge in California before his post to the Supreme Court.

77. Steven Stoll reports that early fruit cultivation subjected workers to insecticidal chemicals made from petroleum, sulfur, lead, and arsenic. *The Fruits of Natural Advantage: Making the Industrial Countryside in California* (Berkeley: University of California Press, 1998), 137.

78. Stoll, *Fruits of Natural Advantage,* 41.

79. As a Bohemian Club member and immigrant of Hungarian descent like Haraszthy, Frenzeny may have felt a particular kinship with the vintner and wanted to depict California viticulture in a flattering light.

80. Jackson, "Outdoor Industries in Southern California," 806.

81. "The Vintage in California," *Harper's Weekly* 10, no. 5 (1878): 790.

82. The population of Chinese laborers in California grew tremendously after the completion of the Transcontinental Railroad in 1869, when many migrated to California for new employment opportunities in agriculture. William F. Heintz's master's thesis provides invaluable information on this topic and should be consulted for any project on California grape labor: "The Role of Chinese Labor in Viticulture and Wine Making in Nineteenth-Century California," Sonoma State College, 1977.

83. Street, *Beasts of the Field,* 255.

84. "Napa Valley," *San Francisco Chronicle,* October 15, 1883, in Street Scrapbook, California State Library, Sacramento, p. 14.

85. "Wine-Making in California," reprinted in the *San Francisco Merchant* 17 (June 10, 1887): 53.

86. John Chinaman was a stereotypical depiction of a Chinese laborer seen frequently in cartoons of the nineteenth century by artists like Thomas Nast. This stock character was commonly depicted with a long queue and a conical hat. John L. Sullivan, on the contrary, was a real-life figure; he was an Irish American boxer and heavyweight champion known as the "Boston Strong Boy."

87. "John Chinamen in the Wine Press," *San Francisco Call,* October 14, 1878, in Bancroft Scrapbooks, "Chinese," No. 8, p. 57.

88. *Cloverdale Reveille,* May 20, 1882, 4. Etiquette expert Eunice White Beecher felt similarly about the cultivation of sugar, asking, is there not a better alternative to "heathen Chinamen" who

"stand ankle deep in the black mass of sugary syrup?" *All Around the House; or, How to Make Homes Happy* (New York: D. Appleton, 1878), 151.

89. Street, *Beasts of the Field*, 290–91.

90. Nayan Shah, *Contagious Divides: Epidemics and Race in San Francisco's Chinatown* (Berkeley: University of California Press, 2001), 44.

91. Shah, *Contagious Divides*, 11, 57. See more about the "laundry wars" in D. Michael Bottoms, *An Aristocracy of Color: Race and Reconstruction in California and the West, 1850–1890* (Norman: University of Oklahoma Press, 2013), 150–58.

92. Shah, *Contagious Divides*, 163; Bottoms, *Aristocracy of Color*.

93. *San Francisco Chronicle*, December 28, 1878, quoted in Charles C. Tansill's *The Foreign Policy of Thomas F. Bayard, 1855–1897* (New York: Fordham University Press, 1940), 127–28. See also the 1901 essay "Some Reasons for Chinese Exclusion: Meat vs. Rice; American Manhood vs. Asiatic Coolieism—Which Will Survive?" (Washington, DC: American Federation of Labor, 1901).

94. Lee, *Picturing Chinatown*, 101.

95. Shannon Steen, *Racial Geometries of the Black Atlantic, Asian Pacific, and American Theatre* (London: Palgrave Macmillan, 2010), 9.

96. Lee, *Picturing Chinatown*, 39.

97. Street, *Beasts of the Field*, 356. William Heintz argues that a pro-Chinese attitude existed in Saint Helena because some of the region's most important winemakers depended heavily on Chinese labor. A pro-Chinese meeting was held in Saint Helena in the spring of 1886, a year before this print in *Harper's Weekly* was published. Heintz, "Role of Chinese Labor," 84.

98. Brian Dippie addresses the representation of the "vanishing Indian" in his brief but insightful article, "Representing the Other: The North American Indian," *Anthropology and Photography* (1992): 132–36.

99. Lee, *Picturing Chinatown*, 120.

100. For a study of the wine industry in the twentieth century, see Heintz, "Role of Chinese Labor," 78–79, and Street, *Beasts of the Field*, 367, 396, 482.

CHAPTER 2. THE CITRUS AWAKENING

1. Harriet Beecher Stowe, "Letter to Susan Lee Warner," February 16, 1880. Reference No. BK 53. Kirkham Papers in the Harriet Beecher Stowe Center Archives, Hartford, Connecticut.

2. "Advertisement for Aurantia Grove, Indian River, East Florida" (Springfield: Clark W. Bryan, 1872) in the Graphic Arts collection of the American Antiquarian Society, Worcester, Massachusetts.

3. Literature on the California orange is abundant. The two most seminal books on California oranges are Douglas Cazaux Sackman, *Orange Empire: California and the Fruits of Eden* (Berkeley: University of California Press, 2005), and David Boulé, *The Orange and the Dream of California* (Los Angeles: Future Studios, 2013).

4. George Barbour, *Florida for Tourists, Invalids, and Settlers* (New York: D. Appleton, 1882), 225.

5. J.F. Bartholf, *South Florida, the Italy of America: Its Climate, Soil, and Productions* (Jacksonville: Ashmead Bros., 1881), 112.

6. *The New South versus the New West: A New Field for Home Seekers, Extracts from the Speeches of a Few Public Men and Newspapers upon This Subject*, in the Henry Leslie Lymon Scrapbook at the Winterthur Museum and Library, Delaware.

7. Edward King, *The Great South: A Record of Journeys in Louisiana, Texas, the Indian Territory, Missouri, Arkansas, Mississippi, Alabama, Georgia, Florida, South Carolina, North Carolina, Kentucky, Tennessee, Virginia, West Virginia, and Maryland* (Hartford, CT: American Publishing, 1875).

8. Ledyard Bill, *A Winter in Florida; or, Observations on the Soil, Climate, and Products of Our Semi-Tropical State with Sketches of the Principal Towns and Cities of Eastern Florida* (New York: Wood and Holbrook, 1870), 19–20.

9. "Oranges," *Harper's Weekly,* August 23, 1879, 663.

10. Noel Kingsbury, *Hybrid: The History and Science of Plant Breeding* (Chicago: University of Chicago Press, 2011), 144.

11. "Our Pineapple Plantation," *Haney's Journal,* August 1, 1871.

12. *Proceedings of the Florida Fruit-Growers' Association and Its Annual Meeting Held in Jacksonville* (Jacksonville: Office of the Florida Agriculturist, 1875), 45.

13. William Bacon, "The War and Agriculture," *Country Gentleman* (March 1864). Some southern farmers, on the other hand, boycotted goods produced in the North that were "tainted with abolitionism" during the Civil War. Lawrence Glickman, *Buying Power: A History of Consumer Activism in America* (Chicago: University of Chicago Press, 2012), 103n24.

14. Marshall P. Wilder, *Address Delivered at the Ninth Session of the American Pomological Society Held in Boston, Mass.* (Boston: McIntire and Moulton Printers, September 17–19, 1862), 6.

15. Kirk Savage discusses imagery that depicted black people as helpless victims dependent on white Americans for liberation in his book *Monument Wars: Washington, D.C., the National Mall, and the Transformation of the Memorial Landscape* (Berkeley: University of California Press, 2011), 86.

16. James Broomall, "Personal Reconstructions: Confederates as Citizens in the Post–Civil War South," in *Creating Citizenship in the Nineteenth-Century South* (Gainesville: University Press of Florida, 2013), 112.

17. Before the arrival of oranges in the Americas, evidence of oranges was found in Asia, the South Pacific, and Australia. For a more rigorous history of the fruit's origins and arrival in the Americas, consult Sackman, *Orange Empire*; John McPhee, *Oranges* (New York: Farrar, Straus, and Giroux, 1967); Helen L. Kohen, "Perfumes, Postcards, and Promises: The Orange in Art and Industry," *Journal of Decorative and Propaganda Arts* 23 (1998): 32–47; and Jay Mechling, "Oranges," in *Rooted in America: Foodlore of Popular Fruits and Vegetables,* ed. David Wilson and Angus Gillespie (Knoxville: University of Tennessee Press, 1999), 120–42. The following nineteenth-century texts deal specifically with the Florida orange: Bill, *A Winter in Florida*; Seth French, *Florida: Its Climate, Soil, and Productions* (Jacksonville: Edwin M. Cheney, 1869); Reverend T.W. Moore, *Treatise and Hand-Book on Orange Culture in Florida* (Jacksonville: Sun and Press, 1877); Helen Warner, *Florida Fruits and How to Raise Them* (Louisville: John Morton, 1886).

18. For references to the consumption of oranges at Christmas, see Sackman, *Orange Empire,* 96, and Susanne Freidberg, *Fresh: A Perishable History* (Cambridge, MA: Harvard University Press, 2010), 138.

19. In his popular series of articles, *The Great South,* Edward King describes a Union soldier in Palatka, Florida, who "could not find it in his heart to ruin Dr. Moragné's beautiful grove; so he picketed his cavalry there, and evaded the order." *Great South,* 404.

20. *Proceedings of the Florida Fruit-Growers' Association and Its Annual Meeting,* 28.

21. A decade later, in 1886, horticultural manual writer Helen Warner also marveled at how "the native Floridian did not long ago wake up to the realization of the wealth within his grasp, of the golden apple lying neglected at his feet." According to Warner, there had only been a "few intelligent, wide-awake Southerners . . . who held the orange at an approximate to its true value." Warner, *Florida Fruits and How to Raise Them,* 12–13.

22. *Semi-Tropical* 2, no. 2 (February 1876): 9–10.

23. Bureau of Immigration, *Semi Tropical Florida* (Chicago: Rand, McNally, 1881), 12. Collection of the Library Company of Philadelphia.

24. J.H. Carleton, "El Dorado, Arkansas," *Grape Culturist* (August 1869): 336.

25. For a longer history of Native American and white American relations in the region, read Steven Noll and M. David Tegeder, *From Exploitation to Conservation: A History of the Marjorie Harris Carr Cross Florida Greenway* (Gainesville: University Press of Florida, 2003), 1–5.

26. "A Voice from Florida," *Godey's Lady's Book* (July 1868).

27. "Florida House Lots, Only $15," *Godey's Lady's Book* (1886): 644.

28. James Muhn, "Women and the Homestead Act: Land Department Administration of a Legal Imbroglio, 1863–1934," *Western Legal History* 7 (1994): 284.

29. The Land Department had a tricky time determining what made a woman a "head of household." Generally, women qualified for land if they were widowed or if their husbands had abandoned them or were imprisoned. It was challenging for married women to be eligible for this law given that men were generally viewed as "head of house." Muhn, "Women and the Homestead Act," 287.

30. Warner was also known publicly as Helen Harcourt. She previously worked for the *Georgia Stock Journal*, *Florida Messenger*, and the *Poultry Dispatch*.

31. Robert Ellis Thompson and Wharton Barker, "Authors and Publishers," *American: A National Journal*, no. 445 (1888): 284.

32. Helen Harcourt, *Home Life in Florida* (Louisville: John P. Morton, 1889), 4.

33. Elizabeth D. Gillespie, "National Cookery Book: Compiled from Original Receipts, for the Women's Centennial Committees," *The Spirit of 'Seventy-Six*, vol. 1 (Philadelphia: Executive Committee of the Women's Branch of the Centennial Association for Connecticut, 1875), 262, 298, 306. See also George Davis, *A Treatise on the Culture of the Orange and Other Citrus Fruits* (Jacksonville: Charles Dacosta, 1882), 86–88, and Warner, *Florida Fruits and How to Raise Them*, 312, 314.

34. Gillespie, "National Cookery Book," 60.

35. Gillespie, "National Cookery Book," 60.

36. For an example of a California set, see Boulé, *The Orange and the Dream of California*, 61, 156.

37. Paul Wallace Gates, "Federal Land Policy in the South: 1866–1888," *Journal of Southern History* 6, no. 3 (August 1940): 305–6, 327. Congress, Gates writes, set out to break up the large sugar, rice, cotton, and tobacco plantations of the South into smaller farms and holdings for freedmen and white refugees to assure that they had the opportunity to have their own land.

38. Barbour, *Florida for Tourists, Invalids, and Settlers*, 296.

39. Barbour, *Florida for Tourists, Invalids, and Settlers*, 296.

40. Barbour, *Florida for Tourists, Invalids, and Settlers*, 296.

41. The towering trees in her front yard were later memorialized in a stained-glass window by Louis Comfort Tiffany for Stowe's Church of Our Savior in Mandarin. The window depicted two oak trees on Stowe's property underneath a sunset. For more information, read Nancy Koester, *Harriet Beecher Stowe: A Spiritual Life* (Grand Rapids, MI: William B. Eerdman's Publishing, 2014), 317.

42. McPhee, *Oranges*, 96.

43. "Letter to Mary Estlin," December 21, 1868. Reference No. BK 31, Kirkham Papers.

44. "What Shall We Raise in Florida?" *Hearth and Home* (May 8, 1869): 312.

45. Philip J. Pauly, *Fruits and Plains: The Horticultural Transformation of America* (Cambridge, MA: Harvard University Press, 2008), 204.

46. "Palmetto Leaves" was published by the nondenominational New York newspaper *Christian Union*. Stowe and her siblings contributed to the newspaper weekly, which was widely read after its first printing in 1870. For more information on the Stowes' affiliation with this publication, see John and Sarah Foster, *Calling Yankees to Florida: Harriet Beecher Stowe's Forgotten Tourist Articles* (Cocoa: Florida Historical Society Press, 2011), 88.

47. Harriet Beecher Stowe, "Southern Christmas and New Year," *Christian Union* 13, no. 3 (January 3, 1876): 144.

48. Stowe, "Personal," *Christian Recorder*, December 21, 1882.

49. Stowe, "Palmetto Leaves from Florida, Swamps and Orange-Trees," *Christian Union* (March 25, 1872): 316.

50. Stowe, "Letter to Charles Edward Stowe," April 28, 1881. Reference No. BK 56. Kirkham Papers.

51. "Letter to Oliver Wendell Holmes," January 1, 1879. Reference No. BK 31. Kirkham Papers.

52. Norman Bryson, *Looking at the Overlooked: Four Essays on Still Life Painting* (Cambridge, MA: Harvard University Press, 1990), 175; Hildegard Cummings, *Charles Ethan Porter: African-American Master of Still Life* (Hanover, NH: University Press of New England, 2007), 14.

53. Stowe compared Rembrandt to Nathaniel Hawthorne, praising the ability of each to capture the mystery of the simplest things in life. Harriet Beecher Stowe, *Flowers and Fruit from Writings of Harriet Beecher Stowe* (Boston: Houghton, Mifflin, 1888), 166.

54. Catharine Ester Beecher and Harriet Beecher Stowe, *American Woman's Home; or, Principles of Domestic Science* (New York: J.B. Ford, 1869), 295.

55. Stowe, "Palmetto Leaves from Florida, a Letter to the Girls," *Christian Union* (February 28, 1872).

56. Stowe was an admirer of Prang and even defended him against art critic Clarence Cook, who wrote a scathing review of Prang's chromolithographs. Prang, in turn, was appreciative of Stowe's support, saying, "We feel proud of her kind, unsought, and unexpected compliments to our chromos." Louis Prang, *Prang's Chromo: A Journal of Popular Art* (Boston: Prang, 1868), 5; Stowe, *Flowers and Fruit*, 166.

57. Stowe's painting looks strikingly similar to Ellen Fisher's chromolithograph, *Magnolia Grandiflora*, for Prang in 1873, which is in the collection of the Boston Public Library.

58. Stowe, "Palmetto Leaves from Florida, Magnolia Week," *Christian Union* (May 15, 1872): 417.

59. Stowe, "Palmetto Leaves from Florida, No. 2," *Christian Union* (January 24, 1872): 156.

60. Stowe, "Letter to Roxana Ward Foote" (January 3, 1828). Reference No. BK 31. Kirkham Papers

61. Stowe, "Letter to Roxana Ward Foote."

62. In a letter to Marie Collings and Mrs. Caleb Strong, Stowe wrote: "I understand you are on the committee for our Hartford Centennial exhibition. Three of my pictures are there and I want to put them under your special guardianship to have returned to their places when the exhibition is over. They are the Magnolia, the Yellow Jessamine, and the Good Shepherd which I bought on the artist's easel at Dusseldorf years ago and prise like gold." Reference No. BK46 (November 1, 1875). Harriet Beecher Stowe, Samuel Clements, and Elizabeth Colt all sat on the advisory board, according to Cummings, *Charles Ethan Porter*, 43.

63. "Letter to M. Bucklin Claflin" (March 6, 1882). Reference No. BK 58. Kirkham Papers.

64. "Letter from Martin Johnson Heade to Eben J. Loomis" on February 12, 1883, in the Smithsonian Archives of American Art, Washington, DC.

65. Harriet Beecher Stowe, "The Economy of the Beautiful," in *House and Home Papers* (Boston: Ticknor and Fields, 1865), 95.

66. Theodore Stebbins has written the most complete biography and exhibition history of Heade's career: *The Life and Work of Martin Johnson Heade: A Critical Analysis and Catalogue Raisonné* (New Haven, CT: Yale University Press, 2000). See page 63 for information on Fletcher. Consult also Maggie Cao's article, "Heade's Hummingbirds and the Ungrounding of Landscape," *American Art* 25, no. 3 (Fall 2011): 48–75.

67. For his contribution to Florida art, Heade was inducted to the Florida Artists Hall of Fame in 1995.

68. The orange industry's "romantic period" spanned from 1884 to 1894.

69. Moore, *Treatise and Hand-Book on Orange Culture*,, 143.

70. Heade's depiction of fruit on mahogany tables, however, complicates this theory since mahogany was a rare wood in the nineteenth century, extracted at the expense of tropical rain forests. More information on Heade's environmental views can be gleaned from the master's thesis by Susan C. Riles, "Martin Johnson Heade: Wetlands Artist and Pro Environmentalist," Rollins College, 2005.

71. "Letter from Martin Johnson Heade to Eben J. Loomis," on March 26, November 23, 1884. Smithsonian Archives of American Art.

72. "Untitled," *Florida Tatler,* March 23, 1901, 7.

73. *Life and Work of Martin Johnson Heade,* 156.

74. "Mr. Heade's studies of flowers peculiar to the State would be another attraction that the State cannot afford to forego," wrote a writer in the *Tatler.* "Artists—Ponce de Leon Studios," *Florida Tatler,* February 11, 1893, 1.

75. Heade as Didymous in "Notes of Floridian Experience," *Forest and Stream* 20, no. 17 (May 24, 1883): 324, at the Saint Augustine Historical Society, Florida.

76. "Letter from Heade to Eben Loomis," on February 12, 1883, cited in Roberta Favis, *Martin Johnson Heade in Florida* (Gainesville: University Press of Florida, 2003), 34.

77. David Leon Chandler, *Henry Flagler: The Astonishing Life and Times of the Visionary Robber Baron Who Founded Florida* (New York: Macmillan, 1986), 102.

78. This statistic is reported by Pauly, *Fruits and Plains,* 210.

79. C.W.D. "Art at the Ponce De Leon," *News Herald, Saint Augustine,* 91, at the Saint Augustine Historical Society, Florida.

80. For more information on the hotel's design, see Susan Braden, *The Architecture of Leisure: The Florida Resort Hotels of Henry Flagler and Henry Plant* (Gainesville: University Press of Florida, 2002), 157.

81. "Artists—Ponce de Leon Studios," *Florida Tatler,* March 16, 1901. Five of the six artists were Frank Shapleigh, Felix de Crano, W. Staples Drown, George W. Seavey, and Robert S. German.

82. "Ponce de Leon Studios" *Florida Tatler,* February 5, 1898, 5; "Notes about Artists and Art," *Saint Augustine News* 4, no. 1 (January 18, 1891): 11.

83. "Ponce de Leon Studios," *Daily News Herald,* February 26 1888, 6.

84. "About Artists," *Florida Tatler,* April 1, 1899, 15.

85. In addition to the orange grove in his hotel, Flagler built orange groves in San Mateo, Florida, according to Sidney Walter Martin in *Henry Flagler: Visionary of the Gilded Age* (Gainesville: Tailored Tours Publications, 1998), 103.

86. John Carrère and Thomas Hastings, *Florida, the American Riviera; St. Augustine, the Winter Newport* (New York: Gilliss Brothers and Turnure, the Art Age Press, 1887), 31–32, cited by Favis, *Martin Johnson Heade in Florida,* 59.

87. "Art Notes," *Florida Tatler,* April 1, 1893, 8.

88. *Florida on Wheels: A Rolling Palace from the Land of Flowers, 1887–1888.* Trade card in the collection of the American Antiquarian Society, Worcester, Massachusetts.

89. California boosters similarly created "California on Wheels," a train with the Southern Pacific Railroad that publicized California oranges in the Midwest. Richard J. Orsi, *Sunset Limited: The Southern Pacific Railroad and the Development of the American West, 1850–1930* (Berkeley: University of California Press, 2005), 324.

90. Peter Hales has written extensively on the photographer's commissions in *William Henry Jackson and the Transformation of the American West* (Philadelphia: Temple University Press, 1988).

91. Krista A. Thompson, *An Eye for the Tropics: Tourism, Photography, and Framing the Caribbean Picturesque* (Durham, NC: Duke University Press, 2006), 98.

92. Thompson, *An Eye for the Tropics,* 23.

93. Bill, *A Winter in Florida,* 19–20.

94. *Semi-Tropical* 2, no. 2 (February 1876): 9–10.

95. Pauly, *Fruits and Plains,* 204.

96. Barbour, *Florida for Tourists, Invalids, and Settlers,* 232.

97. Barbour, *Florida for Tourists, Invalids, and Settlers,* 234.

98. Bill, *A Winter in Florida,* 230.

99. Bill, *A Winter in Florida,* 228.

100. Douglas Blackmon, *Slavery by Another Name: The Re-enslavement of Black Americans from the Civil War to World War II* (New York: Doubleday, 2008), 27, 54.

101. Conditions on Sanford's orange grove were dangerous for black workers. In 1870 and 1871, a band of white southerners threatened black workers and "fired upon" them. Sanford wanted to protect them and resolve the problem by stationing guards at their camps. Read Richard J. Amundson, "Henry S. Sanford and Labor Problems in the Florida Orange Industry," *Florida Historical Quarterly* 43, no. 3 (January 1965): 229–43; Reiko Hillyer, "The New South in the Ancient City: Flagler's St. Augustine Hotels and Sectional Reconciliation," *Journal of Decorative and Propaganda Arts,* Florida Theme Issue 25 (2005): 117; and Jerrell H. Shofner, *Nor Is It over Yet: Florida in the Era of Reconstruction, 1863–1877* (Gainesville: University Press of Florida, 1974), 261, 276.

102. According to historian Lawrence Powell, Daniels wanted "to do something useful and philan-thropic for a race of mankind that for over two centuries had been kept in degrading bondage." *New Masters: Northern Planters during the Civil War and Reconstruction* (New York: Fordham University Press, 1999), 24.

103. Letter to Elizabeth Georgiana Campbell, May 28, 1877. Reference No. BK 48. Kirkham Papers.

104. Amy Dru Stanley, *From Bondage to Contract: Wage Labor, Marriage, and the Market in the Age of Slave Emancipation* (Cambridge: Cambridge University Press, 1998), 124–27; Blackmon, *Slavery by Another Name,* 124.

105. The following scholars discuss Stowe's opinions on black emancipation and free labor: Rachel Klein, "Harriet Beecher Stowe and the Domestication of Free Labor Ideology," *Legacy* 18, no. 2 (2001): 135–52; Kathryn Cornell Dolan, *Beyond the Fruited Plain: Food and Agriculture in U.S. Literature, 1850–1905* (Lincoln: University of Nebraska Press, 2014).

106. Evidence suggests that Tanner visited Florida between 1887 and 1888, and later in 1894, when he visited Tallahassee to conduct church business at the AME conference. Tanner may have spent time in Florida and North Carolina because of chronic health problems. Dewey Mosby, Darrel Sewell, and Rae Alexander-Minter, *Henry Ossawa Tanner* (Philadelphia: Philadelphia Museum of Art, 1991), 244.

107. Henry Ossawa Tanner, *Florida,* 1894. Oil on canvas, 18 × 22 in., Collection of Lewis Tanner Moore.

108. *Jacksonville Florida Times-Union,* February 12, 1895, cited by Gary R. Mormino, "Dream Fruit for a Dream State," *Forum* 38, no. 1 (Spring 2014).

109. McPhee, *Oranges,* 101.

110. Pauly, *Fruits and Plains,* 222. Arguably, it was not until the marketing of orange juice that Florida's orange industry rebounded.

111. Mosby, Sewell, and Alexander-Minter, *Henry Ossawa Tanner,* 244.

112. Marcia H. Mathews, *Henry Ossawa Tanner, American Artist* (Chicago: University of Chicago Press, 1969), 34.

113. Tera Hunter states that forty riots erupted in the South between 1898 and 1908. *To 'Joy My Freedom: Southern Black Women's Lives and Labors after the Civil War* (Cambridge, MA: Harvard University Press, 1997), 127.

114. Meeropol's poem from 1937 was recorded in 1939 by Billie Holiday with Commodore Records.

CHAPTER 3. CUTTING AWAY THE RIND

1. Andrew John Henry Way, "Fruit-Painting in Oils," *Art Amateur* 16, no. 6 (May 1887): 129.

2. Ellen Ficklin has written the most comprehensive history on the watermelon, reporting evidence that Native Americans also grew the fruit. For a more complete history of the watermelon, see Ellen Ficklin, *Watermelons* (Washington, DC: American Folk Life Center and the Library of Congress, 1984); David and Donald Maynard, *Cambridge World History of Food,* ed. Kenneth Kiple and Kriemhild Ornelas (Cambridge: Cambridge University Press, 2000), 307; Sandra Oliver, *Food in Colonial and Federal America* (San Francisco: Greenwood Press, 2005); Patricia Turner, "Watermelons," in *Rooted in America: Foodlore of Popular Fruits and Vegetables,* ed. David Wilson and Angus Gillespie (Knoxville: University of Tennessee Press, 1999), 211–25; and Waverly Root and Richard de Rochemont, *Eating in America* (New York: Ecco Press, 1981).

3. David Maynard and Donald N. Maynard, *Cambridge World History of Food,* ed. Kenneth Kiple and Kriemhild Ornelas (Cambridge: Cambridge University Press, 2000), 307.

4. Maynard and Maynard, *Cambridge World History of Food.*

5. Mark Twain, *Pudd'n Head Wilson* (Hartford, CT: American Publishing, 1894), 179.

6. "The Southern Watermelon Trade," *Harper's Weekly,* July 28, 1888.

7. At watermelon parties, participants played a game that consisted of "watermelon slices painted on cardboard, and with holes in which to place the seeds, which are numbered; the player who empties his slice of the seeds first gets the prize. "Fashion, Fact, and Fancy," *Godey's Ladies Book* (December 1896).

8. "Large Watermelon," *Our Home Journal* (September 30, 1871): 185.

9. Once a drinker was done with the spiked fruit, they could then "reinsert the plug or seal it closed with heavy tape," according to Ellen Ficklin. She also suggests that drinkers could spike a watermelon while it was still growing on the vine. Ficklin, *Watermelons,* 24, 36.

10. "O, Dat Watermelon," *Chicago Daily Tribune,* July 5, 1891, 10.

11. "Watermelons as a Medicine," *Mining and Scientific Press* (August 4, 1877): 71.

12. "Watermelon vs. Diarrhea," *Boston Medical and Surgical Journal* (August 19, 1869): 35.

13. Trudy Eden, *Cooking in America, 1590–1840* (Westport, CT: Greenwood Press, 2006), 116. The word *dyspepsia* was derived from the enzyme pepsin, known for improving digestion. James C. Whorton more closely analyzes the history of dyspepsia in *Inner Hygiene: Constipation and the Pursuit of Health in Modern Society* (Oxford: Oxford University Press, 2000).

14. Thomas W. Handford, *The Home Instructor: A Guide to Life in Private and Public* (Chicago: R. G. Badoux, 1885), 335. Handford encouraged readers to carefully study these time tables to prevent "the dire calamity" of indigestion.

15. Isaac Newton Love, "Dietetic Dots," *Medical Mirror* 2 (1891): 531.

16. "A Colored Man at Des Moines," *Christian Recorder* (September 30, 1886).

17. "Millions of Melons," *Harper's Weekly,* September 26, 1896.

18. "Southern Watermelon Trade."

19. See Anna Paddon and Sally Turner, "African Americans and the World's Columbian Exposition," *Illinois Historical Journal* 88, no. 1 (Spring 1995): 32. *Puck* magazine published a related illustration, "Darkies' Day at the Fair," showing black people with wide eyes and moist lips eagerly waiting in line to purchase "ice-cold watermillons." Displays of African cannibalism in a nearby exhibition of Dahomeyan culture at the Columbian Expo only added fuel to stereotypes about the savagery of black appetites. The minstrel-like performance of Nancy Green as the mammy figure Aunt Jemima for the Davis Milling Company presented another caricature of black people at the Columbian Exposition.

20. "Colored People's Day," *Daily Inter Ocean,* August 22, 1893, p. 6, col. 3; July 24, 1983, p. 7, col. 1; also cited by Paddon and Turner, "African Americans and the World's Columbian Exposition," 32.

21. This includes *The House Servant's Directory* by Robert Roberts from 1827; *Never Let People Be Kept Waiting* by Tunis Campbell from 1848; and *A Domestic Cook Book* by Malinda Russell from 1866. Two exceptions are the cookbooks *What Mrs. Fisher Knows about Old Southern Cooking* from 1881 and E. T. Glover's *The Warm Springs Receipt-Book* from 1897, which respectively include recipes for "sweet watermelon rind pickle" and "watermelon sweet pickle."

22. Years later, actress Butterfly McQueen conducted another act of protest regarding the watermelon; she refused to eat the fruit on camera in the 1939 film *Gone with the Wind*. This gesture, however, was arguably diminished by McQueen's portrayal in the film, which strongly conformed to racial stereotype. See Turner, "Watermelons," in *Rooted in America*, 216.

23. "Fashion, Fact, and Fancy," *Godey's Lady's Book* (February 1896). The full advertisement reads: "The Georgia Watermelon Spoon is the newest departure in souvenir spoons. The spoons are of several sizes and of silver gilt; the golden bowl is enamelled with a slice of watermelon in the luscious red of the ripe fruit; the handle is tipped with a negro's head in relief, in dead black enamel, while below appears a tuft of the green leaves of the watermelon. Showy and distinctively Southern in idea and execution is the new spoon, which is handsome, characteristic, and not expensive."

24. More information on this little-studied artist can be found in Edan Hughes's *Artists in California, 1786–1940* (Sacramento: Crocker Art Museum, 2002).

25. Other representations with similar titles include *Oh! Dat Watermelon*, a song written by Luke Schoolcraft and arranged by John Braham from 1874; *Gim Me Dat Sweet Water-Melon*, a song written by Fred Lyons and published by Richard Saalfield from 1883; and *O Dat Watermillion!*, a print by Currier and Ives from 1882. An article in the *Chicago Daily Tribune* also shared the same title (July 5, 1891, 10).

26. "Millions of Melons."

27. It is unknown how Califano felt about his painting's reenvisioning, yet it is known that artists, in general, had mixed reactions to the print reproductions of their works. While the reproduction of artists' paintings in print promised to publicize their work and improve their reputation, artists also expressed resentment toward lithographers for printing and selling their paintings without fair compensation. For more information, read Michael Clapper, "'I Was Once a Barefoot Boy!': Cultural Tensions in a Popular Chromo," *American Art* 16, no. 2 (Summer 2002): 16–39.

28. Patricia Turner, *Ceramic Uncles and Celluloid Mammies: Black Images and Their Influence on Culture* (Charlottesville: University of Virginia Press, 2002), 15.

29. Sylvester Rosa Koehler, *American Etchings* (1886), referenced by Teresa Carbone in *American Paintings in the Brooklyn Museum*, vol. 2 (New York: Giles, 2006), 656.

30. Koehler, *American Etchings*.

31. There are only a few instances of black girls eating the fruit outdoors, which conform to a long-standing tradition in American art linking fruit with the innocence of childhood.

32. Anne Maxwell, *Colonial Photography and Exhibitions: Representations of the "Native" and the Making of European Identities* (Leicester: Leicester University Press, 2000), 88.

33. Psyche Williams-Forson, *Building Houses Out of Chicken Legs: Black Women, Food, and Power* (Chapel Hill: University of North Carolina Press, 2006), 48. The author also discusses the threat of black men to white power on pages 7 and 37.

34. Williams-Forson, *Building Houses*, 48.

35. See Hovenden's paintings, *I'se So Happy* and *Dat Possum Smell Pow'ful Good*.

36. "A Sketch," *Godey's Lady's Book* (August 1877).

37. Krausz paired his photo of a black boy with a poem that described "how de watah-millun's good 'nuff fo me." Sigmund Krausz, *Street Types of Chicago: Character Studies*, ed. Emil G. Hirsch (Chicago: Max Stern, 1891), 7.

38. Tanya Sheehan, "Looking Pleasant, Feeling White: The Social Politics of the Photographic Smile," in *Feeling Photography*, ed. Elspeth Brown and Thy Phu (Durham, NC: Duke University Press, 2014), 144.

39. Nina Silber, *The Romance of Reunion: Northerners and the South, 1865–1900* (Chapel Hill: University of North Carolina Press, 1997): 124. Caroline Janney agrees that "in the postbellum years, many [northern] playwrights and authors returned to romanticized and comical portrayals of slaves in the name of reconciliation. . . . For some, such stories offered an escape from the Gilded Age's rampant industrialization, labor disputes, immigration debates, and financial panics." Caroline Janney, *Remembering the Civil War: Reunion and the Limits of Reconciliation* (Chapel Hill: University of North Carolina Press, 2013), 210–11.

40. For more information on trade cards, see the work of Robert Jay, *The Trade Card in Nineteenth-Century America* (Columbia: University of Missouri Press, 1986), and Ellen Gruber Garvey, *The Adman in the Parlor: Magazines and the Gendering of Consumer Culture, 1880s to 1910s* (Oxford: Oxford University Press, 1996).

41. Jay, *Trade Card in Nineteenth-Century America*, 3.

42. Native Americans were also shown morphing into foods, displaying bodies made of yellow kernels and green husks like corn. Native American figures bear headdresses and walking sticks, stereotypical accessories that communicated indigeneity to mainstream viewers. Ethnic stereotypes were adaptable on trade cards, no matter what food or group they embodied.

43. Francis J. Grund, *Graham's American Monthly Magazine of Literature and Art* 30 (1847): 337.

44. Melanie DuPuis, *Dangerous Digestion: The Politics of American Dietary Advice* (Berkeley: University of California Press, 2015), 88.

45. Douglas Cazaux Sackman, *Orange Empire: California and the Fruits of Eden* (Berkeley: University of California Press, 2005), 166–67. The author describes one teacher, Pearl Ellis, who argued that Mexican families needed less salsa and tortillas and more body regulators and builders in "Americanization through Homemaking," 19, originally quoted in George Sánchez, *Becoming Mexican American: Ethnicity, Culture, and Identity in Chicano Los Angeles* (New York: Oxford University Press, 1993), 102.

46. DuPuis, *Dangerous Digestion*, 91.

47. DuPuis, *Dangerous Digestion*, 93.

48. Kyla Tompkins, *Racial Indigestion: Eating Bodies in the Nineteenth Century* (New York: New York University Press, 2012), 31.

49. Tompkins, *Racial Indigestion*, 162.

50. Tompkins, *Racial Indigestion*, 181.

51. Tompkins, *Racial Indigestion*, 180.

52. Tompkins, *Racial Indigestion*, 170, 8.

53. See Raphaelle Peale, *Melons and Morning Glories*, 1813, oil on canvas, Smithsonian American Art Museum. Alexander Nemerov analyzes this painting in combination with the artist's biography in *The Body of Raphaelle Peale: Still Life and Selfhood, 1812–1824* (Berkeley: University of California Press, 2001).

54. See Edward Edmondson Jr., *Still Life with Melons, Pear, and Peach*, 1860s. Oil on Academy Board, 18 × 24 in., Dayton Art Institute, Ohio.

55. Dunning trained under artist Daniel Huntington in New York, returning home to Fall River, Massachusetts, to paint portraits, landscapes, and still lifes. He helped shape a specialized school of still life artists that combined conservative, Ruskinian values with the opulence of Victorian dining culture. For more information, read William Gerdts, *Painters of the Humble Truth: Masterpieces of American Still Life, 1801–1939* (Columbia: University of Missouri Press, 1981), 116.

56. Dunning may have depicted this subject matter for patrons who were famously sympathetic to African Americans, including ardent abolitionist and supporter of civil rights Moses Pierce, who had commissioned a still life painting from Dunning a few years earlier. Henry Adams found that Dunning's 1887 still life, *A Fruit Picture,* was commissioned by Pierce. It is possible that many of the art patrons in Fall River were abolitionists during the time of the Civil War.

57. "Watermelon Extraordinary," *Gleason's Pictorial Home Visitor* (October 1, 1874): 245.

58. William Michael Harnett, *For Sunday's Dinner,* 1888. Oil on canvas, 37 × 21 in., Art Institute of Chicago.

59. Harnett's depiction of a bird's lynching on a doorpost might also reference the brutality against African Americans, who were widely associated with consuming and stealing chickens in the time period. See this interpretation by Judith Barter in *Art and Appetite: American Painting, Culture, and Cuisine* (New Haven, CT: Yale University Press, 2013), 142–43.

60. Barter, *Art and Appetite,* 146.

61. Still lifes of dead rabbits by George Henry Hall also addressed racial violence and specifically riots by Irish immigrants against the police. See Ross Barrett's article, "Rioting Refigured: George Henry Hall and the Picturing of American Political Violence," *American Art* 92, no. 3 (September 2010): 211–31.

62. Hildegard Cummings, *Charles Ethan Porter: African-American Master of Still Life* (Hanover, NH: University Press of New England, 2007), 24.

63. Cummings, *Charles Ethan Porter.*

64. Andrew John Henry Way, "Fruit-Painting in Oils," *Art Amateur* 16, no. 6 (May 1887): 129.

65. According to legend, one of Charles Ethan Porter's students, James Craig, was on his way to his art lesson when a watermelon fell off a cart and into the street. Craig scooped up the pieces and brought them to Porter's studio where they both sketched the watermelon and then ate it. This story has become folklore in the Craig family, as articulated in the files of the Michael Rosenfeld Gallery, New York City.

66. "Mr. Porter's Paintings," *Hartford Courant,* December 8, 1898, 5.

67. Emma Grey, "The Beautiful Home-Club," *Godey's Lady's Book* (April 1890): 335.

68. Banjos were akin to watermelons since both objects were gourds, imported to the United States from Africa on slave ships. See Peter H. Wood, "The Calabash Estate: Gourds in African American Life and Thought," in *African American Impact on the Material Cultures of the Americas: Conference Proceedings* (Winston-Salem, North Carolina, Old Salem, 1998), 6–7.

69. Henry Ossawa Tanner, *The Banjo Lesson,* 1893. Oil on canvas, 49 × 35.5 in., Hampton University Museum, Virginia.

70. Cited by Naurice Frank Woods Jr., "Henry Ossawa Tanner's Negotiation of Race and Art: Challenging the Unknown Tanner," *Journal of Black Studies* (2011): 894, taken from notes by Tanner at the Pennsylvania School for the Deaf.

71. "Watermelon Killing," *Illustrated Police News,* August 22, 1872, 10.

72. "Ninety Convicts in a Melon Patch," *Atlanta Constitution,* August 22, 1897, A16.

73. "Difficulties of Watermelon," *New England Homestead,* September 19, 1874, 298.

74. A few examples include Currier and Ives, "Oh Dat Watermillion," from the *Darktown Comic Series,* 1882; Underwood and Underwood, "Black Worker Taking Time Out in a Watermelon Patch to Pose as a Scarecrow," date unknown; *Clark and Morgan's Trade Card,* Grossman Trade Card Collection, Post–Civil War, Winterthur Library, Delaware; and "Dr. Wiley's Department," *Good Housekeeping* 55, no. 1 (July 1912).

75. For more information on this painting, see Karen Dalton and Peter H. Wood, *Winslow Homer's Images of Blacks: The Civil War and Reconstruction Years* (Austin: University of Texas Press, 1989), 83. It is worth noting that Homer was not always sympathetic to black subjects in his other

paintings. See Mary Ann Calo, "Winslow Homer's Visits to Virginia during Reconstruction," *American Art Journal* 12, no. 1 (Winter 1980): 4–27.

76. *American Art and American Art Collections,* vol. 2 (1889), 715–19, quoted in Calo, "Winslow Homer's Visits to Virginia during Reconstruction," 5; see also Karen Adams, "Black Images in Nineteenth-Century American Painting and Literature: An Iconological Study of Mount, Melville, Homer, and Mark Twain" (PhD diss., Emory University, 1977), 135.

77. For this reference to Homer, see August Trovaioli and Roulhac Toldeano, *William Aiken Walker: Southern Genre Painter* (Gretna, LA: Pelican Publishing, 2007), 107.

78. It is unclear who engraved Homer's painting into print. Homer was known for adapting his paintings to woodblock drawings, but his work was also widely engraved by lesser-known print artists. See David Tatham's *Winslow Homer and the Pictorial Press* (Syracuse, NY: Syracuse University Press, 2003), 180, 187.

79. The Freedmen's Bureau parceled out southern land to freedmen, abiding by different regulations throughout time. At one point, African Americans were not allowed to own more than 40 acres of land for a period of three years. Douglas Blackmon, *Slavery by Another Name: The Re-enslavement of Black Americans from the Civil War to World War II* (New York: Doubleday, 2008), 18.

80. Paul Gates supports this point in his article "Federal Land Policy in the South: 1866–1888," *Journal of Southern History* 6, no. 3 (August 1940): 305–6, 327.

81. Daryl Michael Scott, "White Supremacy and the Question of Black Citizenship in the Post-Emancipation South," in *Creating Citizenship in the Nineteenth-Century South* (Gainesville: University Press of Florida, 2013), 228–29.

82. Blackmon, *Slavery by Another Name,* 88.

83. Amy Dru Stanley, *From Bondage to Contract: Wage Labor, Marriage, and the Market in the Age of Slave Emancipation* (Cambridge: Cambridge University Press, 1998), 124–27; Blackmon, *Slavery by Another Name,* 124.

84. Dell Upton, "White and Black Landscapes in Eighteenth-Century Virginia," in *Material Life in America, 1600—1860,* ed. Robert Blair St. George (Boston: Northeastern University Press, 1988), 361. Authors Herbert Covey and Dwight Eisnach specifically found evidence that white owners allowed slaves to maintain small patches of watermelons for their own consumption or to grow melons for sale at market. *What the Slaves Ate: Recollections of African American Foods and Foodways from the Slave Narratives* (Santa Barbara, CA: Greenwood Press, 2009), 178.

85. For more information on the gourd as a symbol of freedom, see Peter H. Wood, *Near Andersonville: Winslow Homer's Civil War* (Cambridge, MA: Harvard University Press, 2010), 77–79, and Wood's, "The Calabash Estate: Gourds in African American Life and Thought," 9.

86. Hegarty's artworks of watermelons were also inspired by the phenomenon of exploding watermelons in China where farmers oversprayed the fruits with growth chemicals that caused their insides to grow faster than their outsides.

87. The politics underlining images of watermelon are no less prevalent in the twenty-first century, especially during the presidency of Barack Obama. In October 2014, a political cartoon published by the *Boston Herald* depicted an intruder who jumped over the White House fence and infiltrated President Barack Obama's home. Illustrator Jerry Holbert showed the assailant soaping himself in Obama's bathtub, while asking the president, who brushes his teeth, "Have you tried the new watermelon flavored toothpaste?" Holbert's cartoon taps into a long visual history that used watermelon to diminish the integrity of African American people. He eventually rewrote the cartoon and substituted raspberry for watermelon-flavored toothpaste. Weeks after Holbert's cartoon was released, another event resurrected the watermelon stereotype. In November 2014, Daniel Handler (author of popular children's book *Lemony Snicket*) invited

National Book Award winner and African American children's author Jacqueline Woodson to the stage by saying: "I said that if [Woodson] won [the National Book Award] I would tell all of you something I learned about her this summer. Jackie Woodson is allergic to watermelon. Just let that sink in your minds." Woodson responded to Handler's remarks in an article in the *New York Times*, "The Pain of the Watermelon Joke," November 28, 2014.

CHAPTER 4. SEEING SPOTS

1. Mark H. Goldberg, *"Going Bananas": 100 Years of American Fruit Ships in the Caribbean* (Kings Point, NY: American Merchant Marine Museum Foundation, 1993), 3.

2. According to James Wiley, Polynesians carried bananas to Hawai'i, Arabs spread the fruit to coastal Africa, and the Spanish introduced bananas to the broader Americas. Virginia Scott Jenkins also found that the fruit was unfamiliar to most Americans, apart from a few records in the seventeenth century indicating that red varieties of the fruit arrived from Cuba. Wiley, *The Banana: Empires, Trade Wars, and Globalization* (Lincoln: University of Nebraska Press, 2008), 4–5; Virginia Scott Jenkins, *Bananas: An American History* (Washington, DC: Smithsonian Institution Press, 2000), xi, 41. For additional and seminal biographies on the banana, consult Peter Chapman, *Bananas: How the United Fruit Company Shaped the World* (New York: Canongate, 2009); Dan Koeppel, *Banana: The Fate of the Fruit That Changed the World* (New York: Plume Publications, 2008); Lorna Piatti-Farnell, *Banana: A Global History* (London: Reaktion Books, 2016); and Steve Striffler and Mark Moberg, eds., *Banana Wars: Power, Production, and History in the Americas* (Durham, NC: Duke University Press, 2003).

3. See, for example, James W. Martin, "Becoming Banana Cowboys: White-Collar Masculinity, the United Fruit Company, and Tropical Empire in Early Twentieth-Century Latin America," *Gender and History* 25, no. 2 (August 2013): 317–38. John Soluri also talks about the "banana men" in his book, yet he addresses the women working at companies such as United Fruit who "forged livelihoods that generated significant incomes for women and their families" as well. John Soluri, *Banana Cultures: Agriculture, Consumption, and Environmental Change in Honduras and the United States* (Austin: University of Texas Press, 2005), 16. See also John Soluri, *Banana Cultures: Agriculture, Consumption, and Environmental Change in Honduras and the United States* (Austin: University of Texas Press, 2006).

4. For an analysis of dining room materials and their capacity to civilize foreign influences, see Kenneth Ames, *Death in the Dining Room and Other Tales of Victorian Culture* (Philadelphia: Temple University Press, 1992); Kathryn Grover, *Dining in America, 1850–1900* (Amherst: University of Massachusetts Press, 1987); Kristin L. Hoganson, *Consumers' Imperium: The Global Production of American Domesticity, 1865–1920* (Chapel Hill: University of North Carolina Press, 2007); Katharine Morrison McClinton, "The Dining Room Picture," *Spinning Wheel* 34, no. 3 (1978); Norbert Elias, *The Civilizing Process: The History of Manners and State Formation and Civilization* (Oxford: Blackwell, 1994); and Susan Williams, *Savory Suppers and Fashionable Feasts: Dining in Victorian America* (Knoxville: University of Tennessee Press, 1996).

5. Alexander von Humboldt and Aimé Bonpland, *Personal Narratives of the Travels to the Equinoctial Regions of America during the Years 1799–1804,* trans. and ed. Thomasina Ross (London, 1852), quoted in "The Banana Tree," *Godey's Lady's Book* (January 1864).

6. Goldberg, *"Going Bananas,"* 3.

7. William H. Gerdts, *Painters of the Humble Truth: Masterpieces of American Still Life, 1801–1939* (Columbia: University of Missouri Press, 1981), 65. Hannah Brown Skeele (who also went by Harriet) was born in Kennebunkport, Maine. She painted her most famous still lifes, animal pictures, and portraits in Saint Louis, Missouri, after moving there in 1845. For more information, consult Martha Gandy Fales, "Hannah B. Skeele, Maine Artist," *Antiques* 121, no. 4 (April 1982):

915–21; Sarah E. Kelly, "Fruit Piece," *Art Institute of Chicago Museum Studies* 30, no. 1 (2004): 12–13, 94; and Lincoln Bunce Spice, "St. Louis Women Artists in the Mid-Nineteenth Century," *Gateway Heritage: Quarterly Journal of the Missouri Historical Society* 4 (Spring 1983): 19.

8. She was awarded first premium and $20 for a fruit picture in 1869. In 1870, she won second prize for a fruit piece. Fales, "Hannah B. Skeele, Maine Artist," 916.

9. Lawrence Glickman, *Buying Power: A History of Consumer Activism in America* (Chicago: University of Chicago Press, 2012), 71. For more information on the free-produce movement, consult Carol Faulkner, "The Root of the Evil: Free Produce and Radical Antislavery, 1820–1860," *Journal of the Early Republic* 27 (Fall 2007): 377–405; Ruth Nuremberger, *Free Produce Movement: A Quaker Protest against Slavery* (New York: AMS Press, 1970), 54–57; and Stacy Robertson, *Hearts Beating for Liberty: Women Abolitionists in the Old Northwest* (Chapel Hill: University of North Carolina Press, 2010), 73–84.

10. "Fifth Annual Report of the Board of Managers of the Free Produce Association of Friends of Ohio Yearly Meeting, *Non-Slaveholder* 2, no. 9 (1854): 73.

11. These artists potentially include Robert Duncanson and Eastman Johnson. See Shana Klein, "Cultivating Fruit and Equality in the Still-Life Paintings of Robert Duncanson," *American Art* 29, no. 2 (Summer 2015): 64–86.

12. Klein, "Cultivating Fruit and Equality," 77.

13. "Godey's Arm-Chair," *Godey's Lady's Book* (June 1875).

14. Jenkins, *Bananas: An American History*, 11; Koeppel, *Banana: The Fate of the Fruit*, 52.

15. W. W. James, "Bananas," *Florida Agriculturist* 19, no. 6 (February 10, 1892): 82.

16. Jenkins, *Bananas: An American History*, 52.

17. Piatti-Farnell, *Banana: A Global History*, 42.

18. "This Seems Liberal in the Offer of a Southern College for a Young . . ." *Godey's Lady's Book* (November 1871).

19. Koeppel, *Banana: The Fate of the Fruit*, xiv.

20. "The Home Circle: Bananas-One Cent," *Arthur's Home Magazine* (August 1, 1868): 120–22.

21. Alex Mayyasi specifically examines the history of banana peels, explaining that they were truly a dangerous menace in historic New York City with the lack of modern trash technologies to dispose of slippery fruit peels. "When New Yorkers Were Menaced by Banana Peels," *Gastro Obscura* (July 24, 2019).

22. Cindy Forster, "The 'Macondo of Guatemala': Banana Workers and National Revolution in Tiquisate, 1944–1954," in *Banana Wars: Power, Production, and History in the Americas*, ed. Steve Striffler and Mark Moberg (Durham, NC: Duke University Press, 2003), 201.

23. Henry R. Blaney, *The Golden Caribbean: A Winter Visit to the Republics of Colombia, Costa Rica, Spanish Honduras, Belize, and the Spanish Main via Boston and New Orleans* (Boston: Lee and Shepherd, 1900), 70, 72.

24. See Frederick Upham Adams's chapter, "Attacking the Wilderness," in *Conquest of the Tropics: The Story of the Creative Enterprises Conducted by the United Fruit Company* (New York: Doubleday Page, 1914), 35–54.

25. Susanne Freidberg has written about the history of refrigeration in her book *Fresh: A Perishable History* (Cambridge, MA: Belknap Press of Harvard University Press, 2010).

26. Freidberg, *Fresh*, 137–38.

27. Kyla Tompkins, *Racial Indigestion: Eating Bodies in the Nineteenth Century* (New York: New York University Press, 2012), 146.

28. Andrew Jackson Downing, *The Fruits and Fruit-Trees of America* (New York: Wiley and Sons, 1888), 1.

29. "Bananas in Brazil," *Christian Recorder* (November 3, 1866).

30. "Western Correspondence: Letters about the West," *National Era* (July 19, 1849).

31. Julie Berger Hochstrasser, *Still Life and Trade in the Dutch Golden Age* (New Haven, CT: Yale University Press, 2007), 255. Hochstrasser explains that she borrowed this idea from Elizabeth A. Honig, *Painting and the Market in Early Modern Antwerp* (New Haven, CT: Yale University Press, 1998), 162.

32. Hochstrasser, *Still Life and Trade,* 267.

33. Hochstrasser, *Still Life and Trade,* 105, 110.

34. Fruits were perceived as bad for digestion when eaten unripe. Fruit was also thought to be dangerous for children. See Jenkins, *Bananas: An American History,* 79–80.

35. Claude Lévi-Strauss, *Mythologiques: The Raw and the Cooked* (New York: Harper and Row, 1969).

36. Lévi-Strauss writes, "The raw/cooked axis is characteristic of culture; the fresh/decayed one of nature, since cooking brings about the cultural transformation of the raw, just as putrefaction is its natural transformation." Lévi-Strauss, *Mythologiques,* 142.

37. Cynthia Enloe also acknowledges the overlooked role of women in the banana industry in her essay, "Going Bananas! Where Are Women in the International Politics of Bananas?" This essay focuses more on the contemporary role of women in the industry, but it provides a good basis for understanding how scholarship on the banana industry has focused the perspective of men. Enloe, *Bananas, Beaches, and Bases: Making Feminist Sense of International Politics* (Berkeley: University of California Press, 2014), 211–49.

38. I extend my gratitude to Kelly Conway and Gail Bardhan at the Chrysler Museum for their information on banana stands.

39. Barry Blackburn, *Art Society and Accomplishments: A Treasury of Artistic Homes, Social Life, and Culture* (Chicago: Blackburn, 1891), 295–96. This idea was reinforced by culinary reformer Mary Lincoln in her speech at the Columbian Exposition, where she declared, "many people have awakened to the fact that eating is something more than animal indulgence, and that cooking has a nobler purpose than the gratification of appetite and the sense of taste. Cooking has been defined as the art of preparing food for the nourishment of the human body." Mary A. Lincoln, "Cookery," in *The Congress of Women: Held in the Woman's Building, World's Columbian Exposition, Chicago, U.S.A.* (Philadelphia: International Publishing, 1895), 139.

40. Amy Kaplan, "Manifest Domesticity," *American Literature* 70, no. 3 (September 1998): 111–34.

41. Kaplan, "Manifest Domesticity," 582.

42. Kaplan, "Manifest Domesticity."

43. See the following canonical scholarship on the United Fruit Company: Soluri, *Banana Cultures*; Striffler and Moberg, *Banana Wars*; and Jason Colby, *The Business of Empire: United Fruit, Race, and U.S. Expansion in Central America* (Ithaca, NY: Cornell University Press 2011). It should be noted that there were other banana monopolies as well; United Fruit was one of three major fruit corporations along with Standard Fruit and Cuyamel.

44. Blaney, *Golden Caribbean,* 70.

45. Harvey Levenstein, *Revolution at the Table: The Transformation of the American Diet* (Berkeley: University of California Press, 2003), 150–51.

46. Caroline E. Janney, *Remembering the Civil War: Reunion and the Limits of Reconciliation* (Chapel Hill: University of North Carolina Press, 2013), 226–28.

47. There were racial hostilities on banana plantations as well, where employers generally treated lighter-skinned workers better than darker-skinned workers. Jason Colby writes: "United Fruit managers and other white Americans carried a complex legacy of race and labor with them to Central America." Colby, *Business of Empire,* 4.

48. See Martin, "Becoming Banana Cowboys," 317–38.

49. Janet McKenzie Hill, *A Short History of the Banana and a Few Recipes for Its Use,* ed. Boston Cooking School (Boston: United Fruit Company, 1904), 11.

50. Laura Shapiro expands on the Boston Cooking School in her book *Perfection Salad: Women and Cooking at the Turn of the Century* (Oakland: University of California Press, 2008), 44–46.

51. Maria Parloa, cited in "Circulars of Information of the Bureau of Education," 1 (Washington, DC: Government Printing Office, 1877), 32; also cited by Shapiro, *Perfection Salad,* 121.

52. Catharine Beecher and Harriet Beecher Stowe, *The American Woman's Home; or, Principles of Domestic Science* (New York: J.B. Ford, 1869), 467.

53. Hester Poole, *Fruits and How to Use Them: A Practical Manual for Housekeepers* (Chicago: Woman's Temperance Publishing Association, 1892), 21–22.

54. Janet McKenzie Hill, "Bananas," *New England Kitchen Magazine* 1 (April–September 1894): 168.

55. Consult Philip Pauly's *Fruits and Plains: The Horticultural Transformation of America* (Cambridge, MA: Harvard University Press, 2008), 67–69, and Bruce Weber's *The Apple of America: The Apple in Nineteenth-Century American Art* (New York: Berry-Hill Galleries, 1993), 10.

56. Hill, *Short History of the Banana,* 18–19, 24.

57. Chapman, *Bananas,* 8.

58. Chapman, *Bananas,* 8.

59. Philippe Bourgois, "One Hundred Years of United Fruit Company Letters," in *Banana Wars: Power, Production, and History in the Americas,* ed. Steve Striffler and Mark Moberg (Durham, NC: Duke University Press, 2003), 104.

60. Colby, *Business of Empire,* 169, 173.

61. The United Fruit's "Publicity Department" was established as early as 1925, according to files discovered by John Soluri in conference materials for the Fruit Dispatch Company in 1925. Soluri, *Banana Cultures,* 64.

62. "On Your Great White Fleet Caribbean Cruise," *Outlook: An Illustrated Weekly Journal of Current Life* 129 (September–December 1921): 446.

63. United Fruit Company Steamship Services, *Great White Fleet: Following the Conquerors through the Caribbean Tour* (New York: William Darling Press, 1929), 1.

64. United Fruit Company Steamship Services, *Cruises O'er the Golden Caribbean* (New York: Refield-Downey-Odell, 1929), 14.

65. United Fruit Company Steamship Services, *Cruises O'er the Golden Caribbean,* 55.

66. For the reference to the "swarthy savages," see Adams, "Attacking the Wilderness," 21.

67. Adams, "Attacking the Wilderness," 356.

68. For more connections between the nineteenth-century American South and colonial agendas in Latin America in the twentieth century, see Peter Schmidt's, *Sitting in Darkness: New South Fiction, Education, and the Rise of Jim Crow Colonialism, 1865–1920* (Jackson: University Press of Mississippi, 2008) as well as his essay, "Tolentino, Cable, and Tourgée Confront the New South and the New Imperialism," in *Creating Citizenship in the Nineteenth-Century South,* ed. William A. Link, David Brown, Brian E. Ward, and Martyn Bone (Gainesville: University Press of Florida, 2013), 247–70.

69. Schmidt, *Sitting in Darkness,* 13.

70. Soluri, *Banana Cultures,* 164.

71. United Fruit Company, *Chiquita Banana's Cookbook* (New York, 196-), Collection of the Winterthur Library, Delaware.

72. Excerpt from Weston's daybook on April 4, 1927. Nancy Newhall, ed., *The Daybooks of Edward Weston* (New York: Aperture, 1990), 13.

73. Excerpt from Weston's daybook on June 22, 1930, p. 170.

74. By the time United Fruit published its cookbook cover, Weston was already well known. He had displayed photographs in major exhibitions at the Museum of Modern Art and in the first book

devoted exclusively to his work, *The Art of Edward Weston*. Exhibition reviews published in the *New York Times* and *San Francisco Chronicle* had also regularly commented on his pictures of food. By the 1960s, his "daybooks" and written records of daily life also were published.

75. Michele Bogart has explored this topic and the role of the art director specifically in the chapter, "Art Directors and the Art of Commerce," in *Artists, Advertising, and the Borders of Art* (Chicago: University of Chicago Press, 1995), 125–57.

76. Weston, on the other hand, may have disliked the appropriation of his art for United Fruit's cookbook cover, aligning himself with photographers such as Alfred Stieglitz and Paul Strand who wanted to see more separation between art and the "coarse" world of commerce. Photographers such as Edward Steichen, however, did not see a conflict in merging the two spheres. See Bogart's book chapter, "The Rise of Photography," 171–205.

77. Striffler and Moberg, *Banana Wars*, 12; Chapman, *Bananas*, 124.

78. United Fruit claimed that they were being cheated out of $19 million of land as a result of Árbenz's proposed land reform. Chapman, *Bananas,* 134.

79. Stephen Schlesinger and Stephen Kinzer, *Bitter Fruit: The Story of the American Coup in Guatemala*, rev. and expanded (Cambridge, MA: Harvard University Press, 2005), 60. Schlesinger and Kinzer write, "No evidence has ever been presented to show that Árbenz himself was under foreign control or that he ever had any substantial contact with Communists abroad, though much was made of the fact that Guatemala had become something of a gathering spot for Latin-American leftists."

80. Chapman, *Bananas,* 124.

81. This film was produced by Ed Whitman, head of public relations at United Fruit. Koeppel, *Banana: The Fate of the Fruit,* 128.

82. Chapman, *Bananas,* 7.

83. Greg Grandin defines soft power as the "spread of America's authority through nonmilitary means, through commerce, cultural exchange, and military cooperation." Grandin, *Empire's Workshop: Latin America, the United States, and the Rise of the New Imperialism* (New York: Metropolitan / Henry Holt , 2006), 3.

84. Striffler and Moberg, *Banana Wars*, 4.

85. The company enjoyed a rise again in the late 1960s and early 1970s, when it was rebranded as Chiquita Brands, operating with a new system of contract farming that supported this large agribusiness. Soluri, *Banana Cultures*, 191.

86. Colombian artist José Alejandro Restrepo also grappled with the abuses of the United Fruit Company in his installation *Musa Paradisiacal*, displaying banana bunches like lynched and tortured bodies to evoke the bodies slain during the government attack in Ciénaga, Colombia, in 1928, which was endorsed by the United Fruit Company. Mexican artist Minerva Cuevas tackled a similar subject in her 2003 installation mural on the Del Monte Foods Company building, reinventing the company's logo by purposely misspelling the name "Del Montte" with two *t*'s to reference José Efraín Ríos Montt, the president of Guatemala who, after a fraudulent election, was put into office by a military coup.

87. Mel Ziegler and Patricia Ziegler, *Banana Republic: Guide to Travel and Safari Clothing* (New York: Ballantine Books, 1986).

88. Ziegler and Ziegler, *Banana Republic*, 80.

89. See, for instance, Abigail Solomon-Godeau, "Going Native: Paul Gauguin and the Invention of Primitivist Modernism," in *The Expanding Discourse: Feminism and Art History,* ed. Norma Broude and Mary D. Garrard (New York: HarperCollins, 1992), 313–29.

90. O. Henry, *Cabbages and Kings* (New York: Doubleday Page, 1913). In 1967, Gabriel García Márquez's book, *One Hundred Years of Solitude,* also described greedy dictators behind banana

monopolies who fostered corruption and prioritized private over public interests, albeit from a different viewpoint than O. Henry.

91. Barrios's painting, *Absolut Banana*, for instance, shows two Disney characters that were designed for Latin American audiences: Panchito Pistoles, a gun-wielding, sombrero-wearing rooster, and José Carioca, a cigar-smoking Brazilian parrot in a Panama hat. Barrios critiques the way Disney cartoons present an exaggerated and unflattering portrait of Latin American people and how these cartoons represent the larger US influence and cultural grip on the region.

92. Laura Raynolds discusses the environmental devastation condoned by banana companies in "The Global Banana Trade," in *Banana Wars: Power, Production, and History in the Americas,* ed. Steve Striffler and Mark Moberg (Durham, NC: Duke University Press, 2003), 23–47.

93. In an interview, Barrios discusses how "the employees of the United States described Guatemala as a national virus. A country that could infect other small Central-American countries and infect them not just by way of Communism, but by interfering with American interests in those countries." For this quote, read Kristel Sabrina López Ruiz, "A Study of the Use of Rhetorical Figures in the Development of a Visual Language in the Work *Bananarama* and *Contaminations* of Moisés Barrios" (master's thesis, Department of Architecture and Design, Rafael Landívar University, Guatemala City, July 2014), 47.

94. Ellen Macfarlane, "Group f.64, Rocks, and the Limits of the Political Photograph," *American Art* 30, no. 3 (Fall 2016): 26–53.

95. Macfarlane, "Group f.64," 41.

CHAPTER 5. PINEAPPLE REPUBLIC

1. For a more complete history on the origins of this fruit, see Fran Beauman, *The Pineapple: King of Fruits* (London: Chatto and Windus, 2005); Gary Y. Okihiro, *Pineapple Culture: A History of the Tropical and Temperate Zones* (Berkeley: University of California Press, 2009); and Richard A. Hawkins, *Pacific Industry: The History of Pineapple Canning in Hawaiʻi* (London: I. B. Taurus, 2011).

2. Beauman, *Pineapple: King of Fruits*, 20.

3. Beauman, *Pineapple: King of Fruits*, 38.

4. Okihiro, *Pineapple Culture*, 172.

5. Beauman, *Pineapple: King of Fruits*, 123, 134.

6. Decades later, the Dole Hawaiian Pineapple Company expanded its business to include the cultivation and export of Latin American bananas in 1961, absorbing the Standard Fruit Company, a competitor to the United Fruit Company.

7. Elijah Ward, "Speech of Honorable Elijah Ward in the House of Representatives" (Washington, DC: Congressional Record, 1876), 5.

8. Ward, "Speech."

9. Ward, "Speech," 6.

10. Ward, "Speech," 2. Southern Democrats in Congress also rejected annexation because they wanted to protect the American investments in sugar that were now being threatened by a new industry in Hawaiʻi.

11. One writer in 1869 was especially cruel, describing Hawaiian culture as representing "the lowest stages of barbarism, sensuality, and vice." Samuel Colcord Bartlett, *Historical Sketch of the Hawaiian Mission, and the Missions to Micronesia and the Marquesas Islands* (Boston: American Board of Commissioners for Foreign Missions, 1869), 4.

12. Okihiro, *Pineapple Culture*, 130, 148.

13. A file in the Hawaiʻi State Archives identifies this photo as a depiction of James Dole, though other archivists at this same institution do not substantiate this claim. The man photographed might be Dole or William Thomas, founder of the Thomas Pineapple Company.

14. Candace Fujikane and Jonathan Y. Okamura, eds., *Asian Settler Colonialism: From Local Governance to the Habits of Everyday Life in Hawai'i* (Honolulu: University of Hawai'i Press, 2008), 5.

15. Noenoe K. Silva, *Aloha Betrayed: Native Hawaiian Resistance to American Colonialism* (Durham, NC: Duke University Press, 2004).

16. The Hawaii Promotion Committee, *Paradise of the Pacific* 22 (December 1909): 9.

17. F.M. Hatch, "Conditions in Hawai'i," *Proceedings of the Twenty-First Annual Meeting of the Lake Mohonk Conference of Friends of the Indian* (1903), 87.

18. Hatch, "Conditions in Hawai'i," 89, 91.

19. James Bryce, "The Policy of Annexation for America," *Forum* 24 (December 1897): 390. Cited in Eric T. Love's *Race over Empire: Racism and U.S. Imperialism, 1865–1900* (Chapel Hill: University of North Carolina Press, 2004), 129. Doctors assured readers that "the white races can do farm work as well here as in America or Europe in Summer, really with less discomfort, as the heat is never so intense and sunstroke is unknown." G.P. Andrews, MD, "Our Wonderful Climate," *Paradise of the Pacific* (May 1898).

20. See the reactions in Hatch's report, "Conditions in Hawai'i," 92.

21. Hatch, "Conditions in Hawai'i," 86.

22. Hawkins, *Pacific Industry,* 138.

23. Hawkins, *Pacific Industry,* 54.

24. This group of moguls included "The Big Five" sugar businesses: Alexander and Baldwin, American Factors, C. Brewer, Castle and Cooke, and Theo. H. Davies. Sugar and pineapple industries were intertwined, but sugar businesses also viewed the pineapple industry as a threat, sometimes fighting over the same pool of laborers. For more history on this relationship, read Hawkins, *Pacific Industry,* 18–20.

25. A market for canning emerged in Baltimore, Maryland, a location near the Mason-Dixon Line that was useful for shuttling food between the North and South. Hawkins, *Pacific Industry,* 6.

26. Caroline Manning, "The Employment of Women in the Pineapple Canneries of Hawai'i," *United States Department of Labor, Bulletin of the Women's Bureau* 82 (Washington: US Government Printing Office, 1930), 4.

27. Hawkins, *Pacific Industry,* 107.

28. Advertisement for the Hawaiian Pineapple Company, "The 'Perfect Servant' Lives in Honolulu," 1928.

29. "The Hawaiian Pineapple Cannery," *Canning Age: Devoted to the Canning, Packing, and Allied Industries* (1922): 6.

30. "Perfect Servant Lives in Honolulu."

31. "Perfect Servant Lives in Honolulu."

32. Manning, "Employment of Women in the Pineapple Canneries of Hawai'i," 7.

33. "Hawaiian Pineapple Cannery," 9–10.

34. "Hawaiian Pineapple Cannery," 11.

35. "Hawaiian Pineapple Cannery," 7.

36. Marion Mason Hale, *The Kingdom That Grew Out of a Little Boy's Garden* (Honolulu: Hawaiian Pineapple Company, 1931), 12.

37. "The Hawaiian Pineapple Cannery," 6.

38. Manning, "Employment of Women in the Pineapple Canneries of Hawai'i," 19.

39. For more information on the topic of food activists, especially as they relate to Libby, McNeil, and Libby, consult Bonnie Miller, "Culinary Encounters at the Fair: 'Pure Food' on Exhibit at the Panama-Pacific International Exposition, San Francisco, 1915," *Southern California Quarterly* 100, no. 2 (Summer 2018).

40. Eunice White Beecher, *All Around the House; or, How to Make Homes Happy* (New York: D. Appleton, 1878), 151.

41. "John Chinamen in the Wine Press," *San Francisco Call*, October 14, 1878, in Bancroft Scrapbooks, "Chinese," No. 8, p. 57.

42. Bonnie Miller explains that the Smith Cannery Machinery Company of Seattle invented the "Iron Chink," a machine that canned fish without human intervention. The company named it the "iron chink" for its replacement of a largely Chinese labor force that had previously canned salmon. Miller writes, "In a cultural climate of anti-Chinese sentiment, surely it was not lost on fairgoers that the machine would protect consumers from ingesting fish touched by Chinese hands." Miller, "Culinary Encounters at the Fair," 151.

43. Melanie DuPuis, *Dangerous Digestion: The Politics of American Dietary Advice* (Berkeley: University of California Press, 2015), 83.

44. "Labor Problems in Hawai'i: Hearings before the Committee on Immigration and Naturalization" (Washington, DC: Government Printing Office, 1921), 496.

45. "Labor Problems in Hawai'i," 320.

46. Shannon Steen, *Racial Geometries of the Black Atlantic, Asian Pacific, and American Theatre* (London: Palgrave Macmillan, 2010), 142–43.

47. Richard Hawkins, "James Dole and the 1932 Failure of the Hawaiian Pineapple Company," *Hawaiian Journal of History* 41 (2007): 153.

48. " Hawaiian Pineapple Cannery," 15.

49. The idea of Hawai'i as a "multiracial nirvana" was made famous by sociologist Romanzo Adams. Judy Rohrer discusses the history of this concept on pages 82 and 83 of her book *Staking Claim: Settler Colonialism and Racialization in Hawai'i* (Tucson: University of Arizona Press, 2016).

50. This display was organized by the Pineapple Growers Association with the Hawaii Promotion Committee, which included leaders of the Hawaiian Pineapple Company. "Participation in the Alaska-Yukon Exposition," 61st Congress, Senate Documents 29 (Washington, DC: US Government Printing Office, 1911), 86.

51. The girls traveled to the exposition chaperoned by Mrs. William J. Hooper, Acting Secretary of the Hawaii Promotion Committee and wife to the director of the Hawaii Promotion Bureau in Seattle. "Participation in the Alaska-Yukon Exposition," 86.

52. *The Blue Book: A Comprehensive Official Souvenir View Book Illustrating the Panama Pacific International Exposition, San Francisco, 1915* (San Francisco: Robert A. Reid, 1915), 213.

53. Frank Morton Todd, *The Story of the Exposition* 3 (New York: G.P. Putnam's Sons, 1921), 323.

54. "Hawai'i at the Panama Exposition," *Mid-Pacific Magazine* 8, no. 1 (July 1914): 493.

55. "Hawai'i at the Panama Exposition."

56. Albert P. Taylor, "Hawai'i: The Best Known Building at the Panama-Pacific Exposition, 1915," in *All about Hawai'i: The Recognized Book of Authentic Information on Hawai'i, Combined with Thrum's Hawaiian Annual and Standard Guide* (Honolulu: Honolulu Star Bulletin, 1913), 149.

57. Hawkins, *Pacific Industry*, 47.

58. Hawkins, *Pacific Industry*, 50.

59. "The Year's Showing," *Paradise of the Pacific* 12.22 (Dec. 1909), 9.

60. Hawkins, Pacific Industry, 54, 57. In 1932, Castle and Cooke bought into the company, diluting James Dole's influence and removing him as the company's manager. By the 1930s, the company still maintained the brand's connection with James Dole, labeling its cans and products "Dole."

61. "Dole in Big Campaign of Advertising: Hawaiian Pineapple Announces Costly Program," *Honolulu Advertiser*, April 13, 1927.

62. Hawkins, *Pacific Industry*, 79, 88.

63. Advertisement for the Hawaiian Pineapple Company, Lloyd Sexton, *Exotic*, 1935.

64. An article indicates that the company paid $235 for Sexton's depiction. "Lloyd Sexton Creates Another Fine Illustration," the Dole Archive at the University of Hawai'i Mānoa Library.

65. For a list of awards, read "Pine Ad Wins Exhibit Honors," *Honolulu Advertiser*, May 13, 1939; "Ads Win Nation Art Prizes at New York," *Honolulu Advertiser*, April 15, 1940.

66. See DeSoto Brown's "Beautiful, Romantic Hawai'i: How the Fantasy Image Came to Be," *Journal of Decorative and Propaganda Arts* 20 (1994): 252–71.

67. Patricia Johnston, "Advertising Paradise: Hawai'i in Art, Anthropology, and Commercial Photography," in *Colonialist Photography: Imag(in)ing Race and Place*, ed. Eleanor M. Hight and Gary D. Sampson (London: Routledge, 2002), 209.

68. Sascha Scott argues that having a white woman of means like O'Keeffe living around or near the working quarters was especially unsuitable after the famous "Massie affair," when a white woman accused Hawaiian and Asian working-class men of assault. Michele Bogart speculates that O'Keeffe wanted to stay near the working quarters for more practical reasons; on a tour around the island, she may have wanted to stay in the village where workers lived to avoid the roundtrip ride back to her accommodations. Sascha Scott, "Georgia O'Keeffe's Hawai'i: Decolonizing the History of American Modernism," *American Art* (Summer 2019); Michele Bogart, *Artists, Advertising, and the Borders of Art* (Chicago: University of Chicago Press, 1995), 165–66.

69. Letter to Alfred Stieglitz from Wailuku, Maui Grand Hotel, March 25, 1939. Georgia O'Keeffe Archive at Yale University in the Beinecke Rare Book and Manuscript Library.

70. Letter to Alfred Stieglitz.

71. "Pineapple for Papaya," *Time*, February 12, 1940, 16.

72. See Bradley Lynch, "Ayer Gets a Taste of O'Keeffe," *Advertising Age*, April 17, 1986, and "O'Keeffe's Pineapple," *Art Digest* (March 1, 1943): 17.

73. Christine Skwiot, *The Purposes of Paradise: U.S. Tourism and Empire in Cuba and Hawai'i* (Philadelphia: University of Pennsylvania Press, 2011), 141.

74. Letter to Alfred Stieglitz, February 22, 1939. Georgia O'Keeffe Archive at Yale University in the Beinecke Rare Book and Manuscript Library.

75. "New Labor Policy Is Announced by Hawaiian Pines," *Honolulu Advertiser*, May 16, 1938, 1; Jared G. Smith, "Trend of Trade," *Star Bulletin*, May 16, 1938, 1.

76. Gerald Horne discusses these strikes and the development of labor unions more deeply in *Fighting in Paradise: Labor Unions, Racism, and Communists in the Making of Modern Hawai'i* (Honolulu: University of Hawai'i Press, 2011), and Skwiot, *Purposes of Paradise*, 148–50.

77. "Pineapple for Papaya," 16.

78. In an article in *American Art*, Sascha Scott persuasively demonstrates how O'Keeffe's approach to Hawai'i still treated the region as an exotic paradise "ripe for the taking." She concludes that O'Keeffe's paintings served to "naturalize and justify U.S. conquest" while working with this company that was deeply intertwined with this very conquest. "Georgia O'Keeffe's Hawai'i" (Summer 2019).

79. Lynch, "Ayer Gets a Taste of O'Keeffe," 24. O'Keeffe's painting, among many others used in Dole advertisements, hung in the new headquarters of Castle and Cooke Foods in San Francisco's Union Bank Building. The company was later asked about creating an exhibition from their art collection. See a letter by Leigh Stevens, assistant secretary, on July 14, 1972, and "Artwork to Dole," University of Hawai'i Mānoa Library.

80. Georgia O'Keeffe, *First Showing: A Dole Pineapple Bud from Hawai'i*, 1939–40.

81. Georgia O'Keeffe letter to Alfred Stieglitz, Hana, March 20, 1939. Georgia O'Keeffe Archive at Yale University in the Beinecke Rare Book and Manuscript Library.

82. William Chapman, *Hawai'i, the Military, and the National Park: World War II and Its Impacts on Culture and the Environment* (Washington, DC: American Society for Environmental History and National Park Service, 2013), 208, 53.

83. "Hawaiian Pineapple Company, Limited Annual Report for the Fiscal Year Ended May 31, 1941," p. 14, at the University of Hawai'i Mānoa Library.

84. The company announced their names in an "In Memoriam" section in at least two of their newsletters: "In Memoriam," *Hawaiian Pineapple Company, Limited Annual Report for the Fiscal Year Ended May 31, 1941*, p. 18; "In Memoriam," *Hawaiian Pineapple Company, Limited Annual Report for the Fiscal Year Ended May 31, 1945*, p. 23, in Dole Archive at the University of Hawai'i at Mānoa Library.

85. *National Wartime Nutrition Guide* (Washington, DC: United State Department of Agriculture, War Food Administration, Nutrition and Food Conservation Branch, 1943), 3.

86. "War on Theft of Pineapples," *Honolulu Advertiser*, July 8, 1942.

87. Hawkins, *Pacific Industry*, 176.

88. Brown, "Beautiful, Romantic Hawai'i, 270.

89. Lizzie Collingham, *The Taste of War: World War II and the Battle for Food* (New York: Penguin Press, 2012), 421.

90. Historian Amy Bentley estimates that 6.5 million Americans grew victory gardens and their own foods to supplement the war effort in 1942. The government called for victory gardens and victory canners, paying volunteers. Amy Bentley, *Eating for Victory: Food Rationing and the Politics of Domesticity* (Urbana: University of Illinois Press, 1998), 117.

91. See Lloyd Sexton's advertisement, "Plenty of Pineapple, But—Sorry—Not for You," *Life Magazine*, June 25, 1941, 92.

92. "Hawaiian Pineapple Company, Limited Annual Report for the Fiscal Year Ended May 31, 1941," p. 19, in Dole Archive at the University of Hawai'i at Mānoa Library.

93. Skwiot reports that three thousand Americans of Japanese ancestry in Hawai'i served in the army during World War II. Skwiot, *Purposes of Paradise*, 148.

94. Skwiot, *Purposes of Paradise*, 148.

95. Judith Schachter, *The Legacies of a Hawaiian Generation: From Territorial Subject to American Citizen* (Oxford: Berghahn Books, 2013), 91–93.

96. "Harvest Waits for No Man," Dole advertisement, *Life Magazine*, July 12, 1943, 42.

97. Skwiot, *Purposes of Paradise*, 150.

98. Skwiot, *Purposes of Paradise*, 149.

99. Aya Hirata Kimura and Krisnawati Suryanata, introduction to *Food and Power in Hawai'i: Visions of Food Democracy* (Honolulu: University of Hawai'i Press, 2016), 4.

100. Beauman, *Pineapple: King of Fruits*, 237.

101. Notably, a number of Hawaiians resisted statehood, worrying that it would further boost land dispossession and place power in the hands of a white, and now Asian, elite. Eiko Kosasa writes, "the United States gave voters only two political choices: to remain a Territory under the United Sates or to become a state within the United States. Neither choice gave voters the option for decolonization. The only 'choice' offered was the degree to which Hawai'i would remain a colonial possession: as a Territory or as a state. For Native Hawaiians, the choice of statehood furthered their colonial subjugation." "Ideological Images: U.S. Nationalism in Japanese Settler Photographs," in *Asian Settler Colonialism: From Local Governance to the Habits of Everyday Life in* Hawai'i, ed. Candace Fujikane and Jonathan Y. Okamura (Honolulu: University of Hawai'i Press, 2008), 231–32.

102. Candace Fujikane discusses how Asian settlers and their descendants were beneficiaries of US settler colonialism, "ushering in a new era of Asian settler political ascendancy" after World

War II. She encourages readers to consider how Asian immigrants were oppressed in Hawai'i in ways that advanced indigenous land dispossession. Fujikane and Okamura, *Asian Settler Colonialism,* 6, 13.

103. Bruehl (1900–1982) was a well-known advertising photographer from Australia. He was celebrated for his experimental color photography, developed in collaboration with photo technician Fernand Bourges. For more information on Bruehl's time in Hawai'i, read Belinda Hungerford, *Anton Bruehl: In the Spotlight* (Sydney: National Gallery of Australia, 2011), 49–53, and Patricia Johnston, "Advertising Paradise: Hawai'i in Art, Anthropology, and Commercial Photography," 214–15.

104. Haunani-Kay Trask, *From a Native Daughter: Colonialism and Sovereignty in Hawai'i* (Honolulu: University of Hawai'i Press, 1999), 18.

105. Trask, *From a Native Daughter,* 18.

106. "Hawaiian Pineapple Company, Limited Annual Report for the Fiscal Year Ended May 31, 1959," Dole Archive at the University of Hawai'i at Mānoa Library.

107. "Hawaiian Pineapple Company, Limited Annual Report."

108. Concerns of this nature are expressed in a letter to Henry White from Louisiana senator Allen Ellender (August 3, 1950), *Hawaiian Statehood Committee Records,* Hawai'i State Archives. See also Ben Adams, *Hawai'i: The Aloha State; Our Island Democracy in Text and Pictures* (New York: Hill Publishing, 1959), 128.

109. Previously, the House Un-American Activities Committee held hearings about "Communist Activities in the Territory of Hawai'i," targeting the International Longshore and Warehouse Union, of which many pineapple workers were members. Horne, *Fighting in Paradise,* 214.

110. Letter from President Henry A. White to Louisiana senator Allen J. Ellender (June 5, 1950) in the file "Washington Office–Mclane Correspondence, Hawaiian Pineapple Company, 1948–1950," *Hawaiian Statehood Commission Records,* Hawai'i State Archives.

111. Dean Itsuji Saranillio, "Colliding Histories: Hawai'i Statehood at the Intersection of Asians 'Ineligible to Citizenship' and Hawaiians 'Unfit for Self-Government,'" *Journal of Asian American Studies* 13, no. 3 (October 2010): 289.

112. The Statehood Commission was formerly the Hawai'i Equal Rights Commission. *Hawaiian Statehood Commission Records,* Records at the Hawai'i State Archives. Saranillio, "Colliding Histories," 291.

113. "Letter from George Crabb to George McLane," April 26, 1950, in the Hawaiian Pineapple Company records at the Hawai'i State Archives.

114. The commission also created *Treasure Islands,* a film on the growing and processing of pineapples. See correspondence between George H. McLane, Executive Secretary of the Hawai'i Statehood Commission, and Calvin White, Public Relations Director at the Hawaiian Pineapple Company in records at the Hawai'i State Archives.

115. The title of the photograph, *Pineapple Guide,* suggests that she is an ambassador for the Hawaiian pineapple. She may have belonged to a group known as the "Dole Ladies," docents who led tours around Honolulu's canneries, according to Jack Larsen in *Hawaiian Pineapple Entrepreneurs: 1894–2010* (Sheridan, OR: Jack Larsen, 2010), 232.

116. There is a long history of water theft in Hawai'i. See Dean Itsuji Saranillio, *Unsustainable Empire: Alternative Histories of Hawai'i Statehood* (Durham, NC: Duke University Press, 2018), 174–75.

117. "Hawaiian Pineapple Cannery," 15.

118. Adams, *Hawai'i: The Aloha State,* 21.

119. Adams, *Hawai'i: The Aloha State,* 21.

120. Gerald Horne discusses racism against African Americans on the Islands since colored troops were recruited to Hawai'i to fight World War II. He also quotes a union leader who swore that

"Honolulu is one of the most prejudiced places against Negroes," rife with racism and segregation in 1954. Horne, *Fighting in Paradise*, 298.

121. Judy Rohrer specifically discusses Hawai'i in the context of cultural amnesia in her chapter "'Melting Pot' versus 'Cauldron of Hate': Cooking Up Racial Discourse in 'Hawai'i," in *Staking Claim: Settler Colonialism and Racialization in Hawai'i* (Tucson: University of Arizona Press, 2016). See also Christin Mamiya, "Greetings from Paradise: The Representation of Hawaiian Culture in Postcards," *Journal of Communication Inquiry* 16, no. 2 (Summer 1992): 86–100.

122. See Henry A. Giroux, *The Violence of Organized Forgetting: Thinking beyond America's Disimagination Machine* (San Francisco: City Lights, 2014).

123. Okihiro, *Pineapple Culture*, 152, who cites Jan K. TenBruggencate, *Hawai'i's Pineapple Century: A History of the Crowned Fruit in the Hawaiian Islands* (Honolulu: Mutual Publishing, 2004), 153–57.

124. Dole whip is also available for sale outside Dole's Enchanted Tiki Room in California's Disneyland, another national venue that presents fantasies of an American past. Research on the relationship between Dole and Walt Disney warrants further investigation.

CONCLUSION

1. https://ciw-online.org/.

2. For a more in-depth analysis of this sculpture, refer to Shana Klein, "Lady Liberty with a Tomato: A Dialogue on Art and Activism with the Coalition of Immokalee Farmworkers," *Public Art Dialogue* 8, no. 1 (2018): 98–113.

3. For more information, consult Stephen Velasquez, "Doing It with 'Ganas': Mexicans and Mexican Americans Shaping the California Wine Industry," *Southern California Quarterly* 100, no. 2 (Summer 2018): 216–43.

4. This monument approved by the Sonoma City Council will include an educational plaque and *ting*—a tile-roofed covered pavilion—to educate viewers on the critical role that Chinese laborers played in building California's vineyards. It will potentially be funded in part by the northeastern Chinese city of Penglai, also known for wine production.

5. See Michael Twitty, *The Cooking Gene: A Journey through African-American Culinary History in the Old South* (New York: Amistad, 2017).

6. Naomi Slipp has written an essay on the subject; see "Gilded Age Dining: Eco-Anxiety, Fisheries Management, and the Presidential China of Rutherford B. Hayes," in *Ecocriticism and the Anthropocene in Nineteenth-Century Art and Visual Culture,* ed. Maura Coughlin and Emily Gephart (London: Routledge, 2019), 135–44.

7. Guy Jordan's dissertation is one example of scholarship on the visual culture of drink: "The Aesthetics of Intoxication in Antebellum American Art and Culture" (PhD diss., University of Maryland, 2007).

8. Kara Walker, *A Subtlety; or, the Marvelous Sugar Baby,* 2014, http://creativetime.org/projects /karawalker/curatorial-statement/; Titus Kaphar, *A Pillow for Fragile Fictions,* 2016, https:// kapharstudio.com/pillow-fragile-fictions/.

9. George Gessert, "Notes on Genetic Art," *Leonardo* 26 (1993): 205–11.

10. Jenni Lauwrens, "Welcome to the Revolution: The Sensory Turn and Art History," *Journal of Art Historiography* 7 (December 2012): 1–17, and Leo Mazow, "Sensing America," *American Art* 24, no. 3 (Fall 2010): 2–11.

11. See Martha Rosler's work, *Semiotics of the Kitchen,* from 1975 in the collection of the Museum of Modern Art, New York, and Judy Chicago's *Dinner Party* from 1974 to 1979 at the Brooklyn Museum, New York.

12. Susan Futrell, *Good Apples: Behind Every Bite* (Iowa City: University of Iowa Press, 2017); Thomas Okie, *The Georgia Peach: Culture, Agriculture, and Environment in the American South* (Cambridge:

Cambridge University Press, 2016); Brad Weiss, *Real Pigs: Shifting Values in the Field of Local Pork* (Durham, NC: Duke University Press, 2016); Michaela DeSoucey, *Contested Tastes: Foie Gras and the Politics of Food* (Princeton, NJ: Princeton University Press, 2016); M. Squicciarini and Johan Swinnen, *The Economics of Chocolate* (Oxford: Oxford University Press, 2016); Marianne E. Lien, *Becoming Salmon: Aquaculture and the Domestication of a Fish* (Berkeley: University of California Press, 2015); Yael Raviv, *Falafel Nation: Cuisine and the Making of National Identity in Israel* (Lincoln: University of Nebraska Press, 2015); Michael Lange, *Meanings of Maple: An Ethnography of Sugaring* (Fayetteville: University of Arkansas Press); and Kristy Leissle, *Cocoa* (Medford, MA: Polity Press, 2018). Reaktion books also has a series devoted to singular food histories.

BIBLIOGRAPHY

PERIODICALS AND ARCHIVAL RESOURCES

Edwin and Robert Deakin Papers (1835–1881). Smithsonian Archives of American Art, Washington, DC.

Florida Tatler. Saint Augustine Historical Society, Saint Augustine, Florida.

Harriet Beecher Stowe Archives. Kirkham Papers. Harriet Beecher Stowe Center, Hartford, Connecticut.

"Hawaiian Pineapple Company, Annual Reports, Dole Archive at the University of Hawai'i at Mānoa Library.

Semi-Tropical Monthly Magazine (1870–1880).

Stowe, Harriet Beecher. "Palmetto Leaves from Florida." *Christian Union.*

Way, Andrew John Henry, *Art Amateur* (1883–1887).

PRIMARY SOURCES

Adams, Frederick Upham. "Attacking the Wilderness." In *Conquest of the Tropics: The Story of the Creative Enterprises Conducted by the United Fruit Company.* New York: Doubleday Page, 1914.

"Ads Win Nation Art Prizes at New York." *Honolulu Advertiser,* April 15, 1940.

"Among the Artists" *The Gazette* (March 25, 188-).

"Among the Artists." *San Francisco Chronicle,* December 28, 1884.

Andrews, G. P. "Our Wonderful Climate." *Paradise of the Pacific* (May 1898).

"The Art Exhibition." *San Francisco News Letter and California Advertiser,* April 22,1882.

"Art: More Substantial Recognition Needed from Leading Citizens." *Daily Evening Post,* May 1, 1880.

"Art Notes." *Overland Monthly* (December 1874): 574.

"The Art Galleries, New Paintings by Old and New Artists." Edwin and Robert Deakin Papers at the Smithsonian Archives of American Art, Washington, DC.

"An Art Proposition: Rotary Exhibitions of Representative Paintings." *Salt Lake Daily Herald,* date unknown.

"Aurantia Grove, Indian River, East Florida." Springfield, MA: Clark W. Bryan, 1872.

Bacon, William. "The War and Agriculture." *Country Gentleman* (March 1864): 41.

"The Banana Tree." *Godey's Lady's Book* (January 1864).

"Bananas." *New England Kitchen Magazine* 1 (April–September, 1894): 168.

"Bananas in Brazil." *Christian Recorder* (November 3, 1866).

Barbour, George. *Florida for Tourists, Invalids, and Settlers.* New York: D. Appleton, 1882.

Bartholf, J.F. *South Florida, the Italy of America: Its Climate, Soil, and Productions.* Jacksonville: Ashmead Bros., 1881.

Bartlett, Samuel Colcord. *Historical Sketch of the Hawaiian Mission, and the Missions to Micronesia and the Marquesas Islands.* Boston: American Board of Commissioners for Foreign Missions, 1869.

Beecher, Catherine Ester, and Harriet Beecher Stowe. *American Woman's Home; or, Principles of Domestic Science.* New York: J.B. Ford, 1869.

Beecher, Eunice. *All Around the House; or, How to Make Homes Happy.* New York: D. Appleton, 1878.

Bill, Ledyard. *A Winter in Florida; or, Observations on the Soil, Climate, and Products of Our Semi-Tropical State with Sketches of the Principal Towns and Cities of Eastern Florida.* New York: Wood and Holbrook, 1870.

Blackburn, Barry. *Art Society and Accomplishments: A Treasury of Artistic Homes, Social Life, and Culture.* Chicago: Blackburn, 1891.

Blaney, Henry R. *The Golden Caribbean: A Winter Visit to the Republics of Colombia, Costa Rica, Spanish Honduras, Belize, and the Spanish Main via Boston and New Orleans.* Boston: Lee and Shepherd, 1900.

The Blue Book: A Comprehensive Official Souvenir View Book Illustrating the Panama Pacific International Exposition, San Francisco, 1915. San Francisco: Robert A. Reid, 1915.

Bryce, James. "The Policy of Annexation for America." *Forum* 24 (December 1897).

Bureau of Immigration. *Semi Tropical Florida.* Chicago: Rand, McNally, 1881.

California Big Tree Joint Wine Exhibit: C. Carpy and Co., J. Gundlach and Co., Arpad Haraszthy and Co., Napa Valley Wine Co. San Francisco World's Columbian Exposition, Chicago, 1893.

Carleton, J.H. "El Dorado, Arkansas." *Grape Culturist* (August 1869): 336.

Carrère, John, and Thomas Hastings. *Florida, the American Riviera; St. Augustine, the Winter Newport.* New York: Gilliss Brothers and Turnure, the Art Age Press, 1887.

Chorlton, William. *Grape Grower's Guide: A Handbook of the Cultivation of the Exotic Grape.* New York: Orange Judd, 1894.

Cloverdale Reveille, May 20, 1882, 4.

Coleman, W.T. "The Pure American Wines: A Plea for the Use of the Native-Grown Article." *Washington Post,* May 19, 1886.

"A Colored Man at Des Moines." *Christian Recorder,* September 30, 1886.

"Colored People's Day." *Daily Inter Ocean,* August 22, 1893, 6.

C.W.D. "Art at the Ponce De Leon." *News Herald, St. Augustine,* 18--, 91.

Davis, George. *A Treatise on the Culture of the Orange and Other Citrus Fruits.* Jacksonville: Charles Dacosta, 1882.

"Difficulties of Watermelon." *New England Homestead* (September 19, 1874): 298.

"Dole in Big Campaign of Advertising: Hawaiian Pineapple Announces Costly Program." *Honolulu Advertiser,* April 13, 1927.

Donaldson, L., and A.J.H. Way. "Fruit-Painting in Oils." *Art Amateur* 16, no. 1 (December 1886): 9–10.

Downing, Andrew Jackson. *The Fruits and Fruit-Trees of America.* New York: Wiley and Sons, 1888.

Ellsworth, Milon. *The Successful Housekeeper: A Manual Especially Adapted to American Housewives.* Harrisburg: Pennsylvania Publishing, 1884.

"The Exhibition of Pictures at the Athenaeum Gallery." *North American Review* 33 (October 1831).

"Fashion, Fact, and Fancy." *Godey's Lady's Book* (December 1896).

"Fifth Annual Report of the Board of Managers of the Free Produce Association of Friends of Ohio Yearly Meeting." *Non-Slaveholder* 2, no. 9 (1854): 73.

"Florida House Lots: Only $15." *Godey's Lady's Book* (1886): 644.

French, Seth. *Florida: Its Climate, Soil, and Productions*. Jacksonville: Edwin M. Cheney, 1869.

Fuller, Andrew Samuel. *The Grape Culturist: A Treatise on the Cultivation of the Native Grape*. New York: Davies and Kent, 1864.

Gardeners Monthly and Horticultural Advertisement 11 (Philadelphia: Brinckloe and Marot, 1869): 120.

Gillespie, Elizabeth D. "National Cookery Book: Compiled from Original Receipts, for the Women's Centennial Committees." *Spirit of Seventy-Six*, vol. 1. Philadelphia: Executive Committee of the Women's Branch of the Centennial Association for Connecticut, 1875.

"Godey's Arm-Chair." *Godey's Lady's Book* (June 1875).

"Greeley Prize on Grapes." *Horticulturist and Journal of Rural Art and Rural Taste* 21 (1866): 341.

Grey, Emma. "The Beautiful Home-Club." *Godey's Lady's Book* (April 1890): 335.

Grund, Francis J. *Graham's American Monthly Magazine of Literature and Art* 30 (1847).

Hale, Marion Mason. *The Kingdom That Grew Out of a Little Boy's Garden*. Honolulu: Hawaiian Pineapple Company, 1931.

Haraszthy, Agoston. *Grape Culture, Wines, and Wine-Making: With Notes upon Agriculture and Horti-Culture*. New York: Harper and Bros. 1862.

Harcourt, Helen. *Home Life in Florida*. Louisville: John P. Morton, 1889.

"Harvest Waits for No Man." Dole Advertisement. *Life* magazine, July 12, 1943, 42.

Hatch, F.M. "Conditions in Hawai'i." *Proceedings of the Twenty-First Annual Meeting of the Lake Mohonk Conference of Friends of the Indian* (1903).

"Hawai'i at the Panama Exposition." *Mid-Pacific Magazine* 8, no. 1 (July 1914): 493.

"The Hawaiian Pineapple Cannery." *Canning Age: Devoted to the Canning, Packing, and Allied Industries*. National Trade Journals, 1922.

The Hawaii Promotion Committee. *Paradise of the Pacific* 22 (December 1909).

———. "Participation in the Alaska-Yukon Exposition," 61st Congress, Senate Documents 29. Washington, DC: US Government Printing Office, 1911.

Heade, Martin Johnson. "Letter to Eben J. Loomis," February 12, 1883. Loomis-Wilder Family Papers, Manuscripts and Archives at the Yale University Library, New Haven, Connecticut.

———. "Notes of Floridian Experience." *Forest and Stream* (May 24 1983). Saint Augustine Historical Society Archives.

Henry, O. *Cabbages and Kings*. New York: Doubleday Page, 1913.

Hewitt, Robert L. "Edwin Deakin: An Artist with a Mission." *Brush and Pencil* 15 (January 1905): 2–8.

Hill, Janet McKenzie. *A Short History of the Banana and a Few Recipes for Its Use*. Edited by the Boston Cooking School. Boston: United Fruit Company, 1904.

"The Home Circle: Bananas—One Cent." *Arthur's Home Magazine* (August 1, 1868): 120–22.

"Honors to the Mammoth Grape-Vine," *Pacific Rural Press* 10, no. 10 (September 4, 1875): 153.

Humboldt, Alexander von, and Aimé Bonpland. *Personal Narratives of the Travels to the Equinoctial Regions of America during the Years 1799–1804*. Translated and edited by Thomasina Ross. London: G. Bell, 1907.

Husmann, George. *American Grape Growing and Wine Making*. New York: Orange Judd, 1880.

———. *The Grape Culturist: A Monthly Journal Devoted to Grape Culture and Wine Making* (Saint Louis: Levison and Blythe Printers, 1869).

———. "The New Era in Grape Culture—No. II." *Horticulturist, and Journal of Rural Art and Rural Taste* 2, no. 227 (May 1865).

Jackson, Helen Hunt. "Outdoor Industries in Southern California." *Century Illustrated Magazine* (October 1883): 806.

James, W.W. "Bananas." *Florida Agriculturist* 19, no. 6 (February 10, 1892): 82.

"John Chinamen in the Wine Press." *San Francisco Call*, October 14, 1878.

King, Edward. *The Great South: A Record of Journeys in Louisiana, Texas, the Indian Territory, Missouri, Arkansas, Mississippi, Alabama, Georgia, Florida, South Carolina, North Carolina, Kentucky, Tennessee, Virginia, West Virginia, and Maryland.* Hartford, CT: American Publishing, 1875.

Krausz, Sigmund. *Street Types of Chicago: Character Studies.* Edited by Emil G. Hirsch. Chicago: Max Stern, 1891.

"Labor Problems in Hawai'i: Hearings before the Committee on Immigration and Naturalization." Washington, DC: Government Printing Office, 1921.

"Large Watermelon." *Our Home Journal* (September 30, 1871): 185.

"Legend of the Montecito Grape-Vine." *Overland Monthly and Out West* 9 (1872): 519.

Lincoln, Mary A. "Cookery." In *The Congress of Women: Held in the Woman's Building, World's Columbian Exposition, Chicago, U.S.A.* Philadelphia: International Publishing, 1895.

Love, Isaac Newton. "Dietetic Dots." *Medical Mirror* 2 (1891).

Lynch, Bradley. "Ayer Gets a Taste of O'Keeffe." *Advertising Age* (April 17): 1986.

Mansfield, Edward. *Address Delivered before the Horticultural Society.* Cincinnati: Wright, Ferris, 1850.

Millard, Hannah. *Grape and Grape Vines of California* (San Francisco: California State Vinicultural Association, 1877).

"Millions of Melons." *Harper's Weekly*, September 26, 1896.

Mintz, Sydney. *Sweetness and Power: The Place of Sugar in Modern History.* New York: Penguin, 1986.

Moore, Reverend T.W. *Treatise and Hand-Book on Orange Culture in Florida.* Jacksonville: Sun and Press, 1877.

"Mr. Porter's Paintings." *Hartford Courant*, December 8, 1898, 5.

"Napa Valley." *San Francisco Chronicle*, October 15, 1883.

National Wartime Nutrition Guide. Washington, DC: United State Department of Agriculture, War Food Administration, Nutrition and Food Conservation Branch, 1943.

"New Labor Policy Is Announced by Hawaiian Pines." *Honolulu Advertiser*, May 16, 1938, 1.

"Ninety Convicts in a Melon Patch." *Atlanta Constitution*, August 22, 1897, A16.

"O, Dat Watermelon." *Chicago Daily Tribune*, July 5, 1891, 10.

"On Your Great White Fleet Caribbean Cruise." *Outlook: An Illustrated Weekly Journal of Current Life* 129 (September–December 1921): 446.

"Oranges." *Harper's Weekly*, August 23, 1879, 663.

"Our Pineapple Plantation" *Haney's Journal* (August 1, 1871).

"Palette and Brush: Our Artists in Pen and Ink." *Daily Morning Call*, November 18, 1884.

Parkinson, James W. *American Dishes at the Centennial.* Philadelphia: King and Baird, 1874.

Phin, John. *Open Air Grape Culture: A Practical Treatise on the Garden and Vineyard Culture of the Vine.* New York: Woodward, 1876.

"Pine Ad Wins Exhibit Honors." *Honolulu Advertiser*, May 13, 1939.

"Pineapple for Papaya." *Time* magazine, February 12, 1940, 16.

"Plenty of Pineapple, But—Sorry—Not for You." *Life* magazine, June 25, 1941, 92.

"Ponce De Leon Studios." *Daily News Herald*, February 26, 1888, 6.

Poole, Hester. *Fruits and How to Use Them: A Practical Manual for Housekeepers.* Chicago: Woman's Temperance Publishing Association, 1892.

Prang, Louis. *Prang's Chromo: A Journal of Popular Art.* Boston: Prang, 1868.

Proceedings of the Florida Fruit-Growers' Association and Its Annual Meeting Held in Jacksonville. Jacksonville: Office of the Florida Agriculturist, 1875.

Roberts, Edward. "California Wine-Making." *Harper's Weekly*, March 9, 1889, 197–200.

Rucker, Kathryn. "Art Review." *Los Angeles Herald*, February 21, 1909, 9.

"Samuel M. Brookes." *California Art Gallery* (May 1873).

"San Francisco Art." *Daily Examiner*, January 26, 1889.

"San Francisco Art: How a Studio Building Might Be Secured." *Daily Examiner*, 1889.

Sarver, Michael. *The History and Legend of the Mammoth Grapevine*. Canton: McGregor and Son, 1876.

Saunders, William. *Both Sides of the Grape Question*. Philadelphia: J.P. Lippincott, 1860.

Shoup, Paul. "An Old Story in Crumbling Walls," *Sunset* 4 (April 1900): 244–45.

"A Sketch." *Godey's Lady's Book* (August 1877).

Smith, Jared G. "Trend of Trade." *Star Bulletin*, May 16, 1938, 1.

"Some Reasons for Chinese Exclusion: Meat vs. Rice: American Manhood vs. Asiatic Coolieism—Which Will Survive?" Washington, DC: American Federation of Labor, 1901.

"The Southern Watermelon Trade." *Harper's Weekly*, July 28, 1888.

Stowe, Harriet Beecher. *Flowers and Fruit from Writings of Harriet Beecher Stowe*. Boston: Houghton, Mifflin, 1888.

———. *House and Home Papers*. Boston: Ticknor and Fields, 1865.

———. "Personal." *Christian Recorder*, December 21, 1882.

———. "Southern Christmas and New Year." *Christian Union* 13, no. 3 (January 3, 1876): 144.

———. "What Shall We Raise in Florida?" *Hearth and Home* (May 8, 1869): 312.

Taylor, Albert P. "Hawai'i: The Best Known Building at the Panama-Pacific Exposition, 1915." In *All about Hawai'i: The Recognized Book of Authentic Information on Hawai'i, Combined with Thrum's Hawaiian Annual and Standard Guide*. Honolulu: Honolulu Star Bulletin, 1913, 149.

The New South versus the New West: A New Field for Home Seekers, Extracts from the Speeches of a Few Public Men and Newspapers upon This Subject. Article in the Henry Leslie Lymon Scrapbook at the Winterthur Museum and Library.

"This Seems Liberal in the Offer of a Southern College for a Young . . ." *Godey's Lady's Book* (November 1871).

Thompson, Robert Ellis, and Wharton Barker. "Authors and Publishers." *American: A National Journal*, no. 445 (1888): 284.

Todd, Frank Morton. *The Story of the Exposition* 3. New York: G.P. Putnam's Sons, 1921.

Tremenheere, John L. "Art in California." *California Art Gallery* 1 (January 18, 1873).

Turner, Frederick Jackson. *The Significance of the Frontier in American History, Annual Report of the American Historical Association* (Washington, DC: Government Printing Office, 1893), 197–227.

Twain, Mark. *Pudd'n Head Wilson*. Hartford, CT: American Publishing, 1894.

United Fruit Company Steamship Services. *Cruises O'er the Golden Caribbean*. New York: Redfield-Downey-Odell, 1929.

———. *Great White Fleet: Following the Conquerors through the Caribbean Tour*. New York: William Darling Press, 1929.

"The Vintage in California." *Harper's Weekly* 10, no. 5, 1878.

"A Voice from Florida." *Godey's Lady's Book* (July 1868).

"War on Theft of Pineapples." *Honolulu Advertiser*, July 8, 1942.

Ward, Elijah. "Speech of Honorable Elijah Ward in the House of Representatives." Washington, DC: Congressional Record, 1876.

Warner, Helen. *Florida Fruits and How to Raise Them*. Louisville: John Morton, 1886.

"Watermelon Extraordinary." *Gleason's Pictorial Home Visitor* (October 1, 1874): 245.

"Watermelon Killing." *Illustrated Police News* (August 22, 1872): 10.

"Watermelons as a Medicine." *Mining and Scientific Press* (August 4, 1877): 71.

"The Way They Talk in California." *Horticulturist* 12 (July 1857): 314–16.

Webber, S.G. "Watermelon vs. Diarrhea." *Boston Medical and Surgical Journal* (August 19, 1869): 34–35.

"Western Correspondence: Letters about the West." *National Era* (July 19, 1849).

Wilder, Marshall P. *Address Delivered at the Ninth Session of the American Pomological Society Held in Boston, Mass.* Boston: McIntire and Moulton Printers, September 17–19, 1862.

"The Wine Business of California." *Moore's Rural New-Yorker* (October 19, 1876): 395.

"Wine-Making in California." *San Francisco Merchant* 17 (June 10, 1887).

"The Year's Showing." *Paradise of the Pacific* 12, no. 22 (December 1909): 9.

SECONDARY SOURCES

Adams, Ben. *Hawai'i: The Aloha State; Our Island Democracy in Text and Pictures.* New York: Hill Publishing, 1959.

Adams, Karen. "Black Images in Nineteenth-Century American Painting and Literature: An Iconological Study of Mount, Melville, Homer, and Mark Twain." PhD diss., Emory University, 1977.

Alpers, Svetlana. *The Art of Describing: Dutch Still Life in the Seventeenth Century.* Chicago: University of Chicago Press, 1983.

Ames, Kenneth. *Death in the Dining Room and Other Tales of Victorian Culture.* Philadelphia: Temple University Press, 1992.

Amundson, Richard J. "Henry S. Sanford and Labor Problems in the Florida Orange Industry." *Florida Historical Quarterly* 43, no. 3 (January 1965): 229–43.

Appadurai, Arjun, ed. *The Social Life of Things: Commodities in Cultural Perspective.* Cambridge Studies in Social and Cultural Anthropology. Cambridge: Cambridge University Press, 1988.

Barrett, Ross. "Rioting Refigured: George Henry Hall and the Picturing of American Political Violence." *American Art* 92, no. 3 (September 2010): 211–31.

Barter, Judith A., Annelise K. Madsen, Sarah Kelly Oehler, and Ellen E. Roberts. *Art and Appetite: American Painting, Culture, and Cuisine.* Chicago: Art Institute of Chicago, 2013.

Barthes, Roland. *Empire of Signs.* Translated by Richard Howard. New York: Hill and Wang, 1982.

Beauman, Fran. *The Pineapple: King of Fruits.* London: Chatto and Windus, 2005.

Bentley, Amy. *Eating for Victory: Food Rationing and the Politics of Domesticity.* Urbana: University of Illinois Press, 1998.

Berglund, Barbara. *Making San Francisco American: Cultural Frontiers in the Urban West, 1846–1906.* Lawrence: University Press of Kansas, 2007.

Blackmon, Douglas. *Slavery by Another Name: The Re-enslavement of Black Americans from the Civil War to World War II.* New York: Anchor, 2009.

Bleichmar, Daniela. *Visible Empire: Botanical Expeditions and Visual Culture in the Hispanic Enlightenment.* Chicago: University of Chicago Press, 2012.

Bogart, Michele. *Artists, Advertising, and the Borders of Art.* Chicago: University of Chicago Press, 1995.

Born, Wolfgang. *Still-Life Painting in America.* New York: Oxford University Press, 1947.

Bottoms, D. Michael. *An Aristocracy of Color: Race and Reconstruction in California and the West, 1850–1890.* Norman: University of Oklahoma Press, 2013.

Boulé, David. *The Orange and the Dream of California.* Los Angeles: Future Studios, 2013.

Bourdieu, Pierre. *Distinction: A Social Critique of the Judgement of Taste.* Translated by Richard Nice. Cambridge, MA: Harvard University Press, 1984.

Bourgois, Philippe. "One Hundred Years of United Fruit Company Letters." In *Banana Wars: Power, Production, and History in the Americas*, edited by Steve Striffler and Mark Moberg, 103–45. Durham, NC: Duke University Press, 2003.

Braden, Susan. *The Architecture of Leisure: The Florida Resort Hotels of Henry Flagler and Henry Plant.* Gainesville: University Press of Florida, 2002.

Breen, T.H. *The Marketplace of Revolution: How Consumer Politics Shaped American Independence.* Oxford: Oxford University Press, 2004.

Broomall, James. "Personal Reconstructions: Confederates as Citizens in the Post–Civil War South." In *Creating Citizenship in the Nineteenth-Century South.* Gainesville: University Press of Florida, 2013.

Brown, DeSoto. "Beautiful, Romantic Hawai'i: How the Fantasy Image Came to Be." *Journal of Decorative and Propaganda Arts* 20 (1994): 252–71.

Bryson, Norman. *Looking at the Overlooked: Four Essays on Still Life Painting*. Cambridge, MA: Harvard University Press, 1990.

Burton, Samantha. "'For the California of Today': Visual History and the Picturesque Landscape in Edwin Deakin's Missions of California Series." *Nineteenth Century Art Worldwide* 18, no. 2 (Spring 2019): 52–74.

Calo, Mary Ann. "Winslow Homer's Visits to Virginia during Reconstruction." *American Art Journal* 12, no. 1 (Winter 1980): 4–27.

Cao, Maggie. "Heade's Hummingbirds and the Ungrounding of Landscape." *American Art* 25, no. 3 (Fall 2011): 48–75.

Carbone, Teresa. *American Paintings in the Brooklyn Museum*. 2nd ed. New York: Giles, 2006.

Chandler, David Leon. *Henry Flagler: The Astonishing Life and Times of the Visionary Robber Baron Who Founded Florida*. New York: Macmillan, 1986.

Chapman, Peter. *Bananas: How the United Fruit Company Shaped the World*. New York: Canongate, 2009.

Chapman, William. *Hawai'i, the Military, and the National Park: World War II and Its Impacts on Culture and the Environment*. Washington, DC: American Society for Environmental History and National Park Service, 2013.

Clapper, Michael. "'I Was Once a Barefoot Boy!': Cultural Tensions in a Popular Chromo." *American Art* 16, no. 2 (Summer 2002): 16–39.

Colby, Jason. *The Business of Empire: United Fruit, Race, and U.S. Expansion in Central America*. Ithaca, NY: Cornell University Press, 2011.

Collingham, Lizzie. *The Taste of War: World War II and the Battle for Food*. New York: Penguin Press, 2012.

Covey, Herbert, and Dwight Eisnach. *What the Slaves Ate: Recollections of African American Foods and Foodways from the Slave Narratives*. Santa Barbara, CA: Greenwood Press, 2009.

Cummings, Hildegard. *Charles Ethan Porter: African-American Master of Still Life*. Hanover, NH: University Press of New England, 2007.

Dalton, Karen, and Peter H. Wood. *Winslow Homer's Images of Blacks: The Civil War and Reconstruction Years*. Austin: University of Texas Press, 1989.

Dippie, Brian. "Representing the Other: The North American Indian." *Anthropology and Photography* (1992): 132–36.

Dolan, Kathryn Cornell. *Beyond the Fruited Plain: Food and Agriculture in U.S. Literature, 1850–1905*. Lincoln: University of Nebraska Press, 2014.

Douglas, Mary. "Deciphering a Meal." *Myth, Symbol, and Culture* 101, no. 1 (1972): 61–83.

Driesbach, Janice. *Bountiful Harvest: Nineteenth-Century California Still Life Painting*. Sacramento: Crocker Art Museum, 1991.

DuPuis, Melanie E. *Dangerous Digestion: The Politics of American Dietary Advice*. Berkeley: University of California Press, 2015.

Eden, Trudy. *Cooking in America, 1590–1840*. Westport, CT: Greenwood Press, 2006.

———. *The Early American Table: Food and Society in the New World*. DeKalb: Northern Illinois University Press, 2008.

Enloe, Cynthia. *Bananas, Beaches, and Bases: Making Feminist Sense of International Politics*. Berkeley: University of California Press, 2014.

Fales, Martha Gandy. "Hannah B. Skeele, Maine Artist." *Antiques* 121, no. 4 (April 1982): 915–21.

Faulkner, Carol. "The Root of the Evil: Free Produce and Radical Antislavery, 1820–1860." *Journal of the Early Republic* 27 (Fall 2007): 377–405.

Favis, Roberta. *Martin Johnson Heade in Florida*. Gainesville: University Press of Florida, 2003.

Ficklin, Ellen. *Watermelons*. Washington, DC: American Folk Life Center and the Library of Congress, 1984.

Foster, John, and Sarah Foster, eds. *Calling Yankees to Florida: Harriet Beecher Stowe's Forgotten Tourist Articles*. Cocoa: Florida Historical Society Press, 2011.

Frankenstein, Alfred V. *After the Hunt: William Harnett and Other American Still Life Painters, 1870–1900.* Berkeley: University of California Press, 1953.

Freidberg, Susanne. *Fresh: A Perishable History.* Cambridge, MA: Belknap Press of Harvard University Press, 2010.

Fujikane, Candace, and Jonathan Y. Okamura, eds. *Asian Settler Colonialism: From Local Governance to the Habits of Everyday Life in Hawai'i.* Honolulu: University of Hawai'i Press, 2008.

Garvey, Ellen Gruber. *The Adman in the Parlor: Magazines and the Gendering of Consumer Culture, 1880s to 1910s.* Oxford: Oxford University Press, 1996.

Gates, Paul Wallace. *Agriculture and the Civil War.* New York: Knopf, 1964.

Gerdts, William H. "The Influence of Ruskin and Pre-Raphaelitism on American Still-Life Painting." *American Art Journal* 1, no. 2 (Autumn 1969): 80–97.

———. *Painters of the Humble Truth: Masterpieces of American Still Life, 1801–1939.* Columbia: University of Missouri Press, 1981.

Gerdts, William H., and Russell Burke. *American Still Life Painting.* New York: Praeger, 1971.

Gessert, George. "Notes on Genetic Art." *Leonardo* 26 (1993): 205–11.

Giroux, Henry A. *The Violence of Organized Forgetting: Thinking beyond America's Disimagination Machine.* San Francisco: City Lights, 2014.

Glickman, Lawrence. *Buying Power: A History of Consumer Activism in America.* Chicago: University of Chicago Press, 2012.

Goldberg, Mark H. *"Going Bananas": 100 Years of American Fruit Ships in the Caribbean.* American Merchant Marine History Series 3. Kings Point, NY: American Merchant Marine Museum Foundation, 1993.

Grandin, Greg. *Empire's Workshop: Latin America, the United States, and the Rise of the New Imperialism.* New York: Metropolitan / Henry Holt, 2006.

Grover, Kathryn. *Dining in America, 1850–1900.* Amherst: University of Massachusetts Press, 1987.

Hales, Peter. *William Henry Jackson and the Transformation of the American West.* Philadelphia: Temple University Press, 1988.

Hannickel, Ericka. *Empire of Vines: Wine Culture in America.* Philadelphia: University of Pennsylvania Press, 2013.

Hardeman, Nicholas. *Shucks, Shocks, and Hominy Blocks: Corn as a Way of Life in Pioneer America.* Baton Rouge: Louisiana State University Press, 1981.

Hawkins, Richard A. "James Dole and the 1932 Failure of the Hawaiian Pineapple Company." *Hawaiian Journal of History* 41 (2007): 149–70.

———. *Pacific Industry: The History of Pineapple Canning in Hawai'i.* London: I.B. Taurus, 2011.

Heintz, William F. *The Role of Chinese Labor in Viticulture and Wine Making in Nineteenth-Century California.* Master's thesis, Sonoma State University, 1977.

Held, Julius, and Donald Posner. *Seventeenth and Eighteenth Century Art: Baroque Painting, Sculpture, and Architecture.* New York: Harry N. Abrams, 1971.

Hillyer, Reiko. "The New South in the Ancient City: Flagler's St. Augustine Hotels and Sectional Reconciliation." *Journal of Decorative and Propaganda Arts,* Florida Theme Issue 25 (2005).

Hjalmarson, Birgitta. *Artful Players: Artistic Life in Early San Francisco.* Los Angeles: Balcony Press, 1999.

Hochstrasser, Julie Berger. *Still Life and Trade in the Dutch Golden Age.* New Haven, CT: Yale University Press, 2007.

Hoganson, Kristin. *Consumers' Imperium: The Global Production of American Domesticity, 1865–1920.* Chapel Hill: University of North Carolina Press, 2007.

Horne, Gerald. *Fighting in Paradise: Labor Unions, Racism, and Communists in the Making of Modern Hawai'i.* Honolulu: University of Hawai'i Press, 2011.

Hughes, Edan. *Artists in California, 1786–1940.* Sacramento: Crocker Art Museum, 2002.

Hungerford, Belinda. *Anton Bruehl: In the Spotlight.* Sydney: National Gallery of Australia, 2011.

Hunter, Tera. *To 'Joy My Freedom: Southern Black Women's Lives and Labors after the Civil War*. Cambridge, MA: Harvard University Press, 1997.

Jacobs, Julius L. *Pioneer Wine Families in California*. San Francisco: California Historical Society, 1975.

Janney, Caroline. *Remembering the Civil War: Reunion and the Limits of Reconciliation*. Chapel Hill: University of North Carolina Press, 2013.

Jay, Robert. *The Trade Card in Nineteenth-Century America*. Columbia: University of Missouri Press, 1986.

Jenkins, Virginia Scott. *Bananas: An American History*. Washington, DC: Smithsonian Institution Press, 2000.

Johnston, Patricia. "Advertising Paradise: Hawai'i in Art, Anthropology, and Commercial Photography." In *Colonialist Photography: Imag(in)ing Race and Place*, edited by Eleanor M. Hight and Gary D. Sampson, 188–225. London: Routledge, 2002.

Jordan, Guy. "The Aesthetics of Intoxication in Antebellum American Art and Culture." PhD diss., University of Maryland, 2007.

Kaplan, Amy. "Manifest Domesticity." *American Literature* 70, no. 3 (September 1998): 111–34.

Kelly, Sarah E. "Fruit Piece." *Art Institute of Chicago Museum Studies* 30, no. 1 (2004): 12–13, 94.

Kimura, Aya Hirata, and Krisnawati Suryanata. *Food and Power in Hawai'i: Visions of Food Democracy*. Honolulu: University of Hawai'i Press, 2016.

Kingsbury, Noel. *Hybrid: The History and Science of Plant Breeding*. Chicago: University of Chicago Press, 2009.

Kiple, Kenneth, and Kriemhild Ornelas, eds. *Cambridge World History of Food*. Cambridge: Cambridge University Press, 2000.

Klein, Lauren. "Dinner-Table Bargains: Thomas Jefferson, James Madison, and the Senses of Taste." *Early American Literature* 49, no. 2 (Spring 2014): 403–33.

Klein, Rachel. "Harriet Beecher Stowe and the Domestication of Free Labor Ideology." *Legacy* 18, no. 2 (2001): 135–52.

Klein, Shana. "Cultivating Fruit and Equality in the Still-Life Paintings of Robert Duncanson." *American Art* 29, no. 2 (Summer 2015).

———. "Lady Liberty with a Tomato: A Dialogue on Art and Activism with the Coalition of Immokalee Farmworkers." *Public Art Dialogue* 8, no. 1 (2018): 98–113.

Knobloch, Frieda. *Culture of Wilderness: Agriculture as Colonization in the American West*. Chapel Hill: University of North Carolina Press, 1996.

Koeppel, Dan. *Banana: The Fate of the Fruit That Changed the World*. New York: Plume Publications, 2008.

Koester, Nancy. *Harriet Beecher Stowe: A Spiritual Life*. Grand Rapids, MI: William B. Eerdman's Publishing, 2014.

Kohen, Helen L. "Perfumes, Postcards, and Promises: The Orange in Art and Industry." *Journal of Decorative and Propaganda Arts* 23 (1998): 32–47.

Komanecky, Michael K. "Spanish Missions in the American Imagination." In *The Arts of the Missions of Northern New Spain, 1600–1821*, 155–99. Mexico City: Antiguo Colegio de San Ildefonso, 2009.

Kropp, Phoebe S. *California Vieja: Culture and Memory in a Modern American Place*. Berkeley: University of California Press, 2006.

Larsen, Jack. *Hawaiian Pineapple Entrepreneurs: 1894–2010*. Sheridan, OR: Jack Larsen, 2010.

Lauwrens, Jenni. "Welcome to the Revolution: The Sensory Turn and Art History." *Journal of Art Historiography* 7 (December 2012): 1–17.

Lee, Anthony. *Picturing Chinatown: Art and Orientalism in San Francisco*. Berkeley: University of California Press, 2001.

Levenstein, Harvey. *Revolution at the Table: The Transformation of the American Diet*. Berkeley: University of California Press, 1988.

Lévi-Strauss, Claude. *Mythologiques: The Raw and the Cooked*. New York: Harper and Row, 1969.

Link, William A., David Brown, Brian Ward, and Martyn Bone, eds. *Creating Citizenship in the Nineteenth-Century South*. Gainesville: University Press of Florida, 2013.

Love, Eric T. *Race over Empire: Racism and U.S. Imperialism, 1865–1900.* Chapel Hill: University of North Carolina Press, 2004.

Macfarlane, Ellen. "Group f.64, Rocks, and the Limits of the Political Photograph." *American Art* 30, no. 3 (Fall 2016): 26–53.

Mamiya, Christin. "Greetings from Paradise: The Representation of Hawaiian Culture in Postcards." *Journal of Communication Inquiry* 16, no. 2 (Summer 1992): 86–100.

Manning, Caroline. "The Employment of Women in the Pineapple Canneries of Hawai'i." *United States Department of Labor, Bulletin of the Women's Bureau* 82. Washington, DC: US Government Printing Office, 1930.

Manthorne, Katherine. *California Mexicana: Missions to Murals, 1820–1930.* Berkeley: University of California Press, 2017.

Marshall, Lucy Agar. "Samuel Marsden Brookes." *California Historical Society Quarterly* 36 (September 1957): 193–203.

Martin, James W. "Becoming Banana Cowboys: White-Collar Masculinity, the United Fruit Company, and Tropical Empire in Early Twentieth-Century Latin America." *Gender and History* 25, no. 2 (August 2013): 317–38.

Martin, Sidney Walter. *Henry Flagler: Visionary of the Gilded Age.* Lake Buena Vista, FL: Tailored Tours Publications, 1998.

Mathews, Marcia M. *Henry Ossawa Tanner: American Artist.* Chicago: Chicago University Press, 1994.

Maxwell, Anne. *Colonial Photography and Exhibitions: Representations of the "Native" and the Making of European Identities.* Leicester: Leicester University Press, 2000.

Maynard, David, and Donald N. Maynard. *Cambridge World History of Food*, edited by Kenneth Kiple and Kriemhild Ornelas. Cambridge: Cambridge University Press, 2000.

Mayyasi, Alex. "When New Yorkers Were Menaced by Banana Peels." *Gastro Obscura* (July 24, 2019).

Mazow, Leo. "Sensing America." *American Art* 24, no. 3 (Fall 2010): 2–11.

McClinton, Katherine Morrison. *The Chromolithographs of Louis Prang.* New York: Clarkson N. Potter, 1973.

McPhee, John. *Oranges.* New York: Farrar, Straus, and Giroux, 1967.

Miller, Bonnie. "Culinary Encounters at the Fair: 'Pure Food' on Exhibit at the Panama-Pacific International Exposition, San Francisco, 1915." *Southern California Quarterly* 100, no. 2 (Summer 2018).

Mintz, Sydney. *Sweetness and Power: The Place of Sugar in Modern History.* New York: Penguin, 1986.

Moon, Michelle. *Interpreting Food at Museums and Historic Sites.* Lanham, MD: Rowman and Littlefield, 2015.

Mormino, Gary R. "Dream Fruit for a Dream State." *Forum* 38, no. 1 (Spring 2014): 4–6.

Mosby, Dewey, Darrel Sewell, and Rae Alexander-Minter. *Henry Ossawa Tanner.* Philadelphia: Philadelphia Museum of Art, 1991.

Muhn, James. "Women and the Homestead Act: Land Department Administration of a Legal Imbroglio, 1863–1934." *Western Legal History* 7 (1994): 284.

Myrick, David F. *Montecito and Santa Barbara: From Farms to Estates.* Vol. 1. Glendale, CA: Trans-Anglo Books, 1989.

Nemerov, Alexander. *The Body of Raphaelle Peale: Still Life and Selfhood, 1812–1824.* Berkeley: University of California Press, 2001.

Newhall, Nancy, ed. *The Daybooks of Edward Weston.* New York: Aperture, 1990.

Noll, Steven, and M. David Tegeder. *From Exploitation to Conservation: A History of the Marjorie Harris Carr Cross Florida Greenway.* Gainesville: University Press of Florida, 2003.

Nuremberger, Ruth. *Free Produce Movement: A Quaker Protest against Slavery.* New York: AMS Press, 1970.

O'Brien, Betty A. "The Lord's Supper: Fruit of the Vine or Cup of Devils?" *Methodist History* 31, no. 4 (July 1993): 203–23.

Okihiro, Gary. *Pineapple Culture: A History of the Tropical and Temperate Zones.* Berkeley: University of California Press, 2009.

Oliver, Sandra. *Food in Colonial and Federal America.* San Francisco: Greenwood Press, 2005.

Orsi, Richard J. *Sunset Limited: The Southern Pacific Railroad and the Development of the American West, 1850–1930*. Berkeley: University of California Press, 2005.

Paddon, Anna, and Sally Turner. "African Americans and the World's Columbian Exposition." *Illinois Historical Journal* 88, no. 1 (Spring 1995): 19–36.

Pauly, Philip J. *Fruits and Plains: The Horticultural Transformation of America*. Cambridge, MA: Harvard University Press, 2008.

Piatti-Farnell, Lorna. *Banana: A Global History*. London: Reaktion Books, 2016.

Pilcher, Jeffrey. *¡Que vivan los tamales! Food and the Making of Mexican Identity*. Albuquerque: University of New Mexico Press, 1998.

Pinney, Thomas. *A History of Wine in America: From the Beginning to Prohibition*. Berkeley: University of California Press, 1989.

Pollan, Michael. *The Botany of Desire: A Plant's-Eye View of the World*. New York: Random House, 2001.

Powell, Lawrence. *New Masters: Northern Planters during the Civil War and Reconstruction*. New York: Fordham University Press, 1999.

Price, Robert. *Johnny Appleseed: Man and Myth*. Bloomington: Indiana University Press, 1954.

Prown, Jules David. "Mind in Matter: An Introduction to Material Culture Theory and Method." *Winterthur* 17, no. 1 (Spring 1982): 1–19.

Riles, Susan C. "Martin Johnson Heade: Wetlands Artist and Pro Environmentalist." PhD diss., Rollins College, 2005.

Robertson, Stacy. *Hearts Beating for Liberty: Women Abolitionists in the Old Northwest*. Chapel Hill: University of North Carolina Press, 2010.

Rohrer, Judy. *Staking Claim: Settler Colonialism and Racialization in Hawai'i*. Tucson: University of Arizona Press, 2016.

Root, Waverly, and Richard de Rochemont. *Eating in America: A History*. Hopewell, NJ: Ecco Press, 1995.

Rotskoff, Lori E. "Decorating the Dining-Room: Still Life Chromolithographs and Domestic Ideology in Nineteenth-Century America." *Journal of American Studies* 31, no. 1 (April 1997): 19–42.

Ruíz, Kristel Sabrina López. "A Study of the Use of Rhetorical Figures in the Development of a Visual Language in the Work *Bananarama* and *Contaminations* of Moisés Barrios." Master's thesis, Department of Architecture and Design, Rafael Landívar University, 2014.

Ruud, Brandon K. "Truth to Nature: Still Life, Exoticism, and Gender." In *Poetical Fire: Three Centuries of Still Lifes*. Lincoln: University of Nebraska Press and the Sheldon Museum of Art, 2011.

Sackman, Douglas Cazaux. *Orange Empire: California and the Fruits of Eden*. Berkeley: University of California Press, 2005.

Sánchez, George. *Becoming Mexican American: Ethnicity, Culture, and Identity in Chicano Los Angeles*. New York: Oxford University Press, 1993.

Saranillio, Dean Itsuji. "Colliding Histories: Hawai'i Statehood at the Intersection of Asians 'Ineligible to Citizenship' and Hawaiians 'Unfit for Self-Government.'" *Journal of Asian American Studies* 13, no. 3 (October 2010): 283–309.

———. *Unsustainable Empire: Alternative Histories of Hawai'i Statehood*. Durham, NC: Duke University Press, 2018.

Savage, Kirk. *Monument Wars: Washington, D.C., the National Mall, and the Transformation of the Memorial Landscape*. Berkeley: University of California Press, 2011.

Schama, Simon. *The Embarrassment of Riches: An Interpretation of Dutch Culture in the Golden Age*. New York: Vintage Press, 1997.

Schenone, Laura. *1,000 Years over a Hot Stove: A History of American Women Told through Food, Recipes, and Remembrances*. New York: W. W. Norton, 2004.

Schachter, Judith. *The Legacies of a Hawaiian Generation: From Territorial Subject to American Citizen*. Oxford: Berghahn Books, 2013.

Schmidt, Peter. *Sitting in Darkness: New South Fiction, Education, and the Rise of Jim Crow Colonialism, 1865–1920*. Jackson: University Press of Mississippi, 2008.

———. "Tolentino, Cable, and Tourgée Confront the New South and the New Imperialism." In *Creating Citizenship in the Nineteenth-Century South*, edited by William A. Link, David Brown, Brian E. Ward, and Martyn Bone, 247–70. Gainesville: University Press of Florida, 2013.

Scott, Sascha. "Georgia O'Keeffe's Hawai'i: Decolonizing the History of American Modernism." *American Art* (forthcoming 2019).

Shah, Nayan. *Contagious Divides: Epidemics and Race in San Francisco's Chinatown*. Berkeley: University of California Press, 2001.

Shapiro, Laura. *Perfection Salad: Women and Cooking at the Turn of the Century*. New York: Farrar, Straus and Giroux, 1986.

Sheehan, Tanya. "Looking Pleasant, Feeling White: The Social Politics of the Photographic Smile." In *Feeling Photography*, edited by Elspeth Brown and Thy Phu, 127–57. Durham, NC: Duke University Press, 2014.

Shields, Scott. *Edwin Deakin: California Painter of the Picturesque*. San Francisco: Pomegranate, 2008.

Shofner, Jerrell H. *Nor Is It over Yet: Florida in the Era of Reconstruction, 1863–1877*. Gainesville: University Press of Florida, 1974.

Siegel, Nancy. "Cooking Up American Politics." *Gastronomica* 8, no. 3 (2008): 53–61.

Silber, Nina. *The Romance of Reunion: Northerners and the South, 1865–1900*. Chapel Hill: University of North Carolina Press, 1997.

Silva, Noenoe K. *Aloha Betrayed: Native Hawaiian Resistance to American Colonialism*. Durham, NC: Duke University Press, 2004.

Skwiot, Christine. *The Purposes of Paradise: U.S. Tourism and Empire in Cuba and Hawai'i*. Philadelphia: University of Pennsylvania Press, 2011.

Slipp, Naomi. "Gilded Age Dining: Eco-Anxiety, Fisheries Management, and the Presidential China of Rutherford B. Hayes." In *Ecocriticism and the Anthropocene in Nineteenth-Century Art and Visual Culture*, edited by Maura Coughlin and Emily Gephart, 135–44. London: Routledge, 2019.

Solomon-Godeau, Abigail. "Going Native: Paul Gauguin and the Invention of Primitivist Modernism." In *The Expanding Discourse: Feminism and Art History*, edited by Norma Broude and Mary D. Garrard, 313–29. New York: HarperCollins, 1992.

Soluri, John. *Banana Cultures: Agriculture, Consumption, and Environmental Change in Honduras and the United States*. Austin: University of Texas Press, 2006.

Spice, Lincoln Bunce. "St. Louis Women Artists in the Mid-Nineteenth Century." *Gateway Heritage: Quarterly Journal of the Missouri Historical Society* 4 (Spring 1983): 18–19.

Stanley, Amy Dru. *From Bondage to Contract: Wage Labor, Marriage, and the Market in the Age of Slave Emancipation*. Cambridge: Cambridge University Press, 1998.

Stavely, Keith, and Kathleen Fitzgerald. *America's Founding Food: the Story of New England Cooking*. Chapel Hill: University of North Carolina Press, 2004.

Stebbins, Theodore. *The Life and Work of Martin Johnson Heade: A Critical Analysis and Catalogue Raisonné*. New Haven, CT: Yale University Press, 2000.

Steen, Shannon. *Racial Geometries of the Black Atlantic, Asian Pacific, and American Theatre*. London: Palgrave Macmillan, 2010.

Sterling, Charles. *Still Life Painting from Antiquity to the Twentieth Century*. New York: Harper and Row, 1981.

Stoll, Steven. *The Fruits of Natural Advantage: Making the Industrial Countryside in California*. Berkeley: University of California Press, 1998.

Storr, Annie V.F. "Raphaelle Peale's 'Strawberries, Nuts, &c.': A Riddle of Enlightened Science." *Art Institute of Chicago Museum Studies* 21, no. 1 (1995): 24–34, 73–74.

Street, Richard Steven. *Beasts of the Field: A Narrative History of California Farmworkers, 1769–1913*. Stanford, CA: Stanford University Press, 2004.

Striffler, Steve, and Mark Moberg, eds. *Banana Wars: Power, Production, and History in the Americas*. Durham, NC: Duke University Press, 2003.

Tansill, Charles C. *The Foreign Policy of Thomas F. Bayard, 1855–1897*. New York: Fordham University Press, 1940.

Tatham, David. *Winslow Homer and the Pictorial Press*. Syracuse, NY: Syracuse University Press, 2003.

TenBruggencate, Jan K. *Hawai'i's Pineapple Century: A History of the Crowned Fruit in the Hawaiian Islands*. Honolulu: Mutual Publishing, 2004.

Terhune, Anne Gregory. *Thomas Hovenden: His Life and Art*. Philadelphia: University of Pennsylvania Press, 2006.

Thompson, Krista. *An Eye for the Tropics: Tourism, Photography, and Framing the Caribbean Picturesque*. Durham, NC: Duke University Press, 2006.

Tobin, Beth Fowkes. *Picturing Imperial Power: Colonial Subjects in Eighteenth-Century British Painting*. Durham, NC: Duke University Press, 1999.

Tompkins, Kyla. *Racial Indigestion: Eating Bodies in the Nineteenth Century*. New York: New York University Press, 2012.

Trask, Haunani-Kay. *From a Native Daughter: Colonialism and Sovereignty in Hawai'i*. Honolulu: University of Hawai'i Press, 1999.

Trovaioli, August, and Roulhac Toledano. *William Aiken Walker: Southern Genre Painter*. Gretna, LA: Pelican Publishing, 2007.

Turner, Patricia. *Ceramic Uncles and Celluloid Mammies: Black Images and Their Influence on Culture*. Charlottesville: University of Virginia Press, 2002.

Twitty, Michael. *The Cooking Gene: A Journey through African-American Culinary History in the Old South*. New York: Amistad, 2017.

Upton, Dell. "White and Black Landscapes in Eighteenth-Century Virginia." In *Material Life in America, 1600–1860*, edited by Robert Blair St. George, 357–69. Boston: Northeastern University Press, 1988.

Veder, Robin. "Mother-Love for Plant-Children: Sentimental Pastoralism and Nineteenth-Century Parlour Gardening." *Australasian Journal of American Studies* 26 (2007): 20–34.

Velasquez, L. Stephen. "Doing It with 'Ganas': Mexicans and Mexican Americans Shaping the California Wine Industry." *Southern California Quarterly* 100, no. 2 (Summer 2018): 216–43.

Weber, Bruce. *The Apple of America: The Apple in Nineteenth-Century American Art*. New York: Berry-Hill Galleries, 1993.

Whorton, James C. *Inner Hygiene: Constipation and the Pursuit of Health in Modern Society*. Oxford: Oxford University Press, 2000.

Wiley, James. *The Banana: Empires, Trade Wars, and Globalization*. Lincoln: University of Nebraska Press, 2008.

Williams, Susan. *Savory Suppers and Fashionable Feasts: Dining in Victorian America*. Knoxville: University of Tennessee Press, 1996.

Williams-Forson, Psyche. *Building Houses Out of Chicken Legs: Black Women, Food, and Power*. Chapel Hill: University of North Carolina Press, 2006.

Wilson, David, and Angus Gillespie, eds. *Rooted in America: Foodlore of Popular Fruits and Vegetables*. Knoxville: University of Tennessee Press, 1999.

Wood, Peter H. "The Calabash Estate: Gourds in African American Life and Thought." In *African American Impact on the Material Cultures of the Americas: Conference Proceedings*. Winston-Salem, North Carolina, Old Salem, 1998.

———. *Near Andersonville: Winslow Homer's Civil War*. Cambridge, MA: Harvard University Press, 2010.

Woods, Frank Naurice. "Henry Ossawa Tanner's Negotiation of Race and Art: Challenging 'The Unknown Tanner.'" *Journal of Black Studies* (2011): 887–905.

Ziegler, Mel, and Patricia Ziegler. *Banana Republic: Guide to Travel and Safari Clothing*. New York: Ballantine Books, 1986.

ILLUSTRATIONS

INDEX

Page numbers in *italics* denote illustrations.

silverware: absence of, and racial stereotypes, 82, 106, 163; array of new utensils for fruit consumption, 114; banana stands and utensils, 106, 113, 114, *115*, 117–18, 125, *126*; etiquette experts prescribing for watermelon, 77; and the Florida orange industry, 62; scholarly inquiry of, 13; for watermelon consumption, 77, 78, *79*, 189n23; and watermelon, racist depictions in designs for, 74, 78, *79*, 83–84, 189n23

Sinclair, Upton, *The Jungle*, 146

Skeele, Hannah "Harriet" Brown, 107, 171–72, 193–94nn7–8; *Fruit Piece*, 107–9, *108*, 135

smallpox, 38

Smith, John, *Reconstruction of the South* (Tholey, lith.), 47–49, *48*

Smithsonian National Museum of American History, 169–70

Soluri, John, 125, 193n3, 196n61

Sonoma, California, memorial to Chinese grape workers, 170, 204n4

South: important sites of food production in, 171; "New South" of Reconstruction, 48, 49; northernization of, 45, 47, 51, 53, 54, 71–72, 124, 143, 184n37; the West as agricultural rival of, 17, 46, 177n4. *See also* Civil War; oranges (Florida); racism; Reconstruction; watermelon

souvenirs: California orange spoons and sets, 53; Columbian Exposition grape exhibit booklet, 24, *25*; of Florida oranges, 52–53, *52*, 62; Martin Johnson Heade's still life paintings as, 60; racist depictions of watermelon and African Americans on, 78, *79*, 84, 189n23

Spanish-American War (1899), 116, 141

Spanish missionaries: "civilizing" mission of, 20–22; colonial purpose of agriculture and, 20–22; and forced labor of Native Americans, 16, 22, 23; and grape culture, 16, 22, 23; Mexican Secularization Act and, 19

Spanish Mission Revival movement, 16, 28, 29–32, *30–31*

Standard Fruit Company, 195n43, 198n6

Stanford, Leland, 181n74

statehood of Hawai'i, 139, 161–65, *164*, 202–3nn101–103,109,114–116

Stebbins, Theodore, 60

Steichen, Edward, 197n76

Sterling, Charles, 10

Stevens, John L., 141

Stieglitz, Alfred, 155, 197n76

still life genre: and artistic expression of controversial commentaries, 5–6, 89–94, *90*, *92–93*, 191nn59,61; botanical engravers as influence on,

28–29; and commentary on national expansion, 5–6; and the dining room, 1, 55, 80, 93–94, 113, 114; and gender norms for artists, 55, 91, 93, 171–72; as historically dismissed as unintellectual, 10, 175n28; history of scholarship on, 10–11; and inclusivity, 2; and racial hierarchy for artists, 55, 91, 93; Harriet Beecher Stowe on dignity of, 55, 185n53; true-to-life, Parrhasius and Zeuxis myth of, 28, 58–59, 102–3, 179n45. *See also* Dutch still life painting

Stoll, Steven, 9, 181n77

Stowe, Harriet Beecher: as abolitionist, 54, 68–69; and abolitionist boycott of slave-labored commodities, 108; as booster for Florida tourism and oranges, 45, 54, 55–56, 60, 71; on cooking, importance of, 117; cottage in Mandarin, Florida, 53, 184n41; on the dignity of the still life genre, 55, 185n53; and gender norms, departure from, 53; orange grove of, 53–54; orange grove of, hiring of newly freed African Americans as purpose, 43, 45, 68–69; on painting and the still life genre, 43, 55–57, 185nn53,56; paintings sold to raise money for freedmen, 43, 45, 57; on women's cultivation of fruit, 55. Works: *The American Woman's Home*, 55; *Magnolia Grandiflora*, 55–56, *56*; *Orange Fruit and Blossoms*, 43, *44*, 54–55; "Palmetto Leaves," 54, 184n46; *Uncle Tom's Cabin*, 48

Strand, Paul, 197n76

Strange Fruit (Meeropol and Holiday), 71, 187n114

Striffler, Steve, 129

Strohmeyer and Wyman, *Jinks! I could'a sworn I saw a leetle darkey in the melon-patch*, 95, *95*

sugar: abolitionist boycott of, 3, 108, 194n11; oranges as displacing importance of, 49–50; in paintings, 107, *108*; and prejudice against Chinese laborers as "impure," 147, 181–82n88
—IN HAWAI'I: cultivation, 143, 147–48, 158, 161, 198n10, 199n24; and lobbying for modifications to Asian immigration exclusions, 147–48; Georgia O'Keeffe's stay on a plantation, 155, 156, 201n68; and World War II, 158

Sullivan, John L., 37, 181n86

Sunkist Oranges, 116, 125, 152

syphilis, 38

Tanner, Henry Ossawa: biographical information, 70–71, 94, 187n106. Works: *The Banjo Lesson*, 94, 191n68; *Florida*, 69–71, *70*, 72

Taylor, Albert P., 151

technology: canning, and belief in "impure" Asian laborers, 147, 200n42; canning, and pineapple, 139, 143–46, 150; grape cultivation and, 36–37,

Walker, Kara, *The Sugar Sphinx*, 171

Ward, Elijah, 140

Warner, Helen Garnie: *Florida Fruits and How to Raise Them*, 51, 183n21; *Home Life in Florida*, 51

wars: Mexican-American War (1846–48), 19, 20, 23; Spanish-American (1899), 116, 141. *See also* Civil War; military; World War I; World War II

Washington, George, 3, 140, 171

watermelon: overview, 7, 73–74; as a gourd, 75, 99, 191n68; alcohol injection into, 75–76, 76, 103, 188n9; cultivation and trade of, 75, 99, 192n84; etiquette experts on proper consumption of, 73, 77, 80, 103; intemperate qualities of, 73–74, 76, 77, 93, 103; medicinal/digestive function of, 76–77, 103, 188nn13–14; origins and history of, 75, 188n2; as party fruit, 75–76, 103, 188nn7,9; silverware designed for eating, 77, 78, 79, 189n23; as symbol of black power and agency prior to Emancipation, 99, 103, 192n84. *See also* watermelon and racist depictions of African Americans; watermelon paintings

watermelon and racist depictions of African Americans: overview, 74, 103–4; abolition of slavery and emergence of, 74; and black masculinity, white anxiety about, 82–83; black resistance to watermelon due to, 78, 89, 94, 189nn21–22; and civil rights of African Americans, white resentment of, 74, 82, 83–84, 98; Columbian Exposition's "Colored People's Day" and, 77–78, 89, 188n19; contemporary artists' responses to, 99–103, 100–102, 192n86; continuation of the trope into the 21st century, 99, 103, 192–93n87; and humanity of African Americans, white denigration of, 74, 85–89, 86–87; humor as alleviating white anxiety, 82–83; humor as naturalizing stereotypes, 85–89, 94; intemperance of watermelon as basis of, 77; as metaphor for and commentary on racial violence, 74, 89–94, 90, 92–93, 191nn56,59,61; northerners as bowing to, in the name of reconciliation, 84–85, 190n39; popular songs and poems and, 79–80, 189n25; prints as medium and normalization of, 80; sexual stereotypes, 82; silverware designs, 74, 78, 79, 83–84, 189n23; thefts from watermelon patches and white anxiety about black land ownership and empowerment, 74, 94–99, 95–97, 192n79; titles of works using stereotypical dialect, 79–80, 83, 97, 189nn25,37; trade-card advertisements and racial stereotypes of people transforming into watermelon, 74, 85–89, 86–87, 190n42; "watermelon smile," 83, 84; women/girls as rarely depicted, 82, 189n31

watermelon paintings: as a party fruit, 75–76, 76; as challenge to the artist's mastery of illusionism, 73, 79; as commentary on racial violence, 74, 89–94, 90, 92–93, 191nn56,59,61; as disobeying the rules of decorum for dining room pictures, 77, 93; and the female body, 73–74, 82, 90; genre paintings, 80–83, 81; still lifes in which no black figures are present, 78–80, 80; sympathetic Winslow Homer painting transformed into a stereotyping print, 95–97, 96–97; titles using stereotypical dialect, 79–80, 83, 189n37

Watkins, Carleton E., 31

Way, Andrew John Henry, 13, 27; on painting watermelons, 73, 91

Weems, Carrie Mae, *Black Man Holding Watermelon*, 99–101, 100

Welch's Grape Juice, 25, 178n31

Weston, Edward, 134–35, 196–97n74; *Still Life with Bananas*, 125, 127, 127, 133, 134–35, 197n76

white anxiety: about African American civil rights, 74, 82, 83–84, 98; about black land ownership, 74, 94–99, 95–97, 192n79; about black male masculinity, 82–83; about loss of white male virility, 82; about Reconstruction, 49; humor as alleviating, 82–83

white figures in Dole pineapple advertisements, 152–53, 154, 156–57, 157

White Hand, 128

White, Henry A., 159, 203n108

whitening: of the banana, 118; of Hawai'i labor force, failure of recruitment attempts at, 142–43, 148, 166, 199nn19,24; of immigrant diets, 88

white resentment. *See* white anxiety

whitewashing, of pineapple laborers, 147

white women: accusations of pineapple laborers of assault ("Massie affair"), 201n68; as allied with white men against alien others, 115; and racist tropes about interracial lust and anxieties about black masculinity, 82; and the visual vocabulary of the western frontier, 118

Whitman, Ed, 197n81

Wilder, Marshall P., 47

Wiley, James, 193n2

Williams-Forson, Psyche, 9, 82

wine: Florida orange, 51; watermelon, 76. *See also* grape cultivation; temperance movement

women: advertisements slanted to, 51, 149; as artists, restricted to the still life genre, 55, 91, 93, 171–72; as banana laborers, 106, 193n3, 195n37; and corporate expansion of bananas into Central America, 118, 119–20, 121, 135; the

domestic sphere and empire-building, 114–15; and Florida orange cultivation, 50–53, 66, 184n29; and grape cultivation, 26–27, 178n35; the Homestead Acts as providing land for, 51, 54, 98, 184n29; and naturalization/assimilation of the banana, 106, 113–15, 116–18, 125, 135, 195nn34,36,37,39; as pineapple laborers, 146, 150; and Reconstruction, 51–53; and tomato cultivation, 169–70, *170*. *See also* gender norms; white women

—IMAGES OF: as allegories of territorial expansion, 23, *24*, 118, *119*, 125; the female body and watermelon paintings, 73–74, *81*, 82, 90, *90*; in the grape industry, *25*, 26; in pineapple advertisements, and tropes of the exotic tropics, 152–55, *153–54*; in pineapple advertisements, white figures, 152–53, *154*, 156–57, *157*; supporting Hawaiian statehood, *164*, 165, 203n115; watermelon racial tropes as rarely depicting, 82, 189n31

Woodwon, Jacqueline, 192–93n87

world's fairs: new foods introduced at, 149; sculptures made of food, 3, *4*, 149, 174n6.

See also Alaska-Yukon Exposition (Seattle 1909); Columbian Exposition (Chicago 1893); grape industry and world's fair exhibitions; Panama–Pacific International Exposition (California 1915); Philadelphia Centennial (1876)

World War I: isolationist policies following, 122; pineapple industry losses during, 151

World War II: African American soldiers in, 203–4n120; food rationing and black markets during, 158, 159; Japanese pineapple laborers, downplaying of, 160, 161; Pearl Harbor, 158; people of Japanese and Chinese descent enlisting in the US military, 159, 160, 161; people of Japanese descent discriminated against and removed to internment camps during, 158, 160–61, 166; pineapple ads during, 158–61, *160*; pineapple workers enlisting in the US military, 158; tourism prohibited, 158–59; veterans of, and political ascendancy for people of Asian descent, 161–62; victory gardens and cannery laborers, 159, 202n90

Ziegler, Mel and Patricia, 131

CALIFORNIA STUDIES IN FOOD AND CULTURE

DARRA GOLDSTEIN, EDITOR

Founded in 1893,
UNIVERSITY OF CALIFORNIA PRESS
publishes bold, progressive books and journals
on topics in the arts, humanities, social sciences,
and natural sciences—with a focus on social
justice issues—that inspire thought and action
among readers worldwide.

The UC PRESS FOUNDATION
raises funds to uphold the press's vital role
as an independent, nonprofit publisher, and
receives philanthropic support from a wide
range of individuals and institutions—and from
committed readers like you. To learn more, visit
ucpress.edu/supportus.